MW00635052

James Longstreet and The American Civil War

The Confederate General Who Fought the Next War

Harold M. Knudsen, Lt. Col. (Ret.)

SB
Savas Beatie
California

Names: Knudsen, Harold M., author.
Title: The Civil War and General Longstreet: The Confederate General who Fought the Next War / by Harold Knudsen, LTC (Ret.).
Other titles: James Longstreet and the American Civil War
Description: California: Savas Beatie, [2022] | Includes bibliographical references and index.
Identifiers: LCCN 2019045463| ISBN 9781611214758 (hardcover) | ISBN 9781940669939 (ebook)
Subjects: LCSH: Longstreet, James, 1821-1904. | Longstreet, James, 1821-1904—Military leadership. | Generals—Confederate States of America—Biography. | Confederate States of America. Army—Biography. | Military art and science—Confederate States of America. | United States—History—Civil War, 1861-1865—Campaigns.
Classification: LCC E467.1.L55 K68 2022 | DDC 355.0092 [B] —dc23
LC record available at https://lccn.loc.gov/2019045463

First Edition, First Printing

SB

Savas Beatie LLC
989 Governor Drive, Suite 102
El Dorado Hills, CA 95762

916-941-6896
www.savasbeatie.com
sales@savasbeatie.com

Savas Beatie titles are available at special discounts for bulk purchases in the United States by corporations, institutions, and other organizations. For more details, please contact Savas Beatie, P.O. Box 4527, El Dorado Hills, CA 95762, or you may e-mail us at sales@savasbeatie.com, or visit our website at www.savasbeatie.com for additional information.

MIX
Paper from
responsible sources
FSC® C011935

Dedication

This is dedicated to the Confederate and Union soldiers and officers who fought the War Between the States. Loyal to either their States or Union in accordance with the Constitution as they understood it and how they were raised. Great Americans all.

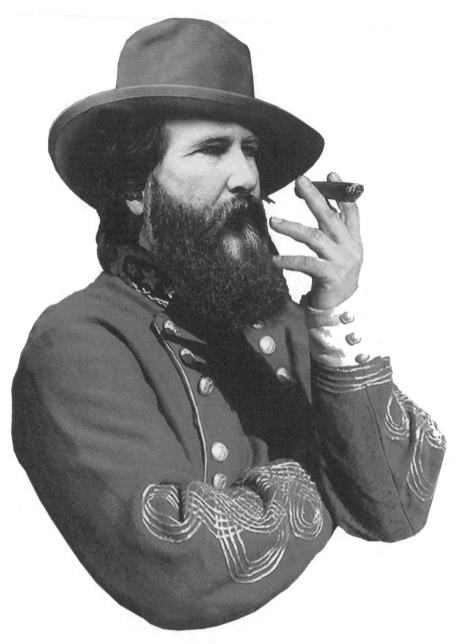

"Longstreet in Contemplation." *Ken Hendricksen*

Table of Contents

Table of Contents (continued)

List of Maps

List of Drawings

Preface

My first thoughts on the theme of General Longstreet as a "modern military thinker" during the War Between the States came to me at the Combat Maneuver Training Center in Hohenfels, Germany, 1988-1995. During these years, I was assigned to an infantry battalion as a forward observer and to two artillery battalions on a wide variety of locations. These units trained on dozens of offensive and defensive battle plans, a few of which approximated the troop dispositions arranged on similar terrain features at Fredericksburg and Chickamauga utilized by Lt. Gen. James Longstreet.

A few years later when I was assigned to the Headquarters Department of the Army Pentagon in Washington, D.C., I picked these thoughts up again. I visited the battlefields and started my research to intersect Civil War tactics with my own professional military education, experiences, and training. What I learned became the genesis for this book.

I used letters, reports, firsthand accounts, and so forth, to better understand Longstreet's actions and apply my own experiences to them. Therefore, this is not intended to be a biography of the general. My primary purpose and approach is to use the tools of the professional operational planner and experienced tactician as a prism or "overlay" to known historical facts, and thus better highlight Longstreet's evolving thinking. I believe an examination of his ideas through the lens of military analysis of this type provides strong evidence that he continued to improve his battlefield tactics, and that he also began to consider the planning facets of what is known today as operational art (the level of war above tactics). As a result, many aspects this study will not be found in other works.

The early war chapters discuss how the Confederate Army started as a collection of brigades, and how its various commanders had to learn how to put together larger formations and use them effectively. Readers will quickly discern that most officers had no idea of how important force structure concepts were (and are), and that Longstreet was one of the few who grasped this concept early on. Longstreet helped Gens. Joe Johnston and Robert E. Lee plan not only the battles, but helped form a quasi-modern army out of mid-19th century disorganization. At the same time, Longstreet evaluated what was working tactically through Second

Manassas, Sharpsburg, that culminated in a modern kill zone at Fredericksburg. The campaign into Pennsylvania chapters focus on planning oversights by General Lee that resulted in the early July battle at Gettysburg, while also introducing some of the operational concepts. These chapters also examine Lee's understanding of the combat arms in which he did not serve, and why Longstreet advised him not to attempt what he did at Gettysburg.

Later chapters examine the crucial afternoon events of September 20, 1863, at Chickamauga and the Chattanooga operations that followed through a continuation of my method of modern comparative analysis. I apply operational art to examine Longstreet's overlooked Bridgeport Plan, an idea he envisioned to seize Bridgeport, Alabama, and maintain the Confederate initiative. Although Gen. Braxton Bragg did not act upon Longstreet's suggestion and thus did not seize Bridgeport, an examination of the plan through the prism and contexts of modern mission analysis and operational art sheds new light on several aspects of the campaign. This study concludes with the campaign into Eastern Tennessee, where Longstreet encountered many difficulties (several of his own making) including a failed attack on Fort Sanders and logistical problems, his final outright battlefield success at the Wilderness, and the end of the war in April 1865.

It is my hope this look at General Longstreet's contributions by way of military analysis of various types sheds new light and demonstrates how his work in many areas became standard methods of war long after his life ended. I hope it helps to cast aside false conclusions about him that still linger, most of which stem from postwar Lost Cause politics. Lastly, it is my hope students of military history will find this work useful and easy to understand.

Acknowledgments

My twenty-five years of continuous active duty military education, experience, training, and use-of-planning methods in wartime and in peacekeeping operations is the foundation of my ability to analyze military history. My years with the 8th Infantry Division and 1st Armored Division were particularly helpful in this regard. I owe my foundation to those with whom I served, superiors, peers, and subordinates alike. These many mentors and practitioners of military decision-making have given me the experiences needed to understand the tactics, techniques, and procedures that make the United States Army the best it can be in war.

I owe a debt of thanks to my faculty at the Joint Forces Staff College, Naval Station Norfolk: Larry A. McElvain CDR, USN and Dave Diorio, and Dr. Keith

Dickson, section instructor. Their expert and professional instruction and training environment was a great experience for me to study operational art and operational design. Their method of applying the facets through a myriad of historical examples and in modern hypothetical scenarios, allowed me to achieve a level of understanding I was then able to apply to this book. Thankfully, the college's library contains a number of primary sources not found anywhere else.

I am indebted to members of the Longstreet Society for their constant encouragement in my work and in the continued study of the general. Richard Pilcher, President of the Longstreet Society, Joe Whitaker, Susan Rosenvold, and Maria Langonia. General Longstreet's great-grandsons, Dan Patterson and Clark Thornton, continue to be great friends who comprise this great organization, as do many others I have had the pleasure of meeting at the Piedmont Hotel in Gainesville, Georgia, for society events and projects.

I also thank my good friend Ken Henricksen of Maine, a renowned Civil War artist who created the unique cover art picture of General Longstreet.

Special thanks are due Dr. Bill Piston, a great friend, renowned Civil War historian, and Longstreet authority who assisted me in many ways over the years. Bill's guidance and azimuth check of my treatment of Longstreet is deeply appreciated. Thanks are also due Dr. John Marszalek, or the "cheerful assassin," as his students like to call him, who marked up one of my early drafts.

I owe a great debt of thanks to Theodore P. Savas of Savas Beatie for accepting my basic thesis on Longstreet and agreeing to publish my work. He provided the guidance of an experienced publisher and helped me make this a much better book. It was Ted who had the vision to expand my basic thesis and apply it to General Longstreet over the course of the entire war. Thanks are also due to his wonderful staff: Sarah Closson (media specialist), Sarah Keeney (marketing director), Lisa Murphy (accounts manager/marketing), Lois Olechny (administrative director), Veronica Kane (production logistics), and Lee Merideth (production manager). All of these fine people had a role in making this a better final product and demonstrated peerless professionalism throughout the process to completion.

I have gained many new professional acquaintances through Ted's efforts, such as Keith Poulter of *North & South Magazine*, the primary editor of my manuscript. Our nearly daily conversations about this history, often in minute detail, was thoroughly enjoyable. Keith is the ultimate editor: a pedantic about the English language who feels every angle is worth a discussion. Keith has a wealth of knowledge about the war and its participants. Jeff Prushankin also helped during the early editing of my manuscript and gave several important suggestions for

which I am thankful. Wayne Wolf served as copy editor, and Edward Alexander produced the outstanding maps.

Lastly, I would like to mention the late Ed Bearss who was my friend during the last three years of his life. Ed read much of this work in its early form and helped tremendously by checking historical accuracy. I enjoyed our talks about Longstreet and military history in general, and will never forget our road trip to Chicago. I wish he lived longer to see this work completed.

There are many other people I have met at the battlefields, in libraries, history centers, Civil War Round Tables, and in the towns and places mentioned in this book who taught me something of value. It is impossible to mention everyone, but they too were contributors to this book. I thank all of them.

If I left someone off this list, please know that I know you helped, and rest assured any oversight was unintentional.

Introduction

The Lost Cause

"Oh I'm a good old rebel, that's what I am . . .
I won't be reconstructed, and I don't give a damn."

— Innes Randolf, *A Good Old Rebel*, 1870

Edward A. Pollard, wartime editor of the *Richmond Examiner*, wrote a book in 1866 titled *Lost Cause*, thus coining the phrase that would forever be associated with the mindset of the secessionists. In a sense, Pollard's *Lost Cause* interpretations were the germ of a second religion for many in the South who were trying to make sense of the origins, conduct, and outcome of the war. This book did not attack Confederate Lieutenant General James Longstreet in any way; though as a matter of record it mentioned certain actions of his corps. Other historians followed with books and articles that fleshed out a growing complex doctrine of how the war was lost.

Attacks on Longstreet by Lost Cause proponents started when he established himself in New Orleans in 1867. During that year, Longstreet supported Congressional passage of the military reconstruction bills. The *New Orleans Times*, after soliciting Longstreet's opinion, confirmed that he did indeed endorse the legislation. Subsequently, Longstreet began to be criticized for failing to reject reconstruction.[1]

In 1872, Lost Cause rhetoric spread to Longstreet's war record, former Confederate general Jubal Early firing the opening salvo. Early sought to identify

1 William Garrett Piston, *Lee's Tarnished Lieutenant*, (Athens, Georgia: University of Georgia Press, 1987), 104. He also supported the 13th and 14th Amendments.

independence. Early's spin examined the errors at Gettysburg. He concocted the fallacious "sunrise order," concerning the second day, and saddled Longstreet with most of the blame for the repulse of the attack on the Union center on the third day of the battle.

Jubal Early had entered the postwar fray as a colossal hypocrite, following a checkered career as a corps commander. He had some successes in the war, but also made decisions that led to the destruction of an entire Confederate Army. This dubious distinction was something that Longstreet never suffered. Coincidentally, Pollard placed blame on Early in his analytical volumes on the war, the second of which spoke of "remarkable misfortunes," such as "The breaking of our line [Early's line] at Fredericksburg." The disintegration of Early's line prompted Lee to cease his pursuit of Hooker at Chancellorsville, and, according to Pollard "robbed us of a complete success." Such passages undoubtedly infuriated Early, who lamented the fact that "newspaper accounts and Pollard's abominable book furnished the main source of information" about the Confederate armies. Early became a strident advocate for Lee and critic of Longstreet, providing an alternative commentary on the war that was welcomed by the more defiant unreconstructed Rebels. Thus, a politically motivated attack on Longstreet entered into the literature of American military history. Early's attacks on Longstreet provided support for another aspect of Lost Cause mythology; the anointing of Lee to some sort of deity.[2]

By the 1880s the populist worship of Lee had gained considerable momentum. Lee he passed away in 1870, and thus did not have an opportunity to intervene and perhaps temper the generation of the fiction advanced by many former Confederate generals and Southern historians. The degree to which Lee might have stood up for Longstreet remains speculative. Lee believed as a general principle that a good leader is humble and should not engage in squabbling over credit or openly attack a peer for a mistake or failure. Nevertheless, had Lee lived longer, he most likely would have provided commentary that would have substantially curtailed the mudslinging. He probably believed that for Confederate military leaders to squabble among one another was to blemish the fine legacy of the Army's efforts and sacrifices.

2 Edward A. Pollard, *Southern History of the War: The Second Year of the War* (1863; reprint, New York: Charles B. Richardson, 1865), 262-263; Jubal A. Early letter to Jedidiah Hotchkiss, Mar. 24, 1868, Hotchkiss Papers, MSS2/H7973/ b/2, VHS.

Longstreet initially ignored the criticisms. The Lost Cause snowball kept growing, however, jettisoning unwanted truths and creating new myths to fit the popular explanations that evolved on the relationship between Lee and Longstreet. The truth about their relationship was that Lee valued Longstreet's counsel and methods, even if he did not follow his advice at Gettysburg. During the war Longstreet freely offered his views to Lee, even if they stood in opposition. Many observers noted Lee did not have a problem with this and in fact appreciated Longstreet's opinions, even if he did not always use them. After the war, however, and without Lee to support him, Longstreet was left alone to suffer incessant attacks on his record, and increased marginalization in the history of the South.

Arguably, the next colossus in the Lost Cause category of historical scholarship came in the lengthy works of William A. Dunning. Dunning, an historian and political scientist, published in the 1880s when the Lost Cause expanded into more and different facets. He built upon earlier writers and speakers like Pollard and Early and shaped the Southern view into the foreseeable future. The "Dunning School" of Civil War and Reconstruction history had established itself; its primary message was to acknowledge that the abolition of slavery was positive, but that slavery would have died out on its own. Dunning theorized that despite the moral argument that slavery was wrong, the Negro was still an inferior being, and was not capable of self-government, thus segregation of the two races was necessary. Northern intervention in Southern life was an evil, and the war was one of unprovoked aggression. Essentially, except for slavery, the Old South was a paradise of traditional feudal virtue. Its destruction was a political, social, and economic crime, committed by an aggressive Northern government guided by vindictive radicals, who subjugated the South through their policies and programs of Reconstruction. Dunning's work set the tone for the way many in the South understood the war and set a historiographical course of interpretation that lasted for a century.

Douglass Southall Freeman emerged as the next influential historian to advance the adoration of Lee. At the same time, Freeman expanded the anti-Longstreet distortions at a mostly subliminal level. Freeman, born in 1886 was a second generation Lost Cause disciple. He spent much of his boyhood in Lynchburg, Virginia, while Jubal Early lived in the city. Freeman shaped the literature of the Confederacy regarding Lee and Longstreet in the 1930s and 1940s, much as Early had in the late nineteenth century. As Lee's greatest literary champion, Freeman wrote multi-volume sets that established his worship of both Lee the general and Lee the man. At the same time, Freeman, ever so subtly diminished, maligned, and ignored Longstreet's innovations and contributions. As

a speaker at the Army War College, Freeman had some influence on an entire generation of twentieth century military thinkers. By advancing his perspectives, he denied these future leaders the lessons of Longstreet's innovations and their bearing on the development of warfare. Not only did Freeman deny credit to Longstreet for the great battles he won, he also tossed aside the general's modern methods. They remained lost for decades, until military necessity forced new generations to put them into use. One wonders what differences in the First World War and even Second World War might have occurred if the innovations and theories had evolved into a doctrinal form at the various United States Army schools for senior officers before these wars. Unfortunately, Longstreet's knowledge and lessons were lost, largely because he did not share the beliefs of Lost Cause ideology. Longstreet was a proud Southerner, a professional army officer and a gentleman who fought for his homeland for many of the same reasons Lee fought for Virginia. Yet, Longstreet had completely moved on from the notion of clinging to what they had lost. To him, the surrender at Appomattox decided things, and the South should move on.[3]

General Lee had officially surrendered the Army of Northern Virginia, accepting General Ulysses S. Grant's magnanimous terms, and that was the end. Longstreet had fought the war from Manassas all the way to Appomattox. He was there to the bitter end, fighting on as a corps commander in the Army of Northern Virginia even when it was whittled down to a small remnant of its former self. Both Longstreet and Lee were certain the cause was lost by the spring of 1865, and they knew better than any armchair critic that the Confederacy as a country had succumbed long before the defenses at Petersburg unraveled. President Jefferson Davis, relatively powerless even in 1864, presided over an inept body of representatives who rarely made decisions that helped the war effort. Richmond as a government at this late date was a façade, and the Southern economy was in shambles. All the remaining hopes for the cause lay with the Army of Northern Virginia and Lee. By 1865, Lee knew he had passed the point where further resistance against such disproportionate numbers and resources was no longer war, but senseless murder.

Longstreet too accepted the verdict of the battlefield. He owed no apology for defeat and thought all citizens must support the United States as a single entity. He decided to become a member of the Republican Party and supported equal rights

3 Gary E. Gallagher, *Lee and His Army in Confederate History*, (Chapel Hill, NC: The University of North Carolina Press, 2001), 263.

for the Negro. He was not concerned that the Republican Party was a metaphor for Union, and that "Solid South Democrats" would soon replace the Northern occupation power. Conversely, the Democratic Party became a metaphor for the division of the country and Lost Cause ideology. Thus, to someone who believed in Pollard or Dunning, Longstreet possessed the principles of a traitor.

Longstreet tried to fight back in the newspapers and magazines as best he could, but often not as ably and modestly, as he perhaps should have. As the years went by, he became bitter and frustrated with the pure fantasies created about the war. For example, the mythology about Thomas J. "Stonewall" Jackson, to wit that he was second in command to Lee, his "right arm," and star lieutenant. In fact, Longstreet's date of rank made him second in line to command the Army of Northern Virginia. At times Longstreet's wounded ego caused him to write and say things that only fueled his antagonists and their arguments.

Longstreet made statements that many of his critics perceived as faulting Lee. During a period of harsh criticism, Longstreet defended himself against the charge that he disobeyed Lee at Gettysburg, and that he was slow to get his assault underway on July 2, 1863, once his corps arrived. Many of Longstreet's critics asserted that he had not prepared his corps for the third day attack on the Union center either. They accused him of dragging his feet throughout the day in an effort to convince Lee of the plan's futility. This allegedly prevented an earlier attack, resulting in the repulse of Pickett's charge.

In more recent historiography of the second day, Longstreet is widely considered correct in his explanations. There is little evidence that perceived delays in Longstreet's assaults were due to hesitancy on his part. The time it took for Lee to decide a course of action, and then to correctly position the two available divisions was accomplished as fast as could be. In fact, Longstreet had already made his understanding known immediately after the war that he understood that Lee wanted to fight a defensive campaign in Pennsylvania, and then only if attacked.

Another great debate has focused on the third day. Critics such as Early believed Longstreet received instructions on the evening of the second day to make an attack in the morning of the third day. Lee actually did not tell Longstreet to attack until that very morning, and his lieutenant tried to prove this through letters he had saved that Lee purportedly wrote several months after the battle. In one, Lee confessed that he should have listened to Longstreet and that the situation might have been much better had he not attacked on the third day. However, Longstreet only mentioned this letter decades after the war, and never showed it to anyone. A fire in Longstreet's Georgia home on April 9th, 1889, probably

destroyed this letter along with most of the general's papers. Ironically, the fire took place on the twenty-fourth anniversary of Lee's surrender at Appomattox. In any case, the content of the letter may have been taken out of context by an aging and angry Longstreet, who was certainly looking for evidence to refute the incessant attacks on his war record.

Most importantly, regardless of Longstreet's story on the timing of Lee's decision at Gettysburg, Longstreet was correct that 15,000 men could not cross that open field and break the defensive line the Union had established behind a stonewall. This was the lesson of Malvern Hill: modern weapons had swung the advantage from attacker to defender, making frontal assaults costly and often futile. Lee acknowledged the reality of this truth after Gettysburg and accepted the blame immediately. As the commanding general, Lee never blamed his subordinates for Gettysburg. He chose the spot, and he ordered the attack. But, to a proponent of the Lost Cause, Lee was always right. Therefore, Longstreet was deemed wrong for not having enthusiastically supported Lee's decision to launch a frontal assault against Cemetery Ridge. Much Lost Cause misperception abounds, including criticism of Longstreet's attempt to convince Lee to disengage from the Union positions at Gettysburg. Longstreet suggested the army continue to maneuver until they found a stronger position, with terrain suited to a defensive posture such as the army held at Fredericksburg in December 1862.

Regardless, Longstreet was not insubordinate at Gettysburg, nor was he a lesser general fumbling through the preparation for an operation that he was unsuited to turn into a success, as some historians have suggested. Longstreet knew the attack would fail before it commenced. He saw the Union advantage as plain as day—the Army of the Potomac (AOP) held a strong defensive position behind a stone wall, and this was the same advantage the Confederates used against the attacking Union Army at Fredericksburg. Moreover, Federal soldiers had been preparing the position and making improvements since the second of July. Longstreet's unique respect and understanding of the power and range of the weapons of the time enabled him to see this. Even the support of massed artillery and the attempt to get the infantry close to the Union line by executing a sequence of obliques (instead of walking straight in as Burnside had done at Fredericksburg) would still have left the Confederate attackers in the open, exposing them to murderous fire for more than enough time to decimate them. He sensed Lee was becoming anxious in the last days of June. Nothing had been heard from the larger portion of this cavalry corps. The lack of routine timely intelligence on the whereabouts of the Union Army left him blind for several crucial days, and Lee did not utilize the cavalry he had retained. Lee's anxiety was intensified by the fact that

he was operating on unfamiliar ground, and perhaps this caused him to accept the long odds of a battle to destroy the Army of the Potomac.

Once contact was made with the AOP, he abandoned his plan to avoid it, and was sucked into a battle over a place of no use to him. By the third day, he gambled with extreme odds in a reckless frontal assault, after two days of inconclusive fighting. As Longstreet stated in his memoir *From Manassas to Appomattox*, "(Lee) knew that I did not believe that success was possible, that care and time should be taken to give the troops the benefit of positions and grounds."[4]

Lee was truly a gifted and able commander, he had many strengths that made him a great commanding general, but he did not think about this modern aspect of a defensive advantage in the way Longstreet did. Longstreet's clarity on this new aspect of war was the lesson of Fredericksburg, where he had inflicted a costly defeat on the AOP. He perceived that a similar disaster loomed for his own troops at Gettysburg if they tried to attack a similar position to the Confederate strongpoint on Marye's Heights at Fredericksburg. He knew how to set such conditions and saw what would happen on a larger scale at Petersburg and on a continental scale fifty years into the future in the trenches of World War I in France. Longstreet clearly envisioned some of the methods of early twentieth century land warfare.

It is important to understand that what happened to Longstreet's legacy was the result of postwar politics and subsequent historiography that sullied his reputation as an advanced military thinker. This was the result of several dynamics within the theory of the Lost Cause intersecting. The postwar canonization of Lee to a Christ-like figure required a meticulous manipulation away from the basic conclusion that the loss at Gettysburg was Lee's responsibility. The notions that Lee was a flawless deity but was also responsible for the failure at Gettysburg were mutually exclusive. Consciously and unconsciously, directly and indirectly, the events at Gettysburg would have to be reinterpreted and retold so that they absolved Lee of any error of judgement and provided a better fit with Lost Cause theory. Lost Cause ideologues had to shift the blame and found it convenient to shift it to the one senior leader present at Gettysburg who questioned Lee, who did not embrace the Lost Cause, and was now in league with the Grant administration and the Republican Party. Longstreet became the perfect scapegoat.

4 James Longstreet, *From Manassas to Appomattox*, (Philadelphia, PA: J.B. Lippincott Co., 1896), 388.

The erroneous blame for Gettysburg created an inaccurate assessment of Longstreet's abilities and insights. Once the fog of the Lost Cause and the prejudices of Early, Dunning, and Freeman are lifted, and one examines Longstreet strictly according to how he applied the art and science of war, a rich military history emerges. Examination of Longstreet from a vantage point of modern method that set him apart from his contemporaries is largely unexplored, and long overdue.

To classify Longstreet's way of war as "modern," as early twentieth century methods introduced in the middle of the nineteenth century, one must establish an understanding of how he broke with the Napoleonic era practices current at the time. Military professionals know the smallest variations in tactics can make the biggest difference. Moments and seconds matter when it comes to synchronizing an attack or volley of fire. Longstreet made such adjustments to the known tactics, techniques, and procedures of his day and proved that his adjustments were decisive modernizations in nineteenth century warfare. His innovations became even more significant with the widespread introduction of repeating rifles and eventually the machine gun (by the time of the First World War). Perhaps today, the notion of earthworks as an advantage is obvious, but it was not obvious to many officers who were students of Napoleonic tactics and had not fully grasped that the lethality of weapons had increased. Napoleon relied primarily on maneuver; he rarely dug in, because he demonstrated that the tactical offense was generally dominant. Many had not grasped in the 1860s that modernity had also brought changes in operational maneuver. Thus, while the tactical defense was generally dominant in the American Civil War against a direct approach attack over open ground, *maneuver* was the key against a strong dug-in defensive advantage. Longstreet understood this.

Chapter 1

The American Understanding of War
From Early Republic to Secession

"I recollect well my thinking; there is a man that cannot be stampeded."

— Fitzhugh Lee on Longstreet at Blackburn Ford

In the years leading up to the Civil War, the United States Army was small and, apart from those who had participated in the Mexican War or in actions against the Indians, most had no combat experience. By 1861 the last major conflict (the war with Mexico) was fifteen years in the past. There was only one remaining general who had commanded as many as 20,000 or more troops—the aging Winfield Scott. Although he had extensive experience as a commander in the field and had received a brevet promotion to lieutenant general in 1855, Scott was too old and infirm to assume a field command in 1861. The US Army was simply devoid of leaders, or anyone for that matter, with formal training in the operational arts. No one had the previous experience necessary to command the larger formations that would take to the field during the Civil War.[1]

Immediately after the Revolution, the Continental Army had an officer corps that understood strategy at the army level. Much of this expertise was subsequently lost, however, as the experienced generals of the period left the service or passed away. Congress did not maintain a large standing army where generals could practice command of large numbers of troops. Moreover, there was no school for

1 Only 125 of the 425 Confederate officers who would rise to general were professional soldiers before the war. Thomas L. Connelly and Barbara L. Bellows, *God and General Longstreet: The Lost Cause and the Southern Mind* (Baton Rouge: Louisiana State University, 1982), 89.

officers of the rank of major or above to study the art and theory of war in the classroom.

The only educational bright spot occurred during President Thomas Jefferson's administration. The president saw the need for university-level education for Army officers and established the United States Military Academy at West Point. The primary focus at West Point was tactical-level training for junior officers. This approach fit Jefferson's vision of western exploration and security requirements in new territories. The training did not address components of large-scale land warfare.

The educational system for officers during the antebellum decades gave a new second lieutenant a decent foundation to lead a detachment of cavalry, several sections of artillery, or several dozen infantry soldiers. It also provided technical training in artillery and engineering. Once commissioned, a young lieutenant served under a veteran captain, who had experience leading the company or battery and would mentor a lieutenant on the expectations of advancement to the next level. However, both the lieutenant and captain were company-grade officers who had tactical unit level duties. Their day-to-day world seldom required an understanding of the higher level planning conducted by colonels and generals. The purpose of officer training during the first half of the 1800s was to develop company and battery commanders, not masters of the operational art of war.[2]

The Operational art of war interrelates tactics and strategy as an area of study for established career officers who command larger units. As a stand-alone concept, it was non-existent in the antebellum United States military. Senior captains, majors, and colonels had to build intuitively upon what they saw and experienced as junior officers.

Jominian Theory

What cadets at West Point did study was the interpretation of Napoleonic warfare from the mind of Swiss military theorist Henri Jomini. Although he offered his ideas on various theories of war, the preponderance of Jomini's work consisted of procedures for how to array troop units—the common variations of line and column formations Napoleon had employed, which Jomini put into still finer geometric shapes. American military theorists translated the Jominian playbooks in

2 Piston, *Lee's Tarnished Lieutenant*, 5.

the early nineteenth century and laid out these formations from the squad up to battalion level, including the movement of multiple battalions.

American theorist Dennis Mahan, who was the Dean of Military History at West Point in the 1830s, believed in Jominian organization and the methods of Napoleon. During his tenure at West Point, Mahan took these ideas, distilled them to his own liking, and drilled this combination into all of the cadets. James Longstreet and the members of his Class of 1842 were familiar with the campaigns of Napoleon, well versed in the basic drill of the battalion, and knew how commanders moved battalions.

This particular area of study for cadets changed little as antebellum officers moved up in years and rank. Variations on the Jominian formation, as interpreted by Mahan, were a facet in the overall understanding needed to conduct battles and campaigns. But the big picture at the operational and strategic level remained untouched. For example, a major at the start of the Civil War was nearly twenty years removed from his education as a cadet. His understanding of how to maneuver a large formation was dated, and most officers did not compensate for the extended ranges of the new weapons available in 1861. Faded recollections of classroom teachings on Napoleonic battles and the Jominian crafting of lines and columns did not prepare the average Civil War officer for battle planning or strategy. Those who were to become effective battlefield leaders to adjust quickly in order to master the modern battlefield.

Longstreet was no exception. He learned quickly in combat, however. His first tactical experiences were with the offensive. He participated in the battles of Resaca de la Palma, Churubusco, and Monterey in Mexico and witnessed firsthand that attacks were successful when carried out resolutely. Leadership and planning mattered and would defeat a prepared defense that lacked strength of leadership. At the battle in El Molino del Rey, however, Longstreet's unit was part of an attack against a heavily fortified structure called Casa Mata. The defensive preparations were thorough and Mexican leadership confident. The Americans were thrown back with heavy loss. The retreat was such a rout that Mexican forces felt confident enough to launch a counterattack.[3]

Longstreet did not forget this bitter lesson, which dashed any notion he may have held that frontal assault was supreme in all situations. He realized that in war,

3 Emma Jerome Blackwood, ed., *To Mexico With Scott: Letters of Captain E. Kirby Smith to His Wife* (Cambridge: Harvard University, 1917), 202-203; Justin H. Smith, *War with Mexico* (New York: The MacMillan Co., 1919), 145-146.

the mechanics boiled down to bringing decisive firepower to bear against your enemy more effectively than he can against you. Firepower in the nineteenth century referred to the aggregate lethal effects a unit of infantry, battery of cannon, or a combination of both could employ against a person, unit, or object. Firepower—the simplest common denominator of warfare—could be enhanced by numerical superiority, maneuver, or the use of cover and concealment. The right combination of firepower, maneuver, and use of terrain or man-made cover at the right place and time ensured the application of decisive firepower.

As a result of the improvement of weapons over those of the Napoleonic period, combat in the Civil War almost always demonstrated that a line formation behind earthworks had a great advantage over a line formation in the open. A defender covering an open area where range to target is optimal, and taking advantage of high ground, walls, buildings, or earthworks, made the defender's position extremely difficult to overcome.

In 1861, however, many military thinkers remained steeped in Napoleonic theory and were caught "fighting the last war." Their understanding of warfare remained Napoleonic both in a tactical sense as it pertained to maneuver, and in the technological sense as it pertained to the application of firepower. Both Jomini and Mahan believed in the direct approach tactical offensive, i.e., that vigorous charges will overcome defenses. The rifles of the Napoleonic era were accurate to only about eighty yards. Thus, after the defender fired an initial volley, the attacking force could initiate a bayonet charge while the defender reloaded. At that close range there existed a high likelihood that the attackers would close on the defenders, which increased the odds of offensive success. Élan and leadership within the attacking force often prevailed over an entrenched defender. Commanders emphasized this sort of thinking to a great degree, while aspects of how and when to utilize defenses received scant attention. While there were a few lopsided massacres, such as the Battle of New Orleans in the War of 1812 and costly assaults like those launched at the Battle of Bunker Hill in the Revolution, the direct approach remained dominant during this era.

During the Civil War, however, many officers failed to recognize that the range and accuracy of modern weapons were much greater than during the time of Napoleon. In the 1850s, the transition from smoothbore to rifled weapons, which could strike a man as far away as 600 yards, significantly increased the tactical defense and made it superior to the direct approach tactical offense. Some who appreciated the improvement in the range and accuracy of firepower still did not understand that an increase in range required a change in thinking about how to successfully engage the enemy. The eighteenth-century way of employing line

formations remained prevalent, and much blood was be shed before the increasingly outmoded methods were discarded.

War Comes to America

The decades preceding the Civil War saw a continuance of the widening gulf both culturally and economically between North and South. Industrialization proceeded more rapidly in the North, while Deep South states were characterized by large cotton plantations worked by slave labor. Politicians and newspapers of each section demonized the other, and many Southerners resented the moral condemnation of slavery. The population of the North was also growing much faster, undermining the South's early political dominance, as representation in the federal government gradually became majority Northern.

The emergence of the Republican Party in 1854 exacerbated the sectional tension, and when Abraham Lincoln—seen as a sectional leader of the Northern Republican states only and committed to the exclusion of slavery from the territories—was elected president in November 1860, five Deep South states seceded, followed shortly after by those of the Upper South when Lincoln called for troops from them.

At the beginning of the secession crisis Longstreet was still a major in the US Army stationed in New Mexico. Asked by a fellow officer how long he thought the impending crisis would last, he replied "At least three years, and if it holds for five years you may begin to look for a dictator." Whereupon a lieutenant rejoined, "If we are to have a dictator, I hope that you may be the man."[4]

As the crisis unfolded, Longstreet hastened east, met with Confederate president Jefferson Davis at the Executive Mansion in Richmond, and was offered a commission in the Confederate Army with the rank of brigadier general. On July 1 he received orders to report to Major General Pierre Beauregard at Manassas Junction, Virginia.[5]

In Washington, Major General Irwin McDowell, was ordered to take his recently recruited army south and capture Richmond. Rebel troops blocked their path at Bull Run Creek. McDowell's initial intention was to move around the Confederates' left flank, and he ordered Union divisional commander Brigadier

4 James McPherson, *Battle Cry of Freedom* (New York: Ballantine Books, 1988), 251-252; Longstreet, *Manassas to Appomattox*, 30.

5 Longstreet, *Manassas to Appomattox*, 32-33.

General Daniel Tyler to reconnoiter the area. Tyler exceeded his orders and pushed one of his brigades toward Manassas Junction in an effort to determine Confederate strength barely visible behind the creek. This brought on a fierce engagement with the Confederate brigade guarding Blackburn's Ford, commanded by Longstreet. Although he was a Brig Gen., Longstreet was cloaked in civilian clothing because he had not yet secured a Confederate uniform. A soldier in the 17th Virginia later remarked "General Longstreet seemed to be everywhere, regardless of danger, and unconscious of what a conspicuous mark he presented to the enemy."[6]

Blackburn's Ford dipped about fifteen feet below the banks on either side of the winding and heavily wooded Bull Run Creek. Confederates challenged the approaching Union troops, and when a Union officer responded by identifying his unit as Massachusetts men, the Confederates opened fire. The engagement lasted about an hour and stopped Tyler's advance cold. After losing eighty-three men Tyler disengaged and withdrew toward Centreville. Longstreet's naturally strong position allowed his soldiers the opportunity to pour fire down into the ranks of the advancing Union force attempting to cross the stream. There was flat front on Longstreet's side of the stream and he had concealed his men from the view of the approaching Federals by positioning them behind a thin line of trees. The result was a more reckless advance than might otherwise have been attempted by men aware of Confederates massed to their front. The position also gave Longstreet the opportunity to take advantage of interior lines by adjusting his troops smoothly and with a degree of stealth. By using a thin observation line of scouts far out in front and positioning reserves to take advantage of the interior lines the location afforded him, Longstreet shifted reinforcements forward to strengthen any part of his line with equal speed and facility. This excellent defensive position provided a quick small-scale lesson in the advantageous use of terrain.[7]

Longstreet had remained mounted during the fight directly behind the 17th Virginia Infantry, where he heard one private ask another, "I wonder what they

6 "The Battle of Bull Run," *Richmond Dispatch*, August 3, 1861. The paper identified the writer as "an eye-witness."

7 Lieutenant Colonel D. B. Sanger, "Was Longstreet a Scapegoat?" *Infantry Journal*, 43: 1, (1936), 48-57.

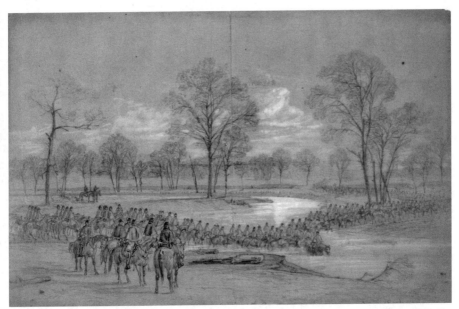

Union troops crossing Blackburn's Ford unopposed, March 1862. General McClellan and staff in foreground. (Alfred R. Waud. *Library of Congress Prints and Photographs Division*)

expect us to do here?" Longstreet told the soldiers that he expected them to keep the enemy from crossing the creek.[8]

This first engagement of the first major battle of the Civil War did not require Longstreet to make any major troop movements. It did, however, provide Longstreet an opportunity to determine how best to array his troops in a defense of this sort. What he came up with was a true mobile defense on a small-scale, and a method that became doctrinal in the twentieth century when the mobility of motorized and tracked vehicles required defenses to become more flexible.

8 Edgar Warfield, *A Confederate Soldier's Memoirs* (Richmond: Masonic Home Press, 1936), 48-58.

Chapter 2

The Peninsula Campaign

"Longstreet is a Capital Soldier."

— General Lee, June 7, 1862

Following the battle of Manassas, Longstreet's Brigade was ordered to a position at Centreville, with strict orders not to advance any further. Alexandria was strictly off limits. President Davis wanted to make no provocation that the Union authorities might interpret as a threat against Washington, DC, in the hope they might suspend hostilities after their defeat.[1]

McDowell was fired by President Lincoln, and Major General George B. McClellan, replaced him on July 26, 1861. A lull of eight months in the East followed the July 1861 battle of Manassas (Bull Run), as a front developed in northern Virginia. Confederate General Joseph E. Johnston's army headquarters was located at Fairfax Court House for much of the fall, as works were dug, signal stations established, and extensive training conducted. General Robert E. Lee had

1 Longstreet, *Manassas to Appomattox*, 59. The Union would also lose the first battle in the west on August 10, 1861, at Wilson's Creek, Missouri. This battle, sometimes referred to as the 'Bull Run of the West,' was of similar geographic scale. Although the number of troops engaged was smaller, the casualty rate was higher, and the battle also claimed the life of Union General Nathaniel Lyon.

surveyed Williamsburg in July and advised a "line of defenses across the Peninsula."[2]

Union success in 1861, came mostly in the form of the naval blockade taking shape along the Confederate eastern seaboard and the Gulf of Mexico. On land, the Confederacy lost control of western Virginia. Vehement secessionist politician Henry A. Wise, now a Confederate officer operating with militia in the region, wrote in August to Robert E. Lee that entire counties were to their cause: "wholly disaffected and traitorous."[3] A few other seceding states, such as Tennessee and Arkansas, also contained areas resistant or ambivalent about leaving the Union.

In the Virginia theater, the Confederate effort focused on the defense of the larger eastern portion with their new national capital at Richmond. The two armies built various fortifications opposite each other in the state throughout the Fall of 1861 and wintered in them into 1862.

In February, 1862, Lincoln got a boost from the taking of Forts Donelson and Henry by Brigadier General Ulysses S. Grant in the Kentucky-Tennessee theater. Grant took an estimated 12,000 Confederates prisoner and then commenced a river-boat campaign south through Tennessee. His objective was Corinth, Mississippi. In March, Gen. McClellan began his own joint naval-land operation. He moved his army by sea to the tip of the Virginia Peninsula, intending to surprise the enemy, move quickly inland, and capture the Southern capital. Longstreet spent much of January in Richmond at the side of his gravely ill children. He returned to the army in February, after he and his wife had endured the loss of their one-year-old baby girl, and two boys, aged four and thirteen, from a scarlet fever epidemic. In March, Longstreet, now commanding a division in Johnston's army, moved with it from northern Virginia to the Peninsula.[4]

2 Porter E. Alexander, *Fighting for the Confederacy: The Personal Recollections of General Edward Porter Alexander* (Chapel Hill, North Carolina: University of North Carolina Press, 1989), 64-65; *The War of the Rebellion: A Compilation of the Official Records of the Union and Confederate Armies*, 128 vols. (Washington, DC, 1880-1901), Series 1, 2/2: 979. Hereafter cited as *OR*. All references are to Series 1 unless otherwise noted.

3 Henry A. Wise, *OR*, 2/2: 1011-1012.

4 U.S. Grant, *OR*, 7: 124-125; Jeffry D. Wert, *General James Longstreet, The Confederacy's Most Controversial Soldier* (New York, Simon & Schuster, 1993), 96-97; James M. McPherson, *Battle Cry of Freedom*, (Oxford: Oxford University Press, 1988), 402. McPherson states in a note that no accurate official count of captured was made, but it is known from records that about 1,000 wounded were evacuated prior to surrender, about 2,000 broke out with Forrest, and possibly 1,000-2,000 later walked out through the porous Union lines, putting losses around 12,000 out of 17,000 defenders.

McClellan landed his forces near Ft. Monroe, and advanced toward the Confederate line that spanned the peninsula. This line ran south from the York River, incorporated some of the old Revolutionary War works at Yorktown, and included new redoubts that stretched to the James River. McClellan's opening advance slowed outside the Yorktown-Warwick River section of the line. Some clever ruses of constant movement by small Confederate units persuaded McClellan he was facing large numbers of Confederates in strong defensive positions, and the ruses used up a month.[5]

This allowed Johnston to complete the shift of his army from north-central Virginia down to the Peninsula. He deployed the divisions of Longstreet and Major General D. H. Hill forward with Brigadier General John B. Magruder, who was already holding the line at Yorktown and along the Warwick River. Longstreet was the senior of the three. Although no major battle occurred, this defense was Longstreet's first experience with limited tactical control of three divisions when Johnston was not present.[6]

Johnston realized that McClellan was going to use his considerable heavy siege artillery to bombard the Confederate line before launching an infantry attack. Before the Union artillery preparation began, however, Union scouting parties found the entire line abandoned. Johnston intended no decisive engagement until closer to Richmond. The Yorktown line had served its purpose—delay.

As the Confederates withdrew, Johnston ordered a stand at Fort Magruder near Williamsburg, on May 5. The night before, Johnston instructed Longstreet (moving through Williamsburg) to send a brigade back to relieve the troops at the fort. Longstreet sent the small brigades of Brigadier Generals R. H. Anderson and Roger Pryor. Union Brigadier General Joseph Hooker reached Ft. Magruder the morning of May 5, and assaulted it at 07.30 am. Longstreet, in Williamsburg when the assault started, rode to the fort, and sent word to D. H. Hill to send one of his brigades to assist in the defense. Longstreet checked the situation at Ft. Magruder,

5 Longstreet, *Manassas to Appomattox*, 66-71. The Confederate line anchored to Yorktown, faced southeast, and was initially manned by about 13,000 men under Magruder against 100,000 Union troops. Later, arrived the divisions of D. H. Hill on the left nearest Yorktown, Longstreet in the center, and Magruder shifted to the right.

6 Ibid., Longstreet's date of rank to Major General was October 7, 1861, which made him senior to D. H. Hill and Magruder and made Longstreet the officer in charge of the Yorktown line in April when Johnston was absent. The Reserve Division, commanded by Major General Gustavus Woodson Smith, was located about three miles behind Longstreet. Smith's date of rank was Sept 19, 1861, which was earlier than Longstreet's, but he had no combat leadership experience yet in this war.

and satisfied with the repulse of Hooker's attack, went back to his headquarters to direct operations from there and ensure the army's trains cleared the area safely. This was the first time Longstreet fought as a division commander, wielding his own brigades in battle, and directing units from another division under his tactical control. In this situation, he was the senior officer in the rear area of the army. He was responsible for fixing the enemy, seeing to the safe passage of the army's trains, and maintaining situational awareness of the larger picture.[7]

In the late morning, Johnston arrived at Longstreet's Headquarters to check on the movement of the rear of his army, and the recent actions. Brigadier General Jubal Early's brigade, of Hill's Division, had moved in as requested by Longstreet earlier in the day. Early sent an officer to Longstreet's HQ, requesting permission to assault a Union battery that was firing on Ft. Magruder from the north-east. Longstreet handed it to Johnston, who authorized it, but urged caution. The inexperienced Early was about to make a costly mistake. A civilian lawyer before secession, now in command of a brigade, Early attacked what he thought initially was a lone battery but was in fact a full brigade in a "well developed front," deployed by a military professional: Brigadier General Winfield S. Hancock. Early's attack, with less than a full brigade, was repulsed with heavy losses, and he was wounded. According to Johnston, after the attack on Ft. Magruder was repulsed, Longstreet counter-attacked and swept Hooker's Division some distance from the fortifications. This enabled the Confederates to withdraw without further harassment.[8]

Johnston stayed with Longstreet for several hours, but other than authorizing the attack by Early, he left the handling of the battle to Longstreet. In fact, he wrote in his report that he was a "mere spectator, for General Longstreet's clear head and brave heart left me no apology for interference." Johnston had full confidence in

7 Longstreet, *Manassas to Appomattox*, 73-80; Joseph Hooker, OR, 11/1: 465-466; Joseph E. Johnston, *Narrative of Military Operations Directed During the Late War Between the States* (New York: D. Appleton and Company, 1874), 120-126. In this rearguard action, Longstreet had what is termed TACON (tactical control) of Early's Brigade from the division of D. H. Hill, also the army's cavalry. See J.E.B. Stuart, OR, 11/1: 571.

8 Johnston, *Narrative of Military Operations*, 122; Winfield S. Hancock, OR, 11/1: 533-543. Hancock had four regiments online plus fire support in a seamless front. Early attacked with three regiments disparately. Hancock's massed fire power was overwhelming against the disjointed Confederate effort. Hancock reported the 5th North Carolina regiment was "annihilated." Hancock was commissioned in 1844, he had no break in service, plus Mexican War combat experience.

Longstreet's abilities to control the battle, cover the trains' movement west, and take responsibility for the tactical and operational control of the rear of the army.[9]

Following the rearguard action at Williamsburg, Johnston resumed moving closer to Richmond, where he wanted to make his stand. On May 15, everything was behind the Chickahominy River, as McClellan followed slowly. It took some ten days to travel about fifty miles from Williamsburg to the outskirts of Richmond in the swamp-filled Peninsula.

President Davis was alarmed that the army was just outside the city limits, but Johnston was probably right to move his army closer to Richmond. There was also a sizeable Union force at Fredericksburg under McDowell, which might come south and cooperate with McClellan. If Johnston was still out on the eastern part of the peninsula, McDowell's force could conceivably threaten Richmond and his rear. Terrain difficulties would make timely escape east for Johnston not so easy, as the movement he had just accomplished proved.

Union forces crossed the Chickahominy on May 20, at what is known today as Bottoms Bridge. Two of their five corps went across, and then torrential rains fell on May 30. The water level in all the swamps rose, as did the Chickahominy River, splitting the Union Army as it faced west toward Richmond. Most of the Chickahominy bridges washed out, and the links between the two Union wings were not adequate for one to reinforce the other if needed. Johnston saw an opportunity to strike the two Union corps on the south side of the river. He had received reinforcements from North Carolina and three brigades from Norfolk, bringing his army to 75,000. He thus had numerical superiority over these two isolated Union corps.[10]

Johnston and Longstreet planned an attack for the morning of May 31, starting against the Union corps at Fair Oaks Station (Seven Pines), while Major General A. P. Hill would press the Union forces north of the river to distract them. Longstreet, in tactical control of two-thirds of the army in this main attack, would assault with six brigades, Major General D. H. Hill with four, and the three-brigade division of Major General Benjamin Huger would support. They had three roads—one per division. However, (according to Longstreet) his road was obstructed by the flooding of Gilley's Creek, which he hurriedly forded by sinking a wagon,

9 Longstreet, *Manassas to Appomattox*, 80; Johnston, *OR*, 11/1: 275; Longstreet, *OR*, 11/1: 564-568. Longstreet wrote in his report that Johnston "with his usual magnanimity, declined to take command" of the operations.

10 McPherson, *Battle Cry of Freedom*, 461; Longstreet, *Manassas to Appomattox*, 87.

emplacing boards over it, then filing his division across. This took him to a lateral road and onto the road intended for Huger, which blocked Huger, who then never got into the attack. Huger had only received dispatches from Johnston with orders limited to his units. This left him inadequately informed of the overall operation; the other units' movements, distances traveled, and timing. Huger was then read into the operation by Longstreet when they met, but Huger lingered past noon. His reason for not joining the battle after Longstreet's Division passed the ford is unclear. Johnston, in his memoir, stated that Huger's men had previously only performed garrison duty, and were too slow in their movements in the difficult terrain. Each record left by the Confederate leaders differs on what exactly happened and what went wrong, but the known result was that only a portion of the Confederate units attacked, so mass was not achieved. D. H. Hill understood his role exactly, and his execution was successful, pushing back the Union forces in front of him. Once joined by Longstreet's men, the attack became stronger, but the looked-for rout of two Union corps was not remotely achieved. The misunderstandings, between Johnston, Longstreet, and Huger foiled what was in the opinion of Porter Alexander "an opportunity for one of the most brilliant strokes in the war." The misunderstandings might have been prevented by conducting a sound leaders' rehearsal on May 30, *particularly one inclusive of Huger* who was new to Johnston's army and uncertain about the overall concept of the operation and chain of command. Alexander's observation is supported by a Union soldier who wrote a few days later: "May 31st, we had not the slightest idea of danger being near till about noon when very heavy fighting broke out from the woods West of us. . ." Surprise seemed to belong to the Confederates, but they lost the benefit of it attacking at partial strength.[11]

Johnston's army was still transitioning from a brigade-centric structure to a divisional one. It was not yet completely built around formal division structure with

11 Johnston, *Narrative of Military Operations*, 132-140; Longstreet, *Manassas to Appomattox*, 87-101; Porter Alexander, *Fighting for the Confederacy*, 83-91; Johnston, *OR*, 11/1: 934-935; Huger, *OR*, 11/1: 935-936; Longstreet, *OR*, 11/1: 939-941; D. H. Hill, *OR*, 11/1: 942-946; Wert, *Longstreet*, 118-119; Stephen Sears. Ed., "Henry Ropes to William Ropes, June 3, 1862," *The Civil War in the Second Year*, 233. General Huger's three brigades were not yet trained field soldiers. Hastily organized into infantry brigades to reinforce Johnston's army, most were garrison troops from Norfolk, Virginia, while others were North Carolina militia. Huger himself was inharmonious at the meeting with Longstreet. He fussed over his date of rank and Longstreet's, rather than the mission. Longstreet then offered to relinquish tactical control to Huger, but Huger turned down the chance. Lee would later transfer Huger out of the ANV, considering him disagreeable, with too much of an old army penchant for placing personal honor, entitlement, and reputation above the mission at hand.

permanently assigned organic brigades and direct support artillery. Since Manassas, the army had fought in an *ad hoc* fashion. In each engagement, different pairings of brigades occurred; putting them together in larger proven formations was still wanting. Longstreet and D. H. Hill were division commanders, and further along in this thinking, but the army as a whole was not. Magruder's Division was commanded by a one-star general on May 31, and Smith had resigned from the old US Army in 1854, when still only a lieutenant. He was wholly unqualified to have been directly commissioned a major general. Add to this the masses of completely green troops, such as Huger's brigades, newly formed into a provisional division. They were deficient in division-level maneuver. Yet the size and scope of attack Johnston had planned with Longstreet was corps-level with multiple divisions, which they had not attempted before. Some of the problems in execution might have been improved with good map rehearsals and use of guides on the assigned roads. However, without close coaching, teaching, mentoring, of all key leaders, without staff supervision during execution, the planned operation was overly complex for a first time, corps-sized offensive. Modernity of organization and method had not yet emerged in the Confederate army.[12]

Johnston was severely wounded near the end of the fighting, which continued through June 1. Command fell to Smith the night of May 31, and into the morning of June 1, but then Jefferson Davis appointed Robert E. Lee, his military advisor, to command the Virginia army. Lee arrived at the army's headquarters a little after noon on June 1, to assume command. He was not a combat arms branch officer, but he had over thirty years of active commissioned service, and was highly regarded for his calm, dignified military demeanor. Union General Montgomery C Meigs, had said in 1837 that he was a "model of a soldier, and the beau-ideal of a Christian." Among his many talents, he was outstanding at organization, could sift through huge amounts of data, and "could work with difficult people." Jefferson Davis seemed to have made an excellent choice at this hour with Robert E. Lee.[13]

Lee went straight to work, starting with an assessment of the army. He sized up his officers, and the troops' morale. He issued orders to the division and brigade commanders that rest, food, and ammunition distribution were the immediate tasks in the wake of the battle. Readiness of all units was the top priority. Next, he

12 Analysis by the author, drawing upon mission planning experiences in the U.S. Army. Huger did not adequately understand the operation from Johnston's dispatches.

13 A. J. Long and Marcus J. Wright. *Memoirs of General Robert E. Lee* (New York: J. M. Stoddard & Co. 1886), 44; Wert, *Longstreet*, 128. Meigs served with Lee in Missouri.

got an assessment of all the locations of the units and front lines of the army. For the moment, he would remain on the defense, and personally check and strengthen every spot he felt was lacking.[14]

In the first week, Lee held a conference with his officers, and the next day invited Longstreet to his headquarters for a "free interchange of ideas," as described by Longstreet. At this meeting, Longstreet offered the idea of attacking the right of McClellan's army on the north side of the Chickahominy. This, Lee seriously considered. He sent Brigadier General J. E. B. "Jeb" Stuart to conduct a cavalry reconnaissance and sent an order to Major General Thomas J. "Stonewall" Jackson to join the main body from out in the Shenandoah Valley.[15]

Lee still faced the same problems that Johnston had. McClellan outnumbered them and would also bring his abundant siege artillery to bear, which the Confederates would not be able to withstand. Thus, after further reinforcing the army, Lee decided to launch his own aggressive large-scale offensive, subsequently known to history as the Seven Days battles, to turn McClellan's right flank. If it worked, Lee would drive him away from the capital, and regain lost territory on the Peninsula. Lee had more meetings with Longstreet privately, and seemed to like his ideas and advice. On June 7, 1862, he wrote to President Davis: "Longstreet is a Capital soldier. His recommendations hitherto have been good, & I have confidence in him."[16]

Longstreet had also suggested that Jackson, who had the furthest to come to join the army, should initiate the offensive upon the arrival of his command. Lee agreed. It was imperative they ensure all possible force structure was in place before attacking. Jackson would fall upon the Union right flank near Beaver Dam Creek (Mechanicsville), signaling the advance. Once Jackson attacked, A. P. Hill would clear the Mechanicsville bridge of Union pickets and drive toward Jackson to support him at Beaver Dam Creek. D. H. Hill and Longstreet would follow and add their weight. Huger and Magruder would hold the main defense line opposite the Union forces south of the Chickahominy. Lee would be accepting risk there, as the two Rebel divisions would be facing Union forces that added up to four corps. In any case, the Confederate plan miscarried. A. P. Hill, expecting to hear Jackson

14 Longstreet, *Manassas to Appomattox*, 112-114.

15 Ibid., 114-119.

16 Douglas Southall Freeman, *Lee's Dispatches, Unpublished Letters of General Robert E. Lee to Jefferson Davis and the War Department of the Confederate States of America 1862-1865* (New York: G. P. Putnam's Sons. 1915), 11.

start the battle, heard nothing. He grew anxious and decided to start the attack to clear Mechanicsville. Jackson, heard the firing, but instead of attacking, had his troops set up bivouacs to rest.[17]

Jackson acted very much as Huger had at Seven Pines. He was a non-participant in the battle, which resulted in A. P. Hill assaulting strong Union defenses and sustaining heavy casualties. D. H. Hill and Longstreet came to his support but could not break the Union defenses. They too lost many men, with no result. Longstreet estimated the Confederate losses between 2,000 and 3,000 men. Lee's first battle as commander of the army had failed, and he was bitterly disappointed. In the years after the war, his young nephew Cazenove G. Lee (1850-1912) asked his uncle his opinion of Jackson. His nephew, parroting the popular common idolatry of Jackson, recorded: "This irritated the Old General, and he turned at once and said, do you think Jackson ran around the country fighting battles without orders? Jackson did what he was ordered to do. Then after a few moments he said, Jackson made me fight the battle of Mechanicsville and lose thousands of men when there was no necessity for it. When I took command after Johnston was wounded at Seven Pines, I sent for Jackson and showed him my plans, and what he was to do to assist in carrying them out, and then asked when he could be in position. He gave the date. I did not think that sufficient time and gave him three days longer." Longstreet recorded in his memoir that Jackson had agreed he could attack on June 26. However, Lee was willing to wait until June 29, according to Cazenove, so that Jackson could be well in place, and his troops not fatigued for the fight. In his report submitted in 1862 concerning this, Lee avoided the issue, and simply wrote it was an "unavoidable delay," but Jackson had miscalculated in his timing.[18]

The Confederates, with their Center of Gravity north of the Chickahominy, were now ripe to be struck in the line manned by the divisions of Huger and Magruder. But they were handed a second chance. McClellan, believing he had to deal with at least double his own numbers, ignored advice to strike the weak line of these two Confederate generals. Instead, his focus became changing his base of

17 Longstreet, *Manassas to Appomattox*, 123-124.

18 Robert E. Lee quoted by Cazenove G. Lee, Lee-Fendall House Collection, Alexandria, Virginia, notebook dated Aug 16, 1897. 13; Longstreet, *Manassas to Appomattox*, 121-122; Lee, OR, 11/2: 491. Cazenove considered writing a book on his uncle and recorded his recollections of conversations with General Lee 1866-70 in several notebooks. Another interesting answer Cazenove got from his uncle that he recorded, was Lee's answer to who he thought was the best general on the Union side. Lee said McClellan. When Cazenove asked about Grant, Lee did not answer, and stared in intense, quiet thought.

supply to the James River, and withdrawing some of this right wing to the southeast on June 27. He gave Lee a day to plan, effectively handing the initiative back to him.[19]

The third time, the Confederates would get offensive operations right. A. P. Hill opened the fight again, crossing Beaver Dam Creek on the morning of June 27, and driving on Gaines's Mill. As he approached, D. H. Hill also became engaged. This first assault failed. Lee himself had been at the spot to help press it. He contacted Longstreet, vented frustration, and asked if he could provide a diversion to allow for the other wing to form more cohesively. Jackson was late again; this time a scout took him down a wrong road, requiring a counter march that ate up an hour. Finally, however, Major General Richard Ewell of Jackson's command arrived in the fight, followed soon thereafter by all of Jackson's troops. Longstreet also came fully online as the right wing of the army. Now Lee had all his pieces in place, and a large-scale push was made into the evening. It was Brigadier General William Whiting, quickly fed into the fight by Longstreet who made the first break in the Union line. Then two more occurred; one near the center, and another further to the left. These penetrations could not be contained, and the Union line began to collapse.[20]

Gaines's Mill allowed Lee to use initiative and then build momentum. For the next few days, he pressed what was essentially an intimidation campaign against McClellan. He had a psychological advantage over McClellan, who believed Lee outnumbered him, and felt he had to retreat to save his army. Lee's army gained confidence, and the key leaders learned to coordinate one with another as an army, rather than as separate entities.

Jackson, particularly, needed this campaign. He had operated far away from the main army in the Shenandoah with success in that environment but did not participate in the previous two months' movements from Yorktown to Williamsburg to Richmond *within the context of army-level operations*. He had not operated with an army since Manassas (then a gathered mass of regiments and brigades). Subsequently, he was inept in the first two battles when he joined the army. *Operating within the confines of specific organizational force structure is far more complex than operating separately.* Cohesive divisions, corps, and the machinery of command and staff control that makes for fluid cooperation, takes time to first build, and then achieve proficiency. However, a smaller army that can execute as a cohesive force,

19 Longstreet, *Manassas to Appomattox*, 125; McClellan, *OR*, 11/2: 20.

20 Lee, *OR*, 11/2: 492-494; Longstreet, *OR*, 11/2: 756-762; Jackson, *OR*, 11/2: 552-559.

is much stronger than a larger army made up of pieces that are poorly unified and cannot come together and operate as large formations.

Longstreet, on the other hand, had solid developmental duty position postings from 1861-62 in the new Confederate Army. This came in addition to his US Army career that had no break in service from his commissioning. This professional development enabled him to participate in shaping the army into a modern force structure. Starting in basic field brigade command at Manassas, he was promoted to major general on October 7, 1861, before the Peninsula Campaign. He started mastering the division level within the same army, making it more intuitive to him, which also gave him the perspective of the corps-level that would come next. Contrast this with Huger, who was also promoted to major general on October 7, 1861. Huger first commanded coastal fortifications, then militia troops in North Carolina. When he joined the army with these untested troops, he had not even had a true field brigade command experience and was now commanding a division of three brigades. Thus, the day he arrived at Richmond he was devoid of any experience of operating a division within an army.[21]

When Johnston moved the army to the Yorktown line, he had in Longstreet an officer who could handle a division's worth of brigades as a single seamless formation, plus track the other operations around him. Longstreet had two roles under Johnston. First as a division commander, second as someone who could manage tactical and operational control of other units and assets. This he did for Johnston from the Yorktown line, controlling much of the army withdrawal from Williamsburg, and exercising tactical control of the offensive operation at Seven Pines. While the Seven Pines operation failed, the problems were mostly attributed by Johnston to lack of proper rehearsal that led to errors in execution. Longstreet still got the experience in tactical and operational control over much of the army that was valuable. Then Lee came into the picture, and within a few days, he too had recognized Longstreet as far ahead of most major generals in his professional development. Lee continued as Johnston had, by utilizing Longstreet in a dual role as a division commander, and as his planning collaborator. Longstreet learned from Seven Pines that the Confederates should now strike the enemy's other flank, and his advice helped his new commander achieve operational success in the Seven Days battles.

21 See the following page for a comparative of Longstreet's U.S. Army service before 1861 to twenty officers who fought at First Manassas.

Military Experience of Longstreet Compared to his Contemporaries who fought at the first battle of Manassas, 1861

Union Officers:

Irvin McDowell 43 yrs. old, no command of troops in Mexico.
Robert Schenck 52, no military experience.
Daniel Tyler 63, resigned commission 1834. No combat.
David Hunter 59, resigned commission 1836, No combat.
Sam Heintzelman 55, Indian & Mexican War experience.*
Dixon S. Miles 56, Indian & Mexican War experience.*
Theodore Runyan 39, no military experience.
William T. Sherman 41, Indian war experience; Seminole War.
Ambrose E. Burnside 37, no combat in Mexico; Indian skirmish experience.

Confederate Officers:

P. G. T. Beauregard 43, Engineer with General Scott in Mexico.
Philip St. George Cocke 52, Plantation owner, no military experience. †
Edmund Kirby Smith 43, Indian & Mexican War experience.*
Milledge L. Bonham 48, Indian & Mexican War experience; politician.
Jubal A. Early 45, Lawyer, no military experience.
Barnard E. Bee 37, Indian & Mexican War; killed at 1 Manassas. †
Richard S. Ewell 44, Indian & Mexican War, w/no break in service.*
Joseph E. Johnston 54, Indian & Mexican War, w/no break in service.*
Thomas J. Jackson 37, Mexican War exp., resigned commission 1851.
David R. Jones 36, Mexican War exp., w/no break in service.*
Francis S. Bartow 44, Lawyer & politician; killed at 1st Manassas. †
James Longstreet 40, Indian & Mexican War, w/no break in service.[22]*

Of these twenty officers who fought at First Manassas, Longstreet stands with seven* officers who had extensive active duty Army experience, including Indian and Mexican war combat experience. Of the seven, only Johnston had more overall active duty experience and similar Indian and Mexican War experience to Longstreet. David R. Jones and Kirby Smith are most similar in experience, and Sam Heintzelman, Dixon S. Miles, and Richard Ewell had less overall combat experience than Longstreet in the Mexican War.† — Died 1861

22 William Garrett Piston, "Longstreet's Military Experience," *Longstreet Society Seminar*, Gainesville, Georgia, October, 2010.

The tactical success of Gaines's Mill spurred Lee forward. "Our victory is said to be glorious, but not complete," wrote a lady from Alexandria, now displaced and living in Richmond. Lee spent the night at Longstreet's headquarters in the house of Dr. Gaines and ordered two of Longstreet's engineer officers to reconnoiter Union dispositions during the night. They reported back in the morning that the Union army was evacuating its positions south of the Chickahominy. This confirmed there was no threat to the defense line of Huger and Magruder, and Lee could continue offensive operations.[23]

The news of the Union evacuation south of the river prompted Lee to make his main effort in that direction. Longstreet and A. P. Hill marched as quickly as possible back toward Richmond, behind the line of Huger and Magruder, positioning themselves to attack the Union forces at Glendale. The plan was for Longstreet and Hill to interpose themselves between the Union main body and the James River. During this movement smaller engagements occurred at Savage Station, when Magruder ran into a Union rearguard and fought an inconclusive battle on June 29.[24]

On June 30, the Union Army had its main line facing the direction of Richmond, with its left flank anchored to a bend in the James River, and its right along White Oak Creek. Jackson was north of the Union Army, facing their right flank, and Longstreet, A. P. Hill, Magruder, Huger, and Major General Theophilus H. Holmes were facing the main Union line. Holmes's Division, previously part of the Richmond defenses, was now temporarily under the operational command of Lee.[25]

Longstreet was again in tactical control of the main attack. His division on the left, and A. P. Hill's on the right of a corps-sized effort, would attack the center of the Union main line, and converge at a crossroad known as Glendale (Frayser's Farm). They were supported by the other three divisions to their right and left, and by Jackson, driving from north to south across the White Oak Creek into the rear area of the Union Army. Execution between Longstreet and Hill was excellent as the battle opened. While this formation was not an entirely 'modern' approach, there were improvements. While they both advanced into the Union line on a wide three-mile front, the two generals did ensure the units were quite seamless. This

23 Freeman, *Lee's Dispatches*, 21; Longstreet, *Manassas to Appomattox*, 130-131; Judith W. McGuire, *Diary of a Southern Refugee During the War* (New York: E. J. Hale and Son, 1867), 123.

24 Longstreet, *Manassas to Appomattox*, 132-133.

25 Ibid., 134.

made for a cohesive corps-sized attack. Another improvement was that this attack was much more heavily weighted at 20,000 troops. In fact, the principle of mass was applied better here than at Seven Pines and Gaines's Mill. This number was in two divisions, instead of three or more. Opposite Longstreet's division, "in less than an hour General McCall's division gave away," wrote his corps commander, Major General Samuel P. Heintzelman. The attack took ground and pushed in the Union line nearly a mile. Unfortunately, the supporting attacks by the other divisions, were not materializing. Jackson ordered his troops to build a bridge over the White Oak Creek, which used up hours, when he should have looked for a spot to ford. He never got into the fight, aside from artillery exchanges and some skirmishing. This allowed Union Major General William B. Franklin to flex some of his troops south to help in the fight to contain Longstreet's attack. Holmes and Huger made their movements, but were then halted in their efforts, which also allowed other Union commands to help contain Longstreet. Holmes was a "sad story," according to Porter Alexander. His division of green troops became quickly unnerved by Union cannon fire, requiring Magruder to divert his division to support them, instead of Longstreet. Ultimately, Longstreet's attack was contained. He and Hill held the ground they took, but they did not cut off McClellan from the James River as planned. Alexander saw this battle as a great opportunity lost, as he did Seven Pines. He put blame on Jackson: "when one thinks of the great chance in General Lee's grasp that one summer afternoon, it is enough to make one cry to go over the story how they were all lost. And to think too that it was our *Stonewall Jackson* lost them."[26]

The final battle of the campaign was at Malvern Hill on July 1. On June 30, as the center of the Union line was engaging Longstreet and A. P. Hill, Union Major General Fitz John Porter was emplacing all the reserve artillery he could gather in successive defensive belts, along with the divisions of Major Generals George Sykes and George Morell on Malvern Hill. His artillery included ten massive siege guns placed in the rear, with a range fan that covered all avenues of approach. This was a classic defense in depth, with a killing field in front of it. After the battle of Glendale, the Union units that had engaged the Confederate push, retreated during the night, and joined the position that Porter had already prepared, adding to its strength.[27]

26 Samuel Heintzelman, OR, 11/2. 100; Longstreet, *Manassas to Appomattox*, 134-140; Alexander, *Fighting for the Confederacy*, 109.

27 Longstreet, *Manassas to Appomattox*, 141.

The night of June 30, Lee and Longstreet stayed together, to discuss the actions at Glendale, when a Union surgeon came to the camp to report to Lee. He was from Union Brigadier General George A. McCall's Division, which Longstreet had dispersed (capturing his Old Army colleague, McCall). Jackson came upon this doctor, tending wounded after the Union Army retired toward the James, and sent the man to find Lee to ask for medical supplies. Lee granted the request. Longstreet told the surgeon his commander was safe in Richmond and asked him about various Union units. The Union officer said he had no knowledge of any other than his own. Longstreet was keen on trying to gather intelligence whenever, wherever, and from whomever. He needed some for the next day.[28]

On July 1, Lee tried to deliver the *coup de grâce*. Since Jackson, Huger, and Magruder were fresh, either not having fought at all or only minimally the day before, Lee decided to press McClellan with these three commands. The divisions of Longstreet and A. P. Hill were kept in reserve.

In the morning at the generals' meeting with Lee, Longstreet had been quite upbeat. D. H. Hill had talked to a local minister about the topography of the area and been told that if McClellan had set himself up on Malvern Hill, he should best be left alone. Longstreet laughed off the comment and told him: "Don't get scared now that we have got him whipped." Hill would prove right, but his comment had no impact on Lee. The attack was on.[29]

Lee had ridden over to Jackson's column, and was satisfied, but left the other side to Longstreet. Lee was not feeling well that day, and asked Longstreet to reconnoiter the right and assist Magruder and Huger in the deployment of their divisions and some of the artillery. After doing so, Longstreet reported back to Lee.[30]

Longstreet told Lee that Malvern Hill was an excellent artillery platform, and although he could not see how the Union artillery was emplaced, he now had misgivings. Before Confederate artillery could commence, the Union artillery opened fire. The Confederates had only moved about two dozen guns up, and they were pounded. By mid-afternoon they were silent, and the Confederate reserve artillery was not called forward into action. Longstreet, at this juncture, did not think the attack should happen, and Lee asked Longstreet to join him for a joint reconnaissance. Lee then received two reports that indicated McClellan was

28 Wert, *Longstreet*, 145-146.

29 Longstreet, *Manassas to Appomattox*, 142.

30 Wert., *Longstreet*, 145.

retreating. They were inaccurate. Union troops were only being repositioned. One report came from Magruder, and Lee ordered him to "press forward with your whole command." Next, the whole army was committed, minus the troops of Longstreet's and A. P. Hill's divisions. The Confederates charged into the well-prepared Union defenses, not as cohesive divisions but mostly as individual brigades. Lee would later comment: "for want of concert among the attacking columns their attacks were too weak to break the Federal Line." All the attacks by Magruder, Huger, and Jackson were repulsed. At day's end nearly 30,000 Confederates had been engaged, and losses were estimated as high as 5,600.[31]

The next morning, McClellan resumed his evacuation of the area, despite having repulsed Lee. Longstreet rode up the slope where the Confederates had assaulted and saw the horrible result. At their morning meeting Lee asked him: "has your morning ride led you to see anything of the scene of awful struggle of the afternoon?" "What are your impressions?" Lee further asked. Longstreet replied tactfully: "I think you hurt them about as much as they hurt you." Lee replied: "Then I am glad we punished them well, at any rate."[32]

Lee had won the campaign and saved the capital. McClellan had been driven back to the James River, where his army would sit for weeks before being siphoned back to Washington. Lee's aggressive series of assaults had shaken the Federal commander's confidence, and then thoroughly intimidated him. Lincoln's hope to converge upon Richmond in 1862 was over, and he would look for a new commander.

31 Jackson, OR 11/2: 558-559; Longstreet, OR 11/2: 760; Lee, OR 11/2: 495-497; Longstreet, *Manassas to Appomattox*, 144; Brian K. Burton, *The Seven Days Battle*, (Bloomington, Indiana: Indiana University Press, 2010), 357.

32 Freeman. R. E. *Lee*, Vol II, 222-223; (New York: Scribner's Sons, 1935); Wert, *Longstreet*, 149-150.

Chapter 3

Union Opportunity Lost & Second Manassas

"The only really practical man is one who is grounded in theory."

— Dennis Hart Mahan, Professor, West Point, 1832-73

After the battle of Malvern Hill, McClellan's forces sat idle on the Berkeley Plantation, tied to their river port of Harrison's Landing. While the Peninsula Campaign had been going on, military authorities in Washington, DC, worked to organize other disparate commands in Virginia under the unified command of Major General John Pope. This command, named the "Army of Virginia" became effective July 26. A few days earlier on July 23, Major General Henry Halleck had assumed command of all Union armies.[1]

Gen. Lee also reorganized his forces. He had Magruder, Huger, and Holmes sent to other commands, and then adopted a two-wing structure for the army. Lee placed the bulk of it under Longstreet, who had demonstrated the ability for operational-level management throughout the Peninsula Campaign. Under Longstreet's command, Lee increased his six brigades to twenty-eight that Longstreet would reorganize into more formal division structure. Jackson was not let go. Despite his poor performance in the campaign, and amid many rumors as to why he had lacked initiative, Lee decided to keep him and develop him. The Confederate press stayed silent on Jackson's recent performance difficulties, and Lee said nothing in his reports. Jackson essentially got a second chance; however,

1 Longstreet, *Manassas to Appomattox*, 153; Alexander, *Fighting for the Confederacy*, 122.

the fourteen brigades under his command in the campaign were reduced by Lee to seven for the meantime.[2]

Pope's immediate objective was to draw Lee away from McClellan. His new command was spread across Northern Virginia, oriented south, with his cavalry forward of his main line at Culpepper Court House. Lee understood this as a threat to the rail networks north of Richmond, particularly the rail crossroads at Gordonsville that connected the Shenandoah Valley with Richmond. He still had to maintain the larger wing under Longstreet between Richmond and McClellan, but he could send Jackson's smaller wing to Gordonsville. Jackson's arrival in mid-July caused apprehension in Washington. Gen. Halleck ordered the withdrawal of McClellan's army from the Peninsula, to bring it further north, reinforce Pope, and protect Washington.[3]

There was no solid reason to remove McClellan's large army from the Peninsula. Even idle, it occupied Lee, and with the creation of a second army under Pope in northern Virginia, the Union forces outnumbered the Confederates two armies to one. There was no threat to Washington. By this time in the war, a ring of artillery forts protected the capital, manned by tens of thousands of Union artillery troops who could have comprised a third field army if they had been organized and trained appropriately. So long as there was a Union field army outside the ring to challenge Lee, a Confederate attempt to pierce it was folly. In the operational realm, the Union had created a new advantage: the operational facet of *simultaneity and depth*: two forces, one above and one below Lee, which forced upon him the problem of facing them in two opposite directions. If Lee moved to confront one Union army, the other might have an open path to Richmond. Or, if Lee sent only part of his army to confront one Union army, he would also have to confront the other Union army outnumbered. The latter situation seemed at hand.[4]

2 Wert, *Longstreet*, 151-152. Lee said: "Longstreet was the staff in my right hand."

3 Longstreet, *Manassas to Appomattox*, 154.

4 McClellan, *OR*, 11/3: 281, 291-292; Lincoln, *OR*, 11/3: 286; McClellan to Lincoln, July 8, 1862, Sears, Ed., *The Civil War in the Second Year*, 306-308. In this letter, McClellan offered his political views on the meaning of the war, rather than the military options. He said he believed secession must not be allowed to succeed, otherwise "dissolutions are clearly to be seen in the future." However, "It should not be a war of subjugation of the people of any state . . . or forcible abolition of slavery. . . ." He urged that the prosecution of the war must be carried out with Christian forbearance toward the rebellious states.

The operational outlook favored the Union, but Gen. McClellan had a different focus. He wrote to Lincoln on July 1: "I need 50,000 more men, and with them I will retrieve our fortunes." To this, Lincoln replied on July 2: "the idea of sending you 50,000, or any other considerable force, is simply absurd." McClellan wrote to Lincoln the next day: "To accomplish the great task of capturing Richmond and putting an end to this rebellion re-enforcements should be sent to me rather much over than much less than 100,000 men." McClellan was not at all inclined to the offense with his current force structure, and clearly failed to recognize the operational possibilities at hand.

Halleck also seemed to miss the excellent operational possibilities, wanting to redeploy McClellan's army north and combine it with Pope's. McClellan's army was larger than Lee's, and more force structure could be added to Pope's army over time as it developed. Pope, however, did see the operational advantage of two armies to one, with one above and one below Lee. He would demonstrate against Lee from above Richmond and try to pull him north. It worked; Lee counter-demonstrated with Jackson.

Pope also began to intrude problematically into the civilian realm. When Jackson's two divisions were arriving in Gordonsville, Pope began issuing three General Orders designed to bring the war to the civilian population of Virginia. The last of these, General Order No. 11, was the most draconian. It sought the arrest of disloyal citizens and allowed for the shooting of those who violated a loyalty oath. McClellan saw these as exactly the sort of un-Christian measures he advised Lincoln to abstain from in the cause of preserving the Union. The Confederates saw them as a license to steal from and murder civilians. Lee was appalled by Pope's General Orders as much as any Virginian; however, he had to remain calm and solve the military problem posed by Pope's army.[5]

Jackson, with his six brigades in two divisions, kept his distance from Union forces during the last two weeks of July. Pope's Army of Virginia, although still spread out from the Rapidan to the Blue Ridge, was comprised of three main corps, a reserve corps, and the Pennsylvania Reserve—the last organization contributing three brigades of infantry and four batteries of artillery. Jackson's wing was a numerical match to only one of the main Union corps, causing him to write to Lee requesting reinforcements. Lee and Longstreet decided to send seven brigades in one division under A. P. Hill to support him. Hill's division was larger than Jackson's two divisions combined. Hill arrived at Gordonsville on July 29, giving

5 Pope, OR, 12/2: 52.

Jackson numerical advantage over the Union corps. On August 2, Jackson began a movement to contact with his cavalry, and found Union cavalry and an infantry brigade at Cedar Creek. Two Union divisions were behind them in support.[6]

A week later, on August 9, Jackson moved to attack the Union II Corps at Cedar Mountain, commanded by Major General Nathaniel P. Banks. Initiated by an artillery duel, Banks had the upper hand, threatening Jackson's left flank. Jackson focused on the fire support at first, but still losing, he then rallied his infantry. Although he lost Brigadier General Charles S. Winder, a very capable career officer, the battle began to turn. Banks, however, only had about 8,000 troops engaged, and a swift and powerful counterattack by A. P. Hill put the Confederates at 16,000, and routed Banks's troops. The next day, Banks was reinforced by the I Corps commanded by Sigel, and Pope ordered the rest of his army to gather in support of the I and II corps. Owing to the growing Union strength in his vicinity, Jackson retired back to Gordonsville on August 12.[7]

Longstreet left Richmond on August 13, moving by rail up to Gordonsville, bringing ten brigades with him. The following day McClellan began the movement of his 100,000-man army from the Peninsula by river and sea to northern Virginia. Lee was now certain he could safely move Longstreet's larger five-division right wing north. The remainder of Longstreet's wing would follow, "as soon as it was apparent McClellan was gone."[8]

When Longstreet arrived in Gordonsville, Jackson came to report to him and "tendered his command to him." Jackson and Longstreet were both Major Generals, but Longstreet was the senior of the two by date of rank. He was Lee's co-planner, who had exercised control over much of the army during the recent campaign, and he was infantry, which Lee was not. According to one of Jackson's staff, the "relations between Longstreet and Jackson were always very cordial." Jackson, however, was not sure where he stood with Lee or in the command

6 Longstreet, *Manassas to Appomattox*, 156; A. P. Hill, *OR*, 12/2: 215. The choice of A.P. Hill was caused by a rift between Longstreet and Hill, started by a somewhat sensationalist newspaper editor at the *Richmond Whig* who implied Longstreet was not on the field at Gaines's Mill, and Hill was in tactical command, which was not true. Longstreet replied to this, which then angered Hill and caused him to request leaving Longstreet's wing. Longstreet endorsed the request, and Lee thought it best to send Hill on this reinforcement mission to calm the waters between the two, who had otherwise cooperated superbly in battle. For more detail, see Wert, *Longstreet*, 154-155.

7 A.P. Hill, *OR*, 12/2: 215-216; Jackson, *OR*, 12/2: 216-217; Ewell, *OR*, 12/2: 226-227.

8 Longstreet, *Manassas to Appomattox*, 158; Alexander, *Fighting for the Confederacy*, 128. Longstreet and Alexander differ on dates. Longstreet said he travelled on Aug 15.

structure. Most of his interactions with Lee had been disaffirming, and probably left Jackson feeling Lee was displeased or unsure of him. While Jackson had done well in his Valley Campaign, he had mostly fought brigade-sized actions, and had been free to do whatever his imagination conjured. On the Peninsula he had to work within the confines of army level operations—understand his commander's intent, put divisions together, synchronize their movements, and a dozen other things under the eye of a superior with over thirty years of service, who was scrutinizing him.[9]

Jackson seemed to think it might be better to work for Longstreet. He had not yet grasped the force structure design Lee and Longstreet were implementing, and asking to be subordinate to Longstreet, was simply not in the cards. The commanding general makes these decisions and Lee had a plan for Jackson. Lee was in the process of training him; Jackson just did not realize it. The day before, Lee wrote to Jackson his first words of approval: "I congratulate you most heartily on the victory which God has granted you over our enemies at Cedar Run." Sending Jackson to counter-demonstrate against Pope also was a test, and Lee was satisfied with Jackson's results. This is one method that professional army officers sometimes use to develop subordinates who are new to an organization. Withhold praise for a period, or express dissatisfaction, and then commend the officer when something is done to standard to build confidence. Lee seemed to be applying this technique. Thus, at this meeting at Gordonsville, Longstreet also took the opportunity to mentor Jackson as a co-wing commander. He turned down Jackson's request, and told him that Lee was coming to meet with them, and that he (Jackson) knew the ground here. Longstreet implied to Jackson that Lee would view him as a wing commander from now on, and therefore he should start thinking like one.[10]

Lee arrived to survey the Union encampments from a signal station that Jackson had established on a peak with a commanding view of the Orange Railroad line. Lee still had to wait for enough of the army to arrive but was anxious to start operations. On August 16 he received word that 108 ships carrying McClellan's

9 Henry Kyd Douglas, *I Rode with Stonewall*, (Chapel Hill, NC: University of North Carolina Press, 1940), 129; *Longstreet, Manassas to Appomattox*, 158-159. On these pages Longstreet paints a revealing portrait of Lee: "When oppressed by severe study, he sometimes sent for me to say that he applied himself so closely to a matter that he found his ideas running around in a circle and was in need of help to find a tangent."

10 Clifford Dowdey, *The War Time Papers of Robert Lee*, (Boston: Little, Brown, 1961), 251. This note was an indication from Lee to Jackson that he had done something to redeem himself.

army had been seen moving on the James River over the last twenty-four hours, five of them carrying troops had turned north into the Chesapeake. Confederate Secretary of War G. W. Randolph wrote Jefferson Davis the next day: "the enemy had gone from the south side of the river and could not be seen on this north side." Lee decided the army would march on August 18, ford the Rapidan and attack Pope's army long before any of McClellan's troops could reinforce him. Lee then delayed a day, when mishaps with the cavalry reconnaissance almost cost the capture of Jeb Stuart. On August 19, Lee and Longstreet went to the top of Clarke's Mountain to view their opponents again and saw them marching off in columns toward the Rappahannock. The chance to attack was gone, perhaps due to the previous day's close call. Now Lee would have to pursue. Commenting to Longstreet, Lee said: "General, we little thought that the enemy would turn back upon us this early in the campaign."[11]

The Confederates moved on August 20, and both armies postured and skirmished along the Rappahannock for several days. On August 22, Confederate cavalry reported the Warrenton Road was open. Stuart linked up with Jackson, who had moved to Sulphur Springs, and engaged the enemy with artillery. On August 25 Lee ordered Jackson, now north of the Rappahannock, to turn east through Thoroughfare Gap and strike the enemy's rear at Manassas Station. Stuart was to follow in support. Jackson reached Manassas Station on August 27, seizing the massive Union depot with two divisions under Brigadier General William B. Taliaferro and A. P. Hill, and posting Ewell at Bristoe Station in reserve. Various Union units tried to harass Jackson but had no chance against his 20,000 men. The Confederates took anything and everything they could carry from the depot and burned the rest before departing after midnight. Pope, surprised by Jackson's appearance in his rear, abandoned his defensive line along the Rappahannock to retreat east and redeploy. During the early morning hours of August 28, Jackson pulled back to the site of the earlier (July 1861) battle and stopped at an unfinished railroad cut below Stony Ridge. He emplaced his troops in the cut to take advantage of the ready-dug trench and its observation of the Warrenton Turnpike. It was a welcome break for his troops, who had marched almost fifty miles in two days on

11 Mary Anna Jackson, *Memoirs of Stonewall Jackson*, (Louisville: The Prentice Press, 1895), 315; S. G. French, *OR*, 12/3: 932; G. W. Randolph, *OR*, 12/3: 932; Longstreet, *Manassas to Appomattox*, 160-162. Mrs. Jackson wrote that "Negro deserters," probably body servants accompanying the ANV, had tipped the enemy off about Confederate movements.

minimal rations supplemented only by corn from the fields. Now they could eat, sleep, and enjoy new shoes and clothing "requisitioned" from the depot.[12]

Unbeknownst to Jackson, McClellan had arrived in Alexandria on August 27. His corps under Heintzelman had landed in Washington and was ready to head west. Major General Ambrose Burnside's corps of McClellan's army was now in Fredericksburg. Pope now reasoned that Lee was probably spread out over a great distance; meaning Longstreet might not have his entire wing available to support Jackson. He decided the best course of action was not to retreat toward McClellan's closest corps at Fredericksburg, but to attack Jackson *en masse.*[13]

Hindsight might suggest that Jackson should have gone further west to get closer to Longstreet, but he had marched all night and the troops needed to get some sleep. Also, his exact location was unknown to Pope, and his present position might afford an opportunity to ambush the Yankees.

Longstreet's wing crossed over the Rappahannock on August 26 and stopped at Orleans that night. On August 27, when Jackson raided Manassas, Lee and Longstreet riding at the head of Longstreet's columns reached the Manassas Gap RR line and turned east toward Thoroughfare Gap, going as far as White Plains. On August 28, they resumed movement at 11 a.m.[14]

A dispatch sent by Lee reached Jackson around 2 pm, August 28, stating he and Longstreet had reached Thoroughfare Gap. They were just twelve miles away. Jackson was elated and thus far there was no threat to him. Longstreet, however, had already been confronted by Union troops at the gap. His vanguard caught Union soldiers felling trees at 9.30 a.m., and he had to spend time moving regiments out of column to secure the high ground over the gap to push aside the Union units. "It was late," Longstreet wrote, by the time he got the gap cleared and when the first engagement between Jackson and Pope's army began. Jackson ordered an attack upon Union units moving on the Warrenton Turnpike across his front late in the day. The fighting lasted several hours and was essentially a draw.[15]

Pope, intending to surround Jackson, started his assaults the morning of August 29. Jackson, taking advantage of the railroad cut, repulsed each attack upon him, one after another. In the afternoon Longstreet arrived on his right and began

12 Longstreet, *Manassas to Appomattox*, 164-171; Jackson, *Jackson's Memoir*, 320.

13 Ibid., 171.

14 Ibid., 171-173.

15 Ibid., 174-175; Alexander, *Fighting for the Confederacy*, 132; Lee, OR, 12/2: 555-556.

to emplace his units at a right angle to Jackson. Lee "was inclined to engage as soon as practicable," but Longstreet asked him for time to make a reconnaissance of the ground along Pope's left. After an hour Longstreet reported back, advising that no immediate attack should be made. There were still Union formations at Manassas that would have "an easy approach" against Longstreet's right. He advised waiting until these units were forward with the rest of the Union forces and committed to their attack. Again, Lee consented. Jackson continued to battle four Union corps plus a division until dark with his three divisions. Postwar writers would criticize Longstreet for allowing this to happen, when they might have attacked that day, but his tactical patience would prove correct and well worth it.[16]

Lee had been anxious, but he knew Longstreet was the infantry expert, not him. Perhaps Lee also had it fresh in his mind that operations on the Peninsula had suffered in execution when preparations and reconnaissance were inadequate. Of course, Longstreet had tactical control over other divisions then, but two of the division commanders were unqualified. This time, the divisions were all under more qualified men, and directly under Longstreet's formal command not just his tactical control. He did not have to command his own division either, he issued orders to five divisional commanders. Modern chain of command, command relationships, and force structure had come to the Army of Northern Virginia (ANV).

In the morning of August 30, the Union army was inactive. Pope consulted with his key officers but remained uncertain if the Confederates had initiated a partial retreat, pulling Longstreet behind Jackson. Without any clear intelligence, they decided to resume attacks on Jackson. At 3 p.m. the Union corps of Fitz John Porter, the commander who built the brilliant defense at Malvern Hill, lunged forward and Jackson's troops opened fire. The artillery of Colonel Stephen D. Lee was positioned to enfilade oncoming troops in front of Jackson. Longstreet brought more batteries over to Lee's location, and these all swept the Union formations, mowing down men as they raked the field. Porter's corps was melting away from the punishing fire and Longstreet saw it was time for the sledgehammer

16 Longstreet, *Manassas to Appomattox*, 181-183; Alexander, *Fighting for the Confederacy*, 133; Longstreet letter, Manassas National Battlefield Park. D.S. Freeman claimed Longstreet had manipulated Lee. See *R. E. Lee*, II, 325. See also Wert, *Longstreet*, 172, for more examples and details of various postwar criticisms.

blow of his five divisions. The staff darted to the commanders with Longstreet's order, and they moved forward. Their objective was Henry Hill.[17]

Longstreet's wing began the attack with the divisions of Brigadier Generals Cadmus M. Wilcox, Hood, and James L. Kemper in advance on about a mile and half front. Major General R. H. Anderson and Brigadier General John R. Jones were initially behind. The exacting preparation had created a powerful battle axe, and the oblique the Union corps made to swing into Jackson made for a particularly vulnerable, wide-open flank. As the massive gray formation, dotted with red battle flags, charged forward, Jackson's men cheered wildly at the spectacle. No one in Jackson's wing had seen over 25,000 men charge like this before. For four hours Longstreet's wing hammered their opponents and pushed them east toward Chinn Ridge. Longstreet rode among the troops, moving batteries, spurring on units. Lee rode with him. Once the Union army was thoroughly smashed and away from Jackson's front, Lee sent him a note to come forward, protect Longstreet's left, and join the push. Jackson advanced at 6 p.m. The Confederate push got as far as Sudley Road, with the Union army on the field the Confederates had defended a year earlier. The fighting ended at dark. All five divisions had worked like a seamless team, executing the largest attack of its kind in the war so far. The enemy was routed. Though Pope's army was not destroyed, Longstreet's attack had come close to doing so.[18]

Pope retreated to Washington and was relieved in September—his Army of Virginia being merged with the Army of the Potomac.[19]

Lee had removed McClellan from the Peninsula, ended the threat to Richmond, won a great battle, developed Jackson, and emerged with an army of better force structure and leadership than when he took over.

It does not matter how much stronger or larger one army might be than its opponent, if the commanding general and his lieutenants cannot see operationally. If they don't know enough military theory, they are flailing in the dark. Their chosen actions will be inept. Halleck and McClellan, for different reasons, did not see the excellent operational possibilities they possessed with the creation of a second army in northern Virginia. McClellan's army had been pushed away from Richmond, but was never seriously damaged as a functioning army, as Johnston and Lee incurred problems in the execution of their plans, robbing them of decisive

17 Lee, OR, 12/2: 557; Longstreet, OR, 12/2: 565; Jackson, OR, 12/2: 646-647.

18 Lee, OR, 12/2: 557-558; Longstreet, OR, 12/2: 565-566; Jackson, OR, 12/2: 646-647.

19 McPherson, *Battle Cry of Freedom*, 531-533.

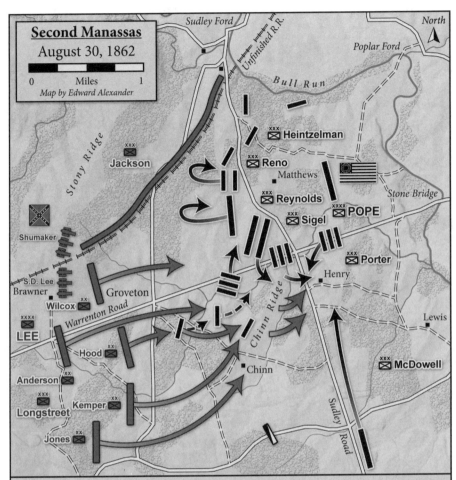

Second Manassas
August 30, 1862

0 Miles 1
Map by Edward Alexander

When McClellan was still on the Peninsula, President Lincoln formed a second army in Northern Virginia under Pope. This gave the Union a two to one army advantage over Lee, but it was soon squandered, when Halleck ordered it north to join with Pope. Lee quickly moved to deal with Pope before McClellan could join him, resulting in the Second Battle of Manassas. Here Jackson defended a railroad cut, while Longstreet positioned five divisions on August 30, 1862, and at 4 p.m. launched the largest, most cohesive assault in hilly and wooded terrain on this scale so far in the war. Longstreet's assault included ~25,000 troops, pushed aggressively by himself and his division commanders, shoving the Union left flank over two miles in some locations. A victory of improvements to organizational structure and command and control.

results. The Union had an opportunity to use their two armies to dominate Lee in any number of scenarios and possibilities, perhaps even end the rebellion in 1862. Instead, they removed their larger army from the Peninsula, and spent weeks redeploying it to northern Virginia. This gave Lee the freedom of movement and time to deal a blow to the smaller, newer, Union army at the battle of Second Manassas.

Union Army retreating east from Manassas. (*Rufus Fairchild Zogbaum, created January 1, 1887, file from the British Library Mechanical Curator Collection*)

Pope's Grand Orders also contributed to ruining the Union's potential military fortunes that year. The Orders fired the engines of Confederate resolve to defend their independence. They offended McClellan as much as they offended Lee, undermining Union unity of effort and harmony in planning. The Orders were also in marked contrast to Lincoln's July 1862 appeal to three Union and neutral slave states, two Confederate states, and West Virginia to accept compensation for gradual emancipation of slaves and their relocation to South America. Pope's threat to private property, civil liberties, and civilian life, thoroughly alienated the northern Virginia citizenry, a majority of whom had been lukewarm at best about secession in early 1861 and might have become more so following Union military success in Virginia. Instead, both political and operational ineptness led to a powerful Confederate victory that threw the Union command structure into turmoil and handed the initiative in the eastern theater solidly to Lee.[20]

20 Lincoln, "Appeal to a convened gathering of Representatives and Senators from Delaware, Maryland, Kentucky, Missouri, Tennessee, and West Virginia, July 12, 1862," Sears, Ed., *The Civil War in the Second Year*, 314-316. Of the gathering 28, 21 rejected the idea as too costly, unconstitutional, encouraging the rebellion, and a threat to personal property rights. On Jul 14, 1862, it was sent to Congress as a draft bill, but no action was taken.

Chapter 4

The Old Ways Unravel at Antietam

"Ah here is Longstreet, here is my old warhorse! Let us hear what he has to say."

— General Lee as he embraces Longstreet after the Battle of Antietam

By the summer of 1862, Robert E. Lee, the commander of the Army of Northern Virginia, had successfully foiled all attempts by the Union to defeat the rebellion in the Eastern Theater. The Confederate tactical victory at Second Manassas, followed two days later by a sharp and bloody rearguard action at Chantilly (Ox Hill), had further dispersed the Union army. It then retired behind the Alexandria and Washington entrenchments and nearby locations.

The fallout from the Manassas debacle mired the Union leadership in a period of confusion. The forces in the vicinity of Washington were divided into five separate groupings with no unity of command. No one general officer held operational control over these forces. President Abraham Lincoln, who had relieved John Pope from command, considered for a second time turning to McClellan. Even though Lincoln had recently placed McClellan under Halleck, following the failures outside Richmond, the President weighed harnessing the general's organizational skills to rectify command and control issues, protect the capital, and make the necessary adjustments in positioning forces for the next operation.

Uncertainty lingered between the Lincoln administration and Halleck, his official general-in-chief who acted more like a chief-of-staff, regarding who should assume command of the Army of the Potomac, and resume combat operations against Lee. Lincoln expressed no clear choice for the command, but with events unfolding rapidly he turned to McClellan almost by default.

The dramatic win at Second Manassas seemed to offer an operational opportunity for Lee to launch a new campaign with politically strategic benefits. Also recognizing the organizational confusion swirling within the Union high command, Lee quickly decided that September 1862 provided the most propitious time since the commencement of the war for a major Confederate army to enter Maryland. "[I]f it is ever desired to give material aid to Maryland and afford her an opportunity of throwing off the oppression to which she is now subject," he wrote President Davis on September 2, "this would seem the most favorable." The next day, he changed the course of the war by moving part of his army across the Potomac River in his first invasion of the North.[1]

In the 1860 national election, Maryland had cast its eight Electoral College votes for the Southern Democrat, John C. Breckenridge, but three attempts at secession in 1861 had twice resulted in no declaration, and the third gathering was dispersed by Federal authorities. Maryland remained ostensibly a Unionist slave state by position of the state's executive. Governor Thomas Holliday Hicks had opposed secession and refused to further convene the legislature. Hicks blamed the entire problem on "secession leaders in South Carolina, and fanatical demagogues in the north." When the mob had taken control of Baltimore, and Federal troops were sent to make it safe for Lincoln to pass through by rail, Hicks was assured by Federal authorities that the troops would only protect the capital, and nothing more. Since then, however, the US Army had controlled the Baltimore area, where the greatest support for secession existed.[2]

There were three other primary reasons, in addition to possible secession, for Confederate action in the Union-controlled state. The Confederacy needed allies in Europe, there was a chance to influence Federal politics, and Lee's army needed provisions. Garnering prestige was a subsidiary benefit of a campaign in Maryland of keen interest to President Davis. When the news of Second Manassas reached London, Prime Minister Palmerston, who disliked the United States and was sympathetic to the Confederacy, agreed it might soon be time to approve a

1 Lee, OR, 19/2: 590; Thomas Prentice Kettell, *History of the Great Rebellion*, (Hartford: L. Stebbins, 1866), 45-46. Maryland held the first secession convention in Feb 1861, which ended with no declaration. A second convention gathered in Frederick in Apr 1861, and also voted against secession. Sep 1861, delegates gathering in Baltimore were prevented a quorum, as Federal authorities arrested many secessionists, including Baltimore Mayor George Brown, thus foiling a third attempt. Lee and Davis believed there was still a chance to reanimate the secession forces in 1862.

2 Kettell. *History of the Great Rebellion*, 118-119. Of 92,502 people voting in MD, 1860, Lincoln only received 2,294, Breckenridge 42,282, Bell 41,760, and Douglas 5,966.

mediation proposal between the two. A de facto recognition of the Confederacy by Britain as a sovereign nation. This in turn, might lead to European aid and perhaps even military assistance along the lines of that which the rebellious English colonies had received from France, Holland, and Spain during the American Revolution. A second was mid-term elections in the Federal Congress. With the war proving costly, and the Confederacy having enjoyed military success in the Eastern Theater, Northern Democrats sought to win a majority of seats in the Congress in November. If the Democrats won a majority and could change the complexion of that legislative body away from support of Lincoln, the Confederacy might gain its independence. The third reason was supplies. Despite the recent organizational and leadership improvements made in the Army of Northern Virginia, professional development of its commanders, and the morale boost from the recent victory, the soldiers were "feeble in transportation, the troops poorly provided with clothing, and thousands destitute of shoes." The army was short of wagons, equipment, and provisions of every kind. Lee surmised that he must transfer the war "from the interior to the frontier, and the supplies of rich and productive districts made accessible to our army." Crossing into the Old Line State was a decision he had already made even as he wrote Jefferson Davis to offer the suggestion. Despite logistical shortcomings, Lee saw positive aspects and opportunities for success in a large-scale movement into Maryland and perhaps beyond.[3]

The Movement North

With movements commencing on the heels of the battle they had just fought Lee had not rested the army adequately. Rigorous movement from the Peninsula, to Manassas, and then again up to Maryland had been nearly continuous. As a result, troops fell out from exhaustion. Some also refused to invade Maryland, believing doing so violated the principle that the war must only be defensive. The Army nevertheless began crossing the Potomac on September 5 over fords near Leesburg, many units moving into Frederick, Maryland, where Lee began gauging Union reaction. "I hope, at any rate, to annoy and harass the enemy," he wrote to President Davis on September 5. The first phase of the operation was essentially a *demonstration* of force: a widespread movement to show the local populace the

3 Lee, *OR*, 19/1: 144; Alexander, *Fighting for the Confederacy*, 139; Jasper Ridley, *Lord Palmerston*, (London: Constable, 1970), 552. Palmerston believed the Confederacy "would afford a valuable and extensive market for British manufactures."

Confederacy could project force into Maryland. The movements reflected Lee's "high estimate of opportunity and favoring condition of circumstances existing at the time," explained Longstreet. One obstacle arose when the Union garrison did not abandon Harper's Ferry. Lee then decided to divide his army to deal with the Union garrison, a decision Longstreet was adamantly against. They had just completed a successful campaign, proving their ability to fight as divisions within two wings, and demonstrating confident operational maneuver with this new force structure. Longstreet and Jackson were arguably far ahead of their Union counterparts in this ability. Yet Lee took a step back by directing specific instructions down to the divisions of D. H. Hill, Walker, R. H. Anderson, and McLaws, going back to an *ad hoc* force structure, instead of issuing orders to two wing commanders only, who then would command the divisions to accomplish the tasks. Doing this ignored both the benefits of chain of command and the advantage of the new force structure—something Lee seemed not to grasp and respect very well throughout the war. This order would divide the army into six operational groups, with no distinctions made between the wing and division levels in the language of the movement order.[4]

At Frederick on the September 9, Lee issued Special Orders No. 191 that dispatched Jackson with two-thirds of his command to take Harper's Ferry and remove the threat to Lee's logistical lifeline. Longstreet was directed to move farther west out to Boonsboro and then swing his command northwest to Hagerstown. From Boonsboro, a small town on the west side of the South Mountain range, Longstreet could cover the several gaps in the range, using it as a barrier in case McClellan moved west from around Washington faster than expected. South Mountain would constitute a visual barrier covering the army while it was divided and protecting Jackson's Harper's Ferry operation. Longstreet would also be in proximity to Hagerstown. According to Lee's plan, "The commands of Gens. Jackson, McLaws, and Walker, after accomplishing the

4 Lee, OR, 19/2: 593-594; Longstreet, *Manassas to Appomattox*, 201-204, 206; Longstreet letter to Heth, Rome, GA., Oct 22, 1892, NYPL; Stephen W. Sears, *Landscape Turned Red: The Battle of Antietam*, (NY: Houghton Mifflin,1983), 83. The invasion of Maryland was a type of demonstration. Not a demonstration against Union forces, such as moving Jackson opposite Pope near Cedar Mountain, but one with the intent of achieving political objectives. Lee hoped to stoke secession again in Maryland, and gain prestige for the Confederacy in European capitals. The letter to Heth emphasizes that D. H. Hill was not part of his command in the battle.

objects for which they have been detached, will join the main body of the army at Boonsboro or Hagerstown."[5]

Beyond the use of South Mountain, and a gathering of the army in that area once the Harper's Ferry operation was complete, Lee did not specify any next step in Special Orders No.191. It seemed to imply they would gauge how well a Confederate presence might impress the Marylanders; whether it convinced them to lobby for secession and encouraged them to join the Rebel army. Once the Army of Northern Virginia had reassembled, Lee would perhaps then evaluate movement farther north and determine to threaten Harrisburg, or Philadelphia, or Baltimore, or even Washington.[6]

One unforeseen reality immediately nullified part of Lee's plans upon his arrival in Maryland. The anticipated welcome of the Confederates by the citizenry of the western part of the state proved an illusion. The heavily German population there greeted Lee's army with cold stares and occasional expressions of disdain for their cause. The anticipated groundswell of support for the Southern 'liberators' failed to materialize in this part of the state. The pro-secession areas were Baltimore and the eastern part of the state. The Lincolnite Germans in the western region were steadfast Unionists who detested secession. They blamed those in secessionist states for dissolving the Union and bringing on war. Many who settled in the Blue Ridge area of western Virginia, western Maryland, and Pennsylvania were members of German Christian sects such as the Dunkers. They were pacifists, against drinking and ostentation, and were among the first in America to openly declare slavery immoral and a sin to Christians. Along with the Baptists of the region, they began to abandon slavery in the mid-1700s. Although not nationally vocal like New England abolitionists, if the men of Lee's army believed slavery should be legal, the German Christian sects were not going to help Lee's troops by voluntarily supplying food or sympathy also for this reason.

Already mentioned, was the problem of the high rate of straggling that befell the 55,000 Confederate army on the march between Manassas and the Potomac crossing areas. A shortage of shoes, more long marches just days after the Manassas operation, pushed many men beyond the point of physical endurance; Lee's

5 Special Order 191 from General Robert E. Lee, September 9, 1862 (Record Group 109: War Department Collection of the Confederate Records), National Archives.

6 Ibid. The order states gathering at Boonsboro or Hagerstown.

numbers were reduced to around 40,000 troops, once they crossed over into Maryland.[7]

Next, a third misfortune for the Confederates occurred on September 13 when Union soldiers discovered a copy of Special Orders No. 191 wrapped around several cigars in a field outside Frederick. The copy of the order that was lost, was sent by Jackson to D. H. Hill, believing Hill was assigned to him for operational control (illustrating the confusion Lee created by not utilizing the wing chain of command in the order). A careless Confederate staff officer was probably responsible for its loss, however, the details of how it was lost and exactly who lost it have remained a mystery. The order ultimately found its way to George McClellan, which also generated a century long debate about precisely when McClellan learned of the information in the order, and its real value to him. At a minimum, he knew the location of where the six parts of Lee's army should be and how it was divided (though the order did not include the strength of each portion) as of four days earlier, when it was issued. McClellan was already moving his army westward toward the area where Lee was, based on other intelligence, but this find probably caused him to move toward the vulnerable South Mountain gaps sooner than he otherwise would have done. Whether it made any difference overall is a matter of opinion. Once he started combat operations against the Confederates at South Mountain the order became irrelevant.[8]

Crampton's, Turner's, and Fox's Gaps

Longstreet knew that holding South Mountain with its three rugged passes was the key to the army's safety. Longstreet pointed out that if McClellan could force the passes, he "might fall on the divided columns of the Confederates and reach Harper's Ferry in time to save its garrison." D. H. Hill ordered the brigade of Brigadier General Alfred H. Colquitt to Turner's Gap, that of Brigadier General Roswell Ripley to defend Fox's Gap, and only part of a brigade, cavalry, and supporting artillery to Crampton's Gap. Most of the Confederates, including Longstreet, anticipated a Union surrender at Harper's Ferry by September 13, "to

7 Ibid. The order addressed collecting up stragglers. *OR*, 19/2: 595. Special Order 188 issued September 5, 1862, also addressed straggling. McPherson, *Battle Cry of Freedom*, 535.

8 Longstreet, *Manassas to Appomattox*, 211-217; Sears, *Landscape Turned Red*, 114-117, 349-352. See Sears, Appendix 1, for a detailed examination of the postwar debate on the 'lost dispatch.'

be promptly followed by a move further west, not thinking it possible that a great struggle at and along the range of South Mountain was impending."[9]

On that day, however, advance elements of the Union army were already watching the gaps, and by nightfall the Federals were arriving *en masse* at the eastern foot of the range. That night when he reported to Lee, Longstreet still had four brigades in Hagerstown. He now argued that it was best to extricate all his troops, those holding the passes and those at Hagerstown, behind Antietam creek near Sharpsburg and await Jackson there. What transpired at the meeting between Longstreet and Lee illustrates a difference between the generals, reflecting Longstreet's earlier advice not to split up the army. Longstreet advocated a concentration of Confederate forces to lure the Union army into a large battle on ground of Lee's choosing and avoid smaller engagements that carried no chance of any significant results. In contrast, Lee maintained a 'fight the enemy at every opportunity' approach, even if outnumbered. They did agree that a fight on South Mountain prior to concentrating the army would be merely a delaying action. Holding this terrain feature indefinitely with few troops was not possible. Neither general seemed worried that the traditionally cautious McClellan (who believed there were 30,000 Confederate troops defending South Mountain) would interpose his army between the divided Confederate forces. Lee listened to Longstreet but made up his mind to make a stand in the gaps. Longstreet sent word to the units with him to prepare for action in the South Mountain gaps.[10]

On September 14, four Union corps attacked a meager group of Confederate units spread out initially by Stuart and D. H. Hill, along the road gaps on South Mountain. The defenders were a combination of infantry, cavalry, and artillery. Astonishingly, all the gaps held into the afternoon against many times their number, by virtue of the heavy terrain advantage.

Union VI Corps commander Major General William B. Franklin's attack at Crampton's Gap began about 3:00 p.m. In overwhelming numbers, the attackers pressed their advantage against Brigadier General Thomas T. Munford's cavalry brigade of Stuart's command and about 300 infantry. McLaws sent the brigade of Brigadier General Howell Cobb to join Munford. The Confederates fought doggedly for every yard, as the Federals pushed them up the eastern face of the

9 Longstreet, *Manassas to Appomattox*, 218-219; D. H. Hill, *OR*, 19/1: 1019-1020; R. E. Rodes, *OR*, 19/1: 1033-1039: Longstreet, *OR*, 19/1: 839.

10 McClellan, *OR* 19/1: 53; Longstreet, *Manassas to Appomattox*, 219-220; Longstreet letter to D. H. Hill, June 6, 1883, D. H. Hill Papers, Library of Virginia.

mountain. For three hours Munford held and prevented a breakthrough into the valley beyond that threatened to trap McLaws's Division. His artillery "exhausted every round of ammunition," and had to retire. The Confederate lines broke late that afternoon and the Union attack reached the crest of the mountain. Munford lost control of the defense effort, and the stalwart exhausted defenders began retreating down the west side of the mountain. Reinforcements from McLaws's Division began arriving, but at this point were too little and too late to change the outcome.[11]

Franklin carried his objective but took no further action that day. Instead, he simply camped at the gap he had just wrested from Munford. The next morning, he went through the gap and advanced about a mile, finding the enemy drawn up in front of him. Believing he was outnumbered, his entire corps—three full divisions—remained in place for more than two days, allowing McLaws's and other Confederate troops to slip away.[12]

At 3 pm Longstreet arrived at Boonsboro, and "upon ascending the mountain, found D. H. Hill heavily engaged" defending Turner's and Fox's gaps. D. H. Hill now came under his operational control as Longstreet added the four brigades he had with him to bolster the defense of the two gaps. Hill had taken advantage of a stone wall at Fox's Gap that ran parallel to the road connecting the village of Sharpsburg with the Old National Turnpike perpendicular to the Union line of advance. From this wall and elsewhere the Confederates repeatedly punished the "restorers of the Union," as Hill called them in his report, and held off XI Corps assaults until the Federals used their numerical advantage to circumvent the Confederate left flank. This flanking movement, led by future president Lieutenant Colonel Rutherford B. Hayes, in conjunction with frontal assaults against the stone wall, finally dislodged the Confederates. A lull lasting several hours gave Hill time to bring up two fresh reserve brigades from their position on the west side of the mountain. Longstreet and Hill held their position until darkness, then retired to the west side of the mountain, thus concluding the battle of South Mountain.[13]

11 Stuart, *OR*, 19/1: 818; Munford, *OR*, 19/1: 825-827. Munford proudly wrote in his report "for at least three hours this little force maintained their position against Slocum's division." He also lamented the fact there were two parallel stone walls at the base of the mountain they could have used, had Cobb's infantry arrived early enough.

12 D. Hunter, *OR*, 19/1: 976. This report was prepared November 3, 1862, by the committee investigating the loss of Harper's Ferry, to which Hunter was assigned.

13 Longstreet, *OR*, 19/1: 839; D. H. Hill, *OR*, 19/1: 1019-1022. Hill was quite proud of this defense, citing his division numbered only about 5,000 available men on Sep. 14 yet held off

The *Official Records* and other correspondence about this battle are naturally devoid of 20th Century military terminology. South Mountain, however, contains small examples of a 'combined-arms' effort. While examples of mixing of branches date back to the ancient world, it was less typical in the 19th Century. Cross-leveling was not done *within a brigade or regimental organization*, to the degree it is in the modern US Army, since organizational structure was mostly single-branch pure. Yet Confederate units at these gaps did it informally, increasing the strength of their positions.[14]

The evidence in the historical record is also not sufficient to pinpoint if Hill personally directed some of this cross-levelling of different branches at Fox's or Turner's Gaps. Stuart alludes to it in his report, but Longstreet does not. The dispositions and tight areas they worked with, certainly do suggest that the commanders below Longstreet, Hill, and Stuart, made some ad hoc improvisations similar to doctrinal cross-levelling today.[15]

The South Mountain engagement was a tactical victory for the Union. It secured the terrain feature that opened the way to close on Lee. However, Longstreet, Hill, and Stuart had achieved some operational success, having checked the Union advance long enough to prevent the Army of the Potomac from attacking a divided Army of Northern Virginia. By the morning of September 15, Longstreet had reached Sharpsburg, where he awaited Jackson's arrival. An opportunity for McClellan had passed, but he now had the initiative.

Once Jackson had secured Harper's Ferry, he crossed the Potomac to join Longstreet, by now deployed on ground around Sharpsburg. Perhaps at this point Lee should have crossed the Potomac and moved back into Virginia. Such a withdrawal was Lee's first thought after the Confederates abandoned South Mountain. Certainly, with the Union Army a few miles to the east there was no

many times their own number, a feat he described as "remarkable and creditable." It is important to note that D. H. Hill's lean divisions plus one brigade fought all day at the gaps against two Union corps, composed of seven divisions—proof of the strength of a well-led combined arms organization harnessing terrain advantage.

14 *Combined Arms Operations* Vol. 1, E716/3, (Fort Leavenworth, Kansas: Combined Arms and Services Staff School, U.S. Government Printing Office, 1990), 3.

15 Typical cross-leveling in the modern US Army is seen in the Brigade Combat Team concept, where a tank brigade of three tank battalions swaps one of its tank battalions for one infantry battalion. The two organic tank battalions then further cross-level companies with the infantry battalion, whereby two battalions become tank-heavy and one infantry-heavy. In addition, each receives other branch assets such as air-defense systems, engineer vehicles, and mortars, assigned them for a particular operation.

place for Lee to maneuver beyond moving south again. Alexander points out in his memoir that Lee could have "easily retired across the river & we would indeed have left Maryland without a great battle, but we would nevertheless have come off with good prestige." But Lee changed his mind and told his officers: "We will make our stand." Despite being outnumbered two-to-one, with his back to a river, Lee decided to offer battle. A fight at Sharpsburg meant if they had to retreat quickly, there would be difficulty. Yet, on September 16, McClellan failed to attack. Lee was given an entire day to prepare and thus increase his chances of a defensive success.[16]

Jackson rode over to Longstreet at noon on September 16 to confer. He found him with Lee, studying the Federals across the way. All day the three watched, planned, and made troop adjustments. The Rohrbach Bridge was to the extreme right covered by several hundred Georgia troops, some in existing pits above the bridge. Lee kept Hood's division as a reserve, bivouacked in the woods near a single structure known as the Dunker Church that belonged to one of the German religious sects. With only 41,000 men, Lee deployed his army with the Potomac four miles to his rear, and prepared to engage about 75,000 troops under McClellan, who issued orders to attack the next day.[17]

McClellan's Attack

McClellan, like his counterpart Lee, did not articulate an overall objective and scheme of maneuver. He issued orders to each specific corps, opening the action by attacking from his right, then progressively attacking from his left. This left some corps idle at points in the battle and lessened the weight of any particular effort. He opened the first attack at dawn, with Gen. Hooker striking Stonewall Jackson. Using a cornfield for concealment, Hooker attempted to secure terrain around the Dunker Church. The attacks on Jackson's sector were known as the morning phase and consisted of a series of costly see-saw struggles including actions in the Miller Cornfield. At the height of this phase, Jackson's line did give some ground under the near-overwhelming pressure. The Rebels became dangerously low on ammunition, but John Bell Hood's counterattack blunted the equally worn Union assaults. Hood's efforts effectively broke any Union

16 Alexander, *Fighting for the Confederacy*, 145; William M. Owen, *In Camp and Battle with the Washington Artillery of New Orleans*, (Boston: Ticknor & Fields, 1885), 138.

17 Douglas, *I Rode with Stonewall*, 166; Sears, *Landscape Turned Red*, 167, 173.

momentum against the Confederate left wing and pressure in this area slackened off by early afternoon.[18]

The next phase was the assault from the left wing of the Union Army, against Longstreet's wing. Longstreet held hilly grounds and a 'sunken road' that allowed two brigades under D. H. Hill deployed in the road to shield themselves to a great degree when approached directly. Conversely, in attacking this position the Union soldiers were completely exposed.

In similar fashion to the back and forth battle that occurred on Jackson's front, Longstreet too experienced great pressure that bowed his lines. The Union attacks upon Hill's brigades were incessant all morning, and the Confederate lines thinned under great Union pressure. To try and unhinge the Confederates in the Sunken Road, the Union began to hit the flank of Hill's position in concert with their frontal attacks, and it worked. At this juncture, Longstreet managed to stem the onslaught with a steady performance of visibly calm battlefield leadership, and some timely employment of artillery fire. At a low point, however, Longstreet feared that Union numbers might carry the day: "Confederate affairs were not encouraging. McClellan with his tens of thousands, whom he marched in healthful exercise the past two weeks, was finding and pounding us from left to right."[19]

At the center of his position Longstreet could see the one Union division enfilading the troops in the sunken road, later named the Bloody Lane. Hill ordered the six guns of Boyce's battery to engage the Union troops that had penetrated the Sunken Road. Longstreet, looking for units to put into the hole, rode to a battery behind the infantry, and found a Lieutenant Andrew Hero Jr., who reported to him. Hero recollected: "He did not seem to recognize me & asked what Battery it was. I replied 3d Battery W. A. He then asked where was Capt. Miller? I replied he went to reconnoiter for a better position & had not yet returned. Genl. L. then said 'Lieut, move your Battery to the top of the hill & go into action. The enemy is advancing immediately in front of us.'" Hero began firing, but was quickly wounded, as were the other crewmen. Longstreet then ordered his entire staff into action on the guns. He stayed on his horse, holding the reins of staff members' horses, as his officers manned the cannon of Captain Miller's Battery. From a few

18 Jones, *OR*, 19/1: 1007-1008; Walker, *OR*, 19/1: 976-977; Hood, *Advance and Retreat: Personal Experiences in the United States and Confederate Armies*, (New Orleans: Hood Orphan Memorial Fund, 1880), 44. A secondary source with more literary presentation of detail on this battle is James M. McPherson *Crossroads of Freedom: Antietam, The Battle That Changed the Course of the Civil War*.

19 Longstreet, *Manassas to Appomattox*, 248.

feet back, Longstreet ordered them to fire canister into the advancing Federals. The thin gray line held. Longstreet's men, awestruck by their commander's fearless example of battlefield leadership, stemmed the Union assault and pushed the attackers back into the Bloody Lane, thus ending this phase of the fighting. Longstreet's personal courage as a commander at a critical spot was a combat multiplier, but so too was his choice of ground. The quick use of artillery by Hill and Longstreet along this front made the difference. The Federals under Major General Edwin V. Sumner made two unsuccessful attempts to break Longstreet's line. Sumner formed up his troops in column, each column with 1,700 in two ranks. They moved forward as perfect automatons out in the open, totally disregarding any modern military precaution. Longstreet's line had been dented after it was enfiladed at the flank, but they managed to deliver a constant hailstorm of canister fire into the awesome Federal display; stopping them cold.[20]

The Union divisions of Brigadier General William H. French and Major General Israel B. Richardson, plus a battery, sustained 2,920 casualties assaulting the Confederates in the Sunken Road. This action in front of the 'Bloody Lane' best illustrates how tactical defense in the 1860s repeatedly defeated direct approach tactical offense, due to weapons advancements and terrain advantage.

Since the first battle at Manassas, the numbers of casualties had grown immensely. While First Manassas resulted in fewer than two thousand casualties, this was largely the result of inexperienced troops and commanders and the resultant inability to synchronize fire and maneuver effectively. As more battles were fought the soldiers became more competent and focused. They gelled into cohesive combat units. Experience, cohesiveness, and confidence helped them to overcome fear to the degree that they stayed in formation in the face of fierce fire. The Union assault against the position at the Sunken Road is a case in point.

Along Longstreet's front the Union assaults in the second phase persisted into the afternoon. Commanders D. H. Hill and R. H. Anderson trooped their positions and with confidence calmed their men in the face of large blue uniformed formations. The Confederate units pushed back at the Federals and managed to retake ground they had lost. Longstreet's front held, and the second phase ended.

20 Rodes, OR, 19/1: 1037; Bennett, OR, 19/1: 1048; Andrew Hero Jr., May 18, 1896, *National Archives*, Antietam Studies, Longstreet Folder, box 2 of 3; Sorrel, *Recollections of a Confederate Staff Officer*, (Jackson, TN: McCowat-Mercer Press, 1958), 106; Alexander, *Fighting for the Confederacy*, 152-153; Sears, *Landscape Turned Red*, 241. Andrew Hero Jr. letter provided by Thomas Clemens, PhD, Antietam Battlefield Guide.

The Union assault under Gen. Burnside, after he had finally crossed the Rohrbach Bridge, characterized the final phase of the battle. Taking his time to organize his order of battle, Burnside consumed vital hours during which his line could have advanced up the slopes of the ridge from the bridge. Finally, the Union force made it to the edge of Sharpsburg. With Lee's line stretched dangerously thin, fresh Confederate reinforcements arrived in the nick of time, like Prussian Marshal Blucher arriving at Waterloo just in time to save Wellington. Commanded by Maj. Gen. A.P. Hill, the new arrivals slammed into Burnside's left flank.

Jackson had directed Hill to oversee the surrender at Harper's Ferry and summoned the general to Sharpsburg without delay. Marching as quickly as they could, Hill's troops covered seventeen miles in seven hours, arriving at a critical time and at a most advantageous angle from which to strike Burnside. This attack caused Burnside to abandon his advance on the Confederate right wing and forced him to retreat to the bridgehead. The battle of Antietam was over.

The overall result of the battle was tactical and operational success for the Confederates. They remained in possession of their positions at the end of September 17 and held against twice their number. Their casualties, however, were also high. In fact, as a proportion of troops engaged, their casualties were greater than the Union's. McClellan would continue to believe Lee's army more than matched his in strength, writing after the battle that: "Nearly 200,000 men and five hundred pieces of artillery were for fourteen hours engaged in this memorable battle." (Implying Lee had over 100,000 troops). He was greatly criticized for not pressing Lee again. Longstreet recalled on September 18, "the Federal line continued to swell with artillery and grow in numbers of brigades' bayonets, closing our front and flanks." However, and perhaps in fairness to McClellan, Lee had pulled his center back to the west side of the Sharpsburg Pike and deployed atop the higher, more formidable Reel's Ridge. Still, the strategic success was Lincoln's. Lee's first campaign north of Virginia was contained and failed to achieve British recognition or Maryland's secession.[21]

21 McClellan, OR, 19/1: 65; McPherson, *Battle Cry of Freedom*, 545; Longstreet to General Ezra A. Carmen, Tampa, Florida, February 11, 1897; Sears, *Landscape Turned Red*, 254; Ezra A. Carmen, *The Maryland Campaign of September 1862*, Vol. 1, ed. Thomas G. Clemens (El Dorado Hills, CA: Savas Beatie, 2012), 297-299. At this point in 1862, except for within the limits of Washington D. C., *abolition was not a declared political aim.* Lincoln, himself against slavery, was still willing to preserve the Union by taking back the seceding states with slavery. His letter to Horace Greeley, August 6, 1862 proves this: "I would save the Union . . . the Union as it was . . . If I could save the Union without freeing any slave I would do it" In September, at a low point after the defeat at Manassas, Lincoln also wrote a Meditation of the Divine Will stating: "God wills this contest . . . He could give the final victory to either side any day." See Sears, Ed. *The Second Year of the War.* 372, 442. In tandem with his plans for an Emancipation Proclamation, he also tried offering compensated emancipation to the Union slave states, and

Longstreet articulated a key reason they lost the opportunity for the type of victory needed to impress Prime Minister Palmerston and his government and have greater impact on Federal Congressional politics. The Confederate Army needed rest after Manassas. To go right into another hard campaign was a mistake. "Twenty thousand soldiers who had dropped from the Confederate ranks during the severe marches of the summer would have been with us," he wrote looking back on it. Had they paced themselves by resting at Manassas for a week, and planned better provisioning for the march, they might have prevented the straggling that reduced their overall strength. Had they arrived in Maryland with the strength they had at Manassas, mounting a defense on South Mountain, for example, with 55,000, might have delivered a severe repulse to the Union Army—one that was timely, when Palmerston was waiting and watching for a Confederate success. Perhaps Democrats would have fared better in the November elections and Maryland might have witnessed a further secession impulse. Even Jefferson Davis emphasized in one of his postwar works, that after the battle, "the condition of our troops now demanded repose."[22]

explored colonization of freed slaves to South America or Liberia. These were both rejected; few Americans pondered abolition as feasible, and free Negroes were mostly against colonization. He stated that his proclamations was "a fit and necessary war measure for suppressing said rebellion," but it did not overturn the Constitution's sanction of slavery. It was still up to states to decide the issue. Had the Union subdued the Confederacy in 1862, and the seceded states came back into the Union, slavery would have remained legal, with a further complication looming. The first XIIIth Amendment or 'Corwin Amendment,' already ratified by Illinois, Maryland, Delaware, Ohio, and Rhode Island by 1862, meant possible ratification for legal slavery in perpetuity. The Emancipation Proclamation had no legal standing if the peace was restored, and the military no longer "maintained the freedom of said persons." Slaves under military control as contraband of war, would legally return to servitude without a new amendment abolishing slavery. In 1861 Lincoln was careful to respect the legality of slavery with his support of the Corwin Amendment, and show the slave holding class he was not a threat to legal slavery. He only took a position against extension of it into the territories. In 1862, in light of Lee's military successes, and the British Prime Minister's overtures of a mediation between the two sides, Lincoln remained fearful that his cause of preservation of the Union was not yet assured. He also faced great domestic political risk, as one observer put it: "The ill successes of the summer campaign of 1862 had now developed a strong opposition party—which, protesting that official interference with the plans of McClellan, the radical views of the Administration on slavery and other subjects, and its intention not to restore the revolted States to the their former condition, were the true causes of our defeats—gladly rallied around McClellan as their leader." Kettell, *History of the Great Rebellion*, 384. As Longstreet points out (next chapter), Lincoln's proclamation is a political coup that openly included slavery in the war, but is still only a device for possible future abolition.

22 Longstreet, *Manassas to Appomattox*, 285; Jefferson Davis. *History of the Confederate States of America* (1890), (Coppell, TX: Arcadia Press, 2017), 182. The identical mistake would be made eighty years in the future by Field Marshall Rommel in North Africa after his taking of Tobruk

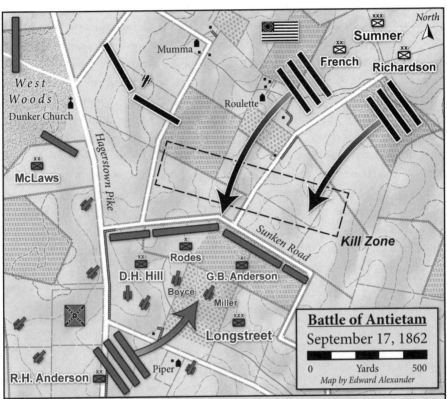

After the battle in Stonewall Jackson's front had subsided, 5,000 of French's Union troops attacked Longstreet's front along the "Sunken Road" at 9:30 a.m. Another 4,000 under Richardson joined the attack at 10:30 against the 2,200 Confederates deployed there. R.H. Anderson's 3,800 Confederate troops moved up to reinforce the outnumbered troops in the Sunken Road. Eventually, the weight of Union numbers prevailed and they succeeded in flanking and seizing the Sunken Road. However, a Confederate counterattack and artillery fire, coordinated by Longstreet himself, checked the Union progress. The Battle of Antietam was a costly and inconclusive tactical draw. Longstreet took notice of the strong defense made by the partially protected troops in the Sunken Road and the disproportionate casualties inflicted upon the fully exposed Union troops in front of them. He brought forward this lesson, creating a larger, 'modern' kill zone, three and a half months later at Fredericksburg, Virginia.

The loss of these strategic political possibilities aside, McClellan's disjointed, unsynchronized battle plan, allowed the Lee-Jackson-Longstreet team, which functioned many levels above their Union counterparts, to counter the various Union assaults. Longstreet and Jackson seamlessly executed handing off

in June 1942. Rommel, forcing his exhausted and depleted Afrika Korps to try and finish British forces in Egypt, was stopped at First El Alamein in July.

operational and tactical control of one another's units during critical periods of the campaign and battle. They remained confident on the evening after the battle, "and not one word was noted or referred to the withdrawal from our position."[23]

The great lesson learned by Longstreet was what befell the Union troops exposed on an open field in front of the Sunken Road. Again, it seemed he had a clear vision in his mind for what would happen in an action as he added up the units available. He could envision consequences. He knew the prepared tactical defense was dominant over the direct approach tactical offense, and the utilization of a road that was almost a trench made a huge difference. Longstreet would incorporate this feature in his next defensive effort: in December, he would fight from behind an improved combination of a sunken road and a stone wall, with a fire support plan on a scale never seen before. The next battle would not only bring the South a major victory, but Longstreet would give the world a glimpse of twentieth century warfare. He was promoted to Lt. Gen. on October 9, 1862.

23 Longstreet letter to Ezra A. Carman, Gainesville, January 28, 1895; Longstreet letter to Ezra A. Carman, Tampa, February 11, 1897. The first letter describes some of the flexing of units between Longstreet and Jackson that allowed them to mass at the right times against Union efforts. The second refutes a claim of a Council of War after the battle. Letters provided by Thomas Clemens, October 2020.

Longstreet's First Kill Zone:
When Maneuver Gave Way to Siege

"A genius is one who shoots at something no one else can see, and hits it."

— Proverb

Throughout

military history there has been a shifting dynamic between offense and defense. In one era offense is superior to defense, but then the introduction of new military technology and/or tactics moves the pendulum in favor of the defense. For example, during the Napoleonic Wars offense was in the ascendant and frontal infantry assaults were commonplace and frequently successful, as defenders could often only get off a single volley against their attackers. As weapons improved and allowed defenders to get off several volleys against the assaulting enemy, frontal assaults became increasingly suicidal. Not until new tactics or technology was introduced would the offense again become dominant.

Immediately before the Civil War most military thinkers believed the offense was always superior, and they largely disregarded the improvements in weapons since the time of Napoleon. James Longstreet found a successful way to combine post-Napoleonic advancements in firearms with field fortifications and became the first in the Civil War to build a cohesive, corps-sized defense using this combination. Longstreet first carried out this most effective and deadly application by stopping a massive Union frontal assault at the battle of Fredericksburg in December 1862. He also updated the practice of using field fortifications, which

increased in scale during later battles such as Cold Harbor and Petersburg, and would dominate the battlefields of World War I.[1]

Maneuver often gave way to siege during the American Civil War, and fortifications generally dominated warfare until Germany's Heinz Guderian perfected offensive armored warfare in the 1930s. During the first year of the Second World War, this approach received the nickname Blitzkrieg (Lightning War). Guderian's massing of the tank ushered in the next revolution in military affairs. He restored maneuver and in doing so finally overcame the conditional stalemate of combat that field fortifications had created in the First World War.

* * *

In military terms the year 1862 was a relatively satisfactory one for the Army of Northern Virginia. Lee's army won a great victory at Second Manassas and followed with an invasion of Union-controlled territory, resulting in the battle of Antietam. After the battle, however, the Confederates fell back to Virginia and Lincoln issued his Emancipation Proclamation. According to Longstreet: "This was one of the decisive political events of the war, and at once put the decisive struggle outwardly and openly upon the basis where it had before only rested by tacit and covert understanding."[2] Longstreet articulates that the Lincoln administration had explicitly added an attack upon slavery's role in the Confederate war effort. This, however, also changed his aims to not only restoration of the Union, but also threatened the overall institution of slavery in the secessionist states. The latter, further diminishing the possibility of European intervention on the side of the Confederacy to zero.

Longstreet recognized that military success had to carry over into the political realm for the Confederacy to survive, and that the aftermath of the Maryland invasion was a major blow. Nevertheless, although the Maryland campaign did not bear the fruit that Lee and the Confederate government had hoped for, the ANV continued to gel, and the skill of its commanders continued to develop.

1 In the 1830s the flintlock began to be replaced by the cap percussion system, and longer, rifled barrels emerged. By the 1840s the newer system was probably more prevalent in North America, and by the 1850s and 1860s, nearly all the weapons available to the armies were superior in range and rate of fire to those of 1815. However, the tactics had not caught up.

2 Longstreet, *Manassas to Appomattox*, 289. Longstreet describes most earlier anti-slavery sentiments by those who wanted complete abolition of slavery, as having been "covert," —largely restrained or kept quiet in his observation.

The crushing Union defeat at Second Manassas was the largest rout of one army by the other thus far in the war. Antietam presented a similar chance for the Union, but McClellan did not recognize it. He did not renew his attack upon Lee after September 17, nor maneuver to advantage. In fact, the war in the East during the first year in many ways still resembled warfare of the earlier Napoleonic period. Each side postured and countered the other and waged battles, but the battles were inconclusive, resulting in little progress toward the goal of winning the war. There was, however, one contrast with the Napoleonic period—the casualties were greater. And while the North had not defeated Lee, the growing attrition rate was not something the South could sustain indefinitely. The much larger population of the Northern states gave the Union a distinct advantage.

Lee had kept the Army of the Potomac at bay and handed it several painful defeats, but he had engaged his adversary in the same manner they had engaged him—with the intent of delivering an overpowering and decisive victory. Perhaps historian Alan T. Nolan was correct in his assessment of the Confederate commander's leadership. Nolan asserts that Lee's offensive sense of the war, as applied in his theater of operations, was not realistic. Nolan maintained that Lee, "believed that the Confederacy could win the war by defeating the Federal armies, by militarily overpowering the North. This is what he said he believed. In my view this was wrong. The South simply did not have the strength to win the war militarily. Its only chance to win was to prolong the war and make it so costly to the North that the northern people would give up."[3]

Lee certainly understood the Confederacy had strategic difficulties. The comparative lack of manpower was its biggest disadvantage, but after dispersing Pope's Army at Manassas, Lee and Longstreet had won some time. Halleck had eliminated the military advantage of two armies to one over Lee, they had developed Jackson into an integral army wing commander, built an army of modern force structure, and gained nascent British favor. In view of these positive developments, a less hurried desire to eliminate the Union force at Harper's Ferry and enter Maryland seemed the more sensible path for Lee. Especially as Lincoln was about to put McClellan back in charge of the field army. However, Lee moved hurriedly into Maryland, despite one-third of his force falling out from straggling. Yet having his full force present was imperative in case of battle. He could handle the Army of the Potomac with the 55,000 men he had in Virginia, but short 20,000

3 Alan T. Nolan, "Confederate Leadership at Fredericksburg," *Rally Once Again! Selected Civil War Writings of Alan T. Nolan*, (Chapel Hill: The University of North Carolina Press, 1995), 43.

and outnumbered 3:1 was too risky, as Antietam proved. Lee did not seem to respect force ratio disadvantage enough. Nor did he acknowledge the reality that he must fight battles resulting in vastly disproportionate casualties to the Union, while sustaining few to his own army. It was the North that shouldered the burden of having to subdue the South, and therefore undertake offensive operations. The South needed to win battles and make the North grow weary of war by inflicting large numbers of casualties and repeatedly repulsing their invasions. When the Army of Northern Virginia stood opposite the Army of the Potomac across the Rappahannock River at Fredericksburg, such an opportunity arose. It was Longstreet who seized the moment to shape such a battle.

After Antietam, the ANV rested along lines of deployment between the Potomac and Winchester through the end of October. On October 26, 1862, McClellan started a tentative movement south, crossing the Potomac east of the Blue Ridge Mountains. Lee reacted with greater speed. He had Jackson cover the passes in the Shenandoah, and Longstreet march through the Shenandoah, via Front Royal to Culpeper Court House. Longstreet moved his troops up to twenty miles a day and covered close to one hundred miles in ten days, arriving in Culpepper with the three divisions of McLaws, R. H. Anderson, and Pickett. In contrast, to Lincoln's dismay, McClellan had barely moved forty miles in almost two weeks from his positions in Northern Virginia.[4]

November 5, 1862, President Lincoln removed George McClellan from command for the second and final time. McClellan's pompous attitude and his continued reluctance to pursue Lee frustrated the president. Major General Ambrose Burnside, who considered himself unqualified to command the Army of the Potomac, replaced McClellan.[5]

Before leaving the AOP, McClellan wasted another week on farewell ceremonies and reviews. Thus, when Burnside took command, Longstreet was far ahead of the Union Army and the direct road to Richmond was blocked by his forces. On the same day that Burnside assumed command, a very upbeat Lee joined Longstreet at Culpeper Courthouse and joked about McClellan's removal.

4 Longstreet, *Manassas to Appomattox*, 290-291; Lee, *OR*, 19/2: 685-687.

5 Lincoln, *OR*, 19/2: 545; McPherson, *Battle Cry of Freedom*, 570. Burnside was a division commander who was skipped over the corps level to take command of the army, and therefore lacked the benefit of corps-level experience.

Lee remarked that he had become so used to his opponent's methods that "he hated to part with him."[6]

His new position intimidated Burnside, who although an experienced brigade and division commander, had no professional development above division level. The appointment of an army commander who both lacked confidence and felt pressured by an impatient administration, would prove disastrous for the Union. Burnside hurriedly committed the Union army to an opposed river crossing, after which it would follow the retreating Confederates straight into a well-prepared defense. Lee, Longstreet, and Jackson could not have hoped for better circumstances.[7]

On November 14, 1862, Burnside reorganized his army into three Grand Divisions, comprised of two corps each. These were designated the right, center, and left Grand Divisions, and one corps was designated a reserve. He began moving toward Fredericksburg with the aim of crossing the Rappahannock River and turning west to approach Richmond. Lee countered immediately and by November 19 he had Longstreet and his five divisions aligned on the hills overlooking Fredericksburg and the crossing sites. Lee had also changed the wings into corps. Even though the ridges southwest of the town assured a significant advantage for the Confederates, Longstreet saw something more he could do on a large scale. He tied together the available terrain features with a digging and construction effort that enhanced them: this was the decisive combat-multiplier for the upcoming fight. Longstreet saw a chance to create conditions that would maximize casualties in the Army of the Potomac and minimize those of the Army of Northern Virginia. He ordered construction of trenches for his infantry, pits for his cannon, and placed abatis in front of the works as well as in the flat fields that lay between the town's edge and his positions at Marye's Heights. In addition to the natural hill and man-made works, an existing stonewall stood perpendicular to the anticipated Union line of advance. Moreover, a "sunken road" ran behind part of the wall, providing a perfect position from which his infantry could rest their elbows on the stone wall, and take steady, well-aimed shots.[8]

6 Wert, *Longstreet*, 213.

7 Jacob Dolson Cox, *Military Reminiscences of the Civil War*, (2 Vols., New York: Scribner's Sons, 1900), 389-390; Charles A. Dana, *Recollections of the Civil War*, (New York: D. Appleton and Company, 1898), 138. See Dana for observations on the personality of Ambrose Burnside. Cox was a Republican in the Ohio State Senate when war began.

8 Burnside, *OR*, 19/2: 583; Longstreet, *Manassas to Appomattox*, 290, 293, 317-321. Burnside's organization was: Right Grand Division: II & IX corps; Center: III & V corps; Left: I & VI

For days he walked among his positions, watching the preparations and making adjustments, much like an artist applying finishing touches to a painting. Longstreet sought to construct an unbreakable position, one that would destroy any size force that attacked, and negate the defender's numerical disadvantage. The ground in front of Marye's Hill was so thoroughly covered by Confederate firepower that Colonel Porter Alexander, Longstreet's artillery coordinator, remarked, "A chicken could not find room to scratch where I could not rake the ground." In twentieth-century military terms, Longstreet created a "kill zone."[9]

The modern kill zone is an engagement area a commander selects in which to trap and destroy an attacking enemy with the massed fire of all weapons available. Every unit assigned must be able to fire into the kill zone, either reaching every space in it, or an assigned sector of it. Ideally, the defense achieves a large degree of interlocking fields of fire that prevent the enemy from finding dead spaces in which to take cover. From the base of Marye's Heights he assigned as many infantry and artillery units as possible; sighted into his chosen kill zone.

While Longstreet worked on his innovations at Marye's Heights, Stonewall Jackson arrived with his corps and placed his troops in the woods to the right and southeast of Longstreet. The two corps were not as closely connected as they were at Second Manassas but remained loosely joined by one of Longstreet's divisions under John B. Hood. Lee placed his headquarters to the left of Hood, on a hill between Longstreet and Jackson. The location provided exceptional sightlines and afforded the general an opportunity to exercise strong command and control. Longstreet was so sure of his preparations that he told Hood before the battle to be prepared to assist Jackson and that he need not concern himself with assisting troops in his own corps.[10]

At the tactical level, Longstreet was thinking defensively with the deployment of most of the troops in the line. His instructions to Hood however, indicated that he also wanted to have a defense flexible enough to attack a portion of the enemy

corps; and XI corps as reserve. Lee's organization: 1st Corps of Longstreet: divisions of McLaws, Anderson, Pickett, Hood, Brig. Gen. Robert Ransom, and Corps Artillery; 2nd Corps of Jackson: divisions of D.H. Hill, A. P. Hill; Ewell: Jackson's Division (Taliaferro), and corps artillery. John R. Jones had commanded before Taliaferro.

9 Alexander, *Fighting for the Confederacy*, 169.

10 Wert, *Longstreet*, 219.

should such a need develop. Later in the battle, the opportunity arose for Hood and a brigade under General Evander M. Law, to attack the flank of a Union thrust.[11]

Longstreet felt that the AOP would strike both his corps and Jackson's to test which side of Lee's Army might yield first and open the way to Richmond. Burnside's self-doubt about his qualifications to lead an army of over 100,000 proved justified; he understood operations at the divisional level but could not see the army-level operational picture. Major General O. O. Howard described him as "sad and weary." His secretary, Captain Daniel Larned, recorded he was in a state of nervous depression for days after his appointment, working long hours, fretting, and becoming physically ill. The combination was disastrous. He sent his army directly into a well-prepared kill zone, where the narrow space between the town of Fredericksburg and the Confederate positions left little room for the massive AOP to maneuver.[12]

This battle was in stark contrast to those of maneuver that required Lee to make many decisions and shift troops throughout the fight. At Fredericksburg, once Longstreet had positioned his units, he had, by virtue of his defensive preparations, compelled much of the ANV to work within the confines of his trenches and earthworks. This maximized the effect of their firepower and ensured that Longstreet and Jackson would control the battle. There was no need for maneuver and Lee needed only stand atop Marye's Heights and observe the carnage.

On Saturday, December 13th, Burnside launched his attack, He opened with an assault on Jackson at 10 a.m. with a portion of his army approximately the same size as the Confederate forces to his front. Jackson's Corps held the line stoutly and only once had a problem. When a gap between two brigades opened in his line, the attacking Union division immediately pushed through. Jackson acted quickly, however, and filled the gap by moving a reserve division into line and driving the attackers out. The Federals made no more effort against Jackson's line. Next came the assault on Longstreet, the strongest position in the line.[13]

11 Hood, *OR*, 21: 621-622. Hood remained unusually passive and did not conduct the flank attack. Consult George Rable, *Fredericksburg! Fredericksburg!*, (Chapel Hill: The University of North Carolina Press, 2002), 524.

12 Captain D. R. Larned to H. L. Larned, November 22, 1862, *Larned Papers, Civil War Manuscripts*, 523, Library of Congress; O. O. Howard, *Autobiography of Oliver Otis Howard*, Vol. I, (New York: Baker & Taylor Co., 1907), 313-314.

13 Jackson, *OR*, 21: 630-635; A. P. Hill, *OR*, 21: 645-649; Alexander, *Fighting for the Confederacy*, 173-174; Longstreet, *Manassas to Appomattox*, 307-309; Howard, *Autobiography*, I, 334-336.

An hour or so later, near 11 a.m., Burnside shifted his attention to Longstreet. The attacking force consisted of two Grand Divisions. The Federals launched their first assault with six brigades that advanced to about 100 yards of Longstreet's line, right into the kill zone, the point where Confederate infantry and cannon fire was at maximum effectiveness. At this distance, Longstreet's men cut down the Union troops with a crescendo of fire. Each Union division was three brigades deep, and one after another they advanced directly into the attack, only to break apart short of the wall. The closer the Union troops advanced, the more intense the fire from the Confederates.[14]

By the time the Union troops had mounted three futile assaults, Lee expressed concern that Longstreet's line might soon give way. Viewing the action from his vantage point on the hill, Lee said to Longstreet, "General, they are massing very heavily and will break your line, I am afraid." Longstreet replied, "If you put every man now in the other side of the Potomac on that field to approach me over the same line, and give me plenty of ammunition, I will kill them all before they reach my line. Look to your right you are in some danger there [at Jackson's positions], but not on my line."[15]

Each successive attack required the Union brigades to charge out of cover and traverse 400 yards of open ground. They came under the direct fire of fourteen cannon on the heights and three brigades of infantry, approximately 5,000 muskets, ensconced safely behind a shoulder high stone wall, rifle pits, and trench line. In order to increase the rate of fire, only the men at the stone wall fired the muskets. Soldiers behind them loaded the empty weapons as fast as they could and handed loaded rifles back to the men at the wall. This ensured "deliberate and effective fire," wrote Brigadier General James B. Kershaw. Behind Longstreet's three front brigades were three more infantry brigades and an additional twenty-two cannon, some of them in protective pits with only the muzzle of the weapon exposed.[16]

Another modern method that Longstreet employed was the use of centralized artillery support during this phase of the defense. Centralized Support role for artillery means that artillery units that did not belong to Longstreet, were to receive an assignment to direct converging fire solely in support of his corps. Normally, the

14 Lee, OR, 21: 550-556; Longstreet, OR, 21: 568-573.

15 Longstreet, cited in Wert, *Longstreet*, 221.

16 Alexander, *Fighting for the Confederacy*, 176; McLaws, OR, 21: 581; Kershaw, OR, 21: 591. McLaws said the mass of Union dead were about 100 yards off. One man was found 30 yards out.

artillery of the nineteenth century fought (in modern United States Army Fire Support terms) in a decentralized manner: that is, they were in a Direct Support role to infantry units in the close fight. When in the Direct Support role, artillery units remained spread out evenly among infantry units so that each division or group of brigades had a certain amount of supporting artillery. Centralizing the artillery became more advantageous as cannon evolved from a direct fire role to an indirect fire role. This became particularly effective once the range of the guns increased and with the perfection of the breach and spiraled rifling inside the cannon tube.

Longstreet incorporated a modern centralization of artillery at Fredericksburg prior to these technological improvements. His own artillery on Marye's Heights delivered direct support, and he also received reinforcing fire support from other batteries. One of these held a position behind him on Lee's Hill, while additional units stood to the left and right of his corps. With these assigned reinforcing roles, all the cannon directed synchronized fire at the advancing Union infantry at the same time.

Even today, when visiting Fredericksburg and standing on Lee's Hill, nearly two miles from gun to target, one can see clearly how cannon on this location used indirect fire over Longstreet's troops to attack targets in front of the stone wall. Coordinated indirect artillery fire of this sort did not evolve until the perfection of breach-loading howitzers, at which point the approach became the standard use of field artillery weapons. This did not happen for decades, and accurate, indirect fire in war did not occur on a large scale until the Russo-Japanese War of 1905. This capability would advance further in the World Wars. In the twentieth century, the use of wire and radio communication would tie disparate artillery units together so they could fire in concert, as directed by forward observers, and deliver centralized, synchronized, massed fire. This early application of indirect fire, albeit using heavier ordinance, was a forerunner of modern artillery employment, and was a key combat multiplier of Longstreet's 'twentieth century' defense.

In all, Burnside hopelessly dashed twenty-two brigades against Longstreet's three brigades and supporting guns. The Confederates mauled fifteen of these brigades to the point of annihilation. From start to finish the unmovable Rebel bastion fired and reloaded as one large well-drilled cannon crew with a precision drill squad of infantry. No number of men, no matter how brave and well-led, could survive this metal storm and take Longstreet's works. If units continued to attack from the same direction in the same manner, they would suffer the same fate.

Yet, Burnside remained committed to the notion that each attack must be weakening the Confederates, and just one more great push would break

Longstreet's line. This recklessness lasted into the late afternoon as wave after wave of Union attackers rushed Longstreet's position with tragic results. At another point during the afternoon combat, Lee expressed a degree of awe and admiration for the magnificent heroics of the Union troops. At the same time, he was unsettled by their slaughter, and confided to Longstreet, "It is well war is so terrible, or we should grow too fond of it."[17]

Lee was winning the battle with fewer casualties among his own ranks, but what he saw happening to the Union soldiers was unsettling. This battle was killing more men in a shorter period than anything yet in military history. It was a marked departure from the Jominian and Napoleonic world of maneuver and bold knightly strokes. This modern method of combat probably rubbed Lee the wrong way, for he was likely not one to think that several hours of this fighting resembled a chivalrous battle. It was still a time when some Confederate soldiers and officers became angry when, at Shiloh, Ulysses S. Grant ordered his troops to lie on their bellies instead of standing in traditional strict linear formations. Disturbing as Longstreet's innovation at Fredericksburg may have been to Lee, a new age of warfare had arrived and in time he would have to embrace it.

Around 4:30 in the afternoon Burnside finally called off the attacks and the slaughter ceased. The following day his troops limped back over the Rappahannock River. Fredericksburg became a new low for the AOP. A distraught Lincoln exclaimed, "We are on the brink of destruction It appears the Almighty is against us." Union losses were 12,653, of which more than sixty percent fell in front of the stone wall. Longstreet's casualties included 130 killed and 1,276 wounded while in Jackson's command there were 328 killed and 2,454 wounded.[18]

The reason Jackson suffered twice as many casualties as Longstreet, even though he engaged fewer Union divisions for a shorter time, reflects the relative effort spent on defensive preparation. Jackson's arrival the day before the battle allowed him only a limited time to dig field fortifications. Most of the trench lines his men dug were about two or three feet deep. This gave his men approximately the same degree of protection Longstreet's men had at Antietam in the Sunken Road; they were still exposed from the waist up. Many of Longstreet's men in front

17 Lee cited in Wert, *Longstreet*, 223.

18 McPherson, *Battle Cry of Freedom*, 575; Theodore C. Pease & James G. Randall, Eds., *The Diary of Orville Hickman Browning*, 2 vols., (Springfield, Il. 1927-33), 1: 600-601; William Marvel, *The Battle of Fredericksburg*, (Washington DC: Eastern National, 1993), 53; Jubal A. Early *War Memories*, (Bloomington, IN: Indiana University Press, 1960), 180.

Confederate troops pouring rifle fire into Longstreet's kill zone. Drawing shows how only some men fired muskets, while others loaded them to increase the rate of fire. (*Allen C. Redwood, January 1, 1887, Library of Congress Prints and Photographs Division*)

of Marye's Heights could lean on the stone wall resting their elbows and rifles, with only their head exposed. They were well protected and could concentrate on accurate musket fire. Longstreet perhaps stated the situation best: "The situation is this: 65,000 Confederates massed around Fredericksburg, and they had twenty-odd days in which to prepare for the approaching battle."[19]

Lee had won another important victory and his confidence, along with the morale of the Army of Northern Virginia, continued to increase. Burnside went to see President Lincoln at the White House, and in one of the most honorable examples of personal responsibility in the war, told him that he would publish a letter taking all the blame for Fredericksburg. The Army of the Potomac was shaken, but the men and officers stayed focused on the mission. The North was nowhere near thinking of giving up the fight. What came of this battle in the mind of Longstreet was a possible way to win the war, and in doing so secure a path to independence. More victories like Fredericksburg might convince the North that Lee could not be defeated. According to one soldier in an Alabama regiment, "It

19 James Longstreet, "The Battle of Fredericksburg," in *Battles and Leaders of the Civil War*, Robert Underwood Johnson & Clarence Clough Buel, eds., 4 vols., (New York: Thomas Yoseloff, 1956), 3: 73.

was the most complete victory for us we have ever had." Longstreet also saw that the formula for winning defensive battles was a means of avoiding a costly attrition rate for the Confederates. In the past, the use of fortification and high ground was a sound tactic, but decisive use of terrain to channel an opponent into a kill zone and maximize the capability of firearms was a leap forward. Even if high ground and fortifications were not available, a flat, open area, where many units could converge, provided an opportunity to employ interlocking fields of fire and synchronize volleys of massed direct and indirect lethal fire. If Lee would embrace this modern way of war in major engagements, winning the war by exhausting the North seemed very possible.[20]

20 Harlan Eugene Cross, Ed. *Letters Home: Three Years Under General Lee in the 6th Alabama* (Fairfax, Virginia: Histrory4All, Inc., 2010), 83; T. Harry Williams, *Lincoln and His Generals*, (New York: Alfred A. Knopf, 1952), 201.

Chapter 6

The Defensive—Offense Evolves

"The secret of success in modern war lay not so much in the display of personal bravery or individual heroism, but in organized, disciplined, collective action."

— Christopher Coker, *War and the 20th Century*

After Fredericksburg, the armies faced each other across the Rappahannock River for the remainder of the winter. Burnside attempted a movement known as the "Mud March," but road conditions quickly frustrated his plans and Lincoln relieved him and placed Joseph Hooker, now a major general, in command. It was May before 'Fighting Joe,' as he was known, attempted to move against Lee. Hooker's operation led to yet another disaster for the army.[1]

Meanwhile, on January 12, 1863, North Carolina Governor Zebulon B. Vance urged Jefferson Davis to direct Lee to provide forces to counter Union activity along coastal portions of the state. Confederate authorities in Richmond were also agitated over a similar situation in Suffolk, Virginia, on the James River. Lee directed Longstreet to take two divisions and conduct operations around Suffolk and in North Carolina.

The previous year, Lee had advised Davis that he was not "able to ascertain the purposes of the enemy in North Carolina," and that Union demonstrations in the state were, in his opinion, mere distractions. He also wrote to Maj. Gen. Gustavus Smith, commander of defenses in Richmond. Smith had responsibility for the areas south of the James River. Lee insisted, "we cannot hope to meet [the enemy] at

1 Sorrel, *Recollections*, 144.

every point with anything like equal force. . . . We must risk some points in order to have sufficient force to concentrate." Nevertheless, in the early spring of 1863 Lee moved Longstreet's Corps into the area.[2]

Lee designed this movement with several objectives in mind. First, Longstreet would draw off a portion of Hooker's increasing strength. Second, he could gather cattle and other foodstuffs from a region that had not yet seen its resources depleted by the war. The move would also secure some of the supply rich counties in the region. Lastly, the Confederates hoped to prevent the Union troops operating in the area from advancing inland to target the Petersburg and Weldon Railroad. The P&W RR was the sole rail supply line east of the Blue Ridge for the Army of Northern Virginia, and as such needed protection during the massive foraging operation. Once there, Longstreet's men worked diligently to forage and successfully helped resupply the remainder of Lee's army. Longstreet and Lee exchanged notes almost daily, as Lee needed intelligence on any Union movements across the region.[3]

While Longstreet did maneuver against the occupied North Carolina towns of New Bern and Washington, and against Suffolk, Virginia, his operations were essentially a reconnaissance in force. He probed various points in the Union defenses for possible weaknesses but found none. He concluded that there was little likelihood of success for major assaults on these strongholds. The *Philadelphia Inquirer* published this account: "General Longstreet went at his plan with energy, and from April 11, when he first drove in our pickets, until Tuesday last he kept up an incessant series of attacks of the most harassing and vexatious character to General [John J.] Peck's troops. He rushed his squadrons of cavalry against our lines in one place and established batteries of field artillery to sweep the Nansemond River, at others . . . he endeavored to penetrate our lines, but was baffled at every attempt by the watchfulness, activity, endurance, skill, and courage of General Peck and his brave companions in arms."[4]

Many Confederate newspapers were critical of Longstreet and expected him to boldly attack and eliminate the Union strongholds. Clearly, these newspapermen

2 Lee, *OR*, 21: 1034, 1938.

3 Douglas S. Freeman, *Lee's Lieutenants, A Study in Command*, 3 vols., (New York: Charles Scribner's Sons. 1942), 2: 467; Lee, Longstreet, *OR*, 18: 943-996. Lee wrote Longstreet March 27, 1863: "I don't know whether the supplies in that state are necessary for the subsistence of our armies, but I consider it of the first importance to draw from the invaded districts."

4 *Philadelphia Inquirer*, April 24, 1863. The article is likely an interview of one of the officers under Union Maj. Gen. John J. Peck.

did not grasp the lessons of Fredericksburg. Nevertheless, several historians followed up this criticism. H. J. Eckenrode Longstreet's first biographer, for example, did so in his 1936 book. In a chapter headed 'Independent Command: Suffolk,' he downplayed Lee's instructions to Longstreet, and in so doing advanced the Lost Cause assertion that the operation was a failure.[5]

Nothing could be further from the truth. Lee did not order Longstreet to take Suffolk. Additionally, there was no command relationship defined as "independent command." The origins of this term are unclear, but it implies there is no higher commanding officer above such a command. It is therefore an erroneous term. In the military there is only command, and no commander is independent. Each command position has a higher command authority above it. At Suffolk, Longstreet remained a corps commander under Lee. The distance from Lee was irrelevant and Longstreet received all his orders from the commanding general as he had done previously.

Once at Suffolk, Longstreet recognized the disposition of the Union positions for what they were—enemy strong points. To comply with the purpose of his primary mission he had to avoid engaging the enemy fully. The Union troops were behind fortifications and Longstreet, recalling vividly what happened to the attacking force in front of his defenses at Fredericksburg, was not going to subject his troops to the same fate. Confederate strength was precious and had to be preserved for more decisive opportunities that were in line with the defensive–offensive strategy that he advocated. Lee was of the same opinion, and writing to Longstreet on April 6, noted that Lee was not in favor of losing precious veterans against these points. "You know much depends on your divisions, and I wish to reserve them as much as possible. You must push them according to your own judgment, and I would recommend careful reconnaissance before attacking Suffolk." Longstreet's primary goals in southeast Virginia were containment of Union forces and resupply of Lee's army. Large-scale operations to eliminate

5 H. J. Eckenrode and Bryan Conrad, *James Longstreet: Lee's War Horse*, (Chapel Hill: University of North Carolina Press, 1936), 151-167. In this chapter, the authors assert that Longstreet was trying to get away from Lee, and this "independent command" gave him that opportunity. The correspondence between Lee and Longstreet does not support this interpretation. Additionally, an "independent command" technically does not exist in the military. Moxley Sorrel was in banking before the war and had no experience as a soldier or officer before the war. He used this term in his own book, which Eckenrode cited in his book. Sorrel probably thought when a portion of a command is operating distant from the army commander, it was somehow independent. Or that a district command position was independent. These assumptions are incorrect. Longstreet's Corps was an organic part of the ANV, regardless of distance from Army HQ. Lee remained his commanding officer throughout the war.

enemy strongholds would have been incompatible with Longstreet's mission. Following probes of Union fortifications, he dropped any consideration of assaulting Union strongholds.[6]

Longstreet decided to undertake a demonstration and apply a type of pressure to the enemy, but not an assault. In this case, the demonstration functioned as a show of force designed to keep the enemy in place and discourage any intention of his moving further inland. He designed the demonstration to convince Union forces that a far superior force blocked their pathway to the interior.

Upon his arrival, Longstreet had considered the option to attack, but he and his subordinates reached the same conclusions regarding Federal positions. General D. H. Hill, who Longstreet had sent to pressure Union forces holding Washington, North Carolina, insisted that he must have more troops to dislodge the enemy. Hood concurred and as he looked for a weak spot in other Union positions remarked, "Here we are in front of the enemy again. The Yankees have a very strong position, and of course they increase the strength of their position daily." Longstreet and his division commanders concluded they did not have enough combat power to attack these Union-occupied towns.[7]

Governor Vance failed to fulfill Hill's requests for state militia to augment Confederate regulars at Washington. While Longstreet seemed irritated that Hill had requested more troops, he did not rebuke his lieutenant. There were simply too many Union advantages in the area. Yet the demonstration convinced Federal commander Major General John G. Foster that a powerful and robust Confederate force lurked nearby. He reported: "heavy operations will be necessary in this state … the most desperate efforts are and will continue to be made, to drive us from the towns now occupied."[8]

Longstreet did as Lee ordered. He had supplied the army, executed a sound demonstration, and returned to Lee with two fit and battle-ready divisions. In addition, Longstreet's demonstration left a lasting impression on local Union leadership, convincing them to stay where they were rather than probe further into southern Virginia and North Carolina. By these standards, the Suffolk operation was a success for Longstreet and Lee.

6 Lee, OR, 28: 966. Here Lee was asking they "not storm the enemy's entrenchments, which might cause the loss of many of our brave men."

7 Freeman, Lee's Lieutenants, 2: 492.

8 Ibid., 493-494.

While Longstreet was detached, Lee fought the battle of Chancellorsville, employing Stonewall Jackson's infantry and Jeb Stuart's cavalry. Lee won another resounding victory. Regarded by many as Lee's masterpiece of maneuver, Chancellorsville nevertheless cost the ANV 13,000 casualties, including Jackson. Still, at this juncture, events in the Eastern Theater were going well for the Confederates. Events in the West were a different story, however, and the Confederacy needed to reverse those Union gains.

Longstreet advocated a western concentration that required the participation of major Confederate commands currently in Virginia, Tennessee, and Mississippi. The chief element of his plan was to shift troops from Virginia to the West, to concentrate superior force against either Major General William S. Rosecrans, currently driving toward Georgia, or Grant in Mississippi. Longstreet saw the victory at Chancellorsville as proof that Lee could manage the Army of the Potomac even if one of his corps was elsewhere. Warfare was evolving into the heavy use of fortifications and siege, and Longstreet had revealed one formula for winning battles in this new age—inflicting mass casualties. However, tactical success must support the operational and strategic levels as well. For the Confederates this meant a defensive–offensive strategy that secured lopsided victories, utilized strength judiciously, and harnessed the South's interior lines across and within the Confederacy. In other words, a strategic defensive approach of creating numerical superiority against select, specific Union forces.[9]

The Progress of General Grant

In early 1863, Longstreet compared the Eastern and Western Theaters through the lens of his strategic vision and realized the South was about to sustain a serious defeat at Vicksburg. Grant's unfolding Vicksburg campaign, one of the most monumental and ingenious of the war, was moving ever closer to success. General Henry W. Halleck, the former overall Union commander in the West, had touted the view that, "Taking the Mississippi would be more advantageous than the capture of forty Richmonds."[10]

Grant's understanding of total war ensured he would follow through with the inland part of the Anaconda Plan, developed at the beginning of the war. The plan

9 Longstreet, *Manassas to Appomattox*, 327. Longstreet wrote that President Davis still believed foreign intervention was "the easiest solution of all problems."

10 Halleck, *OR*, 24/1: 22.

had two parts. First, establish a naval blockade, and then divide the Confederacy by striking down the Mississippi River with a combined navy and army effort. Advancing down river, the "Mississippi River Expedition," would function as a massive turning movement and force capitulation of the enemy's fortified posts and shore batteries. The expedition would finally link up with the Union naval squadron in the Gulf of Mexico, thus completing the encirclement of the Confederacy.[11]

In theory, the Anaconda Plan would surround the Southern states and prevent the Confederacy from receiving war materials and other imports from foreign powers. Striking along the Mississippi and controlling the river also meant the separation of Texas, Arkansas, and western Louisiana from the rest of the Confederacy. This would isolate the Rebel troops stationed there and prevent supplies from crossing the Mississippi and reaching the armies in the east. The Anaconda Plan was a truly modern total war concept that struck directly at the Confederate nation's economic and logistical ability to wage war. Longstreet knew in this new paradigm that lifting the Union naval blockade was impossible and keeping Texas, Arkansas, and Louisiana within the fold against a superior enemy was unlikely. This meant that the Mississippi River must not fall to the enemy. The "must defend" perimeter ran along the Mississippi River, through Tennessee, along the Appalachian Mountains, across the Shenandoah Mountains, and across Northern Virginia to the Chesapeake Bay. To Longstreet, the South had the strength to defend this area, provided it avoided attrition and excessive Napoleonic risk.

Conversely, Longstreet's vision meant that army-sized invasions of the North were dangerous propositions. Even a limited demonstration was risky. For the Confederates to consider a large-scale raid or an invasion, the operation had to have a more than reasonable chance of tactical success to produce the desired strategic results. Otherwise, taking the war to northern soil was a risk far too great for the Confederates to undertake. A tactical victory, as Antietam proved, was fruitless without a gain in material or political prestige. It was not to the benefit of the Confederacy to attempt to defeat the Union with operations on Northern soil. Rather, the greater benefit was to prove to the North they could not win on Southern soil. In early 1863, Longstreet concluded that the South needed to

11 Rowena Reed, *Combined Operations in the Civil War*, (Annapolis, MD: Naval Institute Press, 1978), 5.

coordinate efforts across the nation, utilizing interior lines, while there was still opportunity.

Meanwhile, Lee had handed the Union another defeat at Chancellorsville, and in the West the Confederates thwarted Union attempts to take the heights north of Vicksburg and Confederate cavalry inflicted serious damage to Grant's supply lines, thus forcing his retreat. Despite the setbacks near Vicksburg, Union forces pushed operations deep into Mississippi and gained control of most of the river. Vicksburg was not yet under siege, but the Confederates had to do something about Grant before the city fell. Once the Union controlled Vicksburg they controlled the Mississippi River, and for many, the loss of the river signaled doom for the Confederacy.

Lee Versus Longstreet on Grand Strategy

Lee agreed that the military principle of concentration might necessitate sending a portion of his troops to other areas. Yet, according to his correspondences with Richmond in 1862, he initially resisted sending troops even to the Suffolk area. As for a western concentration, Lee felt no different in early 1863 and initially resisted vigorously. Historian Thomas L. Connelly adds that the arguments Lee employed for giving priority to the eastern theater revealed a limited knowledge of geography, climate, and the aim of enemy advances in the West. Lee insisted, "The climate [in Mississippi] in June will force the enemy to retire."[12]

Unbeknownst to Lee and the Confederates, Grant's tough mid-western veterans were in the process of building a canal through the swamps on the western side of the river as a means of reducing Vicksburg. Connelly argued that Lee's concern for defending Virginia "amounted to an obsession" that warped his strategic thinking. In all fairness to Lee, however, in 1863 he had no command responsibilities over military matters in the West. Following Chancellorsville, Hooker's Army of the Potomac remained opposite Lee along the Rappahannock with 90,000 troops. In the near term, Hooker had not the slightest thought of advance, but it is understandable that Lee would defend the integrity of his organization and seek to preserve the combat power of his army. Connelly's interpretations do not prove Lee's strategic thinking wrong, but they do illustrate

12 Thomas L. Connelly, *The Marble Man: Robert E. Lee and His Image in American Society*, (New York: Knopf, 1977), 202-203.

the South's difficulty in deciding upon a grand strategy, particularly without an army Chief of Staff issuing strategic priorities and supporting directives.[13]

At this juncture, only Longstreet saw the situation in the context of modern war and grasped how to counter the Union grand strategy. As a subordinate, however, he could not convince the leadership to coordinate efforts in this more modern manner. Nor could he get past Lee's parochialism toward Virginia, or the "Virginiaism" that pervaded the Confederate high command and the Davis administration. Additionally, Lee's lack of faith in the Confederate armies in the West, and his apprehension of executing a large-scale movement between theaters, worried him. Longstreet was not a "yes man." He was not a native Virginian either and thus seemed to have had a wider sense of the conduct of the war.

In 1863, Longstreet was Lee's right-hand man and was still comfortable in presenting his views and opinions openly and unreservedly. A letter from Longstreet to Lee dated March 19, 1863, illustrates the personal and professional relationship between the two. "I know it is the habit with individuals in all armies to represent their own positions as the most important ones, and it may be that this feeling is operating with me; but I am not prompted by any desire to do, or attempt to do, great things. I only wish to do what I regard as my duty, give you the full benefit of my views." In this context Longstreet went to Secretary of War James Seddon and suggested moving a corps to Tennessee to help General Braxton Bragg. He also suggested moving troops to Mississippi to reinforce the forces under Joseph Johnston to deal with Grant. Seddon knew Vicksburg was important for many reasons and saw saving the city as paramount. Moreover, Mississippi was the home state of the Confederate president. Seddon liked Longstreet's ideas but was not sure if Lee would support this course of action.[14]

Shortly thereafter, Lee weighed in on the situation. He did not want to relinquish a portion of his army for proposed operations in the West and as an alternative, he proposed initiating an offensive in the East. Lee's plan was to invade Pennsylvania, move toward the eastern part of that state, and possibly threaten

13 Ibid.; McPherson, *Battle Cry of Freedom*, 646. The Confederacy did not have a uniformed Army officer in a Chief of Staff equivalent position to direct strategic priorities and exercise command authority over the commanders of the principal armies, in the way that George Marshall did in World War II. Jefferson Davis attempted to determine priorities but was often indecisive. He frequently led by consensus, as a politician does, rather than as a general who may invite opinions but then makes a decision if necessary without regard to compromise. This was a problem in early 1863, particularly when Davis had to make hard decisions regarding which theater would receive the major effort and assistance from the other theaters.

14 Longstreet, *Manassas to Appomattox*, 331; Piston, *Lee's Tarnished Lieutenant*, 40.

Philadelphia or Baltimore. After he entered Pennsylvania Lee assumed that the Army of the Potomac would have to pursue him, and that Lincoln would apply tremendous pressure to attack immediately. Lee reasoned that an incursion into Pennsylvania might also cause the Lincoln Administration to draw from forces in the West to deal with the crisis. If so, this might force Grant to scale back operations against Vicksburg. There were additional facets in the political realm to Lee's plan. He hoped to sow panic among Northern authorities, particularly within the Lincoln White House. He also hoped to strengthen the anti-war Democrats and Copperheads politically. Lastly, Lee intended to show the Europeans the prowess of his army and in doing so gain tangible support for Confederate independence. To this end, Lee was a master at convincing others to endorse his designs. Once he gained support from many government and military officials, including Longstreet, Lee approached Davis with a united front. Davis sided with him and approved the campaign into Pennsylvania.[15]

A Hypothetical Treatment of a Longstreet Movement to Vicksburg

Prior to Vicksburg, Longstreet did not craft a plan on how to execute a defensive-offense in Mississippi as a means of saving Vicksburg, the 'Gibraltar' of the Confederacy. While the Confederates never sent reinforcements from the Army of Northern Virginia, a hypothetical look at how one might have developed a defensive-offense illustrates Longstreet's modern vision. His strategy meant seizing the opportunity to strike Grant as he maneuvered to lay siege to Vicksburg. This was a bold and potentially decisive move. At no time since Shiloh did the Confederates have a chance to catch Grant in a vulnerable position. Grant practiced a very straightforward approach to war and displayed a keen sense for determining and pressing advantages. Most of the time he pressed the advantage of numbers against his opponents, but he was also a master of the turning movement, something he used with great skill around Vicksburg.[16]

15 For more detailed reading on the planning options the Confederacy faced in early 1863, see Freeman, *Lee's Lieutenants*, 2: 307-315; McPherson, *Battle Cry of Freedom*, 646-649; Archer Jones, *Confederate Strategy: From Shiloh to Vicksburg*, (Baton Rouge: Louisiana State University Press, 1961), 208.

16 The remaining discussion in this chapter of Grant's operations in Mississippi and what a Longstreet movement to the state to oppose Grant might have looked like is an illustration of Operational Art and Design. This level of war and its concepts will be explained in more detail in chapters 13 and 14, in the context of the Chattanooga Campaign.

Grant was not planning to assault Vicksburg until he had adequately confused the disjointed Confederate leadership in the region and had gathered enough troops to give him a decisive advantage. Grant's landing south of the city, first came as a surprise to the Confederates. His initial 23,000 troops were enough to start operations into Mississippi and roll over the token resistance offered by small local Rebel commands. Grant planned to move east and take Jackson, Mississippi, in a manner that would keep both departmental commander Joe Johnston and Lieutenant General John C. Pemberton, in command at Vicksburg, off balance and confused as to his intentions. The seemingly inexplicable movement east toward Jackson instead of north to Vicksburg was designed as a large turning movement that would make it difficult for the Confederates to properly concentrate their forces at the right place and time.[17]

While Grant kept up his movement, he was free to crush smaller Confederate forces piecemeal, while keeping armies under Johnston and Pemberton divided. Grant's own reinforcement would come from Sherman, who would soon cross the river. Still, for Pemberton this presented an opportune time to leave his defenses at Vicksburg, link up with Johnston, and secure the best odds to attack Grant. But Pemberton apparently did not recognize the opportunity. Grant had sown part of the confusion by means of deception: he kept Sherman temporarily opposite Pemberton at Vicksburg to hold the Confederate force in place. This worked, but the key point is that once Grant landed, Pemberton knew his exact location and as with any landing, a short time existed during which the landing force would be outnumbered until all were ashore. This was the moment for Pemberton to thwart the landing. But Johnston, Pemberton's superior, did not issue orders for Pemberton to move against Grant when the Federals had less than half their troops across the river.

After landing at Bruinsburg, Grant hit Port Gibson. Here, he quickly overwhelmed two regiments and a battery of artillery.

In his report on the action around Baker's Creek, Confederate Major General William W. Loring affirmed, "On the 2nd of May while passing within a few miles of Grind Stone Ford, General Bowen, in charge of a small force, had disputed the

17 For more detail on Grant's Operational Design consult Bruce Catton, *Grant Moves South*, (Boston: Little Brown, and Co., 1960), 407-489. Initially, Lincoln considered Grant's movement toward Jackson a mistake. He thought Grant should move south to join General Nathaniel Banks. See Lincoln to Grant, July 13, 1863, in Roy. P. Besler, ed., *The Collected Works of Abraham Lincoln*, 11 vols., (New Brunswick, NJ: Rutgers University Press, 1955), 6: 326.

road to Port Gibson, and was repulsed by an overwhelming force of the enemy. His information satisfied him that they had a force near fifty-thousand."[18]

Loring was inaccurate regarding Grant's strength on the ground that day, but he was correct that Grant threw an overwhelming force against the gray regiments. From this point, Grant moved northeast toward Jackson and about ten days later hit two brigades of Confederates at Raymond, two-thirds of the way to the city. For the vastly outnumbered Confederates to commit small units piecemeal almost certainly ensured their destruction and reduced the pool of forces in the region. The time to avoid such damaging attrition was during Grant's movement from Port Gibson. Once it became apparent that Grant was moving northeast, rather than directly north toward Vicksburg, the Confederates had their best chance for success.

During this period, an application of Longstreet's defensive-offense meant a concentration of troops and applying mass to defeat Grant. Pemberton commanded 23,000 soldiers, who could operate outside Vicksburg, while Johnston was in command of 8,000 men at Jackson, and another 5,000 troops were on the way from smaller commands in northern Mississippi.[19]

The sum of this combat force, excluding those entrenched in Vicksburg, totaled 36,000. In the days when Grant moved from Port Gibson and arrived outside Jackson, his numbers grew to approximately 35,000. Johnston had nearly two weeks when numerical parity existed. Yet, Confederate forces were divided and spread throughout the theater.

The principle of mass stipulates that the Confederates should have concentrated at Jackson or at a point between Vicksburg and Jackson. The Confederate-controlled rail line between Vicksburg and Jackson would have facilitated this, affording Pemberton and Johnston faster movement than Grant. Once the Confederates had concentrated their forces, Johnston would have had an opportunity to attack Grant.

Would Johnston with 36,000 troops have been able to push Grant with 30,000 to 35,000 troops out of Mississippi? This is, of course, unknowable. The point is to highlight the principle of mass in this situation, and to identify the operational opportunities the Confederates had before Grant assembled all his strength east of

18 William Wing Loring, *Report of Major General Loring: The Battle of Baker's Creek and Subsequent Movements in His Command,* (Richmond: R.M. Smith, Public Printer, 1864), 56.

19 Craig Symonds, *Joseph E. Johnston: a Civil War Biography,* (New York: W.W. Norton, 1992), 207.

the Mississippi. A Confederate concentration offered an approximate force ratio of 1:1 against Grant for a short period of time and adding Longstreet's entire corps would have brought another 15,000 to 20,000 men into the operation. A Confederate force of 56,000 concentrated troops would have increased Johnston's force ratio almost to 2:1. With the Chancellorsville campaign ending in early May, Longstreet's troops would have had to board trains and complete the 1,000-mile trip in about ten days in to arrive in time to confront Grant. Ideally, Longstreet would have needed to arrive around May 10. This would have been difficult, but it was not impossible.

Had Grant lost such a battle, the crisis at Vicksburg might have been averted for the near future. Grant's situation would have been made worse due to the nature of the risks he took regarding supply lines from the river. As stated previously, the operational ideas in this section are hypotheticals, and it cannot be claimed that if *x* occurred, then *y* would have happened. However, hypotheticals have uses in military planning. They are used by planning staffs in course of action development. For Longstreet to suggest a western concentration makes clear these were the type of ideas he envisioned in his defensive-offense.

The Confederates failed to achieve the concentration Johnston hoped to accomplish prior to Grant's attack on Jackson. Grant took the place with ease. Johnston sacrificed a percentage of his 8,000 troops in a delaying action outside of town while the rest of his command moved northeast. Pemberton did move east to challenge Grant, but he was outnumbered at Champion Hill and again a few days later along the Big Black River. By then, Grant had over 50,000 troops who pushed the Confederates back to Vicksburg. Pemberton had no choice but to fall back behind the trenches of Vicksburg and endure an assuredly miserable siege and ultimate surrender.

On July 4, 1863, he surrendered Vicksburg and his entire command to Grant. "The Father of Waters again goes unvexed to the sea," announced Lincoln a few days later when the Confederate garrison at Port Hudson, Louisiana fell. "The Confederacy was cut in twain." The Mississippi River and its strategic benefits went permanently over to the Union.[20]

Comparing the two theaters in 1863, Longstreet was correct in maintaining that the Western Theater should have been the priority immediately after Chancellorsville. Understanding that the Confederates had a window of opportunity against Grant to mass and build a force ratio advantage in Mississippi

20 McPherson, *Battle Cry of Freedom*, 638.

Grant's transports running the batteries of Vicksburg, Confederate guns crews in the foreground. *Harper's Pictorial History of the Civil War,* Alfred H. Guernsey and Henry M. Alden, Vol. 2. Page 455. c.1894. (*Library of Congress Prints and Photographs Division*)

is a strong argument that Lee's plan to deny forces to Johnston was a mistake. Lee's ideas about invading Pennsylvania and demonstrating were not guaranteed to pull Grant away from operations in Mississippi. The hopes for a movement into Pennsylvania were merely theoretical in May 1863, but Grant's campaign in Mississippi (and the fact that Johnston and Pemberton were no match for the Federal forces) was not theoretical—it was concrete reality.

Thanks to Grant, the coils of the Anaconda closed on the Confederacy. The loss of Vicksburg was something the Confederates could not reverse. Confederate leadership had allowed this to happen, and the loss marked the beginning of the end in the West. Before Vicksburg fell, however, Lee attempted his invasion of Pennsylvania. This is the event that historians came to call the "high water mark" of the Confederacy. Some would use it to distill Lee and Longstreet's legacy above all else.

Chapter 7

Gettysburg: Lee's Extreme Gamble

"Failure to set a campaign objective sealed Lee's defeat in Pennsylvania."

— Harold M. Knudsen, Lt. Col. (Ret.)

Longstreet

had tried to convince Lee and key political leadership in Richmond that a western concentration was necessary, and the best course of action for the Confederacy in mid-1863 was one designed to prevent the loss of Vicksburg. In his view, the Confederacy had to fight a strategic-defensive with the Mississippi River as the Western boundary and Virginia as the Eastern boundary. Longstreet maintained that the principal Confederate armies should conduct offensive operations within these boundaries. In other words, a 'Defensive-Offensive' grand strategy. Yet, the Confederacy was losing the war in the West and to ignore this reality meant losing the war and nationhood. Victory in Virginia alone was not enough to win their independence. The Confederates had to achieve success in all theaters. Successful defensive operations by the remaining Confederate armies in the field were essential. Longstreet was correct in his assessment that the Western Theater was in jeopardy. Since Grant's first major victory at Fort Donelson, in February 1862, the forces under his command had made continuous progress. By 1863, they were operating deep within the Confederacy and maneuvering to capture Vicksburg, the key component in securing control of the Mississippi River.

In the War of 1812, British General Edward Packenham, upon arriving in the New Orleans area, noted that whoever controlled the Mississippi River controlled the continent. His assessment was even more valid decades later during the Civil War. Several Confederates offered proposals in early 1863 to shore up defenses in the West. Secretary of War James Seddon suggested that Lee detach one division,

Pickett's Division of Longstreet's Corps, to reinforce Pemberton at Vicksburg. Gen. Beauregard proposed that Lee personally take Longstreet's Corps to Chattanooga. There, they would go on the offensive, which in Beauregard's estimation would compel Grant to end his work in Mississippi and move to rescue Chattanooga. Longstreet also knew Vicksburg was key, and in 1863 he was keen to arrest the Union progress towards securing the city and the Mississippi River. He suggested a plan to join Johnston and together they would reinforce Bragg. Longstreet insisted, "the combination once made should strike immediately in overwhelming force upon Rosecrans [in Tennessee] and march toward the Ohio River and Cincinnati." This plan would leave Lee in charge in Virginia with two corps to defend the state and Richmond. However, Longstreet failed to build a consensus among other Confederate leaders in support of his plan. In fact, the Confederate high command did not adopt any of the proposals in time to save Vicksburg.[1]

Lee resisted all these proposed actions. In a letter to Seddon he revealed part of his thinking. His concept ran contrary to those of Longstreet and Beauregard and on May 30, 1863, the same date he reorganized the army into three corps, Lee offered an explanation: "I think it is probable from the information that General Hooker will endeavor to turn the left of my present position and hold me in check, while an effort is made by the force collected on the York River, by forced marches and with the aid of their cavalry under General [George] Stoneman, to gain possession of Richmond. This prompted Lee to desire the removal of the AOP from Virginia, which became the initial basis for the invasion of Pennsylvania."[2]

Lee worried that the Federals planned to launch another offensive against his army and Richmond, and this concern played a role in his strategic thinking. He reasoned that the best way to prevent fighting in Virginia was to go north and force the Army of the Potomac to pursue, thus removing the occupying army from

1 Bruce Catton, *Gettysburg: The Final Fury*, (Garden City, NY: Doubleday & Company, 1974), 4-5; Longstreet, *From Manassas to Appomattox*. 331. After Fredericksburg, the two divisions of Longstreet's Corps took up positions in the vicinity of Richmond. See OR, 25/1: 2 and 25/2: 790.

2 Dowdey, *Wartime Papers of R.E. Lee*, 498; OR, 25/1: 4, 25/2: 846; OR, 27/2: 313; Longstreet, *Manassas to Appomattox*, 335-337; Coddington, *Gettysburg Campaign*, 5-9; James A. Hessler & Britt C. Isenberg, *Gettysburg's Peach Orchard*, (El Dorado Hills, CA: Savas Beatie, 2019), xix. The death of Stonewall Jackson prompted Lee to reorganize the ANV into three corps: Richard Ewell and Ambrose P. Hill took the Second and Third Corps, and Longstreet retained command of the First. Union General George Stoneman commanded a cavalry corps at this time, and like several of his Confederate counterparts, demonstrated the value of large cavalry corps projected against distant objectives.

Virginia. In addition, if such a move resulted in a victory on Northern soil, it would force Grant to suspend his operations around Vicksburg and the Federals would have to send troops east. Another component of Lee's plan, one that President Davis approved, was the notion that foreign recognition and assistance from France and England remained a possibility. If the Confederates won a significant victory on Union soil, the prospect of foreign aid might improve. All these points were at least arguable. Nevertheless, such an invasion offered only very long odds that operating in Pennsylvania would somehow relieve the pressure on Vicksburg.

Lee's concern that the Union would launch another offensive eventually proved correct, but certainly not in the near term. Hooker and the AOP had suffered a stinging defeat at Chancellorsville and the Federals needed time to recover. At the end of May, there was no evidence that Hooker was ready to take the offensive in June or July. Therefore, there was time for the Confederates to send troops to the Western Theater, and time for those troops to return to Virginia when needed. The Confederates had already done something similar in February, with the dispatch of Longstreet's Corps to Suffolk. At that time, according to a Union officer, Lee found his army along, "its line of entrenchments on which so much labor had been bestowed, and on the strength of which he had so far relied as to submit to the detailing of a large force under General Longstreet for operations south of the James River, most unexpectedly turned and rendered of no value, and he was in the presence of an army greatly outnumbering his."[3]

Lee also mentioned the possibility that Stoneman's cavalry would threaten Richmond once Hooker engaged the Army of Northern Virginia. Although Lee planned for Hooker to pursue him north, he discussed no measures to prevent Stoneman's troopers from moving on Richmond while the ANV pushed into Pennsylvania. Nor did Lee mention that the considerable defenses of Richmond would present a substantial obstacle to a purely cavalry attempt to take the city. Artillery forts ringed Richmond, just as they did Washington, and each city had a defense force assigned to secure the capital. Outside and beyond these main forts at Richmond were additional trench lines and works. These were available for the Confederates as outer defense lines to impede enemy advances, thus creating a system of fallback positions from the front lines to the main forts. Regarding Grant, there was no evidence or indication that he would cease operations in

3 G. K. Warren, OR, 25/1: 200; Lee, OR, 25/1: 795.

Mississippi because of a threat in Pennsylvania. That would in any case take an order from higher authority.[4]

Foreign recognition of the Confederacy was still possible, but much less likely than a year earlier, particularly in light of the aggregate progress Union armies had made in the Western Theater. The idea that foreign help was contingent upon a significant victory on northern soil was likewise flawed, primarily because it courted the high risks associated with conducting an invasion. A Saratoga-type win, one that would finally convince England or France or both to get involved on behalf of the Confederacy, was not contingent upon where the battle took place. It was contingent upon a decisive victory. In 1777, Saratoga involved the loss of an entire British field army and that proved the American rebel armies were able to defeat British regulars. That victory also underscored the viability of the colonial rebellion to French King Louis XVI and his military advisors. A defeat of Grant or Rosecrans on southern soil, such that an entire army was destroyed, would probably be equally effective. One of these outcomes might have had the added benefit of stopping an offensive on southern soil already in progress, and thus provide European observers with another parallel to Saratoga. On the other hand, a victory in Pennsylvania would not guarantee an end to Confederate problems in the West and did not assure an immediate end to the war. Despite these issues, Lee chose to undertake a high-risk offensive campaign in Pennsylvania. And he submitted his plans without a clear objective of where exactly he would go in the Keystone State or what he would do once he got there.

Lee's Lack of a Clear Operational Campaign Objective & Commander's Guidance

A campaign plan must first establish the nature of the problem before a commander can decide the objective. Once an objective is determined, the army and corps commanders can apply operational maneuver to shape and create favorable advantages that allow tactical level commanders to dominate their opponents. Enough cumulative tactical success by division and brigade commanders generates opportunities they can exploit toward winning a campaign. A breakthrough of a static defensive line, for example, allows the tactical

4 Longstreet, *Manassas to Appomattox*, 327-328. In June, Lee confided to Jefferson Davis, "I still hope that General Johnston will be able to demolish Grant and that our command of the Mississippi may be preserved: See *OR*, 25/2: 849.

commander to secure larger objectives and decisive points within a campaign's design. This provides the *fulcrum* or *marked advantage* that makes strategic goals attainable. The successful execution of operational maneuver, however, is contingent upon first *identifying an objective* and providing *sound commander's guidance* to maintain discipline toward the objective. Lee, however, failed to declare a clear objective in Pennsylvania, such as seizing a city to generate logistical support or cause political harm to his opponent. Nor did he specify any key terrain his three corps would move to, or that he intended to leverage in a decisive battle. Lee's minimal commander's guidance consisted only of routes for the corps and his desire to avoid contact, but the latter was jeopardized without a well-conceived, clearly stated objective to maintain that focus.

Lee planned to move his army west over the Blue Ridge and into the Shenandoah Valley. From there he would turn north to cross the Potomac and then follow a northeasterly arch, over Chambersburg and Carlisle, and move in the general direction of Philadelphia. Secondary effects included cutting some of Washington's lines of communication and sowing panic in the capital city. This was the extent of it. Official records and correspondence do not conclusively support the notion that Lee sought a decisive battle. Thus, Lee began the movement into Pennsylvania with plans that were both vague and incomplete. He lacked a clear objective and created the circumstances in which subordinates could potentially make rash decisions. This increased the risk of the Confederates finding themselves in a disadvantageous position should a battle occur.

On June 3, 1863, when Lee began his movement, the two armies faced each other across the Rappahannock River at Fredericksburg. First, Stuart moved west to Culpepper Court House to begin screening movements of the three infantry corps. Second, Longstreet's divisions under McLaws and Hood backed away from their positions and marched to Culpepper Court House. Third, on June 4, Ewell's command moved out of its positions, headed for assembly areas near Longstreet, and prepared to march west. A. P. Hill was the last to move his corps from Fredericksburg. He remained for a time to demonstrate in front of Hooker and create the illusion that the whole of the army was still there. Hooker eventually noticed the thinning of Rebel campsites at Fredericksburg. He bridged the Rappahannock and then set up a lodgment with some artillery and infantry. Hill watched these troops, as well as Hooker's main force, until June 5, when the AOP began to shift west and place troops closer to the position that Hooker believed Longstreet still held. Hooker also sent out cavalry to look for Stuart and determine what the Confederates were doing overall.[5]

5 Longstreet, *Manassas to Appomattox*, 334-338.

The largest cavalry battle of the war occurred at Brandy Station on June 9, 1863. For the first time, a Union cavalry corps attacked Stuart's more experienced horsemen. Hooker had created this new Union cavalry when he abandoned the cumbersome Grand Division organization and divided the army into nine infantry corps. Alfred Pleasanton replaced Stoneman in command of the cavalry corps, which numbered 11,000 as compared to Stuart's 9,500 horsemen. At Brandy Station, Stuart held the field, but the Union cavalry gave him a tough fight, proving they had gelled as a corps organization and as a fighting force. From that battle, Pleasanton learned that Longstreet and Ewell were camped at Culpeper Courthouse and he passed a message to Hooker that illuminated the larger situation.[6]

On June 10, Ewell started his march west. Also, on this day Lincoln sent a message to Hooker suggesting what he should do with the knowledge that the Army of Northern Virginia was on the move and possibly heading north. "If left to me, I would not go South of the Rappahannock, upon Lee's moving North of it," advised the President. "I think Lee's Army, and not Richmond, is your true objective point. If [Lee] comes towards the Upper Potomac, follow on his flank, and on the inside track, shortening your lines, whilst he lengthens his. Fight him when opportunity offers."[7]

Lincoln seemed to understand that attacking fieldworks and trench lines could ruin Hooker's army. Hooker took heed of this guidance and began a movement in pursuit of Lee. Shortly thereafter, no significant elements from either Lee's or Hooker's armies held a position near Richmond and Union cavalry did not move against the city. Lee's worry about that possibility proved unfounded. Pleasanton's attack at Brandy Station emerged as part of the larger Federal focus on Lee and his army.

By June 12, Ewell was in the Shenandoah Valley and ready to start north. Two days later, he took a Union outpost at Winchester, capturing 3,300 men, numerous

6 Ibid., 340-342; See OR *Atlas*, Map of the defenses of Richmond and Petersburg." Plate C, #2, prepared by Nathaniel Micheler, 1865. Note: This map depicts the extensive works built around Richmond later in 1864-65, evident by the Cold Harbor line, which did not exist at the time of Gettysburg. However, most of the fort system, and some of the outer lines at Richmond did exist or were under construction in 1863.

7 Lincoln, *OR*, 27/1: 34-35. Lincoln's letter to Hooker is also cited in Ralph Newman & E.B. Long, *The Civil War Digest*, (New York: Grosset & Dunlap, 1956), 254. On Jun 12, Pleasanton reported: "A colored boy captured on the 9th states that Ewell's corps passed through Culpeper on Monday last, on their way to the Valley, and that part of Longstreet's had gone also. A second Negro just across the river confirms this statement. I send a reconnaissance to find out the truth." *OR*, 27/2: 168.

cannon, and much needed supplies. On June 16, Lee notified Hill to start following Longstreet into the Valley and instructed him to join Longstreet and for the two corps to advance together. The next day, the Federals abandoned Harper's Ferry and left the path open for Ewell to move further north. He led with Jubal Early's Division as far as Chambersburg and then sent him east to Gettysburg, York, and the Susquehanna River.[8]

Lee wrote to Ewell on June 22 and expressed his gratitude for the advance thus far. "Your progress and direction will, of course, depend upon the development of circumstances," Lee cautioned, but advised his lieutenant, "If Harrisburg comes within your means, capture it." This provides an example of imprecise guidance from the commanding general that left a strategic-level decision to an operational level commander. Had Harrisburg been Lee's declared objective, Ewell would have focused on it. Ewell's pause at Chambersburg was a symptom of the problems caused by Lee's failure to determine a strategic objective during the planning phase of the campaign.[9]

As it was, Ewell arrived in Chambersburg in his carriage on the morning of June 24. He set up headquarters in the courthouse as his other divisions arrived from points south. Early requisitioned all he could from the towns along his route of advance, starting with Gettysburg. There, he received roughly $6,000 in goods but on June 27, he marched into York and the town handed over $28,000 in material. Early then moved towards Wrightsville, a small town on the Susquehanna. He intended to cut the Pennsylvania Central Railroad. He also hoped to evaluate the practicality of crossing the Susquehanna, moving through Lancaster, and approaching Harrisburg from the rear. Local troops had burned the bridge at Wrightsville just before Early got there, thus removing that avenue across the Susquehanna. Harrisburg, the state capital, was still open to him should he turn and march directly north. With the speed and distance covered in Ewell's advance, Harrisburg remained an achievable objective. Ewell had moved his three divisions over 200 miles in less than three weeks. Southern newspapers heralded his swift movement and for a brief period proclaimed that another fast-moving Jackson had

8 Ewell, OR, 27/2:433; Lee, OR, 27/3:896.

9 Lee, OR, 27/3: 914. This correspondence would have been unnecessary had Lee specified Harrisburg as the objective prior to the army moving north. This letter from Lee to Ewell supports the notion that on Jun 22 Lee still did not know precisely where the army was going. Ewell reported on Jun 21 that Lee instructed him to take Harrisburg. See Ewell, OR, 27/2: 443.

emerged. Meanwhile, Lee remained with Longstreet near Berryville from June 18 through June 23.[10]

Despite Lee's omission of an objective during the planning phase of the operation, Ewell's movement afforded him a great potential advantage over Hooker, who was in no position to block Ewell from entering Harrisburg. Lee still had a chance to order Ewell to move the remaining forty-five miles to occupy Harrisburg and to requisition supplies and equipment from the city. Lee could bring up Longstreet and Hill to Harrisburg faster than Hooker could get to the area. This presented a potentially embarrassing military calamity for Union leadership and provided precisely the sort of thing Lee needed to shape the operational situation. A threat to Harrisburg was an event that would cause an uproar in northern newspapers and put tremendous stress on Pennsylvania's Republican governor Andrew Curtin. This in turn, would put pressure on Lincoln, who might order the Army of the Potomac into battle to wrest Harrisburg from the Rebels. Under these circumstances, Lee might also have prepared a defense in the vicinity of Harrisburg and created a kill zone to receive an attack by Hooker.

As Early moved on Wrightsville with an eye toward Harrisburg, Ewell arrived in Carlisle. Ewell sent cavalry and mounted infantry under Brigadier General Albert Jenkins forward to conduct a reconnaissance of the Harrisburg area defenses. On Sunday, June 28, these troopers reached Mechanicsburg, just eight miles southwest of Harrisburg, and the next day elements reached the Susquehanna River just opposite Harrisburg at the village of Bridgeport (modern day Lemoyne). A short exchange occurred between Jenkins's four cannon and a few Union guns half a mile north of Shiremanstown, west of Bridgeport. There were no casualties. Another fight between Confederate horsemen and Union militia occurred nearby (modern day Camp Hill). The fighting cost Jenkins sixteen men. These elements of Jenkins's command were the northern tip of the Confederate advance. They were also the only troops of a principal Confederate army to venture that far north during the war. On June 29, Jenkins sent word to Ewell, who then reported to Lee, that his men were already knocking at the gates of Harrisburg. The city stood ripe for the taking. All the bridges Jenkins could see remained intact and the Confederates saw no significant defenses or Union regulars in the vicinity. On June

10 Longstreet, *Manassas to Appomattox*, 344; Edward J. Stackpole, *They Met at Gettysburg*, (New York: Random House, 1986), 14-24; Jacob Hoke, *The Great Invasion of 1863*, (Dayton, OH: W. J. Shuey, 1887), 216. In all, Ewell captured twenty-eight cannon, 4,000 prisoners, 3,000 head of cattle, and a trainload of munitions and medical supplies. Lee and Longstreet's locations provided by Brig. Gen. Dan Tyler in OR, 27/2: 28.

28, Lee ordered Longstreet and Hill to move toward Harrisburg with the intention that the army would concentrate there.[11]

Lee had finally made Harrisburg the objective of the campaign, completing the plan he started in Virginia. It was a good choice, a useful fulcrum to gain a marked advantage over his opponent, and a decisive point that offered both political and military damage. If Hooker attacked, and the Confederates had harnessed good terrain, they could inflict a costly repulse upon the Federals. The areas southwest of Harrisburg offered some high ground and space to deploy three corps. From there, Lee could orient his command south to receive an attack by the AOP. Roads to the west, the avenues of Confederate advance, offered an egress route if necessary. The mountains to the rear provided protection and the river was available to anchor one flank. The area around Mechanicsburg and Carlisle, particularly South Middleton, also offered favorable ground. A few miles further south stood a terrain feature known as a bowl (modern day Fairview Park). That designation is for terrain that consists of low ground surrounded by high ground on at least three sides. This location is where the Old York Road leads before angling toward the Harrisburg bridges. The terrain provided a good place for Lee to set up a defense and channel Hooker into the area. The region offered several good choices for battle. A modern example of harnessing a piece of terrain similar to the bowl around Fairview Park, with a proposed 1863 comparative, follows.

There was little that Major General Darius Couch could do to stop Ewell from seizing Harrisburg. As Commander of the Department of the Susquehanna, he had no regulars in his department; only newly-raised regiments of local militia numbering about 17,000 were moving to defend Harrisburg. The militia that was already in town would have to face Ewell's battle-hardened veterans. Couch set his militia to work improving fortifications, but no one torched the bridges that provided Ewell access to the city. On the day of the skirmishes, Couch thought the

11 Longstreet, *Manassas to Appomattox*, 344; OR, 27/2: 213, 316, 443, 998; Harlan Cross *Letters Home*. 107-119. The source Letters are from Lieutenant Thomas Taylor of the 6th Alabama, describing how close they were to Harrisburg. On June 23, he wrote: "I expect tomorrow we will march to Harrisburg," but seemed disappointed in a letter of June 28, implying time and opportunity had been wasted by not having seized the state capitol: "The City of Harrisburg, the Capitol of the State is most certainly gone up the spout I think." In his letters before crossing the Potomac, Lieutenant Taylor seemed to express that he did not believe it was right for the South to invade any Northern states. On June 18, he wrote: "I regret every moment to cross the Potomac into Maryland." He articulated what he believed the South was fighting for: "A cruel foe desires to subjugate our country & force us to live under a government we utterly abhor." For this reason, perhaps he saw invasion as contrary to that cause and the imperative of a strategic defense in principle, just as Longstreet did.

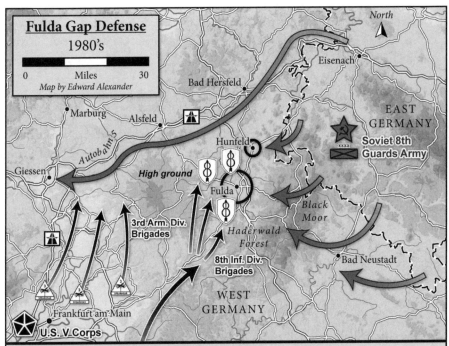

(Above) *The United States Army Europe (USAREUR) during the Cold War was assigned the task to defend much of southern Germany. Depicted (above) is a strategic corridor and Autobahn leading to Giessen and Frankfurt am Main. Prospective Soviet Army thrusts are depicted in gray arrows. Supporting attacks would come through the Fulda Gap, identified by the larger black oval. The smaller oval is the Hunfeld Bowl, a key defensive kill-zone the U.S. army had planned to attrit advancing Soviet forces, before retreating.*

(Below) *Similarly, the Fairview Park area bowl (black oval) offered a blocking position and potential kill-zone to receive an attack from the Army of the Potomac with room to retire if a repulse of the Union army was not achieved.*

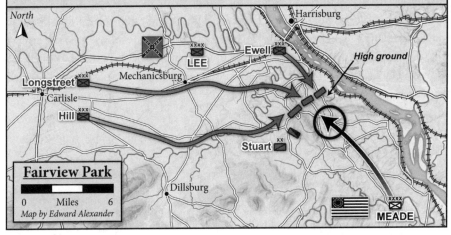

Confederates would throw infantry across no later than June 30. Yet, had Ewell gone straight to Harrisburg from Chambersburg he probably would have arrived by June 26.[12]

Lee Abandons Harnessing the Decisive Point of Harrisburg

Late on June 28, as Longstreet and Hill moved in the direction of Harrisburg, Lee received word that Hooker had crossed the Potomac and two Federal corps were lurking in the vicinity of Frederick. This news did not come from Stuart but from Longstreet, who had employed a spy named Henry Harrison to scout the whereabouts of the main body of the Union army. Harrison started his work in Washington and rode through Maryland, watching various units of Hooker's army as they moved north. Initially, Lee was not sure it was a good idea to accept the intelligence provided by one set of untrained eyes. He was used to proper reports from cavalry that cast the wider net of many eyes. Stuart was not reporting on this day, however, so Lee felt he had little choice. He decided that two Union corps spotted nearby meant the other seven were also near. Perhaps Hooker's entire army was closer to Longstreet and Hill than Ewell was. Lee thought of the safety of concentration and ordered Longstreet and Hill to move east, abandoning their line of march to Harrisburg. He also ordered Ewell to come back and join Longstreet and Hill. The Confederates had lost a superb opportunity.[13]

One aspect of the operational situation on June 28 is worth a brief examination. The hypothetical question is, would an occupation of Harrisburg by Ewell, followed by concentration of the whole army at Harrisburg, have helped Lee? What reactions might have occurred and what opportunities might these reactions have generated? True answers to these questions are of course unknowable, as Harrisburg was not occupied. Nonetheless, had Lee moved his army to Harrisburg he might have enjoyed an advantageous position and exerted even greater pressure on Lincoln and the AOP. Such speculation is relevant, in light of what soon happened at Gettysburg.

12 Couch, his abstracts, *OR*, 27/3: 243, 391.

13 Lee, *OR*, 27/3: 924, 943; Edwin B. Coddington, *The Gettysburg Campaign: A Study in Command*, (New York: Charles Scribner's Sons, 1968), 180-191. Lee did retain some cavalry with him, primarily screening for Ewell and with John D. Imboden covering the rear of the army. It is misleading to assert that Stuart had Lee's entire cavalry east of the Union Army. Stuart moved between the Union army and Washington with three of his brigades: those of Wade Hampton, Fitzhugh Lee, and John R. Chambliss. Lee retained enough cavalry to conduct reconnaissance of the Union army. See Ibid., 107-113.

There is little doubt that Ewell could have occupied Harrisburg by June 28. He would then have put into motion a requisition from the businesses, citizenry, and city government, for a variety of supplies as a means of providing logistical support for his corps. Had Lee designated the city as an objective from the start, Ewell might have reached Harrisburg even sooner and begun collecting a bounty many times the value of that which Early grabbed at Gettysburg and York. Such an event would have embarrassed Pennsylvania governor Curtin as well as the Lincoln Administration and left both searching for answers and a solution to the loss of thousands of dollars in property, the loss of a state capital, and the presence of a massive Confederate army on northern soil.

From the June 28 intelligence that placed Union elements near Frederick, Lee knew Hooker was closer than he had previously thought. Some assert this meant Hooker could cut Lee's supply lines if Longstreet and Hill passed further north to join Ewell, and therefore the appearance of these Union corps prompted Lee to concentrate at Cashtown. Yet Lee's army was not receiving enough supplies from Virginia at this time to sustain it. Part of the reason he was in Pennsylvania was to gather supplies and provision his army. He did have supply trains following each corps, but had no steady flow of supplies along his lines of communication while he was temporarily in Pennsylvania. 'Temporarily' being the operative word, since the Confederates could clean out each town only once. But while there still were towns available, Lee would authorize the requisition of supplies from businesses and local governments.[14]

Harrisburg presented another way to avoid starting a fight while causing the two known Union corps to change direction. Had Ewell moved into Harrisburg, his presence might have started a panic among the people, the government, and the press. As a result, the focus of the contest between the armies might have telescoped to Harrisburg. It is reasonable to assume that Lincoln, under mounting political pressure to eject Ewell from Harrisburg, would pressure Hooker to move with all alacrity to strike Ewell. Doing so would mean a direct northeasterly movement by the AOP and leave Lee's egress routes to his southwest unthreatened. He could move Longstreet and Hill on the route Ewell had used, and

14 Henry Heth, "Causes of Lee's Defeat at Gettysburg," in *Southern Historical Society Papers*, 52 vols., (Richmond: James E. Goode Printers, 1877), 4: 153. Heth also noted: "how strained we were for supplies of all kinds, especially food." Based upon this, historian Douglas Southall Freeman suggested: "Of all arguments that weighed on him, the most decisive single one was that he could no longer feed his army on the Rappahannock." Douglas Southall Freeman, *R. E. Lee: A Biography*, 4 vols., (New York: Charles Scribner's Sons, 1935), 3: 19.

upon effecting a concentration at Harrisburg, deploy a three-corps defense. If Hooker reached Harrisburg before Longstreet and Hill, Lee still had the option to withdraw Ewell so he would not find his corps isolated and facing nine Federal corps. Should Hooker ignore Harrisburg and close on Lee, the Confederate commander could still recall Ewell in time. In a worst-case scenario, Lee would have made a logistical haul of immense size and embarrassed Lincoln and Hooker at little cost. Having pulled the AOP north he would be in a good position to try and develop another course of action to interpose his army between Hooker and Washington. Given this opportunity, Lee could have tried to shape a suitable battle with the Confederates holding the advantage.[15]

As stated previously, the answers to questions regarding an event that did not happen are conjecture, but they may nevertheless be plausible. A short occupation of Harrisburg, even for one day, was a safe play with a lower risk of confrontation and a high probability of benefit in material acquisition. It might have created the type of battle scenario that Longstreet had discussed earlier with Lee.

Lee's failure to select an objective during the planning stages of the operation, and thus establish a decisive point to harness, led to a lack of focus on the low-risk aspects of the campaign. An objective enhances the discipline of a plan and helps the commanding general and corps commanders stay on track in harnessing operational facets and advantages. Objectives help prevent rash changes of plan to pursue other distractors that may look convenient but are of less overall value. As one modern era commanding general of the United States Army Europe explained: "A commander must first define his strategic objectives in both military and

15 Lee, *OR*, 27/3: 942-943. In General Order 73, Lee praised his army for its long movements and discipline "in keeping the yet unsullied reputation of this army, and that the duties exacted of us by civilization and Christianity are not less obligatory in the country of the enemy than in our own." Perhaps implying that invasion of a Northern state came with the risk of undercutting the Southern argument they were fighting a defensive war against an aggressor. Although they paid for food and goods from the citizenry with Confederate money, the locals had no use for the currency, and were being deprived of property nonetheless. Hence, Lee wanted to at least prevent any further losses to civilians in property to contrast what some Union troops did to Fredericksburg. It should be noted, however, that some Confederate units rounded up runaway "contrabands," a dispatch dated July 1, 1863, from Longstreet directed Pickett to move his division toward Gettysburg, concluding with the statement "The captured contrabands had better be brought along with you for further disposition." *OR*, 51/3: 732-733. For more information of this aspect of the campaign see W. P. Conrad and Ted Alexander, *When War Passed This Way* (Shippensburg: White Mane Books, 1982), 1, 24-27.

political terms. Only then can he design a military campaign—the operational level of war—to achieve those objectives."[16]

When Lee finally selected Harrisburg as the identifiable objective, he did not go there. Instead, he ordered a concentration near Cashtown. This heightened the chances of a collision at a time when he was still free to maneuver toward his objective. In his memoir, Longstreet explained, "To remove this pressure towards our rear, General Lee concluded to make a more serious demonstration and force the enemy to look eastward." The military term 'demonstration' is important to understand in this context. Lee intended the demonstration as a show of force to discourage Union movement toward Chambersburg. From that place, the Federals might strike Lee's trains and block his lines of communications to the Potomac crossing sites. Yet, this quick change of mind to move toward his enemy flies in the face of what he was doing in Pennsylvania in the first place. The objectives were to embarrass the enemy politically on his own soil by entering towns and cities and seizing food and material. Lee would engage the Army of the Potomac only if attacked. He clarified this to some degree, but he did so about six months later. In his after action report, Lee wrote: "It had not been intended to fight a general battle at such a distance from our base, unless attacked by the enemy."[17]

One question remains regarding Lee's decision. Was there truly a danger to the rear of the army in relation to the location of its three corps on June 28? Much of the historiography on Gettysburg seems to identify Lee's decision to concentrate at Cashtown as the starting point for a book. An operational military analysis, however, gives clarity to the question of whether Lee's decision was sound.

While Lee knew there were two Union corps at Frederick, there was no intelligence indicating the enemy sought to move across the strategic corridor the ANV had used to enter Pennsylvania. With Longstreet and Hill at Chambersburg, Lee's two southernmost elements were thirty-five miles north and fifteen miles west of Hooker's most northern elements. Longstreet and Hill were in fact still

16 Gen. Glenn K. Otis, quoted in Lt. Col. Clayton R. Newell, *On Operational Art*, (Washington: Center of Military History, 1994), 4. Otis served as Commanding General, U.S. Army Training and Doctrine Command (CG TRADOC) from 1981-83 and as Commander in Chief, U.S. Army Europe/Commander, Central Army Group (CINCUSAREUR/COMCENTAG) from 1983-88. U. S. Army Europe in the 1980s was comprised of the V Corps (two divisions, ACR and Corps Artillery) and VII Corps (three divisions, ACR, and Corps Artillery).

17 Lee, *OR*, 27/2: 308; Longstreet, *Manassas to Appomattox*, 348; James Longstreet, "Lee's Invasion of Pennsylvania," in *Battles and Leaders of the Civil War*, 3: 246-247. Longstreet affirmed in 1896, that "our purpose should have been to impair the morale of the Federal army and shake Northern confidence."

slightly closer to Ewell than they were to the two Union corps at Frederick. Aside from Lee's change of mind and a movement toward his opponent, why would he fear the AOP moving across his path thirty-five miles to the rear? One of the possibilities Lee sought in Pennsylvania was an opportunity to interpose his army between Hooker and Washington. Lee had no supply lines in the true sense. If Hooker moved laterally to the west and got behind Lee, there was no substantial Confederate supply line to Virginia for the Federals to cut. Everything Lee had gathered so far was with the wagon trains of his three corps. A movement west by Hooker might offer Lee the opportunity to move southeast and interpose his army between the AOP and Washington, as well as enter more towns to secure more supplies. Was there reason to fear a movement west by Hooker? If Hooker moved only a few corps west to get behind Lee and try to trap him in Pennsylvania, the AOP would be spread out and unable to hold Lee.

Such a move would create an opportunity similar to the situation Rosecrans presented to Bragg later that year when he spread his army too far apart in Georgia. Rosecrans had violated the military principle of mass, something that Bragg recognized immediately. Bragg seized the initiative and won a stunning victory at Chickamauga. Likewise, the Italian campaign into Egypt in September 1940 saw a massive Italian army advance a short distance and then set up a string of fortified posts that were too far apart to support each other. The comparatively minuscule British Western Desert Force was then able to attack these positions one at a time, and in a piecemeal fashion defeat an entire army many times their own size. Had Hooker tried to cover too much space or moved his entire center of mass west, Lee would have had an opportunity to maneuver elsewhere, and perhaps take a position between the AOP and Washington. Lee was not committed to the exact Potomac crossing sites that he used earlier in the campaign. Lee could return south via any location where he could bridge or ford the Potomac.[18]

There is reason to consider the possibility that Lee over-reacted to the intelligence of Union forces near Frederick. Clearly, Lee felt that given this intelligence he must concentrate his army in the vicinity of Cashtown, and in doing so he abandoned his objective. Although Lee's lack of clear commander's guidance prior to undertaking this invasion proved problematic, two aspects of the Rebel show of force in Pennsylvania had succeeded. The Confederates were subsisting

18 For more on Chickamauga see Glenn Tucker, *Chickamauga: Bloody Battle in the West*, (Indianapolis, IN: Bobbs-Merrill, 1961; reprint, Dayton, OH: Morningside Press, 1972). For insight into the Italian campaign, consult Richard Collins, *The War in the Desert*, (Morristown, NJ: Time Life Books, 1997).

off the local farms and towns, while gathering additional food and supplies to take back to Virginia. Then, when Lee finally declared an objective in Harrisburg, this amplified the message the operation sought to deliver. As Lee said, he had not intended to fight so far away from his base in Virginia. His object was to harm Union morale to the greatest degree possible, without giving battle. Seizing an objective like Harrisburg while Hooker was still well to the south, would make this statement and harm his opponent politically with only a show of force.[19]

Instead, Lee lost sight of the strategic and operational levels and began to think tactically. His idea that a demonstration might push the Union center of mass further east proved false. More importantly, Hooker's actions thus far showed there was no need for Lee to do this and risk a collision away from the objective. Seizing his objective provided a higher probability of forcing the AOP to move east, as compared to a demonstration in a small town with no strategic importance. In fact, the Cashtown and Gettysburg area offered nothing in the operational realm that could be leveraged against the AOP. Early had already raided Gettysburg several days earlier, so there was no statement to make by occupying the place again or occupying Cashtown. Nor were these towns decisive points that Lee could leverage to move the center of mass of the AOP in the direction he wished.

Hooker had essentially given Lee two weeks of free reign to move into Pennsylvania and loot the towns in his path. The Union commander took his time in launching a pursuit. First, he zigzagged his way north in Virginia, then moved northwest from Fredericksburg to Bealeton, and then northeast to Manassas Junction, before advancing over several axes to Leesburg. He did not begin to cross into Maryland until June 25, and by that time Lee was much further north. Longstreet and Hill were fifty miles ahead of Hooker. Longstreet recalled they

19 The Confederate situation in the last days of June 1863 during the invasion of Pennsylvania was similar to the German situation with respect to the battleship Bismarck's sortie into the North Atlantic in September 1940. The ship's mission was to attack Allied convoys en route to England. The German Navy was much smaller than the British Navy and could never attempt a large-scale force-on-force battle, but it could attack the logistical lifeline convoys without which the British could not survive. The raid by the Bismarck was a statement of the Germans' ability to use their limited surface units to destroy convoys, just as Lee's show of force in Pennsylvania, taking food and material at his leisure and embarrassing Union leaders, was a demonstration of how a numerically inferior army was able to raid with impunity. Bismarck won a tactical engagement by sinking the battleship Hood and should have retreated to the safety of Norwegian ports to survive and sortie again. But the German admiral, Lutjens, gambled and headed deeper into the Atlantic, where the Royal Navy marshaled many surface units against his ship. Likewise, Lee lost sight of the strategic objective of going to Harrisburg to reap maximum benefit by damaging Union morale with a show of force, occupation, and material acquisition, and perhaps also generating a defensive battle. Instead, with an unnecessary demonstration at Cashtown, he invited a decisive battle that favored his opponent.

were, "Together at Hagerstown, in Maryland, continue[ing] their march till the 27th, and rested for two days at Chambersburg, in Pennsylvania." Even further north was Ewell, whose corps was close to Carlisle. So successful was Ewell's incursion that he sent 3,000 head of beef cattle down to Longstreet and Hill. Hooker did not seem concerned that Ewell had reached the outskirts of Harrisburg. He surmised that Lee was just going after food, supplies, and plunder. Although this would embarrass the local and national politicians, it was not a significant military threat.[20]

Pennsylvania governor Curtin was fully aware that there were no regular troops ahead of Lee to prevent the Rebels from occupying Harrisburg. On June 26, he issued a call to arms to defend the state and beseeched the people of Pennsylvania to volunteer for military service. "You owe to your country your prompt and zealous services and efforts. The time has now come when we must all stand or fall together in defense of our State and in support of our Government." He concluded by imploring citizens, "Come heartily and cheerfully to the rescue of our noble Commonwealth. Maintain now your honor and freedom."[21]

Lee ultimately decided to deter the, "Enemy from advancing farther west and intercepting our communications with Virginia." He was in error to move toward his opponent instead of continuing the timing and tempo of operational maneuver toward a strategic campaign objective. He forfeited the benefits of leveraging the decisive point of a city like Harrisburg and risked getting into an unplanned battle. A demonstration was entirely unnecessary—Cashtown and Gettysburg offered nothing of strategic value, and Lee did not fully reconnoiter the area before moving his infantry corps to Gettysburg. Nonetheless, the decision would end Lee's unmolested movement in Pennsylvania and result in a battle at a random location, one that offered no advantages whatsoever.[22]

20 Longstreet, *Manassas to Appomattox*, 344-345. Gathering 3,000 head of cattle from dozens of farms was a feat in itself, indicating that Ewell took time to send soldiers out to do this, instead of keeping his command moving to Harrisburg as of June 24, when he reached Chambersburg.

21 Curtin, *OR*, 27/3: 347-348.

22 Lee, *OR*, 27/2: 307; 27/3: 930-931; *The Times*, Richmond, Virginia, June 6, 1897: "Gettysburg Failure, Some Clear Deductions from the Record," reprinted in *S.H.S.P.* Vol 25: 62; Hessler and Isenberg, *Peach Orchard*, 16. Mosby also pointed out in his book that Lee's first task was to pull Hooker's Army out of Virginia, and he believed that Lee had no intention or need to maintain a supply or communications line to accomplish that much. The ordnance stores and ammunition he took with him, was all he planned to use. For food, he planned to subsist off the northern farms. See John S. Mosby, *Stuart's Cavalry in the Gettysburg Campaign*, (New York: Moffat, Yard, & Co., 1908), 99.

Chapter 8

Collision: The Brakes Fail on the Demonstration

"And now, Beware of Rashness—Beware of Rashness."

— Abraham Lincoln, January 26, 1863

When elements of A. P. Hill's Corps arrived at Cashtown, one brigade kept heading east. Something often overlooked in explaining this, is Hill's understanding of the operation. Longstreet maintained that Hill thought Lee wanted him to march through Gettysburg and York, and then head to the Susquehanna River. In his original instructions to Hill concerning the movement to Harrisburg, Lee directed him to follow Ewell's "eastern column." That was Jubal Early, who had already gone through Gettysburg and York on his way to the Susquehanna. Hill affirmed in his own report that he was to move eastward and then northeastward. Thus to mass at Cashtown was a temporary measure, and therein lay the misunderstanding. Hill knew that he was not to become engaged decisively with any large Union forces he encountered, but was to allow a brigade to go to Gettysburg to forage. This was perfectly acceptable, since Hill thought his men would move through the town anyway. Unwittingly, however, once elements of his command moved past Cashtown, he risked a meeting engagement, one that would draw Lee into an unwanted tactical situation and lead to significant contact with the enemy and ultimately a collision of the two armies.[1]

1 Longstreet, *Manassas to Appomattox*, 348; Ewell, *OR*, 27/2: 444; Freeman, *R. E. Lee*, 3: 60. Hill told Ewell he was advancing on Gettysburg and later reported, "I was directed to move . . . in the direction of York, and cross the Susquehanna, menacing the communications of Harrisburg with Philadelphia, and co-operate with General Ewell . . . as circumstances might require." See *OR*, 27/2: 606-607, and Longstreet, *Manassas to Appomattox*, 340. A meeting

By the time Hooker had crossed the Potomac and placed two of his corps near Frederick, Lincoln decided to replace him. It was clear to Lincoln that Hooker had no plan to arrest Lee's movements, or to harass or attack the Confederates. On June 28, Lincoln promoted Pennsylvanian George G. Meade from V Corps commander to command of the Army of the Potomac. Lincoln made the appointment in part because Meade had a reputation as a "reliable professional soldier who did not scare easily." That day, Meade did what he could to gain situational awareness of the army. Except for his own corps, he had no idea where all the pieces of the army were located. Meade confirmed Lincoln's sense that Hooker had developed nothing in the way of planning for offensive operations. Hooker had been collecting what news came into his headquarters and making short distance posturing moves with his seven infantry corps. Meade wrote to Halleck early on June 28 and divulged his broad plan of action: "I must move towards the Susquehanna, keeping Washington and Baltimore well covered, and if the enemy is checked in his attempt to cross the Susquehanna, or if he turns towards Baltimore, to give him battle." However, Lee did not continue on to occupy Harrisburg. His new opponent planned to cover Baltimore by going to the river and did not plan to give battle unless Lee moved against that city.[2]

On June 29, according to historian Douglas Southall Freeman, Lee was apparently quite gloomy. Hill and Longstreet were in motion and Lee sent instructions for Ewell to come to Cashtown as swiftly as possible. With all this movement, however, Lee was unable to ascertain the whereabouts of Jeb Stuart's cavalry. This left him unclear as to the location of five of the Army of the Potomac's seven infantry corps, as well as the Union cavalry. Lee had retained Brigadier General John D. Imboden's cavalry, but at this stage had not deployed them ahead of the infantry to conduct reconnaissance. Lee therefore did not know if the area around Cashtown and Gettysburg was clear of enemy forces. Lee should

engagement is an unexpected collision between two opposing forces more-or-less unprepared for battle.

2 Catton, *Gettysburg: The Final Fury*, 17; Piston, *Lee's Tarnished Lieutenant*, 46; Meade, *OR*, 27/1: 61. Longstreet's spy Henry Harrison informed the Confederates of the change in command of the AOP on the same day. The ANV was divided into three infantry corps, while the AOP was divided into seven. Each of the three Confederate corps was a third of Lee's whole infantry force structure; roughly 80,000 (cavalry added another 11,000) whereas a Union corps was a seventh of Hooker's total infantry force structure; roughly 100,000. Thus, a Confederate corps numbered approximately 20,000 and a Federal corps approximately 14,000 in the Pennsylvania Campaign. Meade's statement to Halleck on June 28, is not particularly aggressive. It is cautious and shows Meade's initial plan was to protect Baltimore and not Harrisburg. This could be interpreted to mean he fully expected Ewell to occupy Harrisburg in the immediate future.

have used Imboden in a reconnaissance role, particularly since he had received no information from Stuart since June 25.[3]

On June 30, Lee and Longstreet rode together toward Cashtown. At the very least, Lee had the company of the man whose judgment he trusted. Longstreet probably assumed the concentration was not going to result in a battle but hoped this demonstration might nudge the Union defenders eastward. That night they stopped at Greenwood. Longstreet had with him the divisions of Lafayette McLaws and John B. Hood. His other division under George Pickett received instructions to remain at Chambersburg and cover the trains until relieved by Imboden. Lee established headquarters and Longstreet pitched his tent nearby. Purportedly, Lee told a group of staff officers that day, "Tomorrow, gentleman, we will not move to Harrisburg as we expected but will go over to Gettysburg and see what General Meade is after."[4]

The next morning, Lee greeted Longstreet and asked him to continue riding with him toward Hill's Corps, so they could assess the positions around Cashtown. Just ahead of Longstreet's advance they observed Major General Edward Johnson's Division of Ewell's Corps pouring onto the pike from the northwest. Lee was satisfied that in accordance with his orders for the concentration, this division had reached the area in good time. It meant he had all three corps around him. Lee told Longstreet to have his columns yield the pike for Johnson's advance. Then, the generals began their ascent up the west side of South Mountain. As they got close to the summit, the sounds of distant artillery fire echoed ahead of them from the direction of Gettysburg. This was extremely worrisome to Lee. Longstreet turned around and rode back to the troops moving at a crawl on the Chambersburg Pike. He tried to alleviate the accordion effects that occur during marches when many units share the same roads. Lee hurried forward to the sound of the guns to ascertain what had happened and who was fighting.[5]

3 Freeman, R. E. *Lee*, 3: 62; Longstreet, *Manassas to Appomattox*, 341-345; Wert, *Longstreet*, 254-256.

4 Lee, *OR*, 27/2: 317; James Longstreet, "Lee in Pennsylvania," in *The Annals of the War Written by Leading Participants North and South*, (Dayton: Morningside, 1988), 420, 439; *Times*, July 29, 1863 (London).

5 Alexander, *Fighting for the Confederacy*, 231; Pendleton, *OR*, 27/2: 348; James Longstreet, "Lee's Right Wing at Gettysburg," in *Battles and Leaders of the Civil War*, 3: 351-352; McCullough Diaries, McCullough-Hotchkiss Collection, University of Virginia; Latrobe Diary, Virginia Historical Society; Wert. *Longstreet*. 256.

The previous day, June 30, Major General Henry Heth had asked A. P. Hill, his corps commander, if he could send part of his division into Gettysburg to forage. Heth apparently did not know that Jubal Early had already cleaned out the town days before. Hill was operating on the understanding that he was to move along the route Early's Division had taken several days earlier. He gave Heth permission to go to Gettysburg, but with the condition that if Union troops were in the town he was not to bring on a major engagement because the rest of the army was not up. When elements of Heth's command under Brigadier General James J. Pettigrew ran into the Union pickets west of Gettysburg, they returned to Cashtown as ordered. Pettigrew reported that Union cavalry was in the town, but Heth and Hill did not believe him. Perhaps, they doubted him because Pettigrew was not a professional soldier, or possibly because he was not a Virginian. Heth asked for and received permission from Hill to go back to Gettysburg the next morning, but this time with a larger force to disperse what he mistakenly believed were Pennsylvania militia. On July 1, Heth's Confederates ran into John Buford's Union cavalry just a few miles northwest of town and the Battle of Gettysburg began.[6]

Buford had arrived in the area before Heth, dismounted his troopers, and deployed them in a blocking position astride the Chambersburg Pike. Initially, Heth did not think this cavalry presence was large, and he deployed two of his brigades to clear them. This action fell within the scope of the commander's guidance from Hill. Buford's dismounted cavalry fought stubbornly, however, and it became apparent to Heth that more than a thin cavalry screen blocked his path. Rather, the enemy to his front was a sizeable unit of cavalry. Buford displayed great initiative and understanding of how he could delay the Confederates until Union infantry arrived. He made the decision to fight a series of delaying actions and sent riders to inform John Reynolds, commander of the I Corps, which was on its way into the area along the road from Emmitsburg. Buford defiantly practiced a maxim that fit this situation: "Obstruct his [the enemy's] advance in the direction followed by his principal force with only a few troops, so that he cannot make conquests somewhere else." In this case, the maxim applies to a Confederate conquest of the key terrain behind Buford and just beyond the town of Gettysburg.[7]

6 Glenn Tucker, *High Tide at Gettysburg: The Campaign In Pennsylvania*, (Old Saybrook, CT: Konecky & Konecky Military Books, 1994), 98-100; Clyde N. Wilson, *Carolina Cavalier: The Life and Mind of James Johnston Pettigrew*, (Athens: University of Georgia Press, 1990), 191; Ewell, *OR*, 27/2: 444.

7 Carl von Clausewitz, *Principles of War*, (Harrisburg: The Stackpole Company, 1960), 51. Not all maxims fit all situations. Lenny Flank, "Gettysburg: The Strange Story of Private Wesley

A Confederate Who Knew the Area

Wesley Culp (1839-1863) was from a family that owned a house near the summit of Culp's Hill and was serving in Ewell's Corps. Wesley had moved to Virginia a few years before the war and joined the Stonewall Brigade, now in Ewell's Corps. Wesley was unfortunately killed on July 3rd, but had his chain of command made him known to Ewell, might he have been a valuable terrain guide such as Private Tom Brotherton was to Longstreet at Chickamauga?

(*photo public domain*)

Within a few hours Reynolds joined Buford on the ridges west of town. The I Corps commander saw the value of the defense Buford had emplaced. Shortly thereafter, his lead infantry brigades arrived and began to relieve Buford's weary cavalryman. The presence of infantry on the Union defensive line strengthened the position and it continued to grow stronger into the early afternoon. Elements from the Union XI Corps soon appeared and took up positions just north of town. When Lee arrived at Hill's location, he received a briefing on the situation at the front. Lee told Hill not to push the issue any further, particularly since Longstreet's Corps was not up and he had not intended to start a battle. Nonetheless, more Confederate units began to approach Gettysburg. West of the town, the division of Major General William Dorsey Pender came out of column and into line to support Heth. Pender conducted a passage of lines through Heth's command to assume contact with the enemy. By mid-afternoon, two of Ewell's Divisions had taken a position ahead of the Union XI Corps north of town. These were divisions commanded by Early and Brigadier General Robert E. Rodes. Union commanders on the field reacted and realigned troops to confront the new threat. Rodes was the first engaged and subsequently Early advanced from the northeast. Early found himself on the exposed flank of the XI Corps, and thus on the right flank of the

Culp," Dailykos.com, January 27, 2015; Brendon Wolfe, "Culp's Hill and Wesley Culp" in Encyclopedia Virginia, retrieved June, 2012 from www.EncyclopediaVirginia.org/Culps_Hill_and_Wesley_Culp _1839-1863.

Union position. He attacked immediately and started to roll up the flank. Once this occurred, Lee reversed himself and ordered a general attack by all units in contact. Hill sent Pender to assault Union I Corps positions on Seminary Ridge, with Heth in support. With three brigades on line, Pender battled a fierce stand by Union I Corps troops until he finally pushed the defenders off the ridge and east through Gettysburg. British Lieutenant Colonel Arthur Fremantle, traveling with the Confederates, recalled Hill saying the enemy fought with unusual determination, particularly at a railroad cut. He also mentioned a nearby spot where he had seen a soldier plant a flag, around which his regiment fought for some time. Including Rodes and Early, attacking from the north, four Confederate divisions forced two Union corps to retreat through Gettysburg in confusion and disarray. Oliver O. Howard, XI Corps commander, selected a position for the men to rally, and planted a flag atop a rise of ground east of town known as Cemetery Hill.[8]

Ewell described the immediate aftermath of the fighting in his report: "The enemy had fallen back to a commanding position known as Cemetery Hill, south of Gettysburg, and quickly showed a formidable front there. On entering the town, I received a message from the commanding general to attack this hill, if I could do so to advantage. I could not bring artillery to bear on it, and all the troops with me were jaded by twelve hours' marching and fighting, and I was notified that General Johnson's division (the only one of my corps that had not been engaged) was close to the town." Early recollected in his memoir that gathering numerous prisoners also slowed his men as they moved through the town at 4 p.m.[9]

Just before Ewell received this message from Lee, the commanding general rode down to where the Chambersburg Pike crosses Seminary ridge and from where he could survey the retreating Federals and the hills just beyond. It was on these hills that the two shattered Union corps reformed. Lee's adjutant, Major Walter H. Taylor, wrote that the general directed him to tell Ewell: "It was only necessary to press 'those people' in order to secure possession of the heights; and if

8 Jubal A. Early, *War Memoirs*, 267; Walter H. Taylor, *Four Years With General Lee*, (New York: D. Appleton and Company, 1877), 94; *OR*, 27/1, 696-699, 27/2: 444-445; Heth, "Causes of Lee's Defeat at Gettysburg," 158; James A. Fremantle "Diary, July 1-4," in, *The Civil War: The Third Year Told by Those Who Lived It*, Brooks D. Simpson, ed., (New York: Library of America, 2013), 294; Charles Carleton Coffin, *The Boys of '61*, (Boston: Estes and Lauriat, 1887), 277.

9 Ewell, *OR*, 27/2: 445; Longstreet, *Manassas to Appomattox*, 356; Early, *War Memoirs*, 270. Early notes that Johnson's Division was "further delayed by a false report that the enemy was advancing on the York road."

possible, he wished General Ewell to do this." Taylor recalled that Ewell acknowledged the message and indicated that he would carry out the instructions.[10]

Ewell followed the verbal message to the letter. He did his job as a commander and evaluated the situation, the troops available, their condition, the hills to which Lee referred, and the activity of the enemy. Ewell made a judgment about whether it was possible to seize the hills based upon the existing commander's guidance that the army was to concentrate in this area and demonstrate. Applying this context, Ewell determined it was not wise to go any farther. His artillery was not in position, his men had reached *tactical culmination*; twelve hours of marching and fighting had left them jaded.

Many historians and Gettysburg participants have voiced opinions about Ewell's actions on July 1. Quite a few are critical, including Moxley Sorrel one of Longstreet's staff officers. Sorrel's assessment, offered in his 1905 memoir, excoriated Ewell for not taking action. "The serious mishap of the day was Ewell's failure to seize the heights on the left," opined Sorrel. "General Lee expected it of him, and we know of no impediment." Other opinions assert that had Stonewall Jackson still been in command of the corps, he would have certainly taken those hills, without even being asked. This conjecture is complete and utter nonsense since it would have required Jackson to read Lee's mind. Beyond that, such an assertion is simply not knowable, as no one can discern what Jackson or anyone else who was not there might have done.[11]

One cannot fault Ewell for his actions or alleged lack of action on the evening of July 1. He did exactly as the commanding general asked of him. "Attack this hill, if I could do so, to advantage," Ewell wrote in his report. Whether the key words were *if possible* as per Taylor's recollection, or *if he could do so to advantage*, or if *if practicable*, as per Lee's report, the commanding general had deferred judgment to Ewell, who was the man on the spot. Lee issued guidance stating that it was for Ewell to make the decision and to strike only if feasible and advantageous.

10 Taylor, *Four Years with General Lee*, 95.

11 Moxley G. Sorrel, *Recollections*, 171. While popular lore often casts Ewell as a less capable or daring commander than Jackson, readers should note that Ewell's movement up to Carlisle was flawless and more than equaled any of Jackson's movements as far as extended distance (Jackson marched 650 miles in 48 days in the Valley Campaign, Ewell marched 250 miles in 18 days). Jackson, known for aggressiveness, also had moments of lethargy, something not stressed in many writings. There is no guarantee he would have done differently with regards to what was practicable in this situation. Witness credibility is lacking in the case of Sorrel's opinion regarding July 1. He was a participant in the battle, but not in Ewell's Corps, thus not a witness to the tactical conditions within Ewell's Corps.

Subsequently, Ewell did not think it was practicable or expedient at that juncture. He based the decision on several tactical factors as well as on the overall operational context Lee had set in motion.[12]

The operation on July 1 was a demonstration only. While the armies had just fought a significant battle that day, the result brought about no change in the overall context of the commander's guidance that Lee proffered. In addition, Lee had continued to use cautionary language, emphasizing that he did not want to get involved in a large battle. In this operational context, the July 1 fighting that had just concluded was an unplanned meeting engagement that became a battle of convenience. This was largely because an exposed Union flank presented an opportunity to Early and he took advantage of the tactical situation. Thus, when Ewell assessed the conditions of his troops, he remained under the constraints of a demonstration designed to coax the center of mass of the Union army to move east. He saw no advantage in attacking formidably defended high ground with his exhausted troops. If Lee wanted to make certain the Confederates took the ground in question, the correct action for him to take was to issue clear and concise orders for Ewell to attack, regardless of any other tactical factors. Lee should have provided direct instructions that left no deferment of judgment to the corps commander. The term *if practicable*, provided imprecise and ambiguous guidance.

Sorrel claimed in his memoir that there was no impediment to prevent Ewell from mounting an attack on Culp's Hill that evening. However, Sorrel was not in Ewell's Corps, and was not fully aware of the tactical elements that Ewell had to take into consideration. Ewell was a career soldier and a West Point trained infantry officer, while Sorrel was neither—he worked as a bank clerk prior to 1861. There were indeed impediments to taking the desired ground and Ewell was aware of the risks. His troops had reached tactical culmination after twenty-five miles of marching, and the Union held a favorable terrain feature. Additionally, he could not bring artillery into position in the remaining daylight, and his division under Johnson would not arrive until after sunset. So, it was not advantageous to attempt an assault late in the day, with exhausted troops, against eminently defensible high ground held by an unknown number of enemy troops. Others, Confederate generals such as Major General Isaac R. Trimble and Brigadier General John B. Gordon, as well as some lower-ranking officers, wrote after the war that Ewell

12 Ewell, *OR*, 27/2: 318, 445.

could have taken the high ground easily. It is important to note, however, that they did not make such claims in their after-action reports.[13]

While these claims seem to have been readily acceptable to subsequent generations of writers, the fact is the event did not happen, so it cannot be proved 'it would have been easy' for Ewell to take the hill. One must also take into consideration the force ratio factor that favors the defender. This usually requires a 3:1 advantage for the offense to be reasonably assured of a successful attack on a prepared defense, especially one with advantageous terrain. On the evening of July 1, Ewell would have had approximately a 1:1 force ratio. These later declarations against Ewell surfaced when memories had faded. Consideration about the conditions of troops at 4 p.m., after a twenty-five-mile forced march and a bloody battle, may have been replaced by how one felt about the politics of Reconstruction. Such claims also emerged within the framework of a postwar tone and tenor that reflected and supported the emerging Lost Cause mythology. Many of those writers deified Lee and Jackson and provided readers with a less than objective assessment of events. Ewell and numerous other former Confederate officers frequently found themselves woven disparagingly into the construction of these mythologies to support the beliefs, legacies, reputations, and in some cases political aspirations of those doing the writing.

One additional piece of popular speculation deserves attention. There has emerged among many a notion that had Ewell taken Culp's Hill and the adjacent East Cemetery Hill, the Confederates would have broken the bend in what would be the fishhook formation of Meade's line and won the battle. This supposition is nonsense. If Ewell had taken Culp's Hill and fortified it, there might not have been any continuation of the battle in Gettysburg. The integrity of the position that Meade built on the night of July 1, would not have been available to him had the Confederates secured Culp's Hill. In all likelihood Meade would have moved

13 Coddington, *The Gettysburg Campaign*, 318. Coddington points out (Note 163. Page 710.) that the case against Ewell is made at great length in Freeman's *Lee's Lieutenants* and the *Southern Historical Society Papers*, which brought the indictment against Ewell and damaged his legacy, casting him as a lesser replacement for Jackson and a reason why the South lost Gettysburg. Trimble wrote a scathing *Addendum* to the *Official Records* in 1883. Jubal Early, however, does not fault Ewell in his memoir. In my own experience as a combat veteran of Desert Shield/Storm 1990-91, thirty-years later in 2021, the details of the austere conditions and what happened over the four-day offensive into Iraq are no longer as clear in my mind as they were in the decade immediately after. While there are many images I can remember clearly—columns, attack formations, howitzers firing, and certain engagements—their exact times and dates even within a four-day offensive are hard to recall. What Confederate officers wrote decades after the war about topics and details they never mentioned during the war, are images from faded memories, and in some cases complete fabrications.

southeast into Maryland to the Pipe Creek line and kept himself between Lee and Washington. From there, he would have awaited Lee's next move.[14]

Leaving Lee in possession of Gettysburg, a town the Confederates had raided four days earlier, was of no strategic importance to Meade or to the prospects of Union victory in the campaign or in the war. Lee had won a modest battle, one he did not want, to gain possession of a town that was of no use to the Confederates. In addition, as of 4 p.m. on July 1, Lee was still without intelligence on the whereabouts of the rest of the Union army. He had engaged two Union corps, about 20,000 men, and the locations of the other enemy corps remained unknown. In fact, Union forces occupied nearly every town south and east of Gettysburg. Lee waited to hear reports of Union troop movements from Stuart's main body of cavalry, but their whereabouts too remained unknown. Lee still had not sent out any of the cavalry elements he had retained to conduct reconnaissance or collect information. Arguably, Lee had the greatest military decision of his life looming before him that evening. Should he initiate a potentially decisive battle under less than advantageous circumstances at Gettysburg? He could not sit outside of the place indefinitely; so two other options emerged for his consideration. First, he could continue the larger operation of moving through Pennsylvania and gathering more supplies while maneuvering to secure a tactical advantage ahead of a challenge by the enemy. Or he could withdraw and head home to Virginia.

Earlier on the afternoon of July 1, as Lee watched the battle unfold, Longstreet issued orders for his lead elements to allow Johnson's Division of Ewell's Corps to pass, as the division moved along the Chambersburg pike toward Gettysburg. Accomplishing this, Longstreet rode east to find Lee, who had by then sent Taylor off to find Ewell. When Longstreet joined Lee, they scrutinized the locations of the two beaten Union corps, repositioned along the hills on the other side of town. There had not been a "ripple of disagreement" between the generals since they embarked on the campaign, but as Longstreet joined Lee on Seminary Ridge, divergent views arose between them.[15]

Longstreet surveyed the high ground where the Union I Corps and XI Corps had set their defense. He and Lee saw that the Union had a strong continuous set of high ground terrain on which to construct defenses. The line ran roughly north to south along Cemetery Ridge and would eventually find its anchor on hills to the

14 For more on Meade's plans in Maryland prior to committing to a battle at Gettysburg consult Coddington, *The Gettysburg Campaign*, 237-240 and Meade, OR, 27/3: 458-459.

15 Freeman, *R. E. Lee*, 3: 73.

south known as the Round Tops. Both men knew that shortly thereafter, the bulk of the Union army would arrive and add strength to the line. Historians have referred to Meade's line as a fishhook line because of its resemblance to a fishhook with the barb on Culp's Hill, the bend at Cemetery Hill, the shank along Cemetery Ridge, and the eye of the hook at the Round Tops. As the Union troops arrived, they would fill out the length and depth of the line and create a seamless position, one tightly packed in some areas, and afforded good interior lines to flex reinforcements from one section to another.[16]

When Lee finished issuing directions to couriers, Longstreet initiated a dialog between them and told the commanding general: "We could not call the enemy to position better suited to our plans. All we have to do is file around his left and secure good ground between him and his capital." In his memoir, Longstreet noted that this point of view, "was thought to be the opinion of my commander as much as my own." Lee saw the situation in a different light, however, and Longstreet recalled that his commander acted somewhat uncharacteristically. "I was then not a little surprised . . . when Lee, seemingly impatient, red in the face and neck, shook his fist in the air toward the Union army." Perhaps, more as an expression of his excitement over the battle than as a response to Longstreet, Lee pointed toward the enemy position and vowed, "If he is there tomorrow, I will attack him." The exchange left Longstreet somewhat shaken and he recalled that as "Lee rode away from me . . . I was at a loss to understand his nervous condition." Longstreet issued orders to First Corps division commanders to "come on to-night as fast as you can without distressing your men or animals. Hill and Ewell have sharply engaged the enemy, and you will be needed for tomorrow's battle. Let us know where you will stop tonight." Longstreet later stated it may have been the cavalry "wanderings" that had put Lee in an angry mood, and he suggested that Stuart's absence was a reason for Lee's rash decision. He also pointed out that while Lee dove into the tactical level from an emotional state he forgot about Pickett's division and the fact that substantial combat power was at this time too far back, and would not be available the next day. In fact, Longstreet's other divisions, those under Hood and McLaws, found themselves delayed by Ewell's trains coming down from the north behind Johnson's Division. Ewell's trains stretched fourteen miles and blocked the advance of Longstreet's Corps. Undoubtedly, the trains were much larger than they were in Virginia because of all the new wagons and livestock collected along the march toward Harrisburg. Thus, Hood and McLaws spent much of July 1 waiting

16 For further analysis of Meade's line see Coddington, *The Gettysburg Campaign*, 330-332.

along the Chambersburg Pike as Ewell's trains rolled passed. Having only one road for all these troops to use was proving problematic. The accordion effect caused a full day of stops and starts along the road that units of these two corps used to get to Gettysburg. It was important to allow Johnson's Division to pass in front of Longstreet's men, to get that division to Ewell so his corps would have all its combat power as soon as possible, but Lee perhaps did not realize how bloated the trains had become, and how far back they stretched. On July 1, the trains would park between Greenwood and Cashtown. Lee and Longstreet had already started riding ahead, but when Hood and McLaws got the order from Longstreet to hurry up, it was not until 2 a.m. on July 2 that they could halt for sleep around Cashtown. In his account of this march, Hood stated that the men only got about two hours rest that night and resumed the advance toward Gettysburg at 4 a.m. Thus, two divisions of Longstreet's Corps would arrive in Gettysburg on July 2 already fatigued. Around 7 p.m. on July 1, Longstreet again went to see Lee, and found that the commanding general still had not formulated any plan beyond seizing Culp's Hill, nor had he given any orders for the next day. Lee remained in a somewhat agitated state, perhaps from the earlier unwanted engagement, and Longstreet described the tension as "painfully evident."[17]

The Second Day

On the night of July 1, Lee remained unsure of what to do next, and issued no specific orders for any sort of movement. Longstreet was confused and Lee's behavior left him worried. Ewell was probably concerned that his commanding officer was not satisfied with his work. Early wrote that Lee had visited Ewell and that the generals "were given to understand that, if the rest of the troops could be got up, there would be an attack." The truth was that not all of Lee's army would be available the next day. Earlier on the morning of July 1, Lee had written to Imboden, who was operating with his cavalry in the vicinity of Mercersburg.

17 Longstreet, *From Manassas to Appomattox*, 358-361; Longstreet, *OR*, 27/2: 358, Lee, *OR*, 27/3: 948. Lee's decision to fight at Gettysburg was first hobbled by the problems of the single road many elements of his army had to travel. It was not a problem if he stuck to a demonstration only, and then decided to continue to maneuver around Meade as Longstreet suggested, but he clearly did not realize how congested the Chambersburg Pike was on July 1. Thus, he did not account for how this would affect getting Longstreet's Corps forward in a timely manner, with all its divisions. (Hood's account appears in Longstreet's memoir). For a refutation of postwar criticisms regarding the arrival of Hood and McLaws, consult Glen Tucker, *Lee and Longstreet at Gettysburg*, (New York: The Bobbs-Merrill Co. 1968), 36-48.

Expecting that Imboden would arrive at Chambersburg that same day, Lee desired him to, "relieve General Pickett, who will then move forward to this place." Edward Porter Alexander held at Greenwood with his artillery throughout the day on July 1. He did not receive word to start moving toward Cashtown until 2 a.m. on July 2. Alexander recorded that he arrived at Gettysburg by mid-morning and had seen "nothing of the infantry" at Greenwood. Pickett's Division also received word to start moving toward Gettysburg. At 2 a.m. on July 2, Pickett started his march. This accounts for Alexander's failure to see infantry at Greenwood. According to one account, the 24th Virginia from Kemper's Brigade in Pickett's Division would march twenty-three miles in twenty-four hours. It would not reach Gettysburg until mid-afternoon on July 2.[18]

While Lee may have been unsure what to do on July 1, so too was the nation. Confusing news reports on the whole affair appeared in the papers and described the invasion of Pennsylvania in contradictory terms. On Tuesday, June 30, the *Galena Daily Advertiser*, from the Illinois town where Grant had lived for a number of years, reported that "a gentleman who left York," Pennsylvania, said it was Longstreet who had come through there and, "everything of value that could be, has been removed." The paper had confused Longstreet with Ewell, or perhaps soldiers from Early's Division had intentionally sowed misinformation. Many speculations abounded in the press. Some writers thought Lee would arrive in Harrisburg at any moment, while others thought he would swing south toward Baltimore. It was day two of the battle that brought national clarity to the event.[19]

Meade was quite clear in his mind regarding what to do on the evening of July 1. He met with his generals and told them there was going to be a battle the next day, as matter-of-factly as Napoleon mentioned Austerlitz to his marshals. Meade insisted, however, that he was not going to attack the Confederates. Instead, he was going to try and give back to Lee what the Confederates had done to the Army of the Potomac the previous December at Fredericksburg. Meade sought to use the terrain at Gettysburg defensively and to his advantage. After the meeting, Meade rode to Cemetery Ridge and arrived at 1 a.m., on July 2. He started emplacing the units of his army, one after the other, in a strong defensive position along all the high ground that ran from Culp's Hill, across Cemetery Hill, and down along

18 Lee, OR, 27/3: 947-948; Jubal Early, *Lieutenant General Jubal Anderson Early C. S. A.*, Ruth Harrison, ed., (Philadelphia: J. B. Lippincott Co. 1912), 271; E. P. Alexander, "Causes of Lee's Defeat at Gettysburg," in *Southern Historical Society Papers*, 4: 100-101; Ralph White Gunn, *24th Virginia Infantry*, (Lynchburg: H. E. Howard, 1987), 43-47.

19 *Galena Daily Advertiser*, June 30, 1863.

Cemetery Ridge. At 3 a.m. he met on Cemetery Hill with Howard, the XI Corp commander. The generals met at the cemetery gates and rode along the line together. Howard assured Meade that they could hold. It was the confidence Meade needed to hear from his commanders. Meade's subordinates appreciated the strength of the ground and thought the army could stop Lee. While Buford deserves great credit for starting the fight with his blocking action that drew in Hill's infantry on July 1, it was in many ways Meade's work that night that ultimately won the battle. Meade envisioned how his deliberate defense should look, and then with careful unit emplacement he executed the preparation stage for battle with precision. By 6 a.m. Meade had 25,000 reinforcements added to the I Corps and XI Corps. An hour later, II Corps and V Corps troops had arrived and by 9 a.m. Meade had six of his seven infantry corps, about 85,000 men, skillfully deployed in the fishhook formation. With his line formed in this shape, Meade could flex combat power over his short interior lines and his fire support reached across much of his longest section of the line on Cemetery Ridge. Sedgwick's VI Corps would arrive at 2 p.m. In contrast, by 9 a.m. Lee still had no battle plan and no knowledge of the extent of the Union coverage along Cemetery Ridge.[20]

Sunrise found Lee riding along his lines reconnoitering Meade's position. Lee had also sent out Major Charles S. Venable from his staff to check the situation opposite Ewell's Corps and ascertain Union troop strength on Culp's Hill. Lee ended the first day thinking he would attack that position, and as the second day dawned, he still had that objective in mind. After Venable rode off, Longstreet joined Lee. They continued the discussion on what to do, and the alleged statements and understandings of this conference have received much speculative scrutiny from historians. One widely held view is that Longstreet again lobbied for continued maneuver around the Union left to interpose the Army of Northern Virginia between Meade and Washington. Lee rejected this notion, based upon the alleged reason that he, "could not withdraw without impairing the morale of his men," insisted on attacking. Although this reason seems to be the most popular in much of the historiography and lore, an examination of Lee's official report seems to contradict this interpretation. Lee wrote: "It had not been intended to deliver a general battle so far from our base unless attacked, but coming unexpectedly upon the whole Federal Army, to withdraw through the mountains with our extensive

20 Coffin, *The Boys of '61*, 274; Meade, OR, 27/1: 115; Longstreet, *Manassas to Appomattox*, 362-364; Coddington, *The Gettysburg Campaign*, 323-358. Coddington devotes an entire chapter to Meade's preparations during the night.

trains would have been difficult and dangerous. At the same time, we were unable to await an attack, as the country was unfavorable for collecting supplies in the presence of the enemy, who could restrain our foraging parties by holding the mountain passes with local and other troops. A battle had, therefore, become in a measure unavoidable, and the success already gained gave hope of a favorable issue." Lee did not indicate that he based the decision to attack at Gettysburg on the prospect that the morale of his troops would decline if he moved away from further contact. In fact, the idea that troop morale would outweigh tactical factors in determining the time and place of battle, is quite alien to the professional military mind. Morale also comes from having leaders who are viewed as competent and caring. It is not plausible that rank and file troops would want their senior officers to throw them into battle at every opportunity. Showing tactical patience and restraint in situations where the enemy has an advantage, particularly one that is plain to see even in the eyes of an eighteen-year-old private, does wonders to improve morale. In other words, the common soldiers of the greatest and most successful armies throughout history were not men who wanted their leaders to sacrifice them needlessly for the sake of creating a fight. They were more willing to make sacrifices knowing their leaders did everything possible to set the conditions in their favor before committing them to a fight.[21]

The notion that Lee decided to stay and fight because his troops would not have liked the idea of backing away after winning a battle on July 1 is hard to believe. Seasoned combat veterans understand that maneuver is integral to successful campaigning. Lee won an engagement where his two larger corps drove two numerically inferior corps several miles, pushed them through a town, but ultimately could not do much more at the end of the day. Although they took prisoners and captured cannon, the Union troops took a strong position on high ground and did not back away any further. For the Confederates, the morning of July 2 rendered the tactical results of July 1 null and void. The Union army was not reeling from heavy losses. In fact, their losses were but a small portion of the whole army and now the AOP was massed in a strong defense. It was a whole new situation. Retreating after a loss may be a morale-lowering event but redeploying and maneuvering after a win is something totally different.

Longstreet recalled that Lee had made up his mind to attack in a moment charged by emotion. At that time, Ewell and Hill were sweeping the two Union

21 Coffin, *The Boys of '61*, 278; Lee, *OR*, 27/2: 318. A good portion of the trains were parked west of the battle area.

corps through town. Certainly, Longstreet's opinion is one eyewitness account. Lee left behind in his record that he decided to give battle primarily based upon logistical reasons. He felt he could no longer effectively forage in the area, due to the presence of the Union army. Additionally, the militia and other Union troops could harass the Confederates when they moved through the mountain passes. This factor had not presented a problem to any of Lee's movements thus far. The only militia the Confederates had encountered were in Gettysburg on June 26, and the 35th Virginia cavalry battalion chased them off. As far as Lee's immediate situation, there were no threats beyond the one posed by the Union army to his front.[22]

Lee's Alternatives

It was true that Lee had won a tactical victory over two Union corps at a meeting engagement, but the Confederates had not secured or achieved any sort of objective that could generate some higher form of benefit. The failure to occupy Harrisburg, for example, had thus far minimized any political damage from the invasion. Even though the Confederates had won a battle on July 1, the result was that the Army of the Potomac arrived en masse and occupied better ground. Lee felt he could no longer forage safely due to the proximity of the AOP, so his alternatives were to continue to maneuver or continue the fight. The latter put him at a disadvantage on the battlefield.

Of the second alternative, Lee stated in his report that a battle was now 'in a measure' unavoidable and the success of the first day gave hope of further success. Was it really unavoidable? Meade was deploying in a well thought out defensive position, quite the opposite of preparing to take the offensive. It takes time for a defensively positioned army to uncoil and switch over to offensive operations. It is not just a matter of units falling in and moving out. The commander and his staff require time for planning the move and cannot start until it is known that the enemy is leaving and in motion. Although the AOP was concentrated, and not much time would be lost in sending out riders with dispatches, Meade could not start planning a pursuit until Lee acted. This meant that Lee had the initiative and could put some distance between himself and Meade's pursuing force.

22 Lee, OR, 27/2: 318; Robert W. Coakley, *The Role of Federal Military Forces in Domestic Disorders, 1789-1878*, (Washington DC: US Army Center for Military History, 1988), 259-260; Couch, OR 27/3: 527. Couch reported to Stanton: "I have sent a large force to . . . the mountains between Carlisle and Gettysburg." This was part of his efforts to assist Meade after the battle as well as to address latent Copperhead activity.

Also, a factor in Lee's favor was that a larger army has more movement challenges than does a smaller force. Thus, Lee did have the luxury of movement on July 2. He could go in any direction he chose to move away from Meade. While Lee was correct that he could not forage effectively in proximity to the Army of the Potomac, his army had already picked clean much of south-central Pennsylvania and only Harrisburg and Lancaster remained as targets. Yet the Army of Northern Virginia had not been through the area directly south of Gettysburg. If Lee wanted to move south and then east there was Baltimore. He also had an immense amount of food that the army had collected. There were, for example, the 3,000 beef cattle that Ewell sent to Chambersburg from the Carlisle area. There is no conceivable way that the army had consumed such a massive amount of food by July 1. Lee's army had several weeks' worth of sustenance while operating outside Virginia. The notion of poor foraging prospects in the immediate area as a reason to attack Meade was flawed thinking on Lee's part.

Lee thought that trying to move his army to Chambersburg and secure access to the strategic corridor of advance was dangerous. This notion deserves further examination. There is little doubt that the Chambersburg Pike was not necessarily the best or only option, were the army and trains to withdraw. Meade was not readying himself to attack, however, and it was Lee who had the initiative on July 2. Confederate trains were already parked on the Chambersburg Pike, and only after the battle moved west toward Chambersburg. Then they went only to Greenwood, before turning south to Waynesboro and moving west to Greencastle. From there, it was south to Hagerstown and finally Williamsport, where they crossed the Potomac River. The three Confederate corps essentially blocked any Federal interference with the trains. They retreated southwest and went through the Monterey Pass in South Mountain, then to Hagerstown, and finally Williamsport. Leaving Gettysburg certainly cannot be considered dangerous or impossible, because Lee did precisely this after the battle. He did not execute this movement only with bloated wagon trains, but with thousands of injured men. If Meade did try to pursue, Lee would have three infantry corps together and could find advantageous terrain at South Mountain. This situation was unlike the battle of South Mountain prior to Antietam when he only had several brigades. Retrograding, that is withdrawing the way they had come, was not an easy option due to the paucity of routes available for so many troops and trains, but it was possible given Meade's defensive posture.

The next option was to resume movement north and northeast to occupy Harrisburg. Would it still be possible to occupy Harrisburg and gain a degree of benefit in the political realm, and would Meade pursue? This is, of course, uncertain. Any movement by Lee toward Harrisburg would have closed the

distance between the two armies and might have led to an immediate Federal attack. Meade had intended to move to the Susquehanna River to cover Baltimore, but now that he had made contact, his plan had changed. The record does not indicate whether Lee made any evaluation of breaking contact at Gettysburg to drive toward Harrisburg after the battle of July 1.

The last maneuver option for Lee was to move south or southeast. Moving directly south was to go through Emmitsburg, then Frederick, and finally return to Virginia. To maneuver southeast was to go through Taneytown and perhaps Westminster and attempt further foraging. That would mean Lee risking battle by moving in the direction of Baltimore. An immediate return to Virginia would have resulted in only the gain of food and materiel from what would have amounted to a large-scale raid. Lee could claim success in that he executed a broad demonstration on northern soil. Although Lee's ill-defined strategic objective might have become a casualty, he might not have lost a battle and thousands of irreplaceable veteran troops. A movement to interpose his army between Meade and Washington might have invited a defensive battle at a suitable site and inflicted another mass casualty event on the Union army. Had that happened, the event would have carried with it the added political benefit of occurring on northern soil. Gettysburg historian and author Edwin B. Coddington pointed out in his 1968 work on the campaign, that Longstreet described this concept only in general terms in his memoir and did not delineate whether he meant a tactical move close by or a sweeping strategic move out of the immediate area. A valid point, but the suggestion by Longstreet, whether he meant to move around the Union army and stay in the local area or move to the southeast with greater distance, would be for Lee to weigh and decide. Both were possibilities.[23]

It is, of course, also possible that Meade would have pursued in a timely manner and forced Lee into a decisive battle. This would have potentially taken Meade away from his advantageous defensive position at Gettysburg and forced him to take the offense without the benefit of key terrain.

There are numerous works that support Longstreet's position as well as those that criticize it. For example, some critics of the idea of maneuvering further south

23 Coddington, *Gettysburg Campaign*, 360. An early postwar source states: "Lee expressly promised his corps commanders that he would not assume the tactical offense, but [would] force his antagonist to attack him." See William Swinton, *Campaigns of the Army of the Potomac*, (New York: Charles Scribner's Sons, 1882), 340. Swinton worked as a journalist and war correspondent and interviewed Longstreet during his research for this book, originally published in 1866.

and east claim Union cavalry would have blocked the Confederates, or that there were not enough road networks, or that the trains were too large. By this point, Lee had his full cavalry corps. He would not have to move in the face of Meade's army with trains packed with wounded. A movement away from Gettysburg on July 2 would have been a movement with an intact and more mobile army with most of soldiers fit and able to march.[24]

Longstreet suggested to Lee that they continue to maneuver and avoid fighting a disadvantageous battle. In his view, there was more to gain in gathering food, further embarrassing Federal authorities, and perhaps shaping an advantageous battle. Would the adoption of Longstreet's suggestion necessarily have led to a better result for the Confederates? No. There is no value in declaring that a course of action not taken would have garnered a certain result. There is value, however, in summing up the options at a particular juncture and using historical analysis to gain further understanding and insight into the overall operational and strategic larger pictures.

24 Scott Bowden and Bill Ward, *Last Chance for Victory: Robert E. Lee and the Gettysburg Campaign*, (Boston: Da Capo Press, 2001), 226-230. It should be noted that the units retained by Lee during Stuart's absence were Imboden' s Brigade, Albert Jenkins's Brigade, and Lt. Col. Elijah V. White's 35th VA BN. Both the latter had screened for Ewell's Corps. Some claim that in Lee's opinion these troops were not adequately trained; however, both Jenkins and White had recent experience performing the tasks required of this campaign. Gen. Buford mentions both Jenkins and White's units in his OR entry on June 30, 1863, 27/1: 924. These units were scouting in advance of Ewell's Corps coming down from the north. He wrote that the road from Cashtown running through Mummasburg and Hunterstown on to York Pike at Oxford, "is terribly infested with roving detachments of cavalry." In the opinion of an expert cavalryman on the other side, these units were doing their job scouting ahead of Ewell's movement into the area. White, in particular, was a man of extensive experience and leadership. In 1855 he fought in the Kansas Border War and spent most of 1862 performing traditional cavalry tasks. White's command essentially screened Ewell's right flank from June 25 through June 30, covering an area much larger than that typically assigned a battalion. Jenkins had experience in West Virginia, early in the war, and had conducted a 500 mile loop of mounted raiding operations in the state. The 35th Virginia Cavalry also led Early's Division through Gettysburg on June 26, confronting and chasing off the 26th Pennsylvania Emergency Regiment. This was probably the first action between Lee's Army and a Northern unit in the campaign. For Buford's observations on White's command, see also John E. Divine, *35th BN Virginia Cavalry*, (Lynchburg: H. E. Howard, 1985), 1, 31-35. Imboden had been an educator before the war. He fought at Bull Run in 1861, participated in Jackson's Valley Campaign in 1862, and in cavalry raids in western Virginia. Imboden was not a formally trained military man, but by 1863 he was not a complete novice either. His superb defense of the trains near Williamsport after the retreat from Gettysburg, seemed to prove him capable, and gained him some words of praise from Lee. During the campaign, Imboden commanded approximately 2,000 cavalry troopers.

Chapter 9

Day 2: The Attack Is Ordered

"Cheer less, men, and fight more."

— General Longstreet, July 2, 1863

Ultimately, Lee was not convinced a continuance of maneuver was best and he put aside Longstreet's idea. Their divergent views became the genesis of a century and a half of theories and claims over which of the two was right. Arguments also included accusations that Longstreet acted improperly in his role as an advisor and counselor to Lee. Some insist he should have simply acted as an obedient subordinate. One example was the assertion by William N. Pendleton in 1873 that Lee issued a "Sunrise Order" to Longstreet. Purportedly, the instructions were to be ready to attack at sunrise on July 2. Pendleton's claim reiterated what Jubal Early had said the year before in a speech. It was a fabrication, debunked by various officers in the decades after the war. Yet, in the years following, there emerged numerous other versions of key discussions between Longstreet and Lee. Many officers in Lee's army claimed to have heard things then that they now wanted the world to know. Some told of a heated exchange between the generals while others alleged purposeful slowness on the part of Longstreet in getting his troops in place. According to these officers, Longstreet delayed because he was upset that Lee did not want to continue to maneuver. Lee never mentioned any problem with Longstreet, and those defending Longstreet after the war rejected these claims entirely. In fact with the exception of McLaws (regarding a different topic), no one

made note of any disagreements at the time of the battle or in the immediate aftermath.[1]

Most of all, disgruntled Confederate veterans leveled their postwar allegations decades later and relied on facts and recollections culled from faded memories in the context of the Lost Cause. Some of the descriptions of divergent views between Lee and Longstreet were fair but others were completely false. Scholars and students should rely, rather, on what the soldiers wrote in 1863. The correspondence, communiqués, and missives written and recorded then, and shortly thereafter, provide the most accurate reflection on events as they unfolded. Additionally, one must also understand that Longstreet and Lee engaged primarily in verbal communications. This was the normal routine of their working relationship. They were close to each other, and spent much of their time together, almost as if they were family members. Emanating from their friendship was a special level of candor that Lee allowed Longstreet; one that was not something other subordinates shared with the commanding general. Longstreet clearly felt a reciprocal closeness to Lee, and thus spoke to him in a way that was reserved for him only. It may be that the two men did not even realize that this component of their personal relationship overlapped with their professional one. In any case, whether this was proper or improper is a matter of opinion. As for Longstreet acting as a counselor to Lee, this may be due to the fact Longstreet was an infantry officer and Lee was an engineer officer.[2]

1 Fremantle, "Diary," 338-340; Wert, *Longstreet*, 422-423. On July 7, 1863, McLaws confided in a letter to his wife: "I think the attack was unnecessary and the whole plan of battle a very bad one. Genl Longstreet is to blame for not reconnoitering the ground and for persisting in ordering the assault when his errors were discovered." McLaws was mistaken, in that it was Lee's plan and he had sent a captain to reconnoiter the area before telling Longstreet they would attack the Union Line. Longstreet tried to dissuade Lee from fighting at Gettysburg as well as attacking the Union Line. McLaws continued: "During the engagement he was very excited, giving contrary orders to everyone, and was exceedingly overbearing. I consider him a humbug—a man of small capacity, very obstinate, not at all chivalrous, exceedingly conceited, and totally selfish. If I can it is my intention to get away from his command." McLaws was clearly upset about Longstreet not stopping the attack, leading part of his division in an attack, and having apparently been hard on him. However, McLaws was not among those who later claimed Longstreet had disobeyed Lee. McLaws supported Longstreet after the war. See Lafayette McLaws's letter to wife, "A Series of Terrible Engagements," in, *The Civil War: The Third Year*, ed. Brooks D. Simpson.

2 Freeman, *R. E. Lee*, 2: 317-349. As covered in earlier chapters, the close relationship between Lee and Longstreet began within a few days of meeting each other after Lee took over from Johnston. Longstreet became his co-planner, Lee stayed with Longstreet, and it is also evident they got along well personally. Lee recognized Longstreet's long, consistent service, and infantry expertise. In theory, it is possible that in 1861 Lee was dissatisfied with his early

Lee's career was that of a typical engineer. As a newly minted officer, commissioned in 1829, he worked on fortifications and improving waterways. He served on Winfield Scott's staff during the Mexican War, learning reconnaissance and how Scott conducted operations at the general officer level. The experience was both influential and special in Lee's professional development. Lee became part of the operational and strategic level planning, including joint operations with other branches. Working closely with Scott in wartime helped make Lee one of a few young officers who had experienced this level firsthand. By 1860, Lee was one of the rare officers in the army with practical operational and strategic wartime planning experience. Lee was not, however, an experienced practitioner of infantry and artillery tactics.

At no time prior to 1861, did Lee hold a command of an infantry or artillery unit. He once led a scouting team that emplaced a battery in combat, but his knowledge of these branches remained theoretical rather than practical. He had seen infantry attack during the Mexican War, but he was never part of any of these attacking units. One broadening assignment outside of his basic branch was with the frontier 2nd Cavalry, from 1855-60, but he served with the unit only periodically and for a total of just fourteen months. The remainder of the time, Lee was on other assignments, including courts-martial, and at one point he apprehended John Brown at Harper's Ferry. Lee's thinking therefore remained abstract as to what worked and did not work in an infantry attack. Perhaps, this provides a measure of insight into his tendency to hurl infantry units into the attack during the Civil War, often without regard for enemy defensive preparations and possible losses. During the Seven Days he experienced success against Union commander George B. McClellan in battles where he employed intimidating aggressiveness. On July 1, 1862, however, at Malvern Hill, McClellan repulsed Lee's attack against a prepared defense. His next offense was Second Manassas, where Longstreet tempered Lee's desire to attack immediately. Longstreet engineered unit positioning for a flank attack which was successful as a result of taking time to prepare. Lee's last offensive before the Gettysburg Campaign was at Chancellorsville where he directed Stonewall Jackson to initiate an attack against

performance in West Virginia, and once he had army-level command he overcompensated with aggressiveness as he went through a period of late-career education, learning the true capabilities of the combat arms branches in 1862 and 1863. Aggressiveness brought success, but at a high cost. Malvern Hill, for example, shows where the aggressiveness went too far, and perhaps Lee then sought the infantry expertise of Longstreet at Second Manassas. At Antietam and Gettysburg he listened but ultimately went with his own judgments.

the Union right flank. Here again, Lee was not involved directly with the tactical planning or execution of the attack.[3]

Lee lacked experiential knowledge of the infantry unit attack, and thus developed a tendency to commit to infantry attacks from an abstract and perhaps nonrealistic thought of success. He did this unwittingly at points throughout the war. In 1864, Lee did abstain from this tendency when fighting Grant, relying instead on the knowledge of his engineer branch to entrench. Lee's inverted 'V Fortifications' in May 1864, exemplify this aspect. Nonetheless, he still had not moved beyond the desire to handle brigade-level units as offensive components. Even in 1865, during the last days of the Petersburg siege, this inclination prevailed. On March 31, 1865, Lee rode to the extreme right of his line and ordered an unnecessary attack. The three-mile section of the line that he inspected was under the command of Bushrod Johnson, whose remnant of a division manned the trench line. Lee ordered an attack when he saw two lines of Union infantry, with their flank exposed, positioned opposite Johnson's men. Lee did summon an additional brigade to assist Johnson, who then deployed the unit into the flank attack. The Confederates initially made some headway into the enemy line, but the Union brought to bear overwhelming numbers. The outnumbered Confederates fell back to their trench line at a high cost. This fight cost 800 casualties out of Johnson's 4,800-man division. Statistically, this was a seventeen percent loss with no useful military result. An unreasonable trade-off at any time. And doubly so at the last gasp.

In contrast, Longstreet was a career infantry officer who had served in infantry units since his commission as a second lieutenant in 1842 and during his rise to the rank of major in 1858. He had extensive experience in infantry tactics during the Mexican War, Indian actions, and years of general infantry training at different duty stations. Even though the US Army engaged in no traditional European-style land war at home or overseas from 1849 to 1860, the peacetime army of the United States still trained for war across a spectrum of anticipated operations with the force structure it had. These included assembling larger units to exercise tactical and operational elements of warfare. During this time, Longstreet had no disruption in military service, unlike many who returned to the army during the secession crisis or at the outbreak of war. Longstreet's service record and experience were special. Just as Lee was one of a few who had real wartime strategic

3 For information on Lee's prewar military career, consult Margaret Sanborn, *Robert E. Lee: A Portrait 1807-1861*, (New York: J. B. Lippincott Co., 1966), 237-317.

level staff experience, Longstreet was one of a few who had tactical wartime experience as well as decades of peacetime training. Thus, when the war started, Longstreet was already at a higher level of infantry branch professional development at the brigade and division levels than most. From First Manassas through Second Manassas, Longstreet commanded infantry brigades, divisions, and a wing of up to five and six divisions at intervals in a variety of engagements. Conversely, Lee had not. This may provide insight as to why Longstreet acted as a co-planner and counselor to Lee on tactics and operations.[4]

By 9 a.m. on July 2, Lee had still no concept of operations at Gettysburg. Yet he formulated a plan of attack. He first thought the Confederates should launch the main attack with Ewell's Corps at Culp's Hill and Cemetery Hill. Lee went to Ewell's sector but soon ascertained that the Confederates could gain little advantage in that area. At the conference with Ewell and his division commanders, Lee decided "to make the principal attack against the enemy's left and endeavor to gain a position from which it was thought that our artillery could be brought to bear with effect." He promptly directed Longstreet to place McLaws and Hood to the right of A.P. Hill, thus partially enveloping the enemy left. From that position Longstreet could drive in the enemy flank, essentially unleashing an *en échelon* attack.[5]

Hood's Division was the first of Longstreet's command to arrive and they rested behind Seminary Ridge out of sight of enemy observation while waiting for McLaws to arrive. Meanwhile, Lee planned the execution of the operation. Although the exact arrival times of these divisions is not clear, most of Hood's command was on the field no later than 9 a.m. At that time, however, his senior brigadier, Evander Law remained on the road and Longstreet had received no commander's guidance from Lee.

4 Freeman, *R.E. Lee*, 1: 360-418. Freeman was critical of Longstreet in his 1930s four-volume biography, regarding this role. It must be noted that Freeman was not a soldier and had no career understanding of Army branch professional development and how a career path determines an officer's suitability for high-level combat arms command positions. Freeman assumed Lee was proficient in combat arms branch tactics at a level equal to or greater than those who were combat arms officers. This is a fallacy, perhaps proven in at least in two major battles: his failed and costly attack against a defense-in-depth at Malvern Hill, and at Gettysburg. Peacetime large unit combat maneuver training in the modern US Army is done several times a year at major training centers. The US Army in the 1840s-1850s also trained at the regiment and brigade level on or near their home station installations.

5 Lee, *OR*, 27/2: 318. An *en échelon* attack is where the assault is commenced by the unit furthest right (in this case) and all other units take their cue to attack from the unit to their right.

By 9 a.m. the Federals had fleshed out their position from flank to flank. Lee believed that the coverage extended only about halfway between the bend in the Union line south of the town and the Round Tops. He thought the rest of the ground, which extended to the Round Tops, remained devoid of unit coverage. At 10 a.m. Longstreet still had no clear instructions regarding an attack. At that point, Lee was still in Ewell's sector or perhaps on his way back to Longstreet.

It was not until 11 a.m. that Lee arrived at Seminary Ridge to apprise Longstreet of his decision. He told Longstreet to attack the left wing of the enemy line and that he was to initiate the attack as soon as McLaws was in position. Lee specified that Longstreet was to place McLaws and Hood to the right of A. P. Hill and attack along the Emmitsburg Road, using it as a control measure. The road would provide a line for Hood and McLaws to follow as they enveloped the enemy left and rolled up the Federal flank. In addition, since Longstreet was still missing Pickett's Division, Lee gave his corps commander operational control of Richard H. Anderson's Division from Hill's Corps; that brought Longstreet's attack force up to three full divisions. There would be supporting attacks from Ewell and Hill that were intended to tie down Union troops to their front. These demonstrations would prevent Meade from using his interior lines to flex units from other sectors and confront the main attack by Longstreet. It was a faulty plan, one based on shoddy intelligence of the Union line.[6]

Part of Lee's plan was to get Longstreet in position by using the terrain to conceal his movements from a Union signal station on Little Round Top, thus gaining the advantage of surprise. The reality was that not only could the Federals on Little Round Top see Longstreet's troops along the Emmitsburg Road, but so could several units to the north along Cemetery Ridge. Union positions had changed since Lee received early morning intelligence on their disposition, but he was not yet aware of the change. As the day progressed and more of Meade's army arrived, the Union line extended farther than just halfway between the bend in the line at Cemetery Hill and the Round Tops. Any advance up the Emmitsburg Road would expose Hood's right flank to fire from those recently arrived Union units.

Nevertheless, Longstreet started the work of getting the divisions out of their assembly area and configured to attack. At the same time, Union Major General Daniel Sickles, opposite Longstreet, felt that he would be in a better position if he moved forward from Cemetery Ridge to the elevated ground along the

6 Ibid, 318, 614; Coddington, *Gettysburg Campaign*, 374-377. Operational Control is often referred to as OPCON.

Emmitsburg road. The road ran along a ridge about a quarter a mile in front of the Union line that Meade had established. In fact, Sickles asked Meade if he could move forward, and the commanding general told him no. Sickles disobeyed Meade's instructions and advanced his corps without orders. In doing so he created nearly a half-mile open seam between his right and the left of Hancock's II Corps. The gap offered Longstreet an advantage and once he recognized the weakness of the Union line he would attempt to exploit the enemy's error.[7]

Longstreet had asked Lee for a delay to allow time for Evander Law's Brigade, of Hood's Division, to reach the field. Law had been on picket duty at Guilford Court House the day before and was hurrying to rejoin the division. Lee consented to this delay. With McLaws and Hood near Lee's headquarters on Seminary Ridge, Longstreet's Corps started moving to the right and getting in position to assault the Union left. Captain S. R. Johnston guided the Confederates toward the position.[8]

Johnston was an army engineer officer on Lee's staff. Early in the morning, Lee had given him the task of reconnoitering the area around the Union left. Johnston supposedly reached the area around Little Round Top and drew a sketch of the terrain upon which Lee devised his plan of attack. While it is part of the job of an engineer officer to find vulnerabilities in man-made enemy fortifications and provide that information to the infantry officers, Johnston did not apply his scientific knowledge to this purely natural terrain. Neither was he trained on how his infantry branch colleagues executed the tactical positioning of troops. Lee sent Johnston to reconnoiter, report, and provide a sketch of the terrain. If after reviewing the information and the sketches, Lee still wanted to attack this area, the correct action was to send Longstreet to personally reconnoiter the location. Had Longstreet examined the area personally, he could have assessed what was necessary for his infantry corps to attack and carry the position, or determine what the problems were, and report back to Lee. That is the job of the unit assigned, not the job of an officer from a commanding general's staff. In fact, staff members should only be sent out to do general reconnaissance for specific purposes related to headquarters. Staff officers should not attempt to do the job of the line infantry

7 Longstreet, *Manassas to Appomattox*, 365; Catton, *Gettysburg: The Final Fury*, 38.

8 Tucker, *Lee and Longstreet at Gettysburg*, 56; Longstreet, *OR*, 27/2: 357-368. In his report Longstreet does not mention that Lee consented to waiting for Law's Brigade before launching the attack. He states this in his memoir in 1896. The whole area opposite the Union position was open, rolling terrain. There were no large, wooded areas useful to cover large movements such as the near 14,000 Longstreet was getting into position on the second day.

officer. Non-infantry branch staff officers do not possess the knowledge and experience with infantry tactics, techniques, and procedures that the units employ.[9]

Johnston's sketch served its purpose, but he also saw a gap in the enemy line that morning between Little Round Top and the position held by the Union left. In the hours after Johnston's visit all this had changed. Lee rode over to Ewell's side of the field but failed to send anyone from his staff to monitor the sector of the Union line that Johnston had reconnoitered hours earlier. Therefore, Lee's decision-making process did not include periodic updates regarding changes in Union line coverage that occurred throughout the morning. As it was, Lee based the action on what Johnston saw much earlier: no Union troops on the southern portion of Cemetery Ridge or on the hills. This intelligence estimate of the battlefield proved incorrect hours later.[10]

Unit leadership reconnaissance also acts as a rehearsal and gives leaders a preliminary once-over of the ground before execution. When Johnston reconnoitered the area, Lee still had not conceived a concept of the operation. He did not know how Longstreet's command might fit into the plan and following the reconnaissance the area was not watched continuously for enemy movement. McLaws was correct that the area had not been properly reconnoitered. Had more eyes, over a longer time observed Cemetery Ridge, the Confederates might have avoided the event known to history as the "counter-march."[11]

This reconnaissance oversight resulted in a late morning discovery that the tactical situation put forth in Lee's orders and guidance at 11 a.m. had changed. When Longstreet got closer to the Round Tops, it became apparent there was no longer a vacant spot in the Union line. Plus Sickles's III Corps held a position blocking the projected path of Longstreet's advance. At this time, Johnston told Longstreet that if the front of McLaws's column went over the crest at a spot a mile and a half from where Hood was, the Union signalers on the high ground would see them. Hence, Longstreet could not execute an attack along the Emmitsburg

9 Coddington, *Gettysburg Campaign*, 373-374. Lee and Longstreet did not seem to handle this planning in the same way they did at Second Manassas.

10 McLaws alluded to this failure in a letter to his wife. The letter was primarily critical of Longstreet. McLaws to wife, July 7, 1863, McLaws Papers, University of North Carolina.

11 Tucker, *Lee and Longstreet at Gettysburg*, 56. Tucker also suggests another local, Henry Wentz, would have been helpful in the reconnaissance. Henry was a sergeant with Lieut. Osmand B. Taylor's Artillery Battery; his family had lived just north of the Wheatfield on the east side of the Emmitsburg road in a farmhouse. Henry had moved to Martinsburg, Virginia before the war, but was at Gettysburg with his battery.

road. He held in place to re-evaluate how best to reposition his forces. Meanwhile, Lee wondered why the attacks had not yet started and rode over to evaluate the situation in Longstreet's sector. Longstreet showed him the problems and the generals set to work to modify the original plan.[12]

They decided to shift further to the south and east of the Emmitsburg road, in part to prevent McLaws from attacking directly into the front of Sickles's position. They wanted to position McLaws to strike Sickles's flank at an angle. Hood would deploy at the far right of the Confederate line in order to assail the Union at their furthest left. The new plan was also going to delay the attack, since repositioning the two divisions, ostensibly at a right angle to one another, required McLaws turning around and moving back behind masking terrain. This became known as the "counter-march." As McLaws moved his division between noon and 1 p.m. Hood received orders to quicken his pace and pass to the front of McLaws. Hood recollected that his movement was finally accomplished by throwing out an advanced force to tear down fences and clear the way. Both divisions were in their attack positions between 3 and 4 p.m.[13]

Hood did not like the axis of advance that the assignment designated. It forced him to attack hilly terrain covered with large rocks and boulders. This was perfect terrain for a defender and did not offer clear access to the enemy flank. The Federals were ensconced among boulders and could lay down a withering fire against Hood's men. Before he reached the Emmitsburg road, Hood had sent out scouts to ascertain the disposition of the Union left flank. They reported that the flank stood on Round Top Mountain and the terrain to the right of that feature was open. Scouts further advised Hood that he could march through an open woodland pasture around Big Round Top and assault the enemy in the flank and rear. The scouts also said that Union wagon trains were parked in the rear of their line and would be vulnerable should the Confederates attack from that direction. Hood felt it was his duty to report this to Longstreet, and that in his opinion it was unwise to attack as ordered. He would be striking a strong section of Union line, a sector that was not truly the flank. Hood sent a dispatch to Longstreet urging that he allow him to turn the Round Tops and attack the enemy in flank and rear. Longstreet sent back a terse reply: "General Lee's orders are to attack." Hood sent two more messages with the same request and Longstreet sent back the same

12 Longstreet, OR, 27/2: 358; Alexander, Fighting for the Confederacy, 237; Longstreet, Manassas to Appomattox, 364-365.

13 John Bell Hood, Advance and Retreat, 71; Longstreet, OR, 27/2: 358-360.

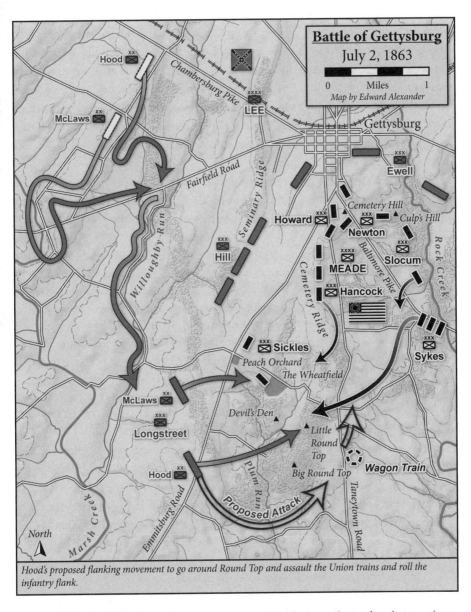

Hood's proposed flanking movement to go around Round Top and assault the Union trains and roll the infantry flank.

answer. Finally, Hood sent a message protesting against the instructions. Longstreet ordered his line to advance and make the assault.[14]

14 John Bell Hood, *Advance and Retreat*, 72-73; Sorrel, *Recollections*, 169. Hood wrote that he believed had he been permitted to turn Round Top Mountain, they would not only have gained that position, but would have finally been able to rout the enemy. This course of action would

As it turned out, Lee reached Longstreet at the same time as a courier from Hood carrying one of his requests rode up. When Longstreet told Lee what the message said, the commanding general rejected the suggestion. Longstreet then rode to meet Hood and told him that the request was denied. Longstreet advised Hood, "A move to the right had been carefully considered by our chief and rejected in favor of his present orders." Hood had to go into action as ordered and Longstreet returned to his location to begin artillery preparation and watch the attacks unfold.[15]

Lieutenant Colonel Fremantle wrote that the attack began sometime around 4:45 p.m., somewhat later than most accounts. Fremantle recalled, "all was profoundly still" up until the moment that Longstreet:

> Commenced a heavy cannonade on the right. Ewell immediately took it up on the left. The enemy replied with at least equal fury, and in a few moments the firing along the whole line was as heavy as it is possible to conceive. A dense smoke arose for six miles; there was little wind to drive it away.... At 5:45 p.m. all became comparatively quiet... but volleys on the right told us that Longstreet's infantry were advancing, and the onward progress of the smoke showed that he was progressing favorably; but about 6:30 p.m. there seemed to be a check, and even a slight retrograde movement. Soon after 7 p.m. General Lee got a report by signal from Longstreet to say 'we are doing well.'"[16]

As Longstreet's artillery batteries pounded Sickles, his divisions began their attack. A lieutenant assigned to Union Brigadier General John Gibbon of Hancock's corps described the scene, "Upon the front and right flank of Sickles came sweeping the infantry of Longstreet and Hill . . . and envelope his flank in the confusion of the conflict." Sickles deployed his corps in a V shape that had its angle located in the Sherfy Peach Orchard. The left portion of the command stretched southeast from that point, through a wheat field, along Houck's Ridge and rested

become a source of endless speculation to this day. See Hood, *Advance and Retreat*, 55-59. Longstreet does not mention Hood's concerns and messages in his OR entry, but does so in *Manassas to Appomattox*, 368.

15 Longstreet, *From Manassas to Appomattox*, 368. Hood contended after the war that going to the right was the correct course of action. Longstreet as well, wrote in 1895: "General Lee should have gone with us to the right." See Hood, *Advance and Retreat*, 55-59. Diagram by the author. Map of Operation Venice, May-June 1942, U. S. Military Academy Department of History. www.dean.usma.edu/history/web03/atlases image is in the public domain.

16 Fremantle, "Diary," 297-298. In Hood's defense, history is replete with examples from every era indicating that turning movements and flanking attacks have been more successful than direct-approach assaults into the strongest areas of defensive lines and fortifications.

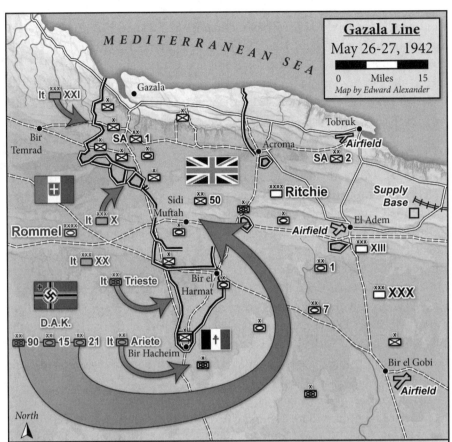

Gazala Line
May 26-27, 1942

0 Miles 15
Map by Edward Alexander

General Hood's idea is similar to General Rommel's plan of a turning movement to make the Gazala Line untenable, prior to his taking of his objective Tobruk. Bir Hacheim, the southernmost British strongpoint, was akin to the Little Round Top. It was well-fortified and proved impossible to take by direct assault. To get at Tobruk, Rommel could either pierce the Gazala Line somewhere or go around it; he chose the latter and was ultimately successful in making the Gazala Line untenable. Bir Hacheim held out much longer than expected, but the defending French Foreign Legion troops were forced to abandon the strong point after German units were around it. Hood's plan was not to drive on another objective (such as Tobruk) in the Union rear, but to attack the parked trains and hit Little Round Top from the flank and rear to roll up the Union left. Critics of Hood's plan have claimed that it could not work due to counterattack. However, Rommel's very similar plan did work in undoing a stout defensive position by turning it. Rommel's forces in the movement also faced British reserves but harnessed the advantage of initiative.

on the rocks known as Devil's Den. McLaws's Division attacked the right or western portion of Sickles's defense, including troops in the Peach Orchard, but ran into difficulty. As his brigades surged forward against heavy Union artillery fire, they met with a determined resistance by III Corps infantry.[17]

17 Frank Haskell, *The Battle of Gettysburg*, (Boston: Mudge Press, 1908), 23-24, 45-46.

Brigades began blocking each other's paths and for short periods blocking the axis of attack. This threatened to retard the momentum of Longstreet's attack. The terrain of the area also affected command and control at the brigade level and turned the attacks into individual unsynchronized brigade efforts instead of a cohesive push by the division. Confusion on the battlefield held up Brigadier General William Barksdale's Brigade, but the Mississippian got his chance to go in once his fellow brigade commanders became fully engaged. McLaws ordered Barksdale forward and Longstreet later wrote, "With glorious bearing he [Barksdale] sprang to his work, overriding obstacles and dangers." Barksdale overran a Union battery in a quick leap forward and got the division momentum going uphill. Anderson's Division to his left, which also had yet to become a factor in the offensive, followed Barksdale's lead and began moving forward as well. Longstreet rode into the fight with Brigadier General William T. Wofford's Brigade, which had been in reserve. He soon joined Barksdale's men and led them into the Peach Orchard, in full view of the enemy. Confederate troops saw him and cheered and shouted to him. Longstreet shouted back: "Cheer less, men, and fight more." McLaws's Division finally overwhelmed Sickles's buckling III Corps in the Wheatfield and the Peach Orchard and pushed ahead into Plum Run Valley. There they met fresh troops of the Union V Corps, arriving from areas around Little Round Top, who pushed them back.[18]

Meanwhile, Hood's troops had advanced up the rocky face past the Devil's Den toward Big Round Top, taking fire from the Devil's Den as they went past it, and then angling left toward Little Round Top. Evander Law's Brigade took fire from a Union battery positioned at Devil's Den. To deal with the threat, Law flexed two regiments to confront them. These two units got in the way of the brigade commanded by Brigadier General Jerome Robertson, who had to file around them, causing confusion and the intermingling of Hood's units. This occurred about twenty minutes into the attack and Hood needed to untangle his brigades to maintain momentum in the *non-permissive terrain*—terrain that is wooded or hilly or otherwise difficult—into which his units had to attack. As Hood sought to regain a measure of control, a shell fragment tore into his arm and knocked him from his horse. Aides carried him to the rear and division command passed to Evander Law.

18 Longstreet, *Manassas to Appomattox*, 370-371; Wert. *Longstreet*, 276; Piston, *Longstreet*, 58. Longstreet's location with McLaws's Division was the wish of Robert E. Lee, who wanted Longstreet to supervise McLaws. This incensed McLaws, who vented against Longstreet in the letter to his wife several days later. See McLaws to wife, "A Series of Terrible Engagements," in *The Civil War: The Third Year*, 338-340.

It took some time for couriers to locate Law and give him the news. In this case, Longstreet recalled, "The well-seasoned troops were not in need of a close guiding hand, at least not at this moment. The battle was on, and they knew how to press its contest contention." In other words, each brigade was decisively engaged, and the fight was in the hands of the capable brigade commanders.[19]

Some historians have criticized Longstreet for not returning to Hood's Division at this point. Once Hood left the field, perhaps Longstreet should have taken charge of the attack, directed the untangling of units, and provided the critical leadership necessary to get them over the summit. It seems Longstreet's battlefield location at this critical time was limited to what Lee wanted, which was for him to supervise McLaws's Division. One modern-era historian contends, "Longstreet himself concentrated on the reduction of the Peach Orchard, which was the keystone of the advanced Federal line and the specific objective to which Lee had directed his attention." Longstreet finally broke this portion of the Union line and drove the defenders back to Cemetery Ridge. The Confederates, however, had too little strength to push the enemy any further. A two-division attack was not adequate. Union reinforcements held their original line through sheer numbers.[20]

After the Confederates captured the Peach Orchard, the center of gravity in McLaws's area became the Wheatfield, an area that exchanged hands six times. This was the bloodiest ground in this battle and was something akin to the Hornet's Nest at Shiloh. It was a battle within a battle and claimed a disproportionate number of lives while stalling the Confederate momentum. Anderson's Division assisted only minimally in support of McLaws for the duration of the four-hour battle. Evidently, Anderson had little understanding of the concept of the operation. In his official report on the events of July 2, Anderson affirmed that his brigades followed the lead of McLaws and that, "They drove the enemy from his first line and possessed themselves of the ridge and of much of the artillery with which it had been crowned; but the situation discovered the enemy in possession of a second line, with artillery upon both our front and flanks. From this position he poured a destructive fire of grape upon our troops . . . the ridge was untenable." Anderson wrote only a paragraph about the entire second day, but for a small piece of writing, it encapsulated succinctly what the men faced. Even though Sickles disobeyed orders in advancing his corps, his mistake of being too far forward resulted in a Union defense in depth. Sickles's III Corps played the role of spoiler

19 Hood, *Advance and Retreat*, 58; Longstreet, *Manassas to Appomattox*, 370-371.

20 Longstreet, *Manassas to Appomattox*, 365-383; Longstreet, *OR*, 27/2: 359.

for the momentum of the Confederate attack on the left. Longstreet's having to reduce Sickles's positions took time and cost the lives of many irreplaceable veteran troops. In addition, McLaws had no chance of breaking a second line of fresh troops. It was that simple.[21]

Hood's Division, now under Law, still made headway. The brigades finally cleared Devil's Den, and then made it to the foot of Little Round Top. They too, however, faced overwhelming Union reinforcements and soon the attack ground to a halt. Meade masterfully practiced the military principle of mass to maintain the integrity of his line. In fact, one of Meade's staff, Brigadier General Gouverneur K. Warren, the Chief Engineer, went over to Little Round Top prior to the Confederate attack. Warren found it devoid of defenders as Hood's troops, visible from the hill, prepared to launch their drive to take the key terrain feature. Warren took the initiative to bring in troops from the V Corps who would keep Little Round Top from falling into the hands of Hood's Division. Unfortunately for Lee, he had overruled Hood's plea to swing around the right. If the Confederates had executed Hood's suggested maneuver to perfection, such a movement might have found the hill unoccupied and thus allowed them to secure this key terrain. Warren deserves credit for getting the Union defenders deployed on Little Round Top and preventing this from happening.[22]

Numerous writings since the war, plus many film and television documentaries, continue to speculate on who should have done what better or who failed to do something that cost the Confederates a victory on July 2. For example, Anderson's Division comes under scrutiny since it entered the fight in a disjointed manner with only three of its five brigades. The implication is that had he thrown in all his brigades at the right time and place, the Confederates would have pierced the Union line and achieved victory. Perhaps, but no such assurance is certain because Anderson did not do this. Moreover, neither Longstreet nor Hill directed him to do so. Ewell's attack on the other end the Union line also comes under criticism. Ewell went into action hours after the action against the Union left had begun. Because of

21 R. H. Anderson, OR, 27/2: 614; Wilcox, OR, 27/2: 618. Wilcox confirmed the same in his report.

22 Alexander, *Fighting for the Confederacy*, 238-244.

the delay, Meade had an opportunity to shift troops to meet Longstreet. In addition, Ewell's attack on Cemetery Hill and Culp's Hill proved unsuccessful.[23]

For every "what if" and "what should have happened," we can only look at the record and the ground and learn from the actual result. The force ratios, the terrain, and the deployments, all combined with the defensive strategy of the Union commanding general, his employment of operational-level mass, and the execution of tactics by subordinates, generated a successful outcome for the Army of the Potomac. Meade built a position the night before that gave him a higher probability of tactical successes along his line. It was the cumulative effects of many tactical events going in favor of the Union that added up to operational dominance over the Confederates. The outcome validated Meade's strategy of defense on the high ground south of Gettysburg.

Lee had ordered Longstreet to attack a stout defensive position at no better than a 1:2 force ratio—in this case 18,000 attacking 32,000. Lee relied primarily on the premise that the élan of his veterans would overcome all the advantages possessed by the Union defenders. Longstreet had to attack without Pickett, meaning his corps went into combat with two-thirds of its organic strength. For Longstreet, Anderson was essentially a non-factor in the fight. Lee gambled that élan was the most important combat multiplier, one that he could rely upon for success. Experienced tacticians know, however, that to be reasonably assured of penetrating a prepared defense even with seasoned troops an attacker needs a force ratio of 3:1, particularly if the position is to be assailed by direct approach. The result of the battle bore this out. Despite some tactical successes by Longstreet's Corps at the Peach Orchard, Wheatfield, and Devil's Den, Meade dominated in the operational realm of this battle. His superior interior lines allowed him to harness the facets of 'balance' and 'forces and functions' by shifting troops quickly from side to side to achieve mass and prevent a rupture of his line. Hence, the tactical successes by Longstreet's Corps against Sickles's III Corps are barely measurable, because Meade's primary line strength stood behind Sickles and outnumbered what Longstreet had in Hood and McLaws.

Later, some would say more cohesive movements by Confederate brigades would have facilitated the powerful divisional efforts necessary to secure the objectives and win the day. Maj. Walter Taylor of Lee's staff recalled after the war:

23 Alexander, *Fighting for the Confederacy*, 241-243; Wert, *Longstreet*, 278. The brigades of Brig. Gens. Mahone and Posey were not committed to the supporting attack on the left of McLaws's Division, an example of unused combat power by the smaller army.

"The whole affair was disjointed. There was an utter absence of accord in the movements of several commands, and no decisive results attended the operations of the second day." Why was this? Much of the terrain was *non-permissive*, making command and control difficult for McLaws, Hood, and Law. The men faced the ordeals that emerge with a loss of command and control. The situation Lee created, by not deciding what he was going to do until 11 a.m., also added to the difficulties in preparing for the attack. The Confederates overlooked many things. They did not execute a leader's rehearsal (i.e., go over the plan with senior commanders, with an opportunity for them to ask questions, make suggestions, and seek clarification), and as changes and modifications came to the front commanders implemented them while on the move. All these elements hampered the execution of the plan. Nevertheless, Longstreet, McLaws, Hood, Law and the brigade commanders managed to land the attacks where Lee wanted them, and they took ground in difficult terrain from a determined defender. This much, élan and strong battlefield leadership was able to achieve. The Confederates overcame some of the initial planning difficulties, until finally Meade's reinforcements stopped them. The true culprit, however, was a lack of strength in the main attack.[24]

It is clear the accusations concocted after the war by Jubal Early and William Pendleton against Longstreet for alleged delaying on July 2 are, as Porter Alexander says in his memoir, are not credible. All the spent time in getting the troops positioned and in the planning is accounted for and reasonable. Lee himself was present on Longstreet's side of the field much of the afternoon. He was fully aware of the work going on and saw that the earliest McLaws and Hood could be ready was 3 p.m. In any case, *strength* was the issue. General Dwight Eisenhower, at one of his visits to the battlefield, quantified the issue and stated that Longstreet, "certainly could not have done it without any strength." Longstreet also recalled "My force was too weak to venture to make an attack" in this part of the Union line. Lee's plan, to make a frontal attack against a strong defensive position with only two divisions had a very low probability of success. Force ratio, not élan, was critical, and "the ground they did take was not worth the terrible cost."[25]

It is clear Lee moved from his role as a strategic thinker to that of a tactician at Gettysburg. Before Fredericksburg, Lee had been with Longstreet at Culpepper

24 Taylor, *Four Years with General Lee*, 99.

25 Alexander, *Fighting for the Confederacy*, 234; Tucker, *Lee and Longstreet at Gettysburg*, 57; Longstreet, "Lee's Right Wing at Gettysburg," *Battles & Leaders*, 3; Longstreet OR 27/2:358; Hessler & Isenberg, *Gettysburg's Peach Orchard*, 41. Eisenhower was also an infantry branch officer.

Court House and issued broad, clear, commander's guidance. He told Longstreet to move his corps to Fredericksburg and set up a defensive position there. Lee did it the right way, expecting his corps commander to select where and how to deploy his divisions and artillery. This Longstreet did, in a manner that won the Battle of Fredericksburg. At Chancellorsville, Lee again gave broad, clear, commander's guidance to Jackson. He told Jackson to move around the left of the Army of the Potomac, find its flank and attack it. Lee acted correctly here as well, expecting his corps commander to select attack positions for his divisions and then execute an attack. In both these battles Lee performed his role as army commander in a superb manner. He stayed out of the tactics and leveraged the considerable abilities of his corps and division-level commanders.

Military men figured out centuries ago that the concepts of rank, organizational structure, and chain of command are all-important in the successful prosecution of war. It takes decades of service to grow a general officer into a competent leader with the right judgement to lead an army. Judgment to know that an army commander, no matter how proficient he was in the ranks he once held as a younger officer, should refrain from interfering in the conduct of tactics by his subordinates. That is no longer his role, and he must understand this to succeed. His role with respect to tactics is limited to selecting the right subordinates and instilling a sense of trust, confidence, and self-sufficiency in them. If a subordinate, after a reasonable amount of time, is still unable to perform the duties of his position, then the commander must replace that individual with a more capable officer. Finding the right men of proper rank and experience to command key leadership positions in the ANV was Lee's job. An army commander must also coach, teach, and mentor, but then step back and allow subordinates to do their jobs. Some writers have claimed that Lee's decision to direct McLaws's Division, for example, "was the best way to do this." Others suggest that Lee's choice to reject the advice of his long-serving infantry branch corps and division commanders regarding a direct assault on the Round Tops, was still a good decision. Yet, one must certainly wonder how Lee could think that attacking in the manner that he directed was sound. There are also those who claim that if Hood had received instructions to outflank the Union position on the Round Tops, his command could have been isolated and destroyed. There is no way of knowing, though we do have the example of success with a similar flank attack when Longstreet moved troops around the Union left at the Wilderness in 1864. There is also the modern example of Rommel's similar attack around Bir Hacheim. Significantly, few argue that the Confederate troops at the Wilderness or Rommel's armor were in danger of isolation and destruction. When such attempts are

successful, success itself generally stifles criticism. The Confederate attack on day two of the battle did not succeed and many aspects of it have been criticized; but the worst decision of the battle was still to come.[26]

26 Bowden & Ward, *Last Chance for Victory*, 252-253, 263, 277-278, n. 119. This book contains varied opinions and speculation on this course of action by people such as Hood, Major General of Volunteers Abner Doubleday, and others. Those who say it would have failed, say so based on the notion Hood would have been descended upon by large numbers of reinforcements sent by Meade. Quite possibly. On the other hand, the side that is attacking has momentum and initiative, which are 'combat multipliers,' in the case of attack against unprepared areas. To this point, General Eisenhower later observed in support of Hood's view, that he could not understand why Lee did not simply order a move around to the right.

The Longstreet-McLaws Estrangement

Lafayette McLaws was a close friend of Longstreet. They were the same age, were both from Georgia, and had been in the same class at West Point. When Longstreet was operating at Suffolk and Lee was forced to fight the Battle of Chancellorsville, McLaws stayed with the army and in Lee's opinion performed poorly during the fighting at Salem Church. From then on, Longstreet had to make an additional effort to keep him in Lee's good graces. Lee wanted Longstreet to supervise his leadership in critical situations, such as the attack on day two at Gettysburg.

McLaws took this 'help' —with a sense that his competence was under question, and that Longstreet was going along with it. Subsequently, McLaws's letter to his wife expressed his frustration over Longstreet's unwanted supervision directed by Lee. Longstreet trusted McLaws, but had to do as Lee directed. This caused the estrangement of these longtime friends.

The tension of this estrangement continued through the end of the war but cooled to some degree afterwards. In June 1873 McLaws wrote Longstreet a refutation about the Sunrise order, and recalled the planning for the second:

"Genl Lee sent for me he was then sitting on a log with a map before him. Genl Longstreet was walking back and forth a few yards off. Genl Lee pointing to the map asked me if I could place my Division in position at a place be designated on the left of the Federal line (their left) I told him I knew nothing to prevent me. Genl Longstreet then came up and remembered, that he wanted my Division in a position pointing to it on the map, which was perpendicular to the one marked by Genl Lee. Genl Lee remarked "No Genl I wish it placed as I have told Genl McLaws" which was parallel to the enemy's line. Genl Lee then remarked that he had ordered a reconnaissance for the purpose of finding out a way to go into position without being seen by the enemy and I must hold myself in readiness to move. I asked permission to go with the reconnoitering party but Genl Longstreet said, "No sir you must stay with your Division."[27]

* * *

Lee's involvement in tactics, such as asking Longstreet to get involved in McLaws's role as division commander, caused resentments. Many writers have assumed, or even declared that Longstreet was irritated by Lee's wanting to take the offense at Gettysburg instead of maneuvering. It is possible that Longstreet was irritated, but it cannot be proven since Lee's, Longstreet's, and other records from 1863 do not confirm this. Also, some of the sources that came long after the war were written for spurious purposes rather than for historical factualness. Corresponding with Union General Ezra Carman in the 1890s, Longstreet advising him on the use of sources wrote: "I beg leave to add that the official accounts [OR's] are the only reliable sources of information of the war and its battles. All accounts of post bellum made should be taken with a grain of salt, and unless supported by other and reliable persons, or by circumstances that justify faith, should be salted away. If you care to compare them with the records you will ben [be] trying to controvert the records when all should be weighed as a judge weighs evidence before the court.[28]

27 Lafayette McLaws letter to James Longstreet, Egypt #4 Central R.R., June 12, 1873, Lafayette McLaws Papers, *Southern Historical Society Papers*, University of North Carolina Special Collections, Chapel Hill, N.C.

28 Longstreet letter to Ezra A. Carmen, Tampa, Florida, February 11, 1897.

Chapter 10

Pickett's Charge: An Artilleryman's Dream

"It was a second Fredericksburg affair, only the wrong way."

— Captain J. J. Young, 26th N. Carolina, July 4, 1863

The casualties to Longstreet's two divisions were heavy. Both were mauled in the course of taking a peach orchard, a wheat field, and an outcropping of ridge rocks. All three locations proved tactically, operationally, and strategically useless. Little Round Top remained in Union hands to anchor the Union left. At no point had the Confederates penetrated Meade's line. Due to his wound, Hood was out of action for weeks and Law commanded his division. In the action on July 2, the effective brigade commander, Barksdale, was killed and several other officers left incapacitated. In order to spur on his troops and get the maximum aggressiveness out of them, Longstreet risked his life in leading an attack. "Everyone deplores that Longstreet will expose himself in such a reckless manner. To-day he led a Georgian regiment in a charge against a battery, hat in hand, and in front of everybody," recalled a soldier under his command. Casualty estimates put Confederate losses at 6,000 of those engaged in Longstreet's attack. This translates to a thirty percent loss in his two divisions engaged. The Union suffered even more with estimates as high as 9,000 casualties.[1]

1 William Parker Snow, *Southern Generals Who They Are, And What They Have Done*, (New York: Charles B. Richardson, 1865), 295; Harry W. Pfanz, *Gettysburg: The Second Day*, (Chapel Hill: University of North Carolina Press, 1987), 429-431; Longstreet, *Manassas to Appomattox*, 386; Coddington, *Gettysburg Campaign*, 442, provides a figure of 16,500 combined casualties for the Second Day, even higher than Pfanz and other historians.

Longstreet thought the painful results of the previous day meant his commanding officer would consent to a flanking movement. After all, the location that Lee chose to contest on July 2 "had been fully tested," although Alexander recollected that Lee informed Longstreet the same evening that they would try again in the morning. Probably a spot to the left of the Peach Orchard. Longstreet sent scouting parties out during the night to see if there was still a way around the Union left and if so a means of threatening the enemy from the rear. In the morning, Lee rode to Longstreet's camp and gave him new orders: a plan to assault the Union line just left of center with Pickett's fresh division and those of McLaws and Hood.[2]

In the early morning of July 3, Lee did not know how many casualties McLaws and Hood had sustained the previous day. Initially he hoped to renew the assault with these divisions, but Longstreet told him they were not able to mount another direct assault against the strong defensive position. Longstreet also informed Lee that these divisions held a mile long section opposite 20,000 Federals who would likely pursue them should they withdraw and redeploy opposite the Union center.[3]

Longstreet again suggested the option of maneuver to outflank the Union left rather than assault the Union line that held a strong position on good ground with the advantage of interior lines. Lee was growing perturbed at having to hear this option once again and he overruled Longstreet. Lee viewed the partial success by Longstreet on the previous day as an indication that a more cohesive attack, one combined with a greater volume of artillery support, would prove sufficient to break the Union defensive line. However, Lee now understood the weakened condition of McLaws and Hood's Divisions and removed them from the order of battle for the planned attack. Their job was to remain where they were and hold the Union left wing in place. For the attack, Lee designated Henry Heth's Division, now under James Pettigrew, Dorsey Pender's Division now under Isaac Trimble, and Cadmus Wilcox's Brigade, all from Hill's Corps. They would join Longstreet's fresh division under George Pickett. Longstreet would again exercise tactical and operational control of the attack force, despite the majority of troops being from Hill's Corps.[4]

2 Longstreet, *Manassas to Appomattox*, 387-386; Alexander, *Fighting for the Confederacy*, 244.

3 Ibid., Longstreet, *Manassas to Appomattox*, 386.

4 Ibid., 386-387; Longstreet, *OR*, 27/2: 359. According to Walter Taylor of Lee's staff, McLaws and Hood should have moved to support the attack on the Union center, "as they were ordered to do by General Lee." Taylor stated that C. S. Venable, another of Lee's staff

After the war, Longstreet claimed that Lee had a Napoleonic bent to him. At times, Lee achieved success with this tendency. His intimidation campaign against McClellan during the Seven Days was a successful example, at least until the costly frontal assault at Malvern Hill. In keeping with this bent, on the third day of Gettysburg, Lee possibly saw similarity to one of the French Emperor's battles. Perhaps combining his bent for aggressive offense with historical example, he endeavored to imitate Napoleon's masterpiece at Wagram.[5]

Pickett's Division arrived on the battlefield just before dawn. Private John Dooley of the 1st Virginia described his commanding general on that day: "As we turned from the main road to the right, Gen. Lee, or better known as Uncle Robert, silent and motionless, awaits our passing by, and anxiously does he gaze upon the only division of his army whose numbers have not been thinned by the terrible fires of Gettysburg. I must confess that the Genl's face does not look as bright as tho' he were certain of success. But yet it is impossible for us to be any otherwise than victorious and we press forward with beating hearts, hundreds of which will throb their last today Now Genls. Lee, Longstreet, and Pickett are advising together and the work of the day is arranged."[6]

Pickett formed his division into two lines. His brigades under Brigadier Generals James L. Kemper and Richard B. Garnett took position in front, with that of Brigadier Lewis Armistead in support. On the right of Pickett was Wilcox and on the left Pettigrew supported by Trimble. The force totaled ten brigades and approximately 15,000 troops. Longstreet believed it would take at least 30,000 men to "do this work." The accepted modern principle is that it takes a 3:1 force ratio advantage for an attacker to be reasonably assured of success in penetrating an enemy defensive line not buttressed by works, but Longstreet was attacking with a

officers, heard Lee give this order. Longstreet maintained that Lee decided these troops "could remain on the defensive line." With no written order by Lee, neither recollection can be verified. See Taylor, *Four Years with General Lee*, 108.

5 Swinton, *Campaigns of the Army of the Potomac*, (New York: Charles Scribner's Sons, 1882), 356. Swinton makes this comparison. But at Wagram, Napoleon split his opponents, resulting in a resounding victory and a favorable armistice. However, Napoleon was more closely matched in numbers to his opponent and the Austrians were much more spread out than Meade was at Gettysburg.

6 John Dooley, *John Dooley, Confederate Soldier His War Journal*, (Georgetown: University Press, 1945), 101-102. Dooley gives a concise but effective description of how his division was decimated by cannon and then rifle fire as it charged. He records firing one volley at the Federals as they closed to thirty yards. Dooley was hit in both thighs by musket fire, and went into captivity, first at Ft. McHenry and later at Johnson's Island in Lake Erie, until he was paroled in a prisoner exchange in early 1865.

barely 1:2 force ratio. Accordingly, the attack stood little chance of success. Union artillerist Henry Hunt made sure that Longstreet's formations would advance into musket range with less even than a 1:2 force ratio.[7]

As noted, Lee was an officer with little practical tactical level infantry experience. He had suffered a costly repulse at Malvern Hill and watched a greater repulse of Union formations at Fredericksburg, both in similar situations. Despite these experiences, Lee still did not grasp the notion of what sort of infantry attack worked, whereas Longstreet did. On July 3, Lee listened to the trepidations of his lieutenant one last time: "General, I have been a soldier all my life. I have been with soldiers engaged in fights by couples, by squads, companies, regiments, divisions, and armies, and should know as well as anyone, what soldiers can do. It is my opinion that no 15,000 men ever arranged for battle can take that position." The infantryman's counsel did not change Lee's mind. The attack was to proceed.[8]

From the Union perspective the charge was an artilleryman's dream, putting "Infantry in the open." Longstreet agreed, and wrote in his OR entry on July 27, 1863: "This distance to be passed over under the fire of the enemy's batteries, and in plain view, seemed too great to insure great results." Lee, however, offered an answer to Longstreet's concerns. He would concentrate as much of his own

7 Swinton, *Campaigns*, 358; Longstreet, *From Manassas to Appomattox*, 386; Longstreet, *OR*, 27/2: 359. The ten brigades were commanded by Mayo, Davis, Lane, Marshall, Fry, Lawrence, Garnett, Kemper, Armistead, and Wilcox.

8 Longstreet, "Lee's Right Wing at Gettysburg," in *Battles and Leaders of the Civil War*, 3: 343; Longstreet, *OR*, 27/2: 359. Lee's great defender, Douglas Southall Freeman, began a great disservice to those who lost their lives in this attack that had no chance of success. In 1935, upon writing volume three of his Lee biography, Freeman aggrandized the general's inept decision to order this suicidal attack by characterizing it as "aggressiveness" and using the phrase: "it seemed a reasonable thing to do in the circumstances." Freeman claimed "Lee never failed to carry a Federal position where he had been able to throw his full strength against it. Only when his assault had been delivered with part of his forces—as at Malvern Hill—had he ever failed." This is also incorrect. At Malvern Hill, the Union army set up a defense in-depth with several lines of infantry and successive belts of artillery. This was a much more deadly position than Freeman understood and one that was not even fully tested. The Union forces repulsed Lee before the defensive belts toward the rear had a chance to engage Confederate troops. The true military reality of the war was that the tactical defense was dominant when infantry attacked in the open, over distance, under enemy artillery fire, and against a resolute defender. If Malvern Hill was a dress rehearsal for Lee's biggest offensive defeat, one must wonder why he did not learn from it and why he attempted a similar assault one year later. See Freeman, *R. E. Lee*, 3: 108-109.

artillery as possible to suppress the Federal artillery and ensure Longstreet's troops could cross the field intact.[9]

Longstreet wrote that, "All of the batteries . . . were put into the best positions for effective fire upon the point of attack and the hill occupied by the enemy's left. Colonel [James B.] Walton, chief of artillery of First Corps, and Colonel Alexander had posted our batteries and agreed with the artillery officers of the other corps upon the signal of the batteries to open." On the surface, Lee's idea of massing artillery to suppress enemy artillery seemed plausible. Yet, the problems existed in the details and the capability of Confederate artillery to accomplish the task.[10]

Modern artillery can adjust and deliver accurate fire in patterns called sheafs. These patterns can be linear, to strike troops in a trench line, or in column, or in irregular shapes. The increased accuracy of massed artillery fire developed with the advent of artillery forward observers and swifter communications. These allowed artillery observers to imbed with infantry and call for fire in support. Grid maps made this possible by using the square kilometer as the standard measure and with each square further divided into tenths. Thus, a forward observer can call target grid coordinates down to a ten-meter increment. The modern forward observer and the grid coordinate system have made fire support a decisive arm.

In attempting to support Pickett's Charge, the Confederate artillery had none of these modern capabilities, nor did they have forward observers. The best the artillery officers could do in 1863 was to try and observe effects on targets from the battery positions. This proved difficult when a target was over one mile away and the view was possibly obstructed by buildings, trees, or smoke hanging in the air. Artillerists had no grid system or computational procedures to make precise adjustments to the guns and apply those adjustments to produce an accurately shaped sheaf and land shot at an exact location. This is not to say that Lee's artillery could not be accurate and have some effect. However, adjustments made to cannon of this period were line-of-sight estimations. Gunners made elevation adjustments by turning a large screw below the rear of the tube and made left and

9 Longstreet, OR 27/2: 359. "Infantry in the open" is the U. S. Army doctrinally correct phrase for a call for fire sent to an artillery fire direction center by a forward observer engaging enemy infantry spotted in open ground. The phrase "an artilleryman's dream" is from a discussion at the Combat Maneuver Training Center, Hohenfels, Germany in 1989. The 4-8 Infantry BN commander LTC Dean W. Cash made the comment that the ideal artillery target was his own branch (i.e., the infantry), to the author (then a 1LT forward observer in the Infantry BN) during the fire support part of a rehearsal. This means that infantry standing up on open ground were fodder for the artillery.

10 Ibid., OR 27/2: 359.

right adjustments by standing behind the piece to aim it like a large rifle. This was strictly trial-and-error and not the result of precise mathematical ballistic computation. Another problem on the third day at Gettysburg was that the Confederate artillery was expected to do two things: suppress the Union artillery and destroy the Union infantry where Longstreet's assault was to break their line. It could not do both with adequate effect. It could not kill or wound enough of the 40,000 Union infantry in Meade's center and knock out enough of the eighty Union cannon in an age when precise predicted fire was not possible. The Confederate artillery could not verify effects of their fire in a timely enough manner to accomplish both.

Since the artillerists could not accurately adjust fire or assess the effect of fire on their targets, the location of the guns was crucial. Longstreet wrote that the batteries, "were put into the best positions for effective fire upon the point of attack." This was not true. Most of the Confederate batteries along Seminary Ridge were positioned at near eighty or ninety-degree angles to the Union infantry directly opposite on Cemetery Ridge. This reduced the possibility of killing and wounding Union infantry positioned in a linear formation behind a wall. Without observers directing the fire, it was less likely the volleys would land precisely on top of the enemy position. Achieving a linear sheaf that could repeatedly hit and attrite some of those units was a low probability. The probability might have been improved by locating most of the artillery to the far right and left of Longstreet's attacking units. Had the Confederates located more batteries behind McLaws's Division and forward of the Emmitsburg road and over in A. P. Hill's Corps area, they might have achieved thirty or forty-degree angles. These better angles might have afforded the artillery some enfilading fire along portions of the Union line and reduced the need for a precise linear sheaf. Another benefit of emplacing most of the artillery at the right and left of the infantry avenue of attack (the perpendicular position) is eliminating the concerns of having advancing infantry in front of the gun line. Additionally, if Confederate advancing infantry was not in the way of the artillery, then firing could have commenced *when the infantry started advancing toward* the Union line. The angle of fire would have been well in front of the infantry and gunners could have sustained the fire until the attackers got close to the Federal line. As it was, the long cannonade signaled to the Union defenders what was coming, long before the Confederate infantry stepped off. It signaled to Meade: start planning to move infantry from other sectors over to the center. Again, these are hypothetical alternatives that the Confederates did not try. Given the inherent limitations of Civil War era artillery the locations chosen for the majority of the batteries were not optimal to support this attack. Better angles of fire were needed

if they were to have a chance at inflicting casualties and breaking the Union infantry sheltered behind the wall.[11]

The Confederate batteries opened fire at 2 p.m. Longstreet wrote that the fire concentrated on the "guns on the hill at the enemy's left," and that those guns were soon silenced. Before the bombardment began, almost 120 Confederate guns were emplaced opposite the center of the Union line. According to Alexander, the guns then attacked targets at about 1,200 yards. They were opposed by approximately 80 guns under the control of Henry Hunt.[12]

While some Union batteries were damaged, Hunt carefully managed his units and offered some counter fire. He slowly moved his batteries back, and soon ceased firing to ensure they would be around to deliver the *coup de grâce* to the Confederate infantry as they came out of their assembly areas. Hunt did not have to suppress the Confederate artillery at all. In fact, he was assuredly happy with Confederate artillery expending so much ammunition. Hunt wanted them to run out of ammunition as soon as possible. Moving batteries back also led the Confederates to believe that the reduced volume of Union artillery fire meant the Rebel guns were having the desired effect.

The command relationship between Hunt and Meade was as it should have been and functioned at a high level of efficiency. Meade trusted Hunt to do his job as the Chief of Artillery. All command and control decisions over the Union artillery in defense of Cemetery Ridge were up to Hunt and Meade did not interfere. Hunt is the one who ordered all movements of the Union batteries, duration of fire, ammunition consumption, and all other aspects. He knew Meade expected him to apply his branch expertise and this he did superbly. History has often applauded him for his work on the third day of Gettysburg.[13]

11 Longstreet, *OR*, 27/2: 359. Artillery preparation in modern doctrine is known as a "fire plan" the object of which is to hit carefully selected target grids by volleys at precise times. Fire plans are closely coordinated and synchronized with maneuver units. See Appendix A for other problems faced by the Confederate artillerists at Gettysburg.

12 Longstreet, *Manassas to Appomattox*, 359-360; Alexander, *Fighting for the Confederacy*, 246, 260. Alexander gives an excellent analysis of Hunt's actions as the senior artillery coordinator for Meade, and correctly points out that Hunt, a brigadier, in the execution of his duties over all the various corps batteries overruled Hancock, a corps commander, in a disagreement over continuation of fire. General John Sedgwick confirmed the artillery of his corps was "under the orders" of the Chief of Artillery of the Army of the Potomac. John Sedgwick, *Correspondences*, (Baltimore: Butternut and Blue, 1999), 139.

13 For Hunt's perspective see Henry J. Hunt, "The Third Day at Gettysburg," in *Battles and Leaders of the Civil War*, 3: 369-385.

On the other side, many writings about Gettysburg criticize Longstreet for directing Alexander to notify Pickett when to commence the infantry attack. One source stated that "Longstreet unhappily seeks to pass the buck," on making a battlefield decision on whether artillery effects were adequate to ensure the infantry could accomplish their mission. This is not in fact inconsistent with how a fire plan works. Artillery fire against certain preparation targets can be used to cue infantry, or maneuver forces, to begin movement toward their objective. The end phase of a fire plan can signal an assault after maneuver. There are many ways the two branches work together to accomplish the mission. One part of this working relationship is placing the responsibility of measuring effects with the tactical commanders. In a world where there were no forward observers to judge effects, the assigned individuals had to get eyes on target. Artillery officers at the battery locations were the closest to the targets, and they had to be able to make the right recommendation. Sometimes fire plans do not work, and it is the artillery officers' task to inform the infantry officers of this. Subsequently, Longstreet sent a note to Alexander: "If the artillery fire does not have the effect to drive off the enemy or greatly demoralize him, so as to make our efforts pretty certain, I would prefer that you should not advise Pickett to make the charge. I shall rely a great deal upon your judgment to determine the matter and expect you to let General Pickett know when the moment offers."[14]

An infantry corps commander giving instructions to his artillery coordinator to make the determination of whether the fire did its job against the target was the correct procedures. It is also perfectly acceptable for the artillery coordinator to tell the tactical commander of the attacking troops when to start moving. If the corps commander directs this arrangement, as Longstreet did, he is placing his confidence in the artillery commander's ability to assess the situation and the impact of his fire. Alexander met with Pickett to notify him that he would provide

14 Stackpole, *They Met at Gettysburg*, 251; Alexander, *Fighting for the Confederacy*, 93. Stackpole served in the US Army and PA National Guard, rising to the rank of Lieutenant General. An author of four books on the Civil War, it is not known why he was not familiar with fire support doctrine and incorrectly wrote in *They Met at Gettysburg* that "Longstreet was passing the buck." Longstreet was not. In Army FM 6-20-1, The Field Artillery Cannon Battalion, Appendix F, Fire Planning Procedures, there is an explanation of how fire support plans are phased and how the command relationships work between the maneuver arm and the artillery. The concept of the Confederate fire support plan of preparation targets was consistent with a modern phased schedule of fire. Typical of Phase I is the attack upon enemy field artillery positions. Phase II is usually artillery attack upon reserves and assembly areas to degrade the enemy's ability to reinforce the defense (this was not part of Day 3 fire support). Phase III is attack upon the defensive areas of the enemy's forward positions that pose an immediate threat to attacking troops.

this information. Alexander then replied to Longstreet, "When our artillery fire is at its best I shall order Gen. Pickett to charge." This is not passing the buck. Those who have claimed this are lacking in fire support education and experience as to how preparation fire can be delivered and coordinated with the maneuver. Longstreet, having designated Alexander as his artillery coordinator, was doctrinally correct. Likewise, he ordered Alexander, "to a point where he could best observe the effect of our fire and to give notice of the most opportune moment for our attack." Also, doctrinally correct today. The artillery coordinator is the best judge of when fire support effects are degrading the enemy infantry positions, and accordingly the decision is his. Unfortunately for Longstreet, Pickett, and Alexander, the fire support plan did not do the job the Confederates had envisioned.[15]

Union Captain Francis Adams Donaldson, of the 118th Pennsylvania, described the situation on the Union side as soldiers "crouched low along the line … I sought shelter from the screaming and exploding shells, to sit and endure this trial of the nerves for at least two hours." In short, the first phase of the preparation was the attack upon Union artillery, and it failed to prevent that artillery enfilading the Confederate infantry advance. Although Hunt's tactics led Alexander to believe the Confederate guns had had some effect on the Union artillery, the Confederate infantry remained vulnerable as they crossed the open ground. The second phase of the preparation was the attack upon the Union infantry, but few Confederate guns participated, and produced no effects. It was certainly a fearful event for the Union infantry during the first phase, who endured enemy ordnance flying overhead. They certainly knew any volley could land directly on their position, even though most of it initially was meant for Union artillery. However, nearly all the Confederate artillery fire, flew over the infantry line and landed in the trains to the rear. Very little touched the Union infantry line, leaving them at full strength and essentially entrenched behind a wall.[16]

After approximately two hours of the cannonade, Alexander realized he could not accurately judge its effect on the enemy. "I could see nothing during the cannonade upon which any safe opinion could be founded," he wrote and insisted that, "the question, whether or not that attack was to be made, must be decided before the cannonade opened." At this point, Alexander probably should have sent word to Pickett apprising him of the situation and advising him to cancel the attack.

15 Alexander, *Fighting for the Confederacy*, 255; Longstreet, OR, 27/2: 360.

16 Francis Adams Donaldson, "This Trial of Nerves," in *The Civil War the Third Year*, 322.

Those were Longstreet's orders. The primary rule for forward observers is having "eyes on target," so as to call accurately for fire and evaluate effects on the target. Alexander was not a forward observer, but he was the designated artillery observer assigned to determine if there were sufficient effects. With little damage sustained by the enemy, and the attack called off, Pickett then would have informed Longstreet and he in turn would have notified Lee. Longstreet would merely cite the failure of the fire support plan as the reason the infantry did not carry out the attack. How Lee would have handled this is open to speculation, but the fire support coordination measures Longstreet put into place on the third day at Gettysburg are considered doctrinally correct control measures in the modern military.[17]

Lee gave no commander's guidance for what to do if the fire support plan had little or no effect on the target. He assumed the plan would work. When it did not, Longstreet faced a dilemma. Should he report to Lee that he had not carried out the orders to execute this attack? He would have to inform Lee of contingency instructions for Alexander to have Pickett cancel the attack if there were no effects on the Union infantry. Longstreet would also have to tell Lee that he put in place a control measure that resulted in cancellation of the attack. This of course did not happen, but it should have. Alexander, despite not being able to gauge the effects of his artillery, gave the word to Pickett to open the attack.

Alexander was unable to assess his bombardment and had just guessed. He did not follow Longstreet's instructions to the letter, which were, "If the artillery fire does not have the effect to drive off the enemy or greatly demoralize him, so as to make our efforts pretty certain, I would prefer that you should not advise Pickett to make the charge." At approximately 1:25 p.m. Alexander wrote to Pickett, "If you are coming at all you must come at once, or I cannot give you proper support, but the enemy's fire hasn't slackened at all. At least 18 guns are still firing from the cemetery hill itself." At 1:35 p.m. he wrote again to Pickett and implored him, "For God's sake come quick. The 18 guns are gone. Come quick or I can't support you." In regard to the comment about the eighteen guns Hunt wrote that this was a "mistaken impression that he [Alexander] had silenced our guns." When Pickett received the first note from Alexander, he rode to Longstreet and showed it to him. Alexander did not say to commence the attack or to cancel the attack. The note left

17 Alexander, *Fighting for the Confederacy*, 255. His second statement is incorrect unless he was implying that the infantry attack should have never been attempted at all. In that case, the statement makes sense. Planning an attack without artillery support is to plan a battle without using all available resources.

Pickett unclear as to what to do. Longstreet read it and made no comment. Pickett then asked, "General, shall I advance?" According to Alexander, Longstreet turned his head away from Pickett and was unable to give the order. Longstreet knew that Alexander did not have any confidence in the results of the artillery fire. Pickett paused, then saluted and said, "I am going forward, Sir." Staff officers who were at the meeting and saw Longstreet's reaction related the encounter to Alexander. Longstreet wrote in 1863 that he rode over to Alexander's location and found he had already advised Pickett that the time had arrived for the attack. Longstreet insisted that he "gave the order to General Pickett to advance to assault." In his memoir, Longstreet noted that his "effort to speak the order failed, and I could only indicate it by an affirmative bow."[18]

From a distance of one mile, the Confederate infantry advanced in plain sight. The Union troops looked on in awe at the display of fine lines and gleam of metal from bayonets atop the Confederates' muskets. The Union artillery kept quiet for a few minutes but once the enemy had come into easy range, it opened fire. Longstreet had ordered the brigades to execute a series of obliques to try and mislead Union artillerists. Perhaps he sought to spare them from some of the pounding they would take if they simply moved in a straight line, but this did little good. There was no cover and Union artillery decimated the Confederates as they advanced.[19]

Still, these veterans of many battles remained calm and determined. They took the punishment and moved forward, dressing their lines each time after the Union artillery ripped into the ranks. Each time, irreplaceable men were killed. Yet, these skilled infantrymen did their duty as Lee expected. In a defensive situation like this, the artillery was the decisive weapon. In the time of Napoleon, when the range of the artillery was shorter, it was often used offensively. Prior to that era, artillery was mostly used statically for a period of nearly 300 years. In offensive use, it would reach out and hit enemy infantry to make holes for their own infantry to exploit. In 1863, artillery could effectively deploy 800 yards from enemy infantry. While

18 Alexander, *Fighting for the Confederacy*, 255-260.; OR 27/2: 360; Longstreet, *Manassas to Appomattox*, 392. Since the memoirs of both Longstreet and Alexander are from memories decades removed from the war, Longstreet's 1863 entry in the *Official Records* is likely the most accurate. If one goes by the report, we know that Longstreet went over to Alexander and was informed that he had already sent word to Pickett to attack. Thus, Alexander had carried out his duty to signal the tactical commander of the attack force when to launch, although he did so without being certain of effects on the enemy infantry. Alexander, from his position with the batteries, made an educated guess about effects, but got it wrong.

19 Longstreet, *Manassas to Appomattox*, 387-396.

beyond canister range it could still fire solid shot that would rip through lines of men. The Union artillery largely disregarded the counter-fire targets of Confederate artillery and set to work on the advancing infantry. When the Confederates got to within 350 yards, the Union artillery changed to canister and over 100 cannon raked Longstreet's formations head on, and in some instances in the flanks.[20]

The Confederates committed approximately 15,000 infantrymen to make this assault, but only about half that number carried the task fully to the Union line. As Union artillery took its toll, Confederate infantry had to contend with three rail fences that slowed their progress and disrupted their formations. These obstacles made it more likely the Union gunners could place several more rounds into the Confederate ranks before they could move again. After Pickett's units crossed the Emmitsburg Road, three Vermont regiments of Brigadier General George J. Stannard's Brigade from II Corps, rushed forward and took a position at a right angle to Pickett's Division. From that position, the Vermonters enfiladed Kemper's men as well as a brigade of support troops under Colonel David Lang and another brigade under Brig. Gen. Cadmus Wilcox. These two had already been severely punished by the artillery. They ceased moving forward and fell back toward the Confederate start position. They were no longer a factor, and thus the attack force thinned even further. The left flank of Pettigrew's Division also suffered a withering flanking fire from an Ohio regiment positioned west of the Emmitsburg Road. The division was decimated even before it came within musket range of the Union main line. Pettigrew's men were repulsed. The flank units of Pickett's Division also collapsed and all that was left of his command were those in the center. These few soldiers still tried to pierce the Union line.[21]

"Our men are falling faster now, for the deadly musket is at work. Volley after volley of crashing musket balls sweep through the line and mow us down like wheat before the scythe," wrote private Dooley of Pickett's Division. The units of the Confederate center closed to within point blank range and gave the Union defenders a volley. Dooley participated in this and wrote: "Thirty more yards Just here—from right to left the remnants of our braves pour in their long-reserved fire; until now no shot had been fired. . . . Shot through both thighs, I fall about 30 yards from the guns . . . while the division sweeps over the Yankee guns but what can our poor remnant of a shattered division do." Only Lewis Armistead's

20 *Combined Arms Operations*, 31-32; Longstreet, OR, 27/2: 360.

21 Longstreet, *Manassas to Appomattox*, 394-401; Longstreet, *OR*, 27/2: 359-360. Of note, Pickett left no OR entry for the battle.

Brigade remained intact enough to make it all the way to the Union center. Longstreet recalled that Armistead, "Put his cap on his sword to guide the storm. The enemy's massing, enveloping numbers held the struggle until the noble Armistead fell beside the wheels of the enemy's battery." Only about 150 men of Armistead's men made it over the wall with him. All were consumed in an overwhelming sea of Union blue. Union batteries rushing to the spot of the breakthrough, raked the Confederates with canister fire. After that, Union infantry wiped out the small Confederate bridgehead that made it a few yards beyond the wall.[22]

Private Dooley and Lieutenant General Longstreet saw the same thing. Dooley saw it at thirty yards and Longstreet from his location well back. Dooley was shot twice and captured. What was left of the Confederate infantry could only deliver a weak blow against a full strength and much larger opponent. The large Confederate wave that the Union troops saw when it emerged from the woods on Seminary Ridge was impressive at that distance, but it melted away as it moved across the field toward the Union lines. Hunt's batteries had done their job as he and his gunners destroyed Pickett's Charge. The entire event was an artilleryman's dream, from the perspective of Hunt and his gunners.

This was Lee's worst decision of the war, and probably the worst order he ever gave. On July 4, 1863, Captain J. J. Young of the 26th North Carolina from Pettigrew's command wrote to North Carolina governor Zebulon Vance. Young confessed that the attack, "Was a second Fredericksburg affair, only the wrong way. We had to charge over a mile and a stone wall in an elevated position." After the war and for over a century and a half, some historians, writers, veterans, and others tried to exonerate Lee regarding his decision. Numerous pundits looked for scapegoats among Lee's lieutenants. A century after the battle, many studied the records and the maps, searching for opportunities lost, in an effort to come up with answers. Some asserted that better decisions made at certain moments by key leaders would have made a difference. There may be some truth in the suggestions of refinements and better decisions. Indeed, had some things been done differently, perhaps more of the attacking infantry would have survived longer. Had the Confederate artillery been deployed differently, as suggested earlier in this work, perhaps the guns would have inflicted damage to the Union infantry. None of these suggestions happened, however, so there is no way to know if they would have made sufficient difference to ensure a successful attack. It is not the job of a

22 Ibid., 267; Dooley, *War Journal*, 106-107; Longstreet, *Manassas to Appomattox*, 394.

historian to try and convince readers that if the Confederates had done something else, they would have won the day. The job of a historian is to explain what happened and it is the job of a military historian to employ military understanding and experience to help explain why events unfolded the way they did. At Gettysburg on July 3, 15,000 infantrymen crossed a mile of open terrain fully exposed to long-range cannon fire and to canister when they got closer. Opposing artillery decimated them so severely they did not have enough combat power to rupture the defensive line. In addition, Meade's defensive position employed a total of 40,000 troops behind the protection of a wall and with good interior lines that allowed reinforcements to bolster almost any spot in the line. For the Confederates, the fire support plan did not achieve its mission to suppress, neutralize, and destroy the defending Union infantry. The supporting attacks by Ewell and Stuart also did not materialize. Lee's plan, one envisioned by a general who was not an expert infantry tactician had a very low probability of success. It truly was an extreme gamble.[23]

Historians who favor Lee may take issue with the assertion that he was not an expert infantry tactician below the division level. He certainly was not one at Gettysburg, and there are notable instances before Gettysburg that indicate his lack of tactical expertise. The question that emerges is how Lee could have command of an army if he was not a tactical genius or at least a better tactician than his subordinates. In the modern United States Army, by virtue of his basic branch and career assignments, Lee would never rise to command a field army of two or three corps. In the decades after the Civil War, the military recognized that generals with long service and experience in combat arms branches must command combat arms divisions, corps, and armies. Even a two-star general engineer branch officer in today's army is not likely to command one of the principal combat arms divisions. Today, it is typically the infantry and armor brigade commanders who are promoted further to eventually command one of these divisions.

In the case of Lee, the Confederacy elevated him to army commander after Johnston was wounded in 1862, because Lee was a capable career soldier who had over thirty years active-duty service in the United States Army. He was well

23 Young, OR, 27/2: 645. Of Pickett's Division, Lafayette Guild, C. S. Army, Medical Director, OR, 27/2: 339 lists its strength was 4,300 men, 232 were KIA (5.4%), 1,157 were wounded (26.9%), and 1,499 were captured or missing (34.9%). In all a 67.2% loss of strength to the division. Stephen Sears, Gettysburg, (Boston: Houghton Mifflin, 2003), 467, puts Pickett's KIA casualty numbers much higher; KIA, 643 wounded, 833 wounded and captured, and 681 captured.

respected as an officer of wisdom and integrity. These were the type of attributes Davis used for his criteria. Lee was thought of as a solid strategist and could effectively communicate with the Davis Administration. He was a leader of men *par excellence*, who possessed a command presence like George Washington's. In this light, Davis believed Lee more qualified for army level command than any other officer who received a commission in the antebellum army. Lee may have been one of the best officers the United States has ever produced, but he was not experienced with infantry tactics below the division level. He never had a chance to practice the tactical arts in that branch at any point in his career.

Lee did not leave Gettysburg immediately on July 4, but Meade did not attack him. Not until July 5 would Lee start the full-scale movement to Virginia. Longstreet did all he could to help Lee bring the army back to safety. In many ways, Longstreet directed the army's steps to safety as the defeat left Lee devastated. In the end, Robert E. Lee accepted complete responsibility, stating, "All this has been my fault."[24]

Politically, Lee's nephew, Fitzhugh Lee, admitted that, "It was a mistake to invade the Northern States at all, because it stirred up their military spirit The invasion was the death blow to what has been called the Copperhead party." The invasion called to arms thousands more men who otherwise would never have enlisted in the Union army. Men, "who became experienced soldiers in '64," re-enlisting to overcome Grant's problem of three-year enlistments running out that year. Fitzhugh Lee may have been right on these political and strategic aspects of the campaign. As such, Confederate reinforcement of armies in the Western Theater, *inside the Confederacy*, would not have reanimated the 'military spirit' Fitzhugh Lee describes that had waned in the North since 1861 because of the cost of the war.[25]

Militarily, the seeds for the defeat at Gettysburg grew from Lee's failure to put together a campaign plan with a precise objective before beginning movement. Selecting an objective improves the maintenance of that objective along the way. A stated objective of Harrisburg and keeping the discipline of 'no decisive

24 Sorrel, *Recollections*, 163-164, Freemantle, *Diary*, 212-215; Wert, *Longstreet*, 292.

25 Fitzhugh Lee to William Jones, March 15, 1877, "Letter from General Fitz Lee," *Southern Historical Society Papers*, 4: 69-76. Fitzhugh Lee also wrote in this piece that since this was really a large raid, in his opinion, it would have been better to send out only small raiding parties to collect cattle and other supplies on Northern soil, rather than use the entire army. Its presence was perceived as a full-fledged invasion that somewhat impaired the Southern argument that they were fighting a defensive war for independence. Also, fighting on northern soil, Fitz Lee said, resulted in the Army of the Potomac "fighting ten times better than it had in Virginia."

Confederate infantry waiting for the end of the artillery preparation. (*Allen C. Redwood, in Battles and Leaders, Vol. 3, 361*)

engagement' with the enemy until reaching the objective, would have made for a much clearer understanding by Lee's subordinates through-out the campaign. It would have aided them when they were confronted with decisions about timing and tempo of operations. It would have helped them understand where not to go and what not to do along the way if and when confronted by a dilemma. All that one can ascertain from the correspondence generated during the planning period is that the Army of Northern Virginia would move into Pennsylvania, steer toward the Susquehanna River, and possibly maneuver toward Baltimore or Philadelphia. This was a broad and open-ended set of activities that lacked precision.

Without a more precise objective, and the implied supporting task of maintenance of the objective, Lee lost the discipline of his own guideline. He even lost sight of *his own directive* that the army must avoid a decisive engagement unless attacked. Continued speculation has focused primarily on the tactical conduct of the battle and often touts alternative tactical actions that could have carried the day. The reality is that the cumulative effects of tactical events favored the Union, and ultimately that is why the Confederates lost the battle. These effects were the result of Lee accepting battle in a place, and under a set of circumstances, that afforded his army no advantages whatsoever. Hence, by the third day he was gambling with a plan that attempted to incorporate a cannonade, a cavalry movement into the rear of the enemy, and a feint by a division of Ewell's Corps. Lee designed these actions to weaken the Union center so that Longstreet's attack would pierce the line. It was complicated, and as stated in an Army Field Manual: "Complex plans have a greater potential to fail in execution, since they often rely on intricate coordination." For the Confederates, none of the separate pieces worked as planned. The fire support did not do its job, the demonstration by Ewell did not materialize, and Union cavalry stopped Stuart's cavalry before it could threaten the rear of Meade's position. In the end, everything rested on the infantry attack against the center, but the supporting actions failed to pull strength away from the Union center and failed

to prevent Hunt's artillery from attriting the Confederate infantry. The attack had no chance of success. Marcus Aurelius, one of Lee's favorite writers, may have summed up the gamble when he wrote, "Desire nothing too eagerly, nor think that all things can be perfectly accomplished according to our own notion." Lee tried to force a win in a situation that probably would not have occurred at all if he had declared an attainable and politically profitable objective before the campaign began.[26]

26 U.S. Army Field Manual FM 6-0, Appendix C, 5 May 2014. Page C-1; Marshall W. Fishwick, *Lee After the War*, (New York: Dodd, Mead, and Company, 1963), 90.

Chapter 11

Chickamauga: The Vindication of Longstreet's Strategic Vision

"Now general, you must beat those people in the West."

— General Robert E. Lee

General Longstreet should not be classified as a defensive or cautious-minded general, as many historians and critics have done. Longstreet understood that the tactical defense was generally dominant in this war, and he believed the victory at Fredericksburg validated this principle. In his view, after Fredericksburg the Confederates had to shape battles designed to inflict disproportionately high casualties on the Union Army. Longstreet also understood, however, that the army must first undertake the defensive to wrest the initiative from the enemy. Once in possession of the initiative, the subsequent freedom of maneuver would provide opportunities to leverage key objectives above the tactical level and dominate in the operational and strategic levels. Longstreet was offensive minded as well but only when an opportunity presented itself.

To Longstreet, offensive actions should be confined to the perimeter of states defended by the Confederacy's principal armies. He knew the Confederates could not only sit behind earthworks. It was not possible to man defensive works, or even dig them, from Mississippi to Virginia. Large-scale positional warfare was hopelessly beyond the manpower capabilities and capacities of the Confederacy. Fighting a strategic defense, however, was possible, particularly at the operational level. At this level the Confederates could harness their defenses successfully, and when feasible follow up with short-term localized superior action against Union

formations. The idea of concentrating against Grant during the Vicksburg Campaign illustrates this concept. It meant creating numerical superiority in a theater against a Union army that had penetrated the perimeter of the nation. "Concentrate, and at the same time, make occasional show of active operations at all points," was one way Longstreet described what the Confederates needed to do in these types of circumstances. Such action was perhaps the only real promise of discouraging the North militarily from continuing their war effort.[1]

Before Gettysburg and Vicksburg, Longstreet's modern vision of interior lines in a defensive-offensive strategy went unheeded. Once Vicksburg fell, and Gen. Johnston deemed the reinforcement of remaining Rebel forces in Grant's vicinity futile, Longstreet's vision became the next logical step.[2]

Following Gettysburg, Meade and Lee engaged in a complicated chess-like contest, the armies maneuvering and posturing and adding names like Bristoe Station and Mine Run to the Civil War pantheon, but there were no major battles involving multiple corps. Longstreet became convinced that now was an opportune time to dispatch troops to Tennessee and shore up Confederate forces in the west for the upcoming fall campaign. The Union Army of the Cumberland under Major General William S. Rosecrans might offer an opportunity for the Confederates to strike with a numerical advantage. Longstreet brought the option to Secretary of War Seddon, and later to Lee. In late August, Lee conferred with President Davis. Some confusion arose over the question of Longstreet replacing Braxton Bragg as commanding general of the Confederate Army of Tennessee (AOT). Davis insisted on keeping Bragg. Nonetheless, the Confederate high command approved Longstreet's suggested strategic movement to the West.[3]

Since the beginning of the war, Bragg had not enjoyed many wins. One good day was his solid work at Perryville, Kentucky, on October 8, 1862. There, he massed his army more cohesively than his opponent, and launched a series of assaults that took enemy ground. At Perryville Bragg proved he could do well at the tactical level. This and earlier battles where he served as a corps commander were linear affairs. That is, the two sides lined up against each other and pushed ahead or gave ground within the parameters of their left and right limits. In April 1862, Bragg's role at Shiloh at the head of a corps under Albert Sydney Johnston, was a

1 Longstreet, *OR*, 29/2: 693-694.

2 Freeman, *Lee's Lieutenants*, 3: 220.

3 Ibid., 222; Longstreet, *OR*, 29/2: 693-694. Neither Longstreet nor Lee had suggested a replacement of Bragg.

prime example. He led his corps in a straight line and simply pushed forward. Shiloh and Perryville had more in common with ancient or medieval battles that depended on multiple units advancing in a seamless manner, with no flanks except at the extreme left and right, rather than battles of maneuver. At Stones River, in late December 1862, Bragg began to maneuver a little more, and thought he had won on the first day. On the second day, however, Federal reinforcements arrived, and Bragg's fortunes were swiftly reversed. Bragg's attempt to coordinate other commands during the Kentucky Campaign suffered from the effects of a divided population. Bragg's environment was tougher than Lee's. Virginia got behind the Confederacy, while divided sentiment in Kentucky contributed to difficulties with unity of command. At one point Bragg was unable to get pro-secession units from Kentucky to join with his army at an opportune time. Many of his letters to Davis illustrated the issue. "The failures of Genl. Breckenridge [Kentucky-born immediate past vice-president of the United States] to carry out his part of my program has seriously embarrassed me, and marred the whole campaign to some extent," he complained to the president. Bragg continued, "I hope we may yet retrieve all that is lost . . . there has been want of cordial cooperation on the part of Genl [Earl] van Dorn since his department merged with mine. He never knows the state of his command and wields it only in fragments." What Davis wrote back was not helpful: "I cannot doubt Kentucky will prove worthy of our love and her own traditions." In November 1862, Bragg lost his home in Louisiana to Union raiders and for a while he was unsure if his wife and family were safe. The considerable challenges in his area of operations, combined with personal anguish over his wife's safety and the loss of his home and possessions, weighed heavily upon the beleaguered general.[4]

Bragg was considered a Mexican War hero after that conflict, but he also had a reputation within the Army as an odd individual. One account described him as "eternally grumpy in life," and another thought him crazy. It seemed that many who served with him thought he was eccentric if not downright strange; distrustful of all his subordinate generals and most of his staff, and unable to create a harmonious command climate. From the difficulties of his personality stemmed functional problems for his army. For example, he did not have a well-organized system of cavalry scouts, such as existed in the Army of Northern Virginia, or as

4 *Papers of Jefferson Davis*, Haskell M. Monroe, James T. McIntosh, Lynda Lasswell Crist, Mary Seaton Dix, and Kenneth H. Williams, ed., 8 vols., (Baton Rouge: Louisiana State University Press, 1995), 8: 416-417, 430, 509-511.

had proved of inestimable service to the Germans in the Franco-Prussian war. Thus, his army's ability to gather intelligence was degraded and this led to missed opportunities and poor situational awareness.[5]

Another problem area, perhaps the result of not having a mentor and cooperative peers in the west, was Bragg's lack of experience in operational maneuver during the first two years of the war. His tactical acumen was probably as sound as that of most professional officers of the time, and the Battle of Stones River showed he could think beyond the rigid confines of linear tactics. The operational realm, however, he was still learning. By 1863, officers like Lee and Grant, as well as some of their lieutenants, were better able to visualize steps ahead, and were proficient with corps maneuver. As the war progressed, this ability became crucial for the high-level commander. Bragg's personal stress along with operating in a theater that suffered from chronic unity of command issues, were bad enough. His lack of operational experience only served to compound his challenges. Under Bragg the Army of Tennessee did not excel—it merely functioned.[6]

Davis knew Bragg was thoroughly challenged by the demands of commanding an entire army. Several officers had warned that Bragg's personality was detrimental to cultivating the command climate necessary for the army to succeed. However, Bragg was an old friend of Davis and the president had appointed him to command. Davis remained loyal to Bragg even though he did not deliver battlefield results that the Confederacy needed. In the fall of 1863, following the fall of Vicksburg and defeat at Gettysburg, the fortunes of war had clearly turned against the Confederacy, and Davis needed a victory. At a conference in Richmond Lee and Davis examined options of an operation against Meade or one against Rosecrans. Events influenced their choice of Rosecrans. On September 2, the Federals occupied Knoxville, Tennessee, and Rosecrans's Army of the Cumberland (AOC) was moving to take Chattanooga. Davis initially thought Lee should preside over a concentration in the West. Lee's first loyalty was to Virginia, however, and he would not abandon the defense of his home state. Instead, he

5 For more detail on Bragg consult Grady McWhiney, *Braxton Bragg and Confederate Defeat, Vol. 1: Field Command,* (New York: Columbia University Press, 1969) and Judith Lee Hallock, *Braxton Bragg and Confederate Defeat,* Vol. 2, (Tuscaloosa, University of Alabama Press, 1991).

6 John Bowers, *Chickamauga and Chattanooga the Battles that Doomed the Confederacy,* (New York: Harper Collins, 1928), 3; Daniel H. Hill, "Chickamauga: The Great Battle of the West," in *Battles and Leaders of the Civil War,* 3: 644.

suggested that his "Old Warhorse" Longstreet should undertake the western operation. This was consistent with Longstreet's views.[7]

In September 1863, the army made use of the Confederacy's interior lines to achieve local and operational superiority prior to initiating an offensive in Georgia. This concept of Longstreet's, to project force between theaters faster than one's opponent, was the same concept that surfaced in future wars. In the Second World War, the side that could build local superiority by using rail and secrecy, created great local advantage. The Germans achieved this in the Ardennes region of Belgium in 1940 and 1944. The Civil War did not have entire fronts as did the First and Second World Wars, but Longstreet achieved an early application of these principles at Chickamauga. The bulk of his corps arrived in Georgia from September 17 through 19. Three additional brigades arrived afterward, too late to see action. Longstreet reached Catoosa Station in Georgia around 2 p.m. on September 19. A train with his horse and some for his staff arrived at 4 p.m. Sometime thereafter, he and his staff officers rode off to find Bragg's headquarters.[8]

By then, Bragg had already crossed Chickamauga Creek and engaged the Union Army in a clear display of emerging operational vision. His objective was to strike the center Union corps, under Major General George H. Thomas, when it was isolated. In fact, most of Thomas's XIV Corps sat in Steven's Gap of Missionary ridge, while his division under Major General James S. Negley was further to the southeast at Davis's Crossroads on Bragg's side of Chickamauga Creek. This meant that in addition to Rosecrans's army being divided, Thomas did not have his full combat strength. One Union private recorded in his dairy, "Our army is scattered over a large scope of the country. If Bragg should fall upon us suddenly, he might whip us in detail." Bragg's army approached Negley along two axes of advance, one from the south-east the other from the east. Thomas would surely come to reinforce Negley, and when he did, Bragg could overpower him and demolish the entire corps. At the very least, Bragg could push Thomas southwest into an area called Lemore's Cove, a place that consisted of non-permissive terrain, that is terrain that makes command and control difficult. Should Bragg's plan work, he would have Thomas in an inferior position, and could interpose the Army of

7 A.L. Long and Marcus J. Wright, *Memoirs of Robert E. Lee: His Military and Personal History, Embracing a Large Amount of Information Hitherto Unpublished*, (New York: J. M. Stoddard and Co., 1886), 268-274.

8 Longstreet, *OR*, 30/2: 287-291.

Tennessee between Thomas and the Union XXI Corps in Chattanooga under Major General Thomas L. Crittenden, thus, splitting Rosecrans's army. Bragg could also cut off Thomas and Major General Alexander M. McCook's XX Corps, located twenty miles to the southwest in Alpine, Georgia, from their logistics base in Chattanooga.[9]

However, Bragg failed to work through the details of his plan and based the attack on limited tactical intelligence. This resulted in several uncoordinated assaults at the tactical level and made the attack less powerful than it could have been. Bragg was able to push the Federals back toward Missionary Ridge, but failed to turn a flank, rupture the Union line, or gain a positional advantage between Thomas and the Union corps at Chattanooga. For Bragg, the offensive of September 19 was a far cry from his more precise handling of the army at Perryville the year before. The Confederate left wing was the most unwieldy portion of the strike. It was a mix of troops from Bragg's army, paroled troops from Mississippi, and three brigades of Longstreet's Corps. Hood and the other division commanders were all equal in rank, thus the wing had no overall commander. This was an example of how Bragg's army was only functioning. It could deliver an uncoordinated push, but not a cohesive and devastating attack. At the end of the day, the Union army had been pushed and had given ground, but it soon united its various components, averting the threat of a single corps being overwhelmed.

Afterward, Bragg held a meeting with corps commander Leonidas Polk and some of his staff to issue instructions for the next morning. He would resume the offensive with an *en echelon* attack from Polk's wing on the right and again try to interpose his army between Rosecrans and Chattanooga. After the meeting, Bragg rested in an ambulance to get a few hours' sleep. He probably thought Longstreet would not arrive until much later and did not send a guide to meet him. As a result, Longstreet and his party bumped into Union pickets on their way to Bragg's camp. The Federal soldiers thought Longstreet's party was a group of Union officers, as the Confederate uniforms did not appear gray in the darkness. They exchanged a few words without incident and then Longstreet and his men backed away, pretending they were simply in the wrong location. Longstreet found Bragg around 11 p.m. and the generals conferred for an hour. Bragg gave Longstreet a map of the area and told him to take command of the left wing. Bragg's plan of action was a continuation of the *en echelon* attack against the Union army, starting from the right

9 Martin P. Mullin ed., *Memoir of a Soldier: Diary of Benjamin Taylor Smith*, (Bloomington, IN: 1st Book Publishers, 1999), 58.

at sunrise. The left wing would then join in the push in sequence. After the meeting, Longstreet stayed at Bragg's camp to get a few hours' sleep by the fire, then rode to the left wing to sort out the situation and ready the men for battle.[10]

When Longstreet got to his position, he found four western divisions arranged in a row. Their right flank was not tied in with the left flank of Polk's wing. These four divisions were, from left to right, under Major Generals William Preston and Thomas C. Hindman, Brigadier General Bushrod R. Johnson, and Major General Alexander P. Stewart. Three brigades of McLaws's Division took a position behind these westerners near the Brock House. Hood was in charge of these brigades as their divisional commander McLaws had not yet arrived. Two more brigades reached the area around the same time as Longstreet's train arrived. These brigades, under Brigadier Generals Joseph Kershaw and Benjamin Humphreys, marched from Catoosa Station to take their place in the assembly area and report to Hood. Five brigades in all from Virginia were available for the action on September 20, an *ad hoc* division, or 'division plus,' in modern military terminology.[11]

Longstreet reported: "I set to work to have the line adjusted by closing to the right to occupy some vacant ground between the two wings and to make room for Hood in the front line. The divisions were ordered to form with two brigades in front, and one supporting where there were but three brigades, and two supporting where there were more. Hood was ordered to take the brigades of Kershaw and Humphreys and use them as supports for his division, thus making his division the main column of attack. Before these arrangements were complete the attack was made by our right wing about 10 o'clock."[12]

Longstreet's 'Schwerpunkt'

The German army pioneered the single most revolutionary aspect of tank warfare in the 1930s and Second World War, which became known as 'Blitzkrieg'. German tacticians based their new doctrine on the 'Schwerpunkt,' the center of gravity or crucial point of the enemy's line, which would become the target of the main weight of an assault. While these concepts first emerged in the nineteenth century, the German military developed them at the end of the First World War

10 Longstreet, *Manassas to Appomattox*, 439; Longstreet, OR, 30/2: 287-289; Bragg, OR, 30/2: 33.

11 Longstreet, *Manassas to Appomattox,* 439; Longstreet OR 30/2., 288.

12 Longstreet, OR, 30/2: 288.

when planning their great offensive of 1918. Germany had just knocked Russia out of the war, and thus could plan an offensive on the Western Front with the troops freed up from duty in the east. They hoped to break the four-year deadlock of trench warfare against the British and French before the arrival of the Americans would tip the scales. Creating and training special storm troop battalions, the Germans dubbed the method by which they would win against the trenches as 'infiltration tactics.' These storm troops would hurriedly close with the enemy trench line, aided simultaneously by artillery smoke shells in no-man's land, as well as by artillery high explosive shell fire directed at the enemy trenches. The Germans thus designed their fire support to obscure their own infantry and suppress that of the enemy. This would allow the storm troops to reach the trench line at near full strength. The storm troops would clear only a narrow section of trench line in front of them, then move into the rear areas of their opponent to create as much havoc as possible. Next, the main body of German infantry would come across and exploit the gaps. They too would drive into the rear and reach open ground, thus restoring the war of movement in the West. The concept was to apply overwhelming mass against a narrow front and avoid decisively engaging other sections of enemy trench line. By doing this, the Germans hoped to compel enemy units in other sectors of the trench line to retreat as soon as they realized a mass of enemy troops was driving into their rear areas. This gave the outnumbered German army numerical superiority at the key points. It worked for the Germans in the spring of 1918, and for a short period they got past the trenches and were on their way to Paris. This was their last chance to win the war. Unfortunately for the Germans, they were stopped before they reached the city. In time, Germany lost the war, but the tactics were correct and not forgotten. The professional German officers at the company grade later became colonels and generals in the 1930s and took infiltration tactics to the next level. These officers incorporated the use of the tank, half-track, dive-bomber, artillery fire support, and radio. Men like Generals Heinz Guderian and Erich von Manstein modernized the infiltration tactics, but the basic idea of how to rupture the line remained true to what it was in 1918, overwhelming mass at the critical point, the Schwerpunkt.[13]

13 This explanation is based on the author's professional military schooling, training experiences in Europe 1988-95, and participation in combat during Desert Storm in 1991. In this war, the American-led coalition employed a massive armored Schwerpunkt against the Iraqi Army that was quite similar to offensives of this scale in the Second World War. Two good sources that discuss the development of these concepts are Heinz Guderian, *Panzer Leader*, (Washington DC: Zenger Publishing Co., 1952), and Erich von Manstein, *Lost Victories:*

Longstreet certainly did not create the idea of the Schwerpunkt. The word was not common usage in any army at the time of the Civil War and there is no direct connection between the German thinkers of the future and Longstreet's work in the 1860s. However, to a trained modern combat arms officer of the 21st Century it is clear that what Longstreet did at Chickamauga was a vast improvement of the corps or wing-sized attack. Additionally, the attack formation he used on September 20, 1863, was indeed a Schwerpunkt of the modern style. Longstreet's attack was narrow, it used a powerful attacker to defender force ratio advantage, and it was aimed at objectives at a distance—the gaps in Missionary Ridge.

Some historians argue that Longstreet did not plan this attack formation, that the unit deployment within the formation were happenstance. That Longstreet merely accepted the arrangement of Johnson's division as the lead of the Schwerpunkt with Hood following because the intended arrangements for him to lead the way were not complete when word came down to begin the attack. Other historians claim that the records do not prove Longstreet was trying to plan a grand-division style attack. It is true that the records do not mention the word 'grand-division' but claims that this formation was accidental or happenstance overlook any number of things.[14]

These voices take Longstreet's official report at face value. Longstreet did report that he had intended to make room for Hood in the front, Kershaw and Humphreys were to support Hood, and movement was going on when he attacked. The fact is, however, that he did not put Hood's Division in the row with the other four divisions, which some historians believe was accidental. What all the reports from Longstreet's subordinates reveal, however, is that the arrangements were all complete shortly after sunrise, and by late morning there were no units still moving. So why did Longstreet write what he did in his report? He did so primarily because his audience was Bragg and not future historians.[15]

The War Memoirs of Hitler's Most Brilliant General, (Chicago: Regenery Press, 1958). Columns of this type had appeared in warfare throughout history, but credit in any war that is stuck in a status quo, goes to those who can change the methods in a timely enough manner to change the overall military situation.

14 William Glenn Robertson, "Bull of the Woods?" in Stephen W. Woodworth, ed., *The Chickamauga Campaign,* (Carbondale: Southern Illinois University Press. 2010), 116.

15 Longstreet, *OR,* 30/2: 288. Reports from subordinates belie Longstreet's sentence that units were still in motion. See *OR,* 30/2: 279-280, 451-467, 471-479, 494-496, 499-501, 502-506, 509-512, 517-519.

One of the jobs of a historian is to evaluate texts, discuss what the historical figure wrote, and explain the context in which they wrote it. Longstreet wrote this report one month after the battle, when Bragg was busy with recriminations against several of the general officers for failing to carry out his orders at Chickamauga. Longstreet was not on good terms with Bragg. He was not, however, part of the chain of command in the Army of Tennessee, and thus Bragg had no administrative authority over him. Longstreet belonged to Robert E. Lee. His First Corps was organic to the Army of Northern Virginia no matter where it was located. Longstreet's Corps was, in modern terms, under Operational Control of Bragg. He took his mission orders from Bragg and his corps received logistical support from the Army of Tennessee. If Bragg had a complaint about Longstreet, he would have to follow protocol and take the problem to Lee. Thus, when Longstreet wrote his report, it is entirely possible that he decided to state his intention of lining up every division in a row at sunrise for an *en echelon* attack, just as Bragg had ordered the night before. He may have done this to avoid any further difficulties in the relationship with Bragg. However, circumstances on the morning of September 20 forced Longstreet to come up with something else rather than follow a plan that had evidently miscarried.

At sunrise on the third day of battle Polk's attack did not start at dawn, as Bragg had ordered. That morning Bragg heard nothing but silence from Polk's line and he raced to the right wing to find out why. He discovered soldiers just waking up and preparing breakfast. Bragg found Polk also having breakfast. Polk had apparently sent the attack orders to his subordinates, but he did not complete the second part of a commander's responsibility, which is to make sure orders are received and understood. In fact, corps commander D. H. Hill at the far right did not receive the orders. Bragg was outraged and had to personally get the right wing moving. He ordered the divisions on the far right to attack at once. The right wing finally did get underway, but long after it should have started. The tardy attacks against the line provided extra time and daylight for Union troops to improve their position. Consequently, they checked the Confederates. Union troops had entrenched and cut and placed logs for cover, and in doing so made the Confederate task that much more difficult. Once again, the spade and ax helped the defender thwart an attacker.[16]

16 Bragg, *OR*, 30/2: 33-34; Hill, "Chickamauga," in *Battles and Leaders*, 3: 653. Also see W. M. Polk, "General Polk at Chickamauga," 662-663 in Ibid.

From his location, Longstreet also heard the silence, and realized that Bragg's plan had failed. It was not until around 10 a.m. that Longstreet heard the first sounds of fire. At that point, the right wing tried to break the enemy left and the Confederates put all they had into the assaults. This cohesiveness came too late to overcome the resolute Union defenders. The right wing could not make headway and an exasperated Bragg abandoned the *en echelon* approach, instead issuing orders for all his division commanders to attack. He sent a staff officer to ride along the right wing and ensure they carried out the order for a general assault.[17]

It seems clear from Longstreet's postwar writings, and from the reports of his subordinates at Chickamauga, that after he issued orders for Stewart to move to the right and close up on Polk he changed his mind. Longstreet decided not to put Hood's *ad hoc* division up front with the others, but rather to leave it behind the provisional three-brigade division of Bushrod Johnson. In his book From *Manassas to Appomattox*, Longstreet reveals that at 11 a.m. he also sent a note to Bragg stating, "My column could probably break the enemy's line if you cared to have it go in." From this evidence, and the deployment of his wing, it is clear Longstreet had abandoned the *en echelon* deployment scheme. The late start rendered the plan impractical, and Longstreet realized his wing must now function as the main attack. This required mass at some point, and not a row of divisions two brigades deep. Hence, Longstreet intended a column of powerful mass and directed Hood to combine the *ad hoc* division and Johnson's for the task. Longstreet decided this shortly after 7 a.m. The *ad hoc* division and Johnson's were already set where they were. Except for the 9 a.m. and 10 a.m. closing up at the rear of Kershaw and Humphreys's Brigades, most units sat still for four hours.[18]

The subordinate officers' reports in the first through fourth echelons confirm this. They were in place by 7 a.m. and none mentioned additional movements to rearrange divisions or brigades. Stewart met with Longstreet before dawn and advised him that there were no troops to the right "within half a mile." Longstreet directed Stewart to shift about "a quarter of a mile in that direction," and he complied. Stewart reported, "Wood's Brigade, of [Major General Patrick] Cleburne's Division was formed on the right and in prolongation of [Brigadier General John C.] Brown's . . . about 9 am." Bushrod Johnson, who was to Stewart's left, reported that his line "was formed by 7 am with [Brigadier General Evander] McNair's brigade on the right, Johnson's brigade in the center . . . [Colonel Cyrus]

17 Bowers, *Chickamauga and Chattanooga*, 108-109; Bragg, *OR*, 30/2: 33.

18 Longstreet, *From Manassas to Appomattox*, 445, 447.

Sugg formed a second line." Sugg concurred with the description of this alignment and confirmed that the division advanced around 11 a.m. Brig. Gen. Jerome B. Robertson's Brigade, one of the three from the ANV that fought on September 19, was in the fourth echelon of the column. Robertson noted: "At daylight on the morning of the 20th, we were moved by the right flank to our position, where we remained until about 11 o'clock, when we were ordered to move forward in the rear of Brigadier General Evander Law's brigade." Brigadier General Henry L. Benning's Brigade, also from Lee's army, had likewise seen action on September 19. Benning was to the right of Robertson and reported, "The brigade was in line a little to the right of the place where it had fought the day before, and a short distance in the rear of Law's brigade. At about 12 pm I was ordered to follow and support that brigade at a distance of from 300 to 400 yards." The last two brigades, under Kershaw and Humphreys, arrived during the night. Humphreys stated his brigade reached the Alexander Bridge at 2 a.m. and took a position parallel to Kershaw around 10 a.m. Humphreys was no more than a few hundred yards back, and thus in the morning the men required only a few moments to move up next to Kershaw.[19]

Although Hood was wounded during the battle, and unable to submit a report, Longstreet contacted him after the war, and asked him to write accounts for both Gettysburg and Chickamauga. His Gettysburg account took the form of a private letter to Longstreet, but Hood added an account of Chickamauga in his book *Advance and Retreat*. In 1875, he wrote: "the next morning, when I had arranged my column for the attack and was awaiting the signal on the right to advance, [Longstreet] rode up, and joined me. He inquired concerning the formation of my lines, the spirit of our troops, and the effect produced upon the enemy by our assault He was the first general I had met since my arrival who talked of victory." According to Hood, Longstreet placed him in "in command of five divisions: Kershaw's, A. P. Stewart's, Bushrod Johnson's, and Hindman's together with my own." In Hood's recollection, Longstreet wanted him to function as the

19 All the subordinates' reports cited here are in *OR*, 30/2: 279-280, 451-467, 471-479, 494-496, 499-506, 509-512, 517-519. All the Virginia troops remained in their assembly area behind Johnson from 7 a.m. until they moved forward at 11 a.m. Brig. Gen. Evander McNair who led one of Johnson's brigades in the first echelon, was wounded in the battle and did not leave a report.

tactical commander while Longstreet worked as the wing commander and would retain Preston's Division to commit if needed.[20]

After the war, in an exchange of letters with Edward Porter Alexander, Longstreet articulated more perspective: "With a column of say four or five brigades, if the first and second are broken or dispersed by the assault, the third, in turn finds itself in full strength and force, and near enough the enemies line to break them. The force is strong enough in itself to give confidence as long as it is in order." From this, one may surmise that since assaults across a wide front had often proven costly failures during the war Longstreet decided to take a new approach in an effort to overcome a defensive line. He knew that the advantage of force ratios made the difference. It was from these considerations that he refined the tactics at Chickamauga.[21]

In the case of using a massed column in a wooded environment, Longstreet also considered a terrain feature as a guide. Historian John Bowers maintains that in the early morning hours, when Longstreet rode to the left wing, he was "on the scent of any loyal Southerners who could furnish intelligence." Private Tom Brotherton was a Georgian, and as luck would have it, he was from the farm just a few hundred yards in front of Longstreet's divisions. Longstreet asked Brotherton about the local terrain and if any trails ran through the Union line and into the open areas beyond. Brotherton told him about a cow path running past his farm and through the woods to the pastures on the other side. Longstreet decided to use this trail as a control measure for some units to follow to get to these pastures. Once there, he had easy terrain on which to advance his Schwerpunkt, and an avenue of approach into the rear of the other Union wing. Perhaps his column could even reach the gaps in Missionary Ridge, closing the door on the retreat routes for the enemy army.[22]

Thus, in Longstreet's wing the units waited for four hours before receiving word of what had transpired on the right. As the right-wing divisions advanced, word finally came via Stewart that it was time to strike. The time was 11 a.m. and

20 Hood, *Advance and Retreat*, 63-64. There are some inaccurate recollections in Hood's 1875 account. He recalled that the attack began at 9 a.m., while others, Longstreet included, said it was 11 a.m. in their reports and other documents. Hood also says of his own division: "The latter formed the center of my line, Hindman on his left and Johnson and Stewart on the right."

21 Longstreet to Alexander, June 17, 1869, in Alexander Papers, University of North Carolina.

22 Bowers, *Chickamauga and Chattanooga*, 118-119; Longstreet, *OR*, 30/2. 228. Control Measures are usually depicted on maps and graphics. Some basic ones are unit boundaries and graphically depicted limitation lines, such as "no fire areas" for the fire support.

Longstreet had just sent a note to Bragg. Longstreet then gave the nod to Hood who ordered Johnson to advance. The two lead brigades of Johnson's Division stepped off first, and once they had moved out a short distance the next echelon went into action. Hood's brigades then moved forward and finally all five echelons of eight brigades in the Schwerpunkt were in motion. Like a tank division, with its brigades parked nose to tail tightly in the Ardennes Forest in 1940, they uncoiled. The left-center of the Army of the Cumberland had no idea what was coming. Sixteen thousand men attacking along a narrow front was unlike anything they had seen before. As one Confederate veteran put it, "Longstreet had been carefully preparing. Stewart's, Hood's, Kershaw's, Johnson's, and Hindman's divisions dashed impetuously forward, supported by Preston."[23]

Like the formations of this type that worked in the Second World War, the spearhead brigades of Johnson's divisions enjoyed success. They mopped up the 100th Illinois picket line and raced forward, leaving the Union brigades to the left and right alone. The 100th Illinois had begun to probe forward before Longstreet gave the word to attack. A small clash occurred in the woods with the advancing Confederate brigades, and the Federals fell back in haste. Surprisingly, the Confederates met little resistance when they came out of the woods near the Brotherton house. Had there been a full Union brigade covering the Brotherton field, they would have opened fire. Yet the Confederates saw nothing more than Union pickets running for their lives. The pickets had no support behind them and Johnson's Division "swept forward with great force and rapidity." A four-gun Confederate battery came onto the Brotherton field, unlimbered, and put their guns at the ready. The lead infantry brigades of Johnson's Division swiftly passed through the batteries. The infantry needed no artillery support for the moment and kept advancing. The guns promptly limbered up and they too moved ahead.[24]

It was not Longstreet or Hood who found a gap in the Union line. Rather, it was Bushrod Johnson. As the Federals to his front fled, the kindhearted Johnson checked on the wounded commanding officer of the 100th Illinois and ordered the man removed to his division surgeon behind Confederate lines. Then, as Johnson walked past the Brotherton cabin, he realized something was amiss on the Union side. There was no enemy line of any kind to his front and his division was evidently

23 Archer Anderson, *The Campaign and Battle of Chickamauga: An Address Delivered Before the Virginia Division of the Army of Northern Virginia*, (Richmond: William, Ellis, Jones, Steam, Book, and Job Printer, 1881), 37.

24 Johnson, *OR*, 30/2: 457.

unopposed. The advance would be uncontested. Unbeknownst to the Confederates, Rosecrans had ordered Brigadier General Thomas J. Wood's Division to shift to the Union left. This occurred as the Confederates launched their attack, and thus they poured into a 400-yard-wide gap to the left-center of Rosecrans's army. Johnson ordered his lead two brigades to pick up the pace and they started running forward. Once Johnson and his first echelon came onto the Dyer field, Hood rode up and told him, "Go ahead, and keep ahead of everything."[25]

It is the mass of tanks that "must be on the spot," wrote German General Heinz Guderian in his book *Panzer Leader*. The deeper into enemy ground they drove, the more damage they inflicted as they gained advantageous positions that became increasingly difficult for the defender to contest. Likewise, Johnson's brigades drove over a mile into the Union position with the entire battering ram formation following. Union units on the flanks of the column fired at the swelling mass of Confederate troops, but the sheer number of men and the momentum of the Schwerpunkt rendered it unstoppable. The excitement for Johnson was like nothing he had experienced in the war. He was a Yankee from Ohio, a Quaker, and an abolitionist who had tried to make a career in the U. S. Army but was compelled to resign in 1848 after an incident concerning an army contract. He was living in Tennessee at the outbreak of the war and joined the Confederate Army. He often struggled with bad luck in his military assignments, and yet it seemed that on this day fortune had smiled upon him. He was in the right place at the right time and reacted accordingly with smooth professionalism. Johnson detected the error on the Union side and ordered his three brigades forward without hesitation. He vividly described: "The resolute and impetuous charge, the rush of our heavy columns sweeping out from shadow of the gloom of the forest into the open fields flooded with sunlight, the onward dash of artillery and mounted men, the retreat of the foe—made up a battle scene of unsurpassed grandeur." Once his lead two brigades came onto the Dyer property, the Union right wing began to collapse.[26]

The Schwerpunkt Longstreet adopted and employed at Chickamauga was probably the brainchild of his experience on the third day at Gettysburg. That

25 Johnson, *OR*, 30/2: 456-458. Johnson noted they took the head-wounded Colonel F. A. Bartleson of the 100th Illinois prisoner at the fences and outhouses of the Brotherton farm. He recuperated in Confederate hands and was exchanged.

26 Guderian, *Panzer Leader*, 46; Charles M. Cummings, *Yankee Quaker, Confederate General: The Curious Career of Bushrod Rust Johnson*, (Rutherford, NJ: Farleigh Dickinson University Press, 1971), 261. See chapters 1-6 for his life before the war.

repulse provided the spur to avoid the conventional way leaders of his time typically deployed for an attack. Additionally, Longstreet and Lee were in the habit of reviewing their earlier actions to identfy improvements. These influences likely led Longstreet to design the column he sent forward at Chickamauga. Whether this arrangement of a narrow front would have worked at Gettysburg is not knowable. It remains a fact, however, that the disadvantages of having to cross a long stretch of open ground with a wide front against prepared artillery did not work at Gettysburg. At Chickamauga, Longstreet's troops moved on a narrow front. Once they emerged from their concealment in the woods, they were exposed and in the open for less than 100 yards. If they had come under artillery fire it would have been for a short duration. As a result, Longstreet's innovation worked well at Chickamauga. In this overlapping of Napoleonic and Industrial Age war, the transition from costly tactical engagements to creating and exploiting opportunity became the coin of the realm in land warfare. As Longstreet theorized, the "mutations of war" required newer ways of breaking enemy formations tactically and producing operational opportunities. This was exactly the problem the Germans had to tackle in 1918 in the circumstances of their war.[27]

In modern war, military planners consider attacker to defender force ratios. Longstreet's Schwerpunkt consisted of eight brigades from two divisions under close supervision by one tactical commander. Planners today, and in the Second World War, concluded that a 3:1 force ratio was necessary in order to be reasonably assured of penetrating an enemy line. Longstreet expected a single Union division to oppose his attack with two brigades to the front and two more behind. To achieve a 3:1 advantage Longstreet would need six brigades to attack that division front. Upon the arrival of Kershaw and Humphreys, he added them to the attacking column for a total of eight brigades. Hence on the morning of September 20, once he knew he had to disregard the *en echelon* scheme and go with a column, Longstreet devised an attacker to defender force ratio of 4:1. When Wood received orders to pull his command from their position, the ratio became 8:1 and the attackers easily swept the one remaining Union brigade from their path. It was a masterpiece that would show up in land warfare in the future.

27 Discussion with William Garrett Piston, Professor of History, Missouri State University, February 2010; Longstreet, *Manassas to Appomattox*, 158. One of the points Longstreet made in his memoir was that this war was highly transitional.

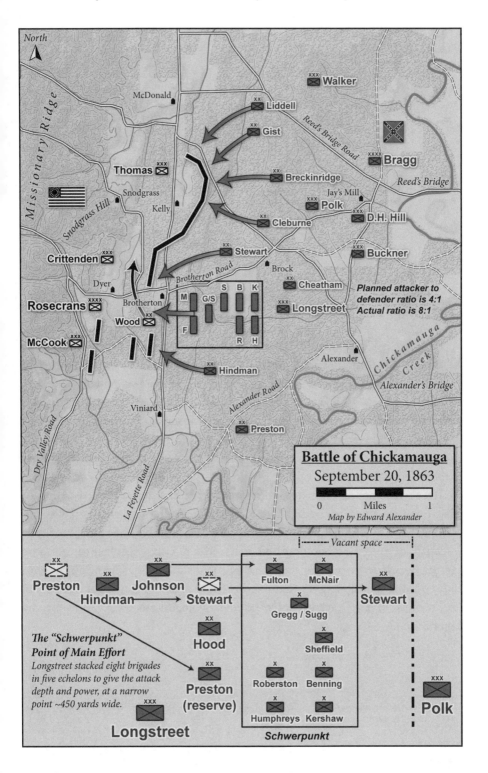

Battle of Chickamauga
September 20, 1863

0 Miles 1
Map by Edward Alexander

Planned attacker to defender ratio is 4:1 Actual ratio is 8:1

Vacant space

Preston Johnson Stewart

Hindman ——→ Stewart

Fulton McNair

Gregg / Sugg

Sheffield

Roberston Benning

Humphreys Kershaw

The "Schwerpunkt" Point of Main Effort
Longstreet stacked eight brigades in five echelons to give the attack depth and power, at a narrow point ~450 yards wide.

Hood

Preston (reserve)

Longstreet

Schwerpunkt

Polk

Chapter 12

Hammer of the Confederacy

"The first general I had met since my arrival who talked victory."

— Hood, describing Longstreet at Chickamauga, 1863

With minimal planning time, Longstreet had orchestrated a masterstroke on a scale like none yet executed in the war. This one was more powerful in terms of formations, and yet more surgical than his work at Second Manassas and Gettysburg, or Jackson's work at Chancellorsville. Longstreet's modification offered a narrow attack front and shortened the distance in the open that his men had to cover. The improvements of scale, tactical control, and discipline at Chickamauga, prove Longstreet as much a master of the offense as the defense.

This was a tactical offense within a strategic defense and a prime example of what Longstreet had advocated as a means of defeating the enemy. It was not essential for the Confederacy to seek offensive battles on Northern soil, but it was essential not to lose on Southern soil. By late 1863, Longstreet had gained more campaign experience and he sought to add innovation to his art. Chickamauga allowed for an initial tactical offense followed by operational maneuver; one that might allow him to create conditions that would destroy the Army of the Cumberland.[1]

1 For an examination of the details of the fighting at Chickamauga consult Tucker, *Chickamauga: Bloody Battle in the West.*

Actions Post-Breakthrough

The hours after the tactical breakthrough at Chickamauga provided the window of opportunity that Longstreet needed to execute "the next step." Just as modern mechanized units use narrow assaults to penetrate an enemy line, Longstreet developed new options when his Schwerpunkt formation passed through the Union line and avoided significant engagements at the shoulders. Moving into the rear area of the Union line would shape new opportunities for the right wing of Bragg's army. Bragg had a chance to coordinate the right wing and use it to fix the Union left wing in position. He could reinforce Longstreet's wing or have Polk attack toward McFarland Gap to close Thomas's escape route. Even if the Confederates did not defeat the Army of the Cumberland on the day of the breakthrough, Bragg would bolster his combat power when the balance of reinforcements from Virginia arrived. At that time, he could press the initiative with fresh troops and Longstreet would tighten the noose.

At the operational level, Bragg had Major General Joseph Wheeler's cavalry corps and mounted infantry under Brigadier General Nathan Bedford Forrest at his disposal. These units could reach out behind Thomas. By nightfall on September 20 Wheeler halted at Carlisle Springs, three miles south of Longstreet. His entire force was fresh and available to cover the road network west of Thomas without any opposition. While no Civil War commander had yet used cavalry to exploit significant ground success, many had used cavalry to create useful blocking positions. The results of the action on September 20 offered many opportunities for cavalry to close certain doors in Missionary Ridge and even threaten Chattanooga itself, especially against the disorganized Union troops.[2]

In fact, at no other time in the Civil War did any Confederate Army commander have as much mounted combat power as did Bragg at Chickamauga. Even the Army of Northern Virginia at its highest level of cavalry force structure, in the summer of 1863, did not exceed the Army of Tennessee's mounted strength. Bragg had six cavalry brigades, plus a horse artillery brigade for a total of approximately 9,500 effectives. The aggregate strength of Confederate cavalry at Chickamauga was over 11,000 or nearly one-fifth of Bragg's entire army. There were eight brigades under Wheeler and Forrest, one-half of Brigadier General

2 Wheeler's position, *Map of the Battlefield of Chickamauga*, from the official reports and maps of both contending armies. Complied and drawn by Edward E. Betts, Map #4 of 4, 1896. *OR* 30/1: 137.

James Deshler's command from Patrick Cleburne's Division, plus several unnumbered cavalry battalions, individual detachments, and six horse batteries of light artillery. One can only wonder why Bragg did not send at least a portion of this mobile force to block the McFarland and Rossville gaps. Further, he could have ordered them to Chattanooga before retreating Union troops reached the city. Confederate cavalry outnumbered the six Union cavalry brigades. The Federals had an aggregate of 8,000 and only two light horse artillery batteries. This gave Bragg a more than 3:2 ratio advantage. Mounted troops had the speed to block key gaps that Union infantry needed to reach the safety of Chattanooga. The Confederate cavalry could accomplish this while infantry wings of the army continued to assault Thomas. Bragg had many good options at a time when part of the Union army had disintegrated into little more than a panicked mob. But he failed to seize any of them.[3]

Among the tools modern military planners use to help unit commanders with command and control, as well as assist in their assigned subtasks, are graphic control measures. These consist of unit boundary lines, phase lines, objectives, and a myriad of other depictions that go into an operations order, as well as onto all associated maps and graphics. The Civil War commander and his staff did not yet have these tools. It was an age of mostly tactical thinking when brigade and regiment level linear tactics were the control measures. Longstreet did envision some of these things at Chickamauga. He knew from Stewart that there was an open area between his wing and Polk's, and subsequently he closed it. This established a firm boundary between the two wings. Next, he spoke with Private Brotherton, inquiring of a pathway into the open terrain behind the Union lines. Brotherton told him of the cow trail near the house and Longstreet used it as a control measure for Johnson to follow in the assault.

Once Longstreet's two-brigade wide narrow column passed through the Union line, Hood in his function as the primary tactical commander, met Bushrod Johnson and told him: "Go ahead, and keep ahead of everything." Johnson cleared the wood line onto the Dyer property and moved north with the Dry Valley road as his immediate objective. His right brigade under Evander McNair encountered resistance from a Union brigade in Brigadier General John Brannan's Division, but

<hr/>

3 Philip Katcher, *The Army of Robert E. Lee*, (London: Arms and Armour Press, 1994), 289-294; Alexander, *Fighting for the Confederacy*, 222, 583; John B. Turchin, *Chickamauga*, (Chicago: Fergus Printing Company, 1888), 231-232, 240. Consult OR 30/2: 11-20, for a complete accounting of force structure and organization. Longstreet underestimates the Confederate cavalry strength at 10,114. Longstreet, *Manassas to Appomattox*, 458.

pushed through them. Across the Dyer field, Union reserve artillery came into action, but they were without infantry support and fifteen of these guns were flanked and captured by Robertson's Brigade of Johnson's Division. Union troops began to withdraw from this end of the field. Hindman's Division, at the left of the column, encountered stiff resistance and engaged units from the Union divisions under Major General Phillip Sheridan and Brigadier General Jefferson C. Davis. Union Brigadier General William H. Lytle managed to check the Confederate advance for a short time, but when he was killed his leaderless troops fled the field. Colonel John T. Wilder was another Union officer positioned to the left of the breakthrough and he sought to strike Hood's column. His mounted infantry with their Spencer rifles could fire "equal to seven times their number of men with muzzle loading guns." They checked one of Hindman's brigades and Wilder considered launching an all-out counterattack. But United States Assistant Secretary of War Charles A. Dana found Wilder and proclaimed the battle lost. Dana demanded a horse detachment to escort him to Chattanooga, and Wilder had no choice in the matter. In the time it took Wilder to organize an escort, the Confederates regained momentum and Wilder further observed the scale of the column and realized his planned attack was pointless against such force.[4]

Union Brigadier General Thomas J. Wood, who had received orders to move his division to support the other wing, understood what was happening. He tried to check, or at least confront the Confederate penetration. Wood went to Colonel Charles G. Harker's Brigade, and ordered him to counterattack the Confederates. Harker drove toward the right flank of Robertson's Brigade, now about three-quarters of a mile from their Line of Departure. Supported by artillery, Harker struck Robertson's flank and the Confederates fell back a short distance. Hood saw this and ordered Kershaw to attack Harker at once. He then rode to Robertson, presumably to redirect him and order a resumption of the advance. As he neared the position, Hood was struck in the right leg and fell from his horse. He was evacuated to Alexander's bridge and surgeons amputated the leg just below the hip. Longstreet had lost the commander who was pushing his vision forward. Meanwhile, Kershaw acted quickly and pushed Harker back toward Horseshoe Ridge.[5]

4 Johnson, OR, 30/2: 458; Benjamin Taylor Smith, *Memoirs of a Soldier*, (Bloomington IN: 1st Books Library, 1999), 62.

5 Robertson, OR, 30/2: 512; Longstreet, OR, 30/2: 288; Longstreet, *From Manassas to Appomattox*, 447-449; Hood, *Advance and Retreat*, 63.

As Kershaw began to clear the Union brigade in the Dyer Field, Bushrod Johnson kept moving across the Dyer property. This slowed the attack in the Dyer Field. In addition, Evander Law had taken Hood's place and it took time for him to assess the situation. The quick-thinking Kershaw changed his axis from following Johnson. Longstreet was also nearby, and at the same time Kershaw acted, he directed a Mississippi brigade under Benjamin G. Humphreys to deploy from behind Kershaw and move to the right. From there they would assault the ridge beyond the Dyer Field. At approximately 1 p.m. Longstreet ordered Humphreys to "drive them," and both Kershaw and Humphreys advanced in the direction of the Horseshoe Ridge. Longstreet's movement forward remained on course, but the follow-on units were coming out of column to engage the Union spoiling attack. Longstreet's fine point was starting to spread out.[6]

One can stand today on the Dyer property at the spot where Hood was wounded and shoot an azimuth with a military compass along the axis of his advance. Then, if one transfers that azimuth as a line to a grid military map of the terrain at Chickamauga, it points to the road junction just before McFarland Gap. Two and one-half miles distant from where Kershaw began to wheel right, McFarland Gap was the only way out for the Union wing opposite Longstreet. McFarland Gap as Hood's objective follows modern doctrine and places more emphasis on seizure of key terrain to shape the battlefield instead of continuous tactical assaults that were typical in the Civil War. If modern mechanized units fought Chickamauga, they would follow open terrain areas to maintain momentum and go around the defenders in wooded areas in to control key escape points behind them. Only a few units of the Schwerpunkt would halt to place suppressive direct and indirect fire on the enemy. They would engage enemy strongpoints and formations that they wanted to fix in position. The main body would turn directly north and use the high-speed avenues of approach. These would include the Dyer Field, the Dry Valley Road, the Snodgrass field, and the area north of Snodgrass Hill. Then the force would pivot toward the gaps in Missionary Ridge to circumvent the other Union wing, thus avoiding any engagement when moving behind the enemy. In 1863, however, there was obviously no such transport, so the most direct route was a straight line. This was the quickest way in which to reach a distant objective. Although Longstreet had to attempt to fight through one wing, the axis of advance he chose reduced the chance he would have to engage troops from the other Union wing. The record does not indicate whether Longstreet

6 Kershaw, OR, 30/2: 503-504; Humphreys, OR, 30/2: 510; Benning, OR, 30/2: 518.

specified McFarland Gap to his subordinates as the objective. Presumably, the map Bragg gave him showed the gap. Hood's direction, the composition of the column, and the insistence upon momentum provide strong evidence to support this notion. Although Bragg had wanted Longstreet's wing to push to its left, once it joined the fight in the planned en echelon attack this became impracticable. Longstreet's was now the main effort, and he would have to turn right to seize the gaps in Missionary Ridge. If he could do this, the battle would be won. Theoretically, the entire Army of the Cumberland would be trapped unless some units could escape over the wooded slope of Missionary Ridge and make their way to Chattanooga.[7]

Longstreet had positioned himself at the Dyer House, a location in between Johnson and Hood. From there he could see most of his wing in action. At the far left of the wing, Hindman had routed and pushed all Union units to the left of the Schwerpunkt. First, he overwhelmed Davis's Division and drove them back over a mile and into Sheridan's Division. Both Union divisions collapsed under the weight of the Confederate momentum. The Federals abandoned the Dyer Field and retreated toward McFarland Gap before Bushrod Johnson could cut them off. Hindman's units wheeled to the right and followed Johnson's axis. Major General Simon B. Buckner then joined Longstreet and the two officers rode north to survey the progress.[8]

Longstreet and Buckner turned right, indicating concern over the activity of the other Union wing. Still, Longstreet maintained the axis of advance in the direction of McFarland gap. Even though the Federals had temporarily blunted Hood, follow-through momentum soon commenced under Law. His units were still pushing the enemy into wooded, hilly terrain to the northwest. The problem was that Longstreet could not see beyond the distance of a single brigade front.

As he rode into the wood line at the right of Dyer Field and toward Humphreys's Brigade, Longstreet looked for any threat to his current axis of advance. This could come from troops in the Union wing opposite Polk. By approximately 1:30 p.m. the right flank of Longstreet's wing had pushed forward

7 Author experiences from the Combat Maneuver Training Center, Hohenfels, Germany 1988-95, and Operation Desert Storm 1991, repeatedly proved mass and momentum will usually defeat static defenses.

8 Corps commander Buckner stayed with Longstreet on September 20, as his two divisions (commanded by Preston and Stewart) started the day on opposite ends of the four western divisions that were in a row. He could not exercise command and control over them that way. Longstreet had also retained Preston's Division for himself as the wing reserve.

for one mile and was farther north than some of the Union units opposing Polk. Longstreet had to consider the potential risk to his rear. Accordingly, he held Preston's Division in reserve and posted it on the Lafayette Road. Preston aligned his three brigades facing due north and readied them to strike Union units from the other wing should a threat emerge from that sector of the field. Appearing at the Poe field opposite Preston's front, Longstreet could see the Union lines and it appeared certain that they were preparing to move against him. Longstreet directed a battery to "shell the woods. The enemy is reinforcing their right."[9]

Dealing with the other Union wing was Polk's mission, but Longstreet still needed to learn of its activity in light of the breakthrough on the Union right. Riding deeper into the woods to the right and rear of his forward elements, he came under fire from the Union left wing. Longstreet marked the spot and hurriedly rode back toward his own troops. A Union brigade under Brigadier General August Willich held a position behind breastworks less than 300 yards from the right flank. Some speculate that this separation between Union positions on Snodgrass Hill and the Union wing near Kelley Field was an opportunity that Longstreet missed. That cannot be proven based merely upon 300 yards of separation in a wooded and obscured environment with no visible opening. Additionally, committing his rear security and reserve in a direction away from the axis of advance, where one cannot determine enemy dispositions, would not have been a sound course of action. A commander must not commit a rear security force without a clear purpose or a visible threat. Otherwise, a movement to contact with this reserve division away from the axis of advance would be a blind and unsupported movement. For the time being, the other Union wing continued to defend against threats from Polk. Longstreet held Preston in reserve primarily to protect the rear of his attacking divisions. Preston's units did receive some fire from the other Union wing, but Longstreet moved them sometime around 3:30 p.m. Longstreet was correct to consider the other Union wing a threat to his advance, and he knew retaining rear security was important.[10]

After reconnoitering the other Union wing, Longstreet and Buckner arrived at Johnson's location to gain understanding of his progress. Johnson was moving toward the Dry Valley Road. Johnson's aide, Captain William T. Blakemore,

9 Culpepper Letter, undated, personal collection, in Larry J. Daniel, *Cannoneers in Gray: The Field Artillery of the Army of Tennessee*, (Tuscaloosa: University of Alabama Press, 2005), 107.

10 Longstreet, *OR*, 30/2: 289, 415, 540. Distance measured by the author. A movement to contact is a form of offensive operation with the mission of locating an enemy force without precise knowledge of its location, size, or activity.

presumably led Longstreet and Buckner to the position sometime after noon. In the meantime, Johnson had spied a Union wagon train parked within artillery range and ordered one of the batteries in his forward brigades to open fire. Then he directed pickets to move out and seize the train. Longstreet arrived shortly thereafter. One of his aides laid out some food and Longstreet invited Johnson to eat with his party. Since the left wing was planning to attack early in the morning, in accordance with Bragg's plan, the units had not taken breakfast. Johnson's men paused as well, eating what they had on them in preparation for a busy afternoon.[11]

In Bragg's estimation, he had done all he could to energize Polk's wing. The units engaged were attacking, but the Yankee defenders fought with equal stubbornness and yielded no ground. By late morning, two brigades of D. H. Hill's Corps had managed to turn the far Union left flank and started to move into Kelly Field to threaten the rear of the enemy left wing. This is exactly what Bragg wanted to do as a means of facilitating his en echelon attack. However, Hill's brigades received no support. No one directed the remaining idle brigades in Polk's wing to exploit Hill's success. Union units from inside the concave shape of their left wing, moved to confront Hill. By noon they had pushed the brigades out of the Union rear and back from the flank. In doing so, the Federals stabilized their situation. With this action, Bragg rode to the vicinity of the Brotherton House and summoned Longstreet.

At this juncture, the Confederates had routed approximately one-third of the Army of the Cumberland. Longstreet had cleared all the ground occupied by the right half of the Union army south of the Brotherton cabin. Most of the defeated elements of the Union right fled to the McFarland Gap while others headed toward the Snodgrass farm.

The first Union unit to arrive on the Snodgrass farm and take up a defensive position was the 82nd Indiana. The first Union general to envision the high ground here as a rallying point was George H. Thomas. The Confederate brigades that first reached the Kelley Field launched an assault, but the Federals threw them back. Longstreet had tried to deliver the coup de grâce by hurling the fifth echelon of his column, including Kershaw and Humphreys, to crush Thomas and send him into flight. By 2 p.m., however, elements of Gordon Granger's Reserve Corps had reinforced Thomas. Granger had been guarding the roads to Rossville, but realized

11 Cummings, *Bushrod Johnson, Yankee Quaker*, 260-262. William Blakemore was a successful planter living in Kentucky when the war started. He served under Johnson throughout much of the war until he was wounded in 1864. He received commendations by Johnson in his reports of Shiloh, Murfreesboro, and Chickamauga.

the army was in trouble and moved to help. The timing of his movement was perfect and checked the fresh assaults by Longstreet's right. By 3 p.m. Thomas had arrayed his divisions, and had gathered other fleeing units, to establish a defensive position. Thomas stood firm against Confederate assaults by Johnson and the Virginia brigades.[12]

To Longstreet, it was clear that seizing McFarland Gap was an operational objective of great importance if the Confederates were to cut off large numbers of retreating Union units. If the Confederates could do so, they would achieve a total victory and perhaps compel the Army of the Cumberland to surrender. To accomplish this, however, he would need Bragg to shift some troops to his wing, since Thomas had not folded.

Longstreet's meeting with the commanding general did not result in securing the reinforcements necessary to break Thomas on Snodgrass Hill. Nor was Longstreet able to persuade Bragg to change his battle plan and use Polk's wing to maneuver toward McFarland Gap, seize the Dry Valley Road, and move mounted troops to Rossville Gap. Bragg was not interested in any other option to outflank the Union left or to assault Thomas's rear. Longstreet failed to convince Bragg of the overall Confederate success that day. Bragg ordered him to hold rather than commit the available divisions for pressure and pursuit. The commanding general wasted a sublime set of military opportunities. Bragg was not an incompetent soldier. In fact, he had a talent for administration and had demonstrated sound martial judgment in other battles. On this day at Chickamauga, however, he made a poor command decision in not reinforcing success. It seemed his state of mind was consumed by anger at Polk for a lack of attention to detail in disseminating orders properly the night before. While this certainly clouded his judgment, Bragg could not clear his mind of the failure on the right wing and embrace the superb opportunity he had that afternoon with the left wing. His mindset simply would not let him think imaginatively about the operational need for timing and tempo of reinforcement to his left.[13]

12 Augustus D. Dickert, *History of Kershaw's Brigade*, (Newberry, SC: Elbert H. Aull Co., 1899), 273-274. See for hourly details of Kershaw's Brigade in this battle.

13 Longstreet, *Manassas to Appomattox*, 451-452; Hill, "Chickamauga: The Great Battle of the West," in *Battles and Leaders of the Civil War* 3: 652-653; George Ratchford, "General D.H. Hill at Chickamauga," in *Confederate Veteran Magazine*, 24, Mar 1916, 121; Irving A. Buck, *Cleburne and his Command*, (New York: Neale Publishing, 1908), 151. Timing and Tempo is one of the facets of Operational Art. In this case, it refers to flexibility on the part of a commander, such that he recognizes swiftly when to move strength away from where it is least effective and send it where

Without reinforcement, Longstreet could only try to break Thomas's position with the force he had available. After the meeting, Longstreet ordered Johnson to turn right and move to strike the Union troops gathering at Snodgrass farm. For a short period, Johnson had an opportunity to crush the Union right flank as it coalesced on the Snodgrass property. Of this fleeting moment in time, Longstreet would recall that Johnson, "thought he had the key to the battle." Hindman would support Johnson on the new direction of attack. Hindman had been wounded three hours earlier, and although he pushed through the pain as he routed two Union divisions himself, then he had to seek aid and put his brigades under Johnson's control. Johnson reformed his line accordingly. He was functioning essentially as a corps-level commander and wielded two divisions' worth of brigades. At least an hour passed as Johnson integrated Hindman's brigades and reformed his attack formation. He ordered the captured ammunition issued across all units, and his troops to eat as they worked and repositioned. By 3 p.m. Johnson was ready and started the next series of assaults.[14]

Longstreet now had all his divisions, except Preston's, engaged against Thomas's stand on Snodgrass Hill. Johnson's efforts were linked with the five Virginia brigades and the units attacked, reformed, and attacked again for hours. Longstreet had no choice but to commit his reserve and sent Preston in to relieve some of his weary brigades. Between 3:00 and 5:00 p.m. Longstreet furiously assaulted the Union positions on Snodgrass Hill. He used all his leadership skills to muster all the ferocity he could from the troops. Finally, Longstreet brought up a battalion of field artillery and positioned it perpendicular to the angle created by the "bending back of the enemy's right." The guns promptly began to enfilade the Union lines. It seemed this would eventually chew away the Union position. Nothing could stand "before the tornado of shot and shell," wrote one observer. However, Thomas simply would not fold. He knew darkness had almost arrived and would bring an end to the fighting. Thomas and his men endured the punishment and stood toe-to-toe with Longstreet. They held until nightfall and then withdrew to the high ground of Missionary Ridge.[15]

Longstreet had conducted a large "modern" penetration of an opposing front by using units from different armies led by an officer corps not formally trained in

it can reinforce success. Ratchford was a member of Hill's staff and was present at the meeting between Bragg and Longstreet.

14 Cummings, *Bushrod Johnson*, 262-267; Longstreet, *Manassas to Appomattox*. 450.

15 Dickert, *Kershaw's Brigade*, 275.

this doctrine. The soldiers had completed preparations by 7 a.m. and fought on unfamiliar ground and in wooded terrain. This is a tough assignment for any brigade or task force at any time. This large-scale penetration, conducted so well in these conditions, was truly a masterpiece. A basic blueprint to others like it in later decades.[16]

Longstreet's post-breakthrough combat operations, in comparison to 1918 German Infiltration Tactics or Second World War maneuver, also deserve high marks. He aimed at McFarland Gap as the objective and clearly moved that way after the breakthrough. His axis of advance is also evidence that he wanted to avoid decisive tactical engagement with the other Union wing following the breakthrough. The objective was to seize the McFarland Gap and bag the entire portion of the Army of the Cumberland under Thomas. The follow-on steps Longstreet took were also sound. His decision to hold a reserve division to exploit possible successes on Snodgrass Hill was a sound one. Likewise, Preston also functioned as an insurance policy against any unforeseen Union action against the rear of his units. Longstreet made good use of his reserve force that afternoon.

A tank unit or mechanized infantry unit today would most likely break contact with the Snodgrass Hill position once it solidified. They would go around it by using the available sections of open terrain to move north to the roads and then northwest to get to McFarland Gap. Modern maneuverist thinking (i.e., doctrine for mobile units) would certainly seek to reach the gap with enough combat power to box in the opponent. However, Longstreet had no motorized transport. With the facts he had in the heat of the action, he probably made the best choices available. Nevertheless, his Schwerpunkt was tactically brilliant. It ruptured the Union defenses and collapsed half the Union Army of the Cumberland. Redirecting the column around Snodgrass Hill, and not allowing it to come out of column, might have preserved its momentum longer. His choice was shaped by the speed of foot soldiers, and thus he calculated the straight-line distance as the quickest way. He assumed that the Union position would break but it didn't. Still, a few elements of modern military follow-on operational thinking were part of his plan and execution that day.

Thomas proved a great source of difficulty for Longstreet's hopes to seal off the enemy escape route. Thomas understood what Longstreet was doing and he would not allow the Confederates to get past him or behind him. Thomas

16 Assessment by the author drawn from training deployments and combat experience in large-scale land warfare during Desert Storm.

personally encouraged each ad hoc group to stand and fight. In Granger's opinion, however, the retreating troops did not have the strength to oppose Longstreet.

The second decisive obstacle was the timely deployment of key Union reserves under Granger on Snodgrass Hill. This occurred sometime between noon and 1 p.m. and stiffened Thomas's defense. Of particular note was Brigadier General William Hazen's Brigade and its artillery. Hazen placed the battery on the left of the wing and the guns had a perfect range fan to block the axis of advance around Snodgrass Hill. This is substantiated by the number of times the battery repulsed Humphreys. The battery could also have pounded a Confederate thrust north around Snodgrass Hill. Such a scenario illustrates the need for Bragg to have reinforced Longstreet's wing, in order to push past the strongpoint along the Kelley Road. Thus, the assault aimed over and through Snodgrass Hill was Longstreet's best course of action. Even though Thomas managed to stop the assaults, the intention to traverse the straight-line distance through unnerved enemy units was the correct one. The clock was ticking for the Confederates, and it was quicker to reform and assault than to disengage and try to move the majority of the force around a flank. Longstreet's momentum also had the psychological element of élan. Union General Granger commented they were "impetuously attacked" by Longstreet's veterans. Longstreet needed to keep the men energized for as long as possible to harness shock effect as well.[17]

By nightfall, Thomas's position was untenable, and he determined not to stay to find out what might happen the next morning. The Virginia-born Yankee general had done a magnificent job in creating a seamless defensive position. The time had come for his withdrawal or he would confront Longstreet the next morning and face enfilading massed artillery fire. Thomas covered for the other wing while it moved through McFarland Gap. The movement started around 4:30 p.m. and Thomas ceded the hill sometime after 5:30 p.m. He slipped away toward Chattanooga during the night. As darkness fell, Polk's troops met Longstreet's men on the hill. The Union soldiers, depressed by the unarguable defeat, dragged themselves along in shame. As one writer put it, they heard "the sound of the rebels celebrating with loud yells over the ridge behind them."[18]

The Confederates did not realize the full value or extent of their victory that day. Nonetheless, abundant opportunity remained. On the morning of September

17 Granger, *OR*, 30/1: 855; Steedman, *OR*, 30/1: 862. Range fan verified by author.

18 Shelby Foote, *The Civil War: A Narrative, Fredericksburg to Meridian*, (New York: Random House, 1963), 756.

Drawing of Confederate troops of Longstreet's wing advancing in wooded terrain.
(*Alfred R. Waud, Library of Congress Prints and Photographs Division*)

21, however, when Longstreet found his opponent missing, Bragg ordered him to hold his position. So, during the first hours of the day Longstreet tended to his wing and the casualties. He gathered captured equipment, spread it around to his command, and deployed three more Virginia units that had arrived with McLaws during the afternoon.

Private John S. Jackman, an infantryman in the 1st Kentucky Brigade of John C. Breckenridge's Division, saw Bragg that morning. He wrote in his diary: "The Army of Tennessee, for once had beaten the enemy in an open field. Gen'l Bragg rode along the lines, and everywhere was loudly cheered." It was probably one of the happiest moments in Bragg's life. He commanded an army that had won one of the most spectacular Confederate offensive victories of the war. The victory was every bit the achievement of Second Manassas or Chancellorsville in that they had collapsed an entire portion of an enemy army. Some opinions would say it was greater. Union corps commander Major General Carl Schurz wrote in his memoir decades later that the "rout of the right wing in that battle was far more disastrous and discreditable than the defeat of the Eleventh Corps at Chancellorsville." Moreover, Chickamauga was the only major Confederate victory of this scale in the west. Bragg unquestionably held the initiative, and several fresh infantry and artillery units were yet to arrive. There was still a chance to thoroughly defeat this

Union army and perhaps to finish it off. Longstreet's improvisation and his corps had made the difference. To achieve more, Bragg had to take the initiative and make the right moves. He had a chance to preside over a decisive victory and perhaps to capture an entire Union army. Not even Lee had gotten this close and succeeded.[19]

19 John S. Jackman, "Lying so Thick Over the Field," in *The Civil War: The Third Year Told By Those Who Lived It*, Brooks D. Simpson, ed., (New York: The Library of America, 2013), 534; Carl Schurz, *The Reminiscences of Carl Schurz*, Vol. Three 1863-1869, (New York: The McClure Company, 1908), 55.

Chapter 13

Chattanooga: The Lost Victory

"There is only a step from the sublime to the ridiculous."

— Napoleon Bonaparte, December 1812

Napoleon reflected in hindsight that staying in abandoned Moscow as long as he did turned his initially successful Russian campaign into a failure. He was supremely confident during the summer drive on Moscow, and even after his inconclusive victory at Borodino, September 1812, that he could force the Russians into a battle that would finish them. The Russians had lured him across a vast distance, however, and left Moscow as a worthless prize. It was bait, in anticipation of the harsh Russian winter. Napoleon was accustomed to using his uncanny abilities to shape decisive battles in countries with limited boundaries. He was never allowed to do so in Russia.

Just as the Russians baited Napoleon into an irrelevant occupation of Moscow in 1812, the Union command eased Bragg into the wrong course of action at Chattanooga. In luring Bragg, the Federals bought themselves enough time to bring significant reinforcements into the operational area and take back the initiative. Like Napoleon in Russia, Bragg saw a city as an instrument for defeating his opponent. Napoleon saw Moscow as the key to bring his opponent to battle, and Bragg saw Chattanooga as the place where his opponent would starve. Both miscalculated.

Yet, much of the popular historiography of the Chattanooga campaign describes the Confederate failure as one caused primarily by officers who undermined the army commander and committed key tactical level errors. Tactical

errors at Chattanooga were not the cause of defeat. Rather, it was the operational and strategic stagnation created by Bragg's desultory siege that lost the campaign.[1]

Other interpretations accuse Bragg of dysfunctional leadership. His subordinates thought him psychologically unfit for command. Once they felt he had squandered the victory at Chickamauga, they recommended his removal. Bragg understood the problem this created and worked to counter the sentiment. The alienation between Bragg and his subordinates was a serious problem, one that has often been debated in Civil War historiography. Many historians conclude that removing Bragg was the right solution. However, separating the dysfunctional command climate problems and examining the unwise operational choices, reveals the root of Confederate failure. Bragg was unable to see the enemy's Center of Gravity and had yet to master the calculus of fluid, continuous, modern operational maneuver.

The first serious outcry against Bragg occurred immediately following Stones River in January 1863. Bragg had been aggressive on December 31, but did not maintain the momentum on New Year's Day. Rosecrans began to receive reinforcements, and after the battle on January 2, Bragg decided to retreat. President Davis realized that the command climate in the army was a problem and sent Gen. Joseph E. Johnston to poll Bragg's lieutenants. Davis wanted Johnston to act as a theater commander with the power to coordinate efforts between the two primary armies in the West, Pemberton's in Vicksburg and Bragg's in Tennessee. Johnston never embraced this role and did not act accordingly. For the most part, he acted as an observer and consultant, never issuing any significant orders to Pemberton or Bragg. He did, however, interview Bragg's subordinates and submitted a report to Davis. Most of Bragg's lieutenants concurred that Davis should replace the general, but Johnston demurred. He did not see evidence that Bragg had lost the confidence of the soldiers and believed that army operations under his leadership had been "conducted admirably." Johnston concluded that, "the interests of the service require that General Bragg should not be removed."[2]

Davis was at times an indecisive executive. Occasionally, he let decisions evolve by allowing events to take their course, rather than shaping events. This trait

1 See James Lee McDonough, *Chattanooga: A Death Grip on the Confederacy*, (Knoxville: University of Tennessee Press, 1984); Hallock, *Braxton Bragg and Confederate Defeat*; Thomas L. Connolly, *Autumn of Glory: The Army of Tennessee, 1862-1865*, (Baton Rouge: Louisiana State University Press, 1973); H. J. Eckenrode and Bryan Conrad, *James Longstreet: Lee's Warhorse*.

2 Cummings, *Bushrod Johnson*, 235; Johnston to Wigfall, March 8, 1863, *L.T. Wigfall Papers*, Library of Congress; Johnston, *OR*, 23/2: 624, 632-633.

was evident as he evaluated a possible replacement of Bragg in early 1863, and again during the Chattanooga campaign. Perhaps the Confederate Commander-in-Chief was the one responsible for the military failure because he avoided the hard choice of removing Bragg. Davis allowed Bragg, a man seriously hobbled by chronic health problems and psychological issues, to continue in command of an important army. Johnston's opinion, that what had transpired under Bragg was 'admirable,' overinflated the true results. Bragg had shown some aggressiveness, but twice in the past year, had relinquished the initiative. He did this again, even after receiving enough reinforcements to defeat the Army of the Cumberland for the first time.[3]

At that time, a general's health problems were not always viewed as disqualifiers for holding key positions. Illnesses were viewed as part of life that all had to cope with. Few societies barred unhealthy individuals from holding high authority and making life and death decisions. While Bragg's periodic misery from chronic physical ailments and infirmity were not his fault, they likely contributed to igniting what Ulysses S. Grant described as his "irascible temper." This character trait did not promote the harmony that is essential for effective leadership. In the planning phase, Bragg was often the antithesis of harmony. He distrusted many of his officers. When agitated, he focused on the disagreement rather than the mission. His ability to make strategic and operational command decisions became severely degraded once his mind entered a haze of anger. Command level stress also caused him to become perplexed and pessimistic, and he frequently vacillated when solving problems. One military professional medical observation of Bragg has survived. A doctor named Stout, a surgeon and the medical director of Confederate army hospitals, wrote the report. It describes Bragg as having "severe and persistent mental and physical labors." In concert with this opinion, nearly every account by officers who worked with or for Bragg noted that he seemed to suffer from issues severe enough to influence his professional judgment and performance. Regardless of the cause, his behavior damaged the mutual trust and confidence necessary to conduct successful military operations and rendered this important combat multiplier nonexistent. Bragg's pessimistic portrayal of difficulties in absolutes was so excessive that at Chattanooga it contributed to a miscalculation of the enemy Center of Gravity and committal of his army to a partial siege. While history may fault Bragg for many things, it is unfair to overlook

3 Richard E. Berringer, "Jefferson Davis's Pursuit of Ambition: The Attractive Features of Alternative Decisions," *Civil War History*, (Kent State University Press, Volume 38, Number 1, Mar 1992), 5-38.

his poor health as well as the fact he also had a superior who was responsible for the overall results. Davis had the responsibility to pick officers who were able to apply sound judgment and lead the armies. Yet he kept Bragg in command.[4]

Campaigning Time Wasted on the Wrong Mission

Many treatments of Chattanooga highlight the crisis in confidence with Bragg and his recriminations against his subordinates. These did indeed waste time, but the combination of terrain, the Union retreat into the city, and Bragg's inability to see operational possibilities outside the immediate area, induced a state of mind that caused him to repeat Napoleon's choice in Russia. Napoleon thought the enemy would come to him. While waiting, he misapplied three important Principles of War: objective, mass, and offense. Similarly, Bragg did not understand that his opponent would reinforce Chattanooga faster than his partial siege could work. He did he not grasp the need for continued and timely operational maneuver.

The concentration the Confederates achieved at Chickamauga was an opportunity to work within the strategic parameters of Longstreet's defensive-offensive theory. As General Dwight Eisenhower articulated in his memoir; in modern war battle areas are now extended over great distances in both width and depth, requiring everything in the area to be coordinated toward the achievement of the strategic plan. From success at Chickamauga the relevant area in terms of military decision expanded from the tactical area of that battlefield, to a large area of operational relevance and an even larger area of strategic significance. From the tactical victory came an operational opportunity, but harnessing this success required the operational philosophy of *continued decisive maneuver* against the Army of the Cumberland. The Confederates had no other sound options because Union reinforcements would eventually arrive. The Southern ideal of invincibility, fervently innate in many Confederate soldiers, was a strong combat multiplier and officers counted on it when they wielded their formations. It was, however, a double-edged sword that eroded their limited formations. A dozen high-cost attritional battles would not win the war for the Confederates. European military

4 Ulysses S. Grant, *Personal Memoirs of U.S. Grant: Two Volumes in One*, (New York: Charles L. Webster and Company, 1894), 388; L. H. Stout, *Reminiscences of General Braxton Bragg*, in Special Collections, Joint Forces Staff College, Norfolk, VA, (Heartman's Historical Series No. 63. Roswell: GA, December 1876, reprint; Hattiesburg: MS, Book Farm, 1942), 7. Bragg suffered migraines, and had to rest in darkness and quiet solitude for long periods. He also took mercury pills for melancholy, which is known to cause irrational and violent outbursts. See Joseph B. Mitchell, *Decisive Battles of the Civil War*, (New York: Fawcett Premier Books, 1955), 161.

intervention on the Southern side was unlikely after Antietam, and arguably it was lost forever following Gettysburg and Vicksburg. Reliance on maneuver warfare and leveraging concentration to create high probability conditions to win battles at a lower cost was what Longstreet advocated. This approach would give the Confederates their best chance for victory, particularly if it led to the defeat of President Lincoln in the upcoming 1864 elections. Thus, committing to siege operations for an undetermined length of time violated the tenets of the defensive-offensive strategy. It threw away the hard-won victory at Chickamauga and all its potential benefits. A siege at Chattanooga was complete folly in the tactical, operational, and strategic realms of the Confederates' situation.[5]

The window of opportunity after Chickamauga was short, but it was adequate for Bragg to decisively leverage his advantage of initiative against Rosecrans and demolish the enemy army. Bragg had to execute the operation without pause. Tempo of operations was crucial if he was to defeat, break up, or force Rosecrans's army to retreat deeper into Tennessee before numbers tipped back in favor of the Federals. The best time for the Confederates to achieve one of these desired outcomes was when the Union army was in retreat following Chickamauga.

The first chance came when Longstreet broke through the Union line and Thomas went to ground on Snodgrass Hill. The afternoon portion of Chickamauga presented the greatest opportunity for the Confederates to reinforce their success and possibly force the Army of the Cumberland to surrender. Bragg, however, did not reinforce Longstreet, commit his cavalry, or take any other actions toward securing a complete victory. Subsequently, Thomas built a defense on Snodgrass Hill, a location that gave him a place to rally and hold out until nightfall ended the Confederate assault. Thomas escaped and for the Confederates the situation transitioned from the tactical level to the operational level. As Longstreet recalled, the "mutations of war," required the sustained offense of operational offensive maneuver. This was something that would become more and more imperative in the Industrial Age.[6]

On September 21, Bragg ordered Longstreet to hold his position. Thus, during the first hours of the day, Longstreet tended to his wing and the casualties. He gathered captured equipment, and later deployed the Virginia troops under McLaws. Nathan Bedford Forrest, reconnoitering the Rossville Gap, rode up to an

5 Dwight D. Eisenhower, *Crusade in Europe*, (Baltimore: The Johns Hopkins Press, 1948), 74.

6 Longstreet, *Manassas to Appomattox*, 158. One of the points in his memoir where Longstreet tries to emphasize that this war was highly transitional.

enemy observation perch in a clump of tall oaks. He ordered the Union soldiers to come down and took a pair of their field glasses. Forrest then climbed the tree to observe the activity of the enemy army. He reported, "Two pontoons thrown across for the purpose of retreating. I think they are evacuating as hard as they can go. I think we ought to press forward as rapidly as possible." Forrest's notion was to close on Chattanooga and seize the opportunity to attack as the enemy built their bridges.[7]

Bragg visited Longstreet's camp to meet with his subordinate. Longstreet noted that Bragg "asked my views as to our future movements." Longstreet suggested they cross the Tennessee River east of the Union position in the city as a means of getting behind the enemy and forcing their evacuation. If they were not able to take such a position with sufficient force he suggested keeping a smaller force to hold Rosecrans while moving the majority of the army to strike Ambrose Burnside at Knoxville. From Knoxville, the Confederates could "threaten the enemy's railroad communication in rear of Nashville." When the generals concluded their conference, Longstreet believed Bragg favored the movement to get behind Rosecrans at Chattanooga, at least as the first step in the operation.[8]

Bragg was probably preparing to issue orders according to Longstreet's suggestion, when shortly thereafter he received the report from Forrest. Unlike Longstreet, Forrest actually saw the Union situation and he recommended aggressive action. Forrest's message, however, meant something else to Bragg. Instead of understanding it to mean that the Union force was vulnerable, Bragg concluded the enemy would abandon Chattanooga the following evening. He issued orders to move into Chattanooga, but quickly modified the instructions. The Confederates would move no further than Missionary Ridge and Bragg cited supply issues as a concern. Forrest pointed out that the additional supplies the Confederates needed were in Chattanooga. To Longstreet, a shortage of wagons in his two divisions meant they should march to cross the river at a point northeast of the city. There, they could harness the benefits of the Western and Atlantic Railroad line and interpose the army between Burnside in Knoxville and Rosecrans in Chattanooga. Where Forrest argued for a direct approach, Longstreet advocated a positional advantage. The recommendations by Longstreet and Forrest both

7 John Allen Wyeth, *The Life of General Nathan Bedford Forrest*, (New York: Harper and Bros., 1899; reprint, (New York: Barnes and Noble, 2006), 243-246.

8 Longstreet, *OR*, 30/4: 705.

favored continued operational maneuver, but for the next day or two, Forrest's suggestion was the better option and should have generated an order to attack.[9]

Throughout his career, Bragg had been an efficient subordinate. As an army commander, he seemed to struggle with experiencing some initial success, only to be thwarted by an enemy that did something other than he expected. He believed Rosecrans was about to retreat, and so he inched toward the enemy's defense works, fully expecting a Union evacuation. When the "Yankees did not evacuate, Bragg became unsure of his next move, and precious time was wasted," Longstreet later declared. Bragg stated that wagons were the problem, but wagons were not a problem. The infantry walked, and from Chickamauga they were close enough to march the ten or eleven miles from Snodgrass Hill to Chattanooga. Even then, they could still attack the demoralized Union forces with or without all the new wagons and ammunition they had seized at Chickamauga.[10]

On September 22, the Union panic of the previous day began to subside. Rosecrans also came back into the picture. Having panicked when Longstreet penetrated his line, he had fled the battlefield and raced back to his headquarters in Chattanooga. He sent frantic telegraph reports that painted a gloomy picture of affairs. Then he waited for the leadership of the Army of the Cumberland to arrive and meet with him. This must have seemed awkward to those subordinates who had stayed to fight with Thomas.

Rosecrans decided on September 23 that the army would go into a tight defensive position in Chattanooga. By the end of the following day, the Union had completely evacuated the two mountains. Those who say that Thomas objected to Rosecrans's decision, subscribe to the thought that a defense of Missionary Ridge would have afforded the retreating Federals an opportunity to punish the Confederates before ceding the ground. The reality was that a defense by the Union of Missionary Ridge, with a large river immediately behind them, would have provided little room for a retreat. Another problem was that the Confederates could flank the position. Rosecrans did not have enough units to occupy the entire ridge and cover the ground extending to the river. Even though Rosecrans had lost a measure of credibility, because of his personal actions at Chickamauga, his

9 Wyeth, *Forrest*, 243, 250. In 1896 Wyeth sent a copy of this dispatch to Longstreet, who replied in a letter: "it was this dispatch which fixed the fate of the Confederacy. General Bragg had decided to march around Rosecrans, leaving him in Chattanooga, when the dispatch was received which caused Bragg to think that the place would be abandoned on the night of September 22, when he decided to turn back and march through Chattanooga."

10 Longstreet, *Manassas to Appomattox*, 461.

judgments about the current situation were correct. If a defensive battle went poorly for the Army of the Cumberland, and the Confederates broke the line again or went around the flank and forced Union troops to abandon the ridge, Rosecrans would have lost the last natural piece of defensive terrain available. Below and to the rear, only two to three miles of flat open ground ran between the mountain and the town of Chattanooga. There were some abandoned fieldworks, but they needed improvement. The real danger in this scenario was that the Tennessee River would be impossible to cross during a hasty retreat with Confederates in hot pursuit. Should the Army of the Cumberland be pushed off Missionary Ridge, the Confederates could immediately sweep down and finish them off. The situation was akin to Napoleon's breaking of the Allied center in the last phase of the 1805 Battle of Austerlitz, and his assault of the Allied left wing as it tried to retreat over the frozen Littlawa River. Rosecrans could not risk such disaster for the Army of the Cumberland. The Union commander therefore chose to create a defensive pocket anchored to the river. It was the correct decision.

Having occupied Missionary Ridge slowly and deliberately, Bragg gave Rosecrans and his men time to initiate position improvement. Days went by and Rosecrans, still unmolested by the Confederates, was within a perimeter to his liking. His troops continued efforts to strengthen their position and were relatively safe after working at it for four days.

On the Confederate side, since Bragg gave an order to move no further than Missionary Ridge, it will never be known if a Confederate attack against the Union pocket in Chattanooga would have destroyed the Army of the Cumberland. Although this 'second chance' existed only for a few days, many Union accounts state that the position could not have withstood a general attack on the first or second day. Accounts by Union officers, written a week or so later, indicate that the defenses of Chattanooga were by then impregnable. Meanwhile portions of the XI and XII Corps from the Army of the Potomac boarded trains at Manassas Junction, Bealeton Station, and Culpepper, Virginia, and began a 1,200 miles journey to Bridgeport, Alabama. On September 25 and 30, the first trains arrived. General William T. Sherman also received orders to move 17,000 troops from Vicksburg to join the reinforcement.[11]

Strategically, Lincoln saw Chattanooga as crucial. On September 23, he ordered Grant to go to Chattanooga and take command of all forces in the area as well as those that were on the way. He knew that holding the city was a way to retain

11 Dana, OR, 30/1: 197-199. On September 24, C.W. Dana told Stanton that Chattanooga would hold.

some of the gains from the successful Tullahoma campaign. Chattanooga was a key city to the Union, the gateway to Northern Georgia. Its rail lines would be important once the Union had regained the initiative.

Tactically and operationally, further retreat would also have spelled disaster. Rations were quickly becoming an issue and the troops took priority over the animals. Within days, most animals were no longer being fed and thus became weakened to a point where they could not haul the Union artillery. Should the Confederates force a rapid withdrawal from Chattanooga, the Federals would have to abandon or spike the guns.[12]

Basic Mission Analysis of Bragg's Partial Siege

It is astonishing to see how wrong Bragg was in opting for a partial siege of Chattanooga. The fundamental method that the modern military staff uses in mission planning is a separate systematic analysis of several components, including the mission, the enemy, the troops available, the terrain, and the time available. After weighing these factors separately, in terms of advantages and disadvantages, planners can decide upon and construct a plan of action. This modern approach, when applied to the Battle of Chattanooga, proves quite revealing.[13]

The Mission and Troops: The mission Bragg undertook was a partial siege. He had approximately 48,000 troops after sustaining over 18,000 casualties of the 66,000 available at the start of Chickamauga.[14]

Enemy Troops: Opposite Bragg was Rosecrans in command of an estimated 42,000 troops. Rosecrans sustained 16,000 casualties at Chickamauga out of the 58,000 available. A popular belief is that Rosecrans was trapped and in danger of annihilation. This was true for two to four days. The Confederates did indeed have the Federals confined to Chattanooga and they were not in any shape to break out, but they held their position by design. Looking at the force ratios of 42,000 Union troops against 48,000 Confederate troops, the odds were 1:1. The Union troops held a tight defensive position over a five-mile front, while the Confederates covered a fifteen-mile siege front. Since the Union was on the defensive, the slight

12 Grant, *Personal Memoirs*, 350-354.

13 FM 3.0 and Joint Publication 5.0.

14 Dana, *OR*, 30/1: 179; Longstreet, *Manassas to Appomattox*, 459; Thomas L. Livermore, *Numbers and Losses in the Civil War in America, 1861-1865*, (Boston: Houghton Mifflin Co., 1900), 105-106. The losses were 2,312 dead, 14,674 wounded and 1,468 missing. for a total of 18,545.

numerical advantage possessed by the Confederates meant little. The force ratio was still 1:1 and given the terrain and position improvement of the Union forces, the Confederates had no way to maneuver advantageously against the Union pocket. Had the Confederates faced the Federals on an open field where maneuver was possible, the numbers may have made a difference, but such was not the case. The battle space, when considered two-dimensionally, the troops available, and the straight-line distance of exterior lines, shows the strength of the siege position. Even with Longstreet's Corps and Forrest's mounted infantry, Bragg had little left to send elsewhere. Weighing the aspects of mission and troops available it becomes clear that Bragg erred in deciding to lay siege to the city. Siege was an abdication of his initiative and something that violated the principle of objective. Siege also violated the principles of mass and offensive because massing in front of the Union trenches was suicide. Rosecrans's choice to defend against a siege was entirely appropriate. The damage to morale in the Union army after Chickamauga necessitated time for the troops to regain confidence. In addition, a defense created the appearance of a trapped army, which helped keep Bragg focused on his pointless siege while the Union build up was underway.[15]

The Terrain: The exterior lines of Bragg's siege around Chattanooga stretched fifteen miles. The longer leg was Missionary Ridge, the shorter leg was a right angle from the west end of Missionary Ridge running along the low ground to the base of Lookout Mountain. Five divisions on the right wing occupied the line on Missionary Ridge. Breckenridge was in the center and covered the east bank of the creek to the Bird's Mill road across Missionary Ridge. Polk's Corps completed the line to the end of the ridge and to the far right of the army. There simply were not enough troops available to cover the additional two miles to the river. A line of pickets watched this area. They formed a semi-circular line opposite the Union positions. Longstreet's wing covered three additional miles from the west bank of Chattanooga Creek to the bottom of Lookout Mountain. The wing was comprised of the two divisions from Virginia, and one from the Army of Tennessee. In front of the Confederates was a relatively open plain with a few small hills that ran from Missionary Ridge about three miles to the Tennessee River. Along the river stood Chattanooga, a medium sized city for the period with a population of a few thousand.

15 Grant, *Personal Memoirs*, 350; Rosecrans, OR, 30/1: 169-179. Returns and casualty abstracts in Rosecrans's report: Numbers total 1,657 dead, 9,756 wounded, and 4,757 missing, for an actual total of 16,179. By late November the Union had closer to 45,000 in the city, and Confederate strength had risen back to 66,000.

Conversely, the terrain offered Rosecrans exactly what he needed for a strong defense. In the first weeks, the Tennessee River proved a logistical barrier to the Union, one that kept them in one place. While Bragg saw this as an advantage, the river was wide enough so that the Confederates could not approach from behind. In addition, the river protected Union positions without the need for troops to secure the flanks or protect the rear. The angle of the Tennessee River provided an advantageous terrain feature and since they had a narrow front, Rosecrans possessed short interior lines. This created a compact position, one with enough depth to build strong successive defensive belts. Once Rosecrans completed his defensive arrangements, the river was of greater benefit to the Union than the Confederates. In fact, it was the illusion of terrain that made the siege irrelevant and doomed Bragg's army.

Time Available: It was predominantly the time factor that defined this siege as the wrong mission. Siege was not an option Bragg should have attempted to execute against a foe in a position that could not be taken by frontal assault and had a supply line.

Such are the facts. Five facets of military mission planning demonstrate that the siege was the wrong mission. Four of the five dimensions gave the Confederates only minor short-term advantages, while time, the fifth, did not do even this. With Henry W. Halleck and Grant directing the buildup of reinforcements, the time available for Bragg was limited. Yet he remained inactive while the Union hurried.

Politics, Pride, Paranoia, and a Persecution Complex

Jefferson Davis left the loss of confidence problem in the command structure unresolved. His inaction guaranteed the issue would resurface later. When it did, the Confederates risked paralysis and mission failure. Bragg weathered the early scrutiny, but he knew that many of his subordinates opposed the decision to retain him. This realization only exacerbated his paranoia and fueled his persecution complex. Bragg's partial siege was only twenty-four hours old when he started sending notes to Polk and Hindman about delays at Chickamauga and at McLemore's Cove. On September 29, he initiated actions to relieve them, and also transferred much of Forrest's command to Wheeler. This infuriated Forrest, who allegedly threatened to kill Bragg if he ever saw him again. Forrest departed the Army of Tennessee.[16]

16 Wyeth, *Forrest*, 249. Forrest allegedly scolded General Bragg in his command tent, and then stormed out. Bragg did nothing about the incident and the two never served together again.

On September 26, Buckner, Hill, and Cheatham approached Longstreet to discuss Bragg. Longstreet was technically part of Lee's command and not part of the Army of Tennessee, and consequently the generals felt secure in expressing their concerns. Longstreet agreed that Bragg needed to go, and he wrote to Davis and other politicians stating the case. The written protests prompted Davis to travel to Tennessee to try to restore some semblance of harmony. When Longstreet voiced his opinion personally to Davis, he presented the facts as he saw them. Longstreet was direct in his views, as any officer might be after sustaining 8,000 casualties. His professionalism and commitment to the mission allowed him to do no less.[17]

A few critics over the decades have cited Longstreet for disloyalty or called him insubordinate. The key is that Davis questioned Longstreet. Answering the president's question was not insubordination, even if the interview took place in front of Bragg. It was Davis who perhaps erred in conducting a conference to poll subordinates with Bragg present. He should have interviewed each subordinate individually, decided about Bragg, and then told him personally of the resolution.

Officers will sometimes find themselves in situations to which they object. Unless the situation involves grave consequences, however, the nation expects officers to obey. This situation was clearly one of grave consequences to the Confederate military and the quest of the secessionists for independence. To remain reticent would have hurt Longstreet's credibility in the eyes of his officers and men who were disillusioned by Bragg's squandering the victory at Chickamauga.[18]

In this campaign the Confederates were trying to apply the defensive-offensive strategy. For the offensive action they sought a quick concentration by rail and strategic interior lines. These elements held the promise of taking the initiative against Union penetration in Georgia. This was Longstreet's vision, and it took much of 1863 for him to articulate it through the lens of Gettysburg and Vicksburg. It was Longstreet, not Bragg or his subordinates, who advocated for this change of strategy. Once Longstreet received approval of the plan to move his corps to Georgia, the administration endorsed follow-on operations to secure defeat of the Army of the Cumberland. Those leaders who outranked Longstreet were co-architects, bound to support the strategy and provide whatever support was

17 Foote, *Fredericksburg to Meridian*, vol. 3, 762; Donald Sanger, *James Longstreet*, (Baton Rouge: Louisiana State University Press, 1952), 215.

18 George M. Clifford III, "Duty at All Costs," *Naval War College Review*, 60 (Winter 2007), 108.

necessary to prevent it from failing. This included removal of those who did not understand the plan or were unable to follow it. Military professionalism requires that officers speak up when they believe they are faced with instances of poor judgement that may lead to bad military consequences. Longstreet was doing the right thing at this juncture by informing Davis, and those who had approved this operation, that Bragg was failing the mission. Regardless of how it looked politically, Longstreet was the general officer sent to this theater and he enjoyed a high level of trust and confidence. Longstreet had a professional and moral responsibility to advocate offensive operational maneuver necessary for the western concentration to succeed. Bragg had presided over a failed campaign prior to Chickamauga, purged and alienated key leaders in the Army of Tennessee, and was turning Chickamauga into a lost victory. Longstreet's duty superseded any loyalty to Bragg. He had to do something if, as one civilian observer put it, Bragg was going to "take the time to stop and argue with his generals."[19]

Upon reflection after the war, Longstreet probably believed that he should have stayed out of the Bragg crisis completely. Not because postwar Lost Cause mythologists distorted these events, but because his intervention achieved nothing. Whatever Longstreet said in the meeting, Davis did not heed the advice. This cost Longstreet a measure of credibility with Davis and hurt him as the campaign continued. Of course, he did not know beforehand what Davis would do with any recommendations he made. A reasonable person might assume that numerous calls to remove Bragg from command after Stones River would carry an increased degree of credibility after the general failed to exploit his success at Chickamauga. It is not difficult to understand why the blunt and politically careless Longstreet joined the faction that called for Bragg's removal. Many professional officers would agree that it is wrong to follow incompetence to the point of defeat and the needless loss of lives. Longstreet tried to use his chain of command to rectify the problems. He insisted on continued maneuver, as did Forrest, and sought help from the higher authority when Bragg could not grasp the correct action. Apparently that authority (i.e., Jefferson Davis) failed him, failed the Army of Tennessee and its officer corps, and failed the Confederacy. There is nothing whatever to justify the contention that Longstreet acted improperly by voicing his professional opinion during the interview with Davis. The next day, in a private

19 Martin L. Cook, "Revolt of the Generals: A Case Study in Professional Ethics," *Parameters* Vol. 28, No. 1 Spring 2008, 14; Mary Chestnut, *Mary Chestnut's Civil War*, C. Vann Woodward, ed., (New Haven: Yale University Press, 1981), 469.

meeting with Davis, Longstreet reinforced the point that, "we failed to follow success and capture or disperse the Union Army," and he suggested Johnston replace Bragg. Davis refused and admonished Longstreet for making the suggestion. Ever since First Manassas, Davis had expressed displeasure with Johnston, and he allowed his personal animus toward the general to influence his judgment.[20]

The stress of the confrontations, and the rebuke by Davis for doing his duty as he saw it, undoubtedly made Longstreet's continued work under Bragg nearly impossible. Regardless of any moral dilemma Longstreet may have faced, the fact remains that this partial siege operation was the wrong course of action. Given the fact that Bragg did not eliminate the Army of the Cumberland when he had the chance, and let it escape to establish an entrenched defensive position at Chattanooga, the Confederates could attempt a siege only briefly. At most, Bragg had two weeks to dislodge Rosecrans, or perhaps convince him to surrender. Confederate cavalry failed to stop Union movement along the supply routes and did not eliminate the Union supply depot at Murfreesboro. In addition, Wheeler's cavalry failed to wreck sections of track along rail lines Rosecrans needed to supply Chattanooga. Frontal assault of the city was impossible, as was getting around flanks that were anchored on the river. Yet, Bragg set his sights on punishing those in his own ranks whom he deemed negligent or insubordinate, rather than focusing on defeating his opponent.

The months following Chickamauga quickly turned into the worst period of Longstreet's Civil War career. After wasting nine days on Bragg's purge and Davis's attempt to sooth tempers, a reorganization of the Confederate forces around Chattanooga got underway. Eventually, Hardee and Breckenridge each took command of a corps, while Longstreet retained command of most of his troops. Bragg eliminated some of his vocal critics and took away the division he had assigned to Longstreet. While this might have afforded Bragg a degree of personal satisfaction, the partial siege became more irrelevant each day.

In October, the Confederates burned the railroad bridge at Bridgeport, Alabama that led through Lookout Valley to Chattanooga. Subsequently, all supplies to the city had to follow a circuitous sixty-mile route north of the river and over a mountainous path. By mid-October, this had caused a shortage of rations in the city and numerous diaries described the troops as "very hungry." Nonetheless, the Union soldiers endured because without a complete encirclement, and with

20 Longstreet, *Manassas to Appomattox*, 466; Freeman, *Lee's Lieutenants*, 3: 235.

plenty of time, inanition (i.e., exhaustion caused by lack of nourishment) of the defenders remained a remote outcome. The Union supply operations were difficult, but enough food got through.[21]

This is not to downplay the shortage of food. Yet, provided the supply routes were not cut, the Army of the Cumberland could hold out. There is no denying that the Haley's Trace route, the main line of supply, sustained Chattanooga. Almost the entire route lay beyond the reach of the Confederates and only a few miles of it ran along the east bank of the river as it neared Chattanooga. Bragg remained oblivious to the operational realities that worked against him and clung to the belief that he could starve the enemy into submission. With food and reinforcements arriving regularly, there was little chance of that. Likewise, there was no chance to take Chattanooga by frontal assault.

Bragg thought he could unhinge the Federal pocket in Chattanooga by shelling the position with artillery. A general bombardment began on October 5, and on October 30 cannon were positioned atop Lookout Mountain in the hope more areas could be reached by fire. Since Longstreet held the left flank of the army, this task fell to him and his artillery coordinator E. P. Alexander. Why an artilleryman like Bragg thought that field artillery could deliver the type of damage to entrenched infantry that he envisioned, is puzzling to say the least. The weapons at his disposal could normally shoot about a mile. From atop Lookout Mountain, and factoring in the natural elevation, they could reach a little further. However, most of the Union defensive line was further than a mile, gun to target, and the town further still. It appears Bragg failed to apply his basic artillery knowledge and experience to this scenario. The futile bombardment smacked of a course of action by a general who had no idea what else to do. His army had no heavy ordnance and no siege weapons, such as the heavy mortars the Union army would have brought to bear in a comparable situation.[22]

The field artillery pieces at Alexander's disposal were light and deadly against infantry in the open or against a foe massed in a relatively small area, such as the kill zone at Fredericksburg. But firing at a range of three to three-and-a-half miles at an army that was dug in was a waste of ammunition and effort. Alexander proclaimed, "Long range, random shelling is far less effective than it is popularly supposed to

21 Grant, *Personal Memoirs*, 352; James A. Connolly, *Three Years in the Army of the Cumberland*, (Bloomington, IN: Indiana University Press, 1959), 133-137; Ebenezer Hannaford, *The Story of a Regiment*, (Cincinnati: Published by the Author, 1868), 486-492.

22 Alexander, *Fighting for the Confederacy*, 300-305.

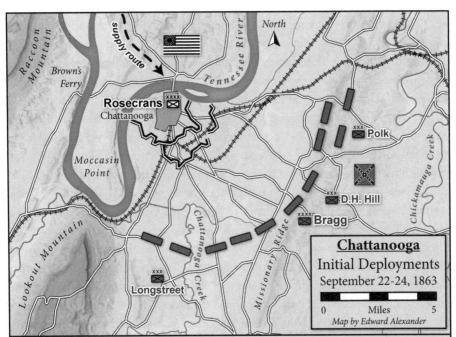

(Above) *Bragg failed to continue his attacks on the retreating Union army and settled into a partial siege. The initial Union supply line from Bridgeport ran ~60 miles through Anderson's Mill. Improvements to Haley's Trace shortened the route to ~40 miles.* (Below) *Grant assumed overall command on September 23, 1863. He used Bridgeport/Stevenson as a force flow entry point for reinforcements and the origin of the logistics flow to Chattanooga. These two rail termini provided multiple axis of advance into the rear of Bragg's army, eventually forcing Bragg to face his opponent in two directions. Grant's Center of Gravity (CoG) was all the troops in the process of gathering, which Bragg did not comprehend: Thomas (42,000) + Hooker (17,000) + Sherman (17,000) + Burnside (20,000) = ~100,000 available in the Operational Area to overmatch Bragg.*

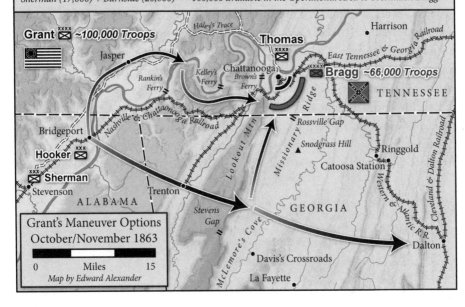

be." The chances of striking Union soldiers positioned in earthworks that were located three miles away carried with it a low probability for success, particularly when firing solid shot. Fused rounds would have had a slightly greater chance, but the smaller field ordnance the Confederates used limited their effectiveness in this application. Alexander recalled that they could reach most of the territory in the pocket, but at extended ranges a large percentage of the fuses detonated during trajectory, or tumbled, or did not explode at all. Sherman surveyed the Union defenses and affirmed that: "these shots could barely reach Chattanooga." His remark illustrates that the perception of those on the receiving end was that the mission was beyond the capability of the available weaponry. Effective artillery bombardment against trench lines required heavy ordnance, such as the 24-pounders the French employed to demolish the British berm sandy earth fortifications at Yorktown in 1781. To impact the harder earthworks at Chattanooga required numerous heavy guns. Nevertheless, Longstreet's men hauled twenty long-range pieces to the top of Lookout Mountain and began the futile exercise. The bombardment continued for a week. The Confederates added a few howitzers and buried their trails into the ground, so as to use them in high-angle fire. There were too few to make any difference.[23]

On October 5 Bragg ordered all artillery from the other corps to open fire as part of a general bombardment, but later in the day allowed the crews to cease firing. Alexander insisted, "there was no result of importance to show." This concluded the ineffective artillery action.[24]

On October 8, Bragg ordered Longstreet to close part of the sixty-mile-long Haley's Trace supply line. Longstreet assigned the task to Evander Law. This operation attempted to cut traffic at a three-mile section of road where it ran closest to banks of the river. Pickets from two of Law's regiments fired on the wagon trains as they passed. This minor tactical swipe at enemy logistics was Bragg's attempt to extend his reach about five miles away from the army. Perhaps in theory this seemed prudent, but they were shooting at wagons and not physically taking the road or the available terrain behind the Federal position. Unfortunately for the Confederates, the Tennessee River was about 300 yards wide at the section Law attempted to cover with rifle fire. The road was another 100 yards beyond the

23 Alexander, *Fighting for the Confederacy*, 304; William Tecumseh Sherman, *Memoirs of General W.T. Sherman*, (New York: The Library Press of America, 1990), 387; Daniel, *Cannoneers in Gray*, 112-114. Siege artillery would become more effective with the development in World War I of large howitzers with longer indirect trajectories, and larger calibers massed in great number.

24 Alexander, *Fighting for the Confederacy*, 304-305.

riverbank. With rifles that had a maximum effective range of 300 yards the target wagons took some fire from the pickets, but not massed fire. Some sharpshooters armed with British Whitworth rifles and scopes, later joined the effort to help the pickets. Able to reach out to 400 yards, these caused more problems for the Union teamsters. Longstreet later claimed that this action slowed Union efforts a little but was still ineffective in stopping supply traffic. With Union efforts making progress, the situation had changed from the time Longstreet advised Bragg to go around Chattanooga to the north as a means of forcing Rosecrans to abandon the city. Since the Union had chosen to hold the city, Longstreet looked for another option to change the effort from siege to maneuver. Since the Union pocket in Chattanooga was not approachable and employing sharpshooters for harassment did not completely cut the supply route north of Chattanooga, Longstreet "conceived the idea" to restore maneuver.[25]

25 Longstreet, *Manassas to Appomattox*, 463-464; First Lieutenant R. T. Coles, *From Huntsville to Appomattox: R.T. Coles History of the 4th Regiment, AL Vol. Infantry, C.S.A. and the Army of Northern Virginia*, Jeffrey B. Stocker, ed., (Knoxville: Knoxville University Press, 1996), 140; Evander Law, "From Chickamauga to Chattanooga," *Philadelphia Weekly Press*, July 11, 1888; Alexander, *Fighting for the Confederacy*, 305.

Chapter 14

Applying Operational Art: The Bridgeport Plan

"Always conduct operations elastically and resourcefully."

— Field Marshal Erich *von* Manstein, 1955

Frederick the Great once stated: "Little minds try to defend everything, but sensible people look at the main point." This maxim summarized the Confederate situation after the Union had committed itself to hold Chattanooga. The analogy is that Bragg thought only to harm enemy logistics and spread himself thinly in Lookout Valley, whereas Longstreet looked across the wider operational radius relevant to the campaign. He looked for a Decisive Point, that if seized would generate the events necessary to harm the enemy's Center of Gravity, the enemy's true power.[1]

What is Operational Art? Quite simply, it is the envisioning of timely, synchronized large unit movements, taking place above the tactical level and across distance. Although the term did not exist in 1863, many of the operational concepts emerged at a time when Industrial Age logistical capabilities increased in scale and when the corps became the prominent war-fighting structure. The increased tempo and scale of war added a new level to applications of creativity and imagination, harnessing professional skill, knowledge, and experience in planning major operations for large units. Operational Art became the ways, means, and ends of

1 Army FM 3-0, *Defensive Operations*, 8-1; A Decisive Point is a geographical place, specific key event, critical factor, or function that when acted upon allows commanders to gain marked advantage over an adversary. Not to be confused with the Center of Gravity, which is the chief aspect that gives an army its power, Decisive Points provide great leverage and influence upon a Center of Gravity.

campaigning. Envisioning the right synchronization of troop concentrations across time and distance would produce the right combination of effects against an enemy Center of Gravity. The actual creation of a framework and the mechanics of what a commander and staff plan, are known as Operational Design.[2]

A comparative example of modern Operational Art is Douglas MacArthur's seizure of the Decisive Point at Seoul, Korea, in 1950 when the North Korean Army had the entire 8th US Army bottled up in the Pusan Perimeter. Like Bragg, the North Korean high command thought they would enjoy the initiative indefinitely and defeat the pocket they were pressing. In October 1863, Longstreet found himself in nearly the same construct of Operational Design. He saw Bridgeport as the Decisive Point for the Union in the Chattanooga Campaign. In MacArthur's Inchon Plan, seizing the Decisive Point of Seoul, and using the operational facet of balance of a dual effort, would force the North Koreans to fight in two directions, one of which was at their rear. After a successful landing by United States forces, the North Koreans realized that they had lost the initiative and retreated north. MacArthur's plan was an achievement of Operational Art and Design. In Longstreet's case, taking Bridgeport would prevent Union reinforcements from supporting Chattanooga or threatening Bragg's rear. In addition, it would shut down most of their logistics flow. Conversely, if the Union secured Bridgeport, they would gain the advantage of forcing the Confederates to fight in two directions. Thus, for Bragg to maintain the initiative and win this campaign, he could not simply harass the enemy logistics routes near Chattanooga at the tactical level. He had to deal decisively with the flow of Union reinforcements. Longstreet conceived the Operational Design to accomplish this. He would also utilize the facet of balance, as well as incorporate all thirteen other primary facets, as part of two Confederate efforts that emerge as similar to MacArthur's Inchon Plan.

* * *

Barely considered in the existing historiography is Edward Porter Alexander's personal recollection titled *Fighting for the Confederacy*, in which the artillerist describes his reconnaissance for Longstreet's plan. Typical of the day, the planning was mostly verbal, and since it was not executed, it is largely forgotten. Longstreet

2 FM 100-5, *Operations*, Department of the Army, Washington, DC, 5 May 1986, 9. (Operational Art formally entered the Army's lexicon in 1982 as part of doctrinal terminology.)

mentions the Bridgeport Plan briefly in his memoir, but his remarks have probably been ignored because Lost Cause politics required their omission. Clearly, there is operational significance to the plan.

Most writings are limited to following Bragg's tactical focus. Bragg never considered the operational facets of anticipation, forces and functions, balance, and operational reach as starting points toward a design. He did not understand that preventing Union reinforcement of the operational area was more important than tactical actions in Lookout Valley. Writers who take this viewpoint, and who are not schooled in the Operational Arts, often contend that Bragg's, "First error was allowing the Federals to open a line of supply (the Cracker Line) into Chattanooga." Douglass Southall Freeman opined, "Bragg had prepared the road to ruin when he permitted Rosecrans to open short and sure lines of supply at Chattanooga." Freeman's assertion is incorrect, because the Union Center of Gravity was not an additional supply route. By late September, the Federals had already established rail and wagon routes to supply their position at Chattanooga. In November, steamers began to ferry supplies between Chattanooga and Bridgeport and further improved the situation. Logistics into the pocket was important, but it was not the Center of Gravity when time was on the Union side and the siege was limited. The road to Confederate ruin led back to the place where Union corps-size elements, in the process of gathering, were going to arrive and outnumber Bragg's forces.[3]

The true Center of Gravity for Union forces in the Chattanooga campaign was the aggregate strength of their gathering reinforcements in combination with the troops already in the city. The Decisive Point was the town of Bridgeport because whichever side controlled that place held a marked advantage, a fulcrum over the other side within the operational area.

It is Bragg's misidentification of the Union Center of Gravity, and the absence of correct operational level analysis recognizing this error, that perpetuated the long-standing myth that Lookout Valley was more important than reinforcements. The notion that the Confederates had to maintain a grip on Brown's Ferry and Lookout Valley "if they were to continue depriving the Union forces in Chattanooga of all but bare minimum" was not a solution that impacted the Union Center of Gravity.[4]

3 Connelly, *Autumn of Glory*, 255; Hallock, *Braxton Bragg*, 113; 122-126; Freeman, *Lee's Lieutenants*, 3: 295.

4 McDonough, *Chattanooga*, 81.

Alexander elaborated on the Bridgeport Plan: "So, when the plan of forcing the enemy to abandon Chattanooga failed, something else had to be tried." Between October 10 and 12, Longstreet sent Alexander on a reconnaissance mission to evaluate and map the anticipated operation, one that would establish a Confederate corps-size presence in Bridgeport.[5]

Indeed, the most important geographical location to the Union forces outside of Chattanooga was Bridgeport, Alabama. Bridgeport was vital because of its railroad terminus. Although the Confederates had attempted to burn much of the railroad bridge over the Tennessee River, the town remained the nearest rail hub for the Federals to receive supplies and reinforcements. It was a key enabler for the Union and conversely a key objective for the Confederates.[6]

Alexander rode out to the town and spotted a few Union defensive earthworks as well as a pontoon bridge stretching from Bridgeport to a narrow island called Long Island. The first troops under Hooker had arrived earlier on September 30 through October 2, and Alexander only saw approximately 100 Union soldiers. Thousands more by then were working Haley's Trace, moving supplies back and forth. He envisioned a raid to take the town. In Alexander's estimation, the "Situation seemed to give a very fair chance for a surprise." Returning to Longstreet on October 12, he briefed the general on his findings and offered the idea of transporting troops across to the Union side by seizing their pontoon boats as a means of taking Bridgeport. Longstreet liked the idea and began to devise a plan to attack Bridgeport. The plan required the Confederates to reduce the siege effort at Chattanooga and establish a better logistics base at Rome, Georgia, as a means of supporting the forces that would operate in northeast Alabama.[7]

Longstreet first took the idea to Bragg, who was preoccupied with a visit by President Davis and said nothing about it. He also wrote to Lee and offered his opinion on the situation. Lee then articulated Longstreet's views to Davis who agreed with the strategy. With Rosecrans confined to Chattanooga, and the offensive morale of his army somewhat diminished, it was conceivable that the Confederates could pull most of the army "from the lines at Chattanooga and put it to active work in the field." Davis was agreeable to the greater portion of the army being used against another objective. The Confederates needed a strike force to handle Joseph Hooker's command gathering around Bridgeport. Such a force

5 Alexander, *Fighting for the Confederacy*, 305-306.

6 Dana, *OR*, 30/1: 184, 214-215.

7 Alexander, *Fighting for the Confederacy*, 305-306; Schurz, *Reminiscences*, Vol. 3., 56.

required close to double Hooker's numbers, and thus the Confederates needed at least four of the eight divisions in the Army of Tennessee to move against Bridgeport and seize the rail terminus. During the first days that Union reinforcements from Virginia operated in the area, Hooker deployed many troops over the sixty-mile route of Haley's Trace, the supply line running between Bridgeport and Chattanooga. This is probably why Alexander saw only 100 enemy troops across the river. This also meant that the number of troops Hooker had in Bridgeport was less than 15,000. An equal number of Confederate forces might have been adequate for a successful operation, particularly if commenced in a timely manner. Assuming the Confederates achieved their objective of seizing the Decisive Point, the result of the Bridgeport Plan would be Interdiction. That is considered an action to divert, disrupt, delay, or destroy the enemy's military potential before it can be used effectively. If the Confederates had executed Longstreet's Bridgeport Plan, the action might have forced the Federals to abandon Chattanooga and prevented Sherman from coming to the area.[8]

Attacking Bridgeport, immediately after Alexander returned, might have been desirable, as an engagement at this stage would have forced Hooker to fight with only a few thousand combat troops ready and available at the town. Had the Confederates sent several divisions of infantry, plus their idle cavalry, they might have overwhelmed the Union garrison.

If they had taken down this key Union rail line, Longstreet's plan would have retained the Confederate initiative and begun the leveraging of this Decisive Point. The Confederates would have denied Hooker the ability to support or cooperate with the Army of the Cumberland. By eliminating a key Union supply hub, the Confederates would also have denied Sherman a secure entry point east of Stevenson, and in doing so put him at a disadvantage. Bragg had two weeks from the date of Longstreet's October 12 proposal before all of Hooker's 15,000 men concentrated to advance into Lookout Valley. He had one month before Sherman's 17,000—20,000 arrived.[9]

Conditions in Chattanooga also supported Longstreet's plan, as Union soldiers were on short rations and the animals were too weak to haul equipment. Sherman recalled that as late as November 14, the situation remained tenuous:

8 Alexander, *Fighting for the Confederacy*, 306, Longstreet, *Manassas to Appomattox*, 468; Army FM 3.0. 2.68. Davis visited the army October 9-14 to address the discontent among Bragg's subordinates. He gave a speech to the officers and about 100 men at a farmhouse on October 10. Simpson, Ed., *The Civil War: The Third Year*, 546-547.

9 Sherman, *Memoirs*, 386. Sherman did not reach Bridgeport until November 13.

The mules and horses of Thomas' army [Thomas had taken over from Rosecrans in late October] were so starved that they could not haul his guns; the forage, corn, and provisions were so scarce that the men in hunger stole the few grains of corn that were given to favorite horses; that the men of Thomas' army had been so demoralized by the battle at Chickamauga that he feared they could not be made to get out of their trenches to assume the offensive; that Bragg had detached Longstreet with a considerable force up into Tennessee, to defeat and capture Burnside; that Burnside was in danger, etc., and that he (Grant) was extremely anxious to attack Bragg in position, to defeat him, or at least force him to recall Longstreet. The Army of Cumberland had been in the trenches so long, he wanted my army to take the offensive *first*; after which, he had no doubt the Cumberland army would fight well.[10]

Sherman saw that the Union soldiers in the pocket were hungry, but they were not starving. The condition of the animals was the issue. Having animals that were not strong enough to haul cannon and caissons to support offensive operations meant that Thomas could neither attack with artillery support nor haul out the batteries. Still, as demoralizing as the situation was, it was far from hopeless. Grant could wait for a fresh force to start the offensive and spark confidence in the soldiers at Chattanooga. He would do this with the arrival of Sherman. The conditions, verified by Grant and Sherman and understood by Longstreet, meant Bragg could go after Bridgeport with most of his divisions and keep only a few around Chattanooga. The key to making this happen was for Bragg to recognize the need to modify the siege and convert it into a minimal investment. A holding action or ruse around Chattanooga was in order while the army maneuvered decisively against Bridgeport.

While President Davis was visiting, Longstreet had communicated this plan to him. Davis approved the plan and wanted Bragg to execute it at once, but the general delayed any action. Subsequently, Bragg notified Longstreet that rain was a consideration and there was not adequate transport to support the movement of the troops to Bridgeport. He settled on cavalry actions instead. The cavalry produced no results and Bragg still did not take decisive action against Bridgeport. Longstreet, having explained directly to Davis his plan, may also have caused Bragg to oppose its execution. Perhaps Bragg's mental state also played a role in his inaction. Bragg remained irate over the miscarriage of his plans at Chickamauga. He had one voice in agreement with him regarding Longstreet's plan. Hardee, who

10 Ibid., 387; Schurz, *Reminiscences*, 55. Longstreet was detached and sent to Knoxville on November 4.

wanted Bragg replaced after Murfreesboro, agreed with Bragg this time that transport was a problem. This did not help Longstreet's argument to strike Bridgeport. Although Longstreet's main ally was Davis, the President was no longer in the area, and discussion about the Bridgeport movement ceased.[11]

Almost ninety years later, MacArthur also faced significant opposition from the Joint Chiefs, including Omar Bradley. Navy and Marine Corps leadership in Theater wanted to "land [100 miles south at Kunsan] where we can best land." Countering his critics, MacArthur responded: *"Let's land where we must land* to achieve our strategic objectives." MacArthur, from his authority as Theater Commander, and by virtue of his reputation and force of will, was able to push his vision through. Longstreet had none of these assets under Bragg. Unable to convince Bragg to go where they must, Longstreet lost confidence that he could accomplish anything further and became reticent. His only friend and ally was his commanding general Robert E. Lee, who wrote to him at the end of September. Lee told him how great the Chickamauga victory was, and of his problems in Virginia without him there to help. "But I miss you dreadfully, and your brave corps…I hope you will soon return to me. I trust we may soon be together again…. Very truly yours, R. E. Lee." Longstreet pondered resolution in Georgia, but also a return to Lee.[12]

The long-standing, prevailing view of this situation tends to agree with Bragg's erroneous estimation of his *operational reach*. This misses the point that Bragg simply did not understand the opportunity. Therefore, this facet warrants detailed discussion to better understand the first step of Longstreet's Operational Design. Bragg states in his series of reports that "Nearly half our army consisted of re-enforcements just before the battle (Chickamauga) without a wagon or an artillery horse." The number of wagon transports before, during, and after Chickamauga was not optimal, and in some units was minimal. Longstreet also noticed this and mentioned it in his report. However, that did not stop eight divisions from following the ten-mile Union retreat from Chickamauga to Chattanooga between September 21 and 23. During that time, the Confederates buried thousands of dead, collected thousands of pieces of captured equipment, and went through a significant reorganization. A shortage of wagons was not a

11 Longstreet, *Manassas to Appomattox*, 469-470.

12 *The Visionary: MacArthur at Inchon*, rand.org/pubs/monograph reports/MR775. Ch. 6, 78-87; Longstreet, *Manassas to Appomattox*, 470; The Navy and Marine leadership wanted to land at Kunsan, Korea, 100 miles south, to use the considerably better beach sites, compared to the difficult port and pier facilities of Inchon. (Maps at end of chapter).

valid reason to remain idle around Chattanooga when Bridgeport was within a one or two-day twenty-six-mile march.[13]

To clarify, Longstreet's divisions under Law and McLaws had no wagons or horses for artillery, since trains from Virginia had transported them. The other divisions in Bragg's army, however, had some wagons. Although perhaps not as many wagons as Bragg would have liked, the fact remains that more than half of his divisions had wagons. Divisions under Cheatham, Cleburne, Breckenridge, Walker, Liddell, Hindman, Preston, and Johnson all had wagon transport. Additionally, in after action reports from Chickamauga, many officers mentioned capturing wagons. According to these reports the aggregate number of captured wagons reached forty.[14]

A regiment of infantry typically had up to six wagons to haul supplies. If a typical division had four brigades and each brigade had four regiments, they would require ninety-six wagons plus a few additional for the artillery and various headquarters elements. Standards varied by army and period in the war, and it is difficult to find exact records about how many wagons Bragg's divisions had in the time between Chickamauga and mid-October. Several Confederate officers mentioned using their own wagons to haul captured muskets, ammunition, and supplies from the battlefield. Adding forty or more captured wagons was at least enough to outfit nearly half a division or to increase wagon numbers in all divisions. Clearly most of Bragg's divisions had wagons enough to operate within a radius around Chattanooga that included Bridgeport. In other words, if most regiments in the Army of Tennessee did not have the optimal six wagons each, there were still enough to evenly cross-level wagons so that Bridgeport was within the operational reach of more than half of Bragg's army.[15]

Longstreet's divisions possessed no wagons and were the logical choice to remain on Missionary Ridge to keep the pressure on Thomas. They needed to stay close to Chickamauga Station to receive their logistical support and have quick access to it in case of emergency. The bulk of Bragg's Army consisted of the six western divisions, and they did have some wagons. One-fifth of Bragg's army was mounted and available to move against Bridgeport. The fact that Bragg later

13 John B. Turchin, *Chickamauga*, 159.

14 *OR*, 30/2: 304, 305, 321, 365, 403, 471, 482, 497, 502; Glen Tucker, "The Battle of Chickamauga," in *Civil War Times Illustrated*, May 1969; 30.

15 H. D. Clayton, *OR*, 30/2: 403; JNO. S. Fulton, *OR*, 30/2: 478.

detached Longstreet to Knoxville without wagons illustrates that the proposed move to Bridgeport was possible.

Marching the twenty-six miles to Bridgeport, perhaps on October 15, would have brought decisive strength there. Two days later, at the latest. Hooker's troops marched into Lookout Valley, crossing the river at daybreak, and most were at Wauhatchie by 3 p.m., while the remainder arrived at Brown's Ferry after nightfall. Troops on foot in every war since the ancient world have typically marched fifteen to twenty miles a day in most conditions. Bragg might have arranged the operation so that a significant mounted element could have struck Bridgeport at an opportune time. At least two infantry divisions should have been able to travel from Missionary Ridge to the east bank of the Tennessee River, opposite Bridgeport, in thirty-six hours at most, rain or no rain. As many as four more divisions could have followed through Lookout Valley or south of Lookout Mountain and been available two to three days later. If a wagon shortage prevented four divisions from following these routes, some divisions could have gone to Rome by rail, gathered supplies and wagon transport, and proceeded into Alabama south of Bridgeport. Then, they could have moved north to join the forces already in place or support an assault from the south. If the Confederate strike force forded near Bridgeport, per Alexander's idea, and another portion came another way, the bulk of the army would be in possession of Bridgeport and concentrated to attack Hooker. A large strike force would probably need a new supply base, and Longstreet considered this in the Operational Design of his vision.

Rome, Georgia: The Perfect Logistical Support Base

At sixty-seven miles from Atlanta, with an adequate rail line between the two cities via Kingston, Rome was comparable to Chattanooga in size and population. Eighty miles from Bridgeport, it was capable of supporting an army and was already a major war industry center. Noble Brothers' Foundry & Machine Works was in Rome, manufacturing high quality cannon ranging from three-inch rifles up to 32-pounder seacoast rifles. Other manufacturers produced uniforms and accouterments. As a center for heavy ordnance and other military supplies, the city had a transportation network that moved materials in and manufactured goods out by means of road, rail, and river.[16]

16 George Magruder Battey Jr. *A History of Rome And Floyd County*, (Atlanta: The Webb & Vary Co., 1922), 451.

14 Facets of Operational Art Compared

Bragg's Partial Siege:	Longstreet's Bridgeport Plan:
Center of Gravity (wrong CoG)	**Center of Gravity (Correct CoG)**
Decisive Point (none seized)	**Decisive Point (DP=Bridgeport/Stevenson)**
Synergy (none)	**Synergy (yes)**
Simultaneity & Depth (none)	**Simultaneity & Depth (yes; multi effort)**
Anticipation (none; ignored reinforcement)	**Anticipation (yes; Interdicts Hooker & Sherman)**
Balance (none, single effort only)	**Balance (yes; dual effort, uses Rome, GA)**
Leverage (no DP leveraged)	**Leverage (yes; time, mass, Union isolation)**
Timing and Tempo (none; inactive)	**Timing and Tempo (yes; continued maneuver)**
Operational Reach (yes)	**Operational Reach (yes)**
Forces and Functions (yes)	**Forces and Functions (yes)**
Arranging Operations (none)	**Arranging Operations (yes; use of Rome, GA)**
Direct versus Indirect (ineffective dir.approach)	**Direct versus Indirect (yes; indirect approach)**
Culmination (arrival of Union reinforcements)	**Culmination (open ended)**
Termination (no; unknown)	**Termination (upon collapse of Chattanooga)**

Items in **BOLD** indicate success. Bragg gets two while Longstreet gets them all.

As a logistical center for the Bridgeport operation Rome was perfect, and that is why Longstreet picked it to support the move. It was twenty miles from the Alabama state line and had a good road network; one that provided at least two (axes) of advance into Alabama and on to Bridgeport.[17]

A move utilizing Rome for support, as Longstreet advocated, would remedy several problems simultaneously. All eight divisions invested in a partial siege of Chattanooga were also on partial rations. Atlanta was over 100 miles away and Confederate logisticians struggled to support the large army with the patchwork rail system running between the two locations. If the two Virginia divisions, plus one other, remained on Missionary Ridge, the Confederates would have reduced the burden of logistical support along the Atlanta to Chattanooga railroad line by one-third. The other five divisions would receive their logistics directly from Rome. The entire logistical situation would have improved for Bragg, as the longer

17 Longstreet, *Manassas to Appomattox*, 468.

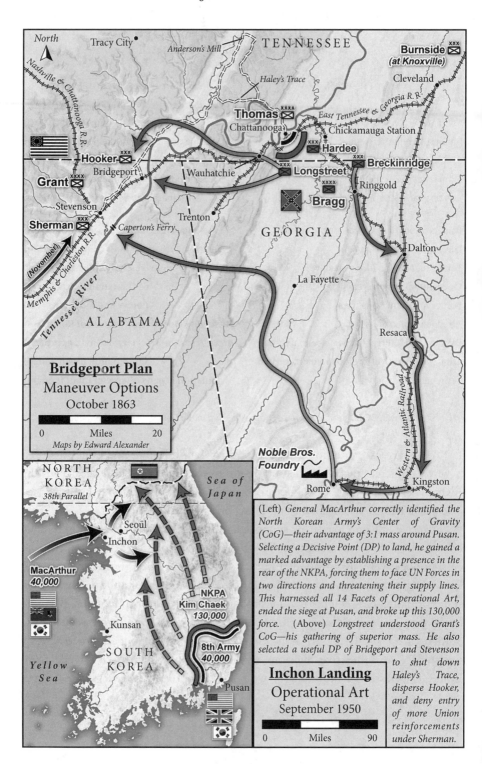

Bridgeport Plan
Maneuver Options
October 1863

0 Miles 20
Maps by Edward Alexander

Noble Bros. Foundry

(Left) *General MacArthur correctly identified the North Korean Army's Center of Gravity (CoG)—their advantage of 3:1 mass around Pusan. Selecting a Decisive Point (DP) to land, he gained a marked advantage by establishing a presence in the rear of the NKPA, forcing them to face UN Forces in two directions and threatening their supply lines. This harnessed all 14 Facets of Operational Art, ended the siege at Pusan, and broke up this 130,000 force.* (Above) *Longstreet understood Grant's CoG—his gathering of superior mass. He also selected a useful DP of Bridgeport and Stevenson to shut down Haley's Trace, disperse Hooker, and deny entry of more Union reinforcements under Sherman.*

Inchon Landing
Operational Art
September 1950

0 Miles 90

support line would no longer be the main source of logistics for the Army of Tennessee. A large portion of supplies would come from a closer base at Rome.

Once the town was in Confederate hands, they could establish a pontoon bridge for foot traffic and work on repairing the railroad bridge over the river. All routes would allow Confederate forces to redeploy to Rome, and back to the Chattanooga area if Thomas initiated action. Thus, Longstreet's idea to establish a new logistics base at Rome and take the Decisive Point of Bridgeport, would have both restored operational maneuver and improved the overburdened state of logistics by splitting the effort between Rome and Atlanta. It would have created a network of secure interior lines for the AOT and put a large area of northeastern Alabama and northern Georgia under their control. Most importantly, the Confederates would control the best entry point for Union reinforcements to help Thomas at Chattanooga.

The capture of this operational Decisive Point would also secure the strategic left flank of the AOT. In fact, the Confederates could apply all fourteen facets of Operational Art. Distance would separate large elements of the Union force and render them unable to support one another. The Confederates would have a strength advantage over Sherman if he arrived at Stevenson for a move against Bridgeport. Four miles west of the town at Mount Carmel there was adequate open space to maneuver offensively, and closer to Bridgeport stood a series of hills suitable for a defensive battle. The severe reduction to the existing minimal supply would provide the worst blow to Thomas, as the loss of Bridgeport would have exponentially reduced the logistics flow.

Lookout Valley has been incorrectly viewed as "terrain they had to hold." Bragg was incorrect when he wrote to Longstreet, "it is almost vital; it involves the very existence of the enemy at Chattanooga." It was not vital, because the Haley's Trace *supply lines maintained the existence of the enemy in the city*. Although the troops in Chattanooga had to go on reduced rations, this is not an indication that the siege was working or that the Federals could not survive. History is replete with sieges lasting longer than that at Chattanooga, in which defenders on less than half rations maintained their position and the ability to resist.[18]

Considering the idea of effectively controlling Lookout Valley, the Confederates could not robustly block all the potential spots along the river and prevent Union troops from entering the area. From Bridgeport, there were numerous ways Union troops could engage and cut off Confederate presence in

18 McDonough, *Chattanooga*, 81-82; Bragg, *OR*, 30/1: 215.

Lookout Valley. There were several locations for Union engineers to bridge the Tennessee River to expedite a strike against the Confederates. To try covering the whole valley, in the face of growing Union strength, would have been a hopeless juggling act for the Confederates—a dyke that Grant would have breached, sooner or later.

Since the Union supply line started in Bridgeport, seizing the town would have resulted in Lookout Valley being absorbed into the larger area of operational control and becoming *irrelevant* to the situation. Once this happened, the time aspect, shown through the mission analysis process as not supporting Bragg's partial siege, would become his biggest lever against the forces in Chattanooga. The last place supplies could come into Chattanooga was from the rail spur at Tracy City, Tennessee, and over Waldon's Ridge by wagon. This was the least desirable route, due to difficult terrain.

Had the Confederates controlled Bridgeport, the flow of supplies to Chattanooga would have effectively ended before Sherman's arrival. Bragg could next target Tracy City and if he occupied the town, Thomas would have no supply line. Then, the prospect of starvation would become more likely and probably make the Union position untenable. Surrendering, or attempting to shift his infantry north and northeast toward Knoxville for a junction with Burnside, may have been Thomas's only remaining options. If the Union had to abandon Chattanooga, and the strategic initiative remained with the Confederates in Tennessee, it would have been a long time before they could regain the initiative in this theater. Atlanta would have stayed out of reach for a longer time as well, perhaps long enough to influence the election in 1864.

The Initiative Shifts to the Union

On October 19, Grant travelled to Louisville, Kentucky, to meet with several members of the War Department including Secretary of War Edwin Stanton. The next day, Grant received an appointment to take command of the Military Division of the Mississippi and overall direction of efforts in the west. That night, a War Department official in Chattanooga wired a report to Grant indicating that Rosecrans was considering a retreat. Although untrue, Grant immediately wired back to Chattanooga and relieved Rosecrans. In his place Grant appointed Thomas and instructed him to hold.[19]

19 Grant, *Memoirs*, 350-353; Schurz, *Reminiscences*, 58-59; Foote, *The Civil War: A Narrative*, 803.

The next day, Union forces made the move Longstreet had feared, an unopposed arrival of significant combat power into the area of operations. On October 20, Hooker's largest troop trains arrived at Bridgeport and downloaded completely within twenty-four hours. On October 21, Grant instructed Thomas to increase the number of parties on the Haley's Trace wagon road to push more supplies into the pocket. Next, he wired Burnside at Knoxville and ordered him to begin fortification work. On October 23, Grant arrived in Chattanooga and the initiative in the Western Theater swung back to the Union. The success of Chickamauga had become a lost victory. The rest of the Chattanooga campaign was simple math and the next six weeks exemplified Grant's irreversible will.[20]

Bragg's *idée fixe* to commit the AOT to a partial siege had failed, and in an operational sense the whole situation grew close to hopeless. Hooker's unchallenged arrival meant the siege was surely over. Hooker could support Thomas and the two sides were at parity. Although it would still take time for all of Sherman's reinforcements to arrive and start offensive operations against Bragg, the appearance of Hooker achieved the level of *simultaneity and depth* of operations that the Union needed. It gave them the ability to fix and attack from two directions at the same time, and even without an additional line, the activation of Bridgeport as a major logistics hub increased the flow of supplies into Chattanooga over existing routes.

Contrary to what some have indicated, Lookout Valley itself was not the Center of Gravity and neither was the interdiction of supplies through it. The Center of Gravity was Hooker's force of 15,000 troops. The number of troops would grow with the addition of Sherman's 17,000 and potentially included Burnside's 20,000 in Knoxville, should Grant choose to summon his command. The arrival of reinforcements gave the Union the initiative and ended any chance Chattanooga would starve or surrender. It gave Union corps-size units the ability to mutually support each other for a variety of courses of actions. The key for the Confederates was to interdict Hooker's force, keep it away from Bridgeport, and prevent the arrival of Sherman by seizing his best entry point. With that chance gone, Bragg wanted to keep the reinforcements out of the valley with minimal deployment of force, while sustaining the siege indefinitely. These actions were not possible. As Frederick the Great postulated, "If you hold everything, you hold nothing." Longstreet tried to convince Bragg, in the context of the Bridgeport Plan, to use minimal force to maintain the siege line while developing the left flank with

20 Grant, *Memoirs*, 353.

maximum force to take Bridgeport. Once there, confront and interdict the Union reinforcement at or near their arrival point in Alabama, and attempt to destroy this force before it could support the pocket in Chattanooga. At the very least, chase it away long enough to sever the key supply artery and force Thomas to pull out or give up. Bragg's desire to block Lookout Valley was an inept tactical response to the enemy already coming in via the backdoor and did nothing to prevent the eventual disparity in numbers. By late November, Bragg had 66,000 aggregate troops present, but within the entire operational area, Grant had 100,000 in four commands at his disposal.[21]

The Myth That Occupying Lookout Valley Was a Sound Course of Action

Many who have commented on this campaign hold that Longstreet erred in not occupying Lookout Valley to prevent the Union from establishing the Cracker Line. Some believe this caused the Confederates to lose the campaign. This is not true. Trying to occupy Lookout Valley solves nothing. To put forces in the Valley was to isolate them in a separate terrain compartment and put them at risk of being cut off. It would not have prevented Union troops from coming into the Valley from several different spots along the river. Most importantly, an occupation of Lookout Valley would do nothing to stop the flow of Union reinforcements into the area or the continued operation of Haley's Trace.

Many commentators later promoted the myth that the "Cracker Line" caused the Confederate defeat. For example, author James L. McDonough asserts that Longstreet was wrong in his official report about Brown's Ferry. In the report Longstreet stated, "That the point is not essential to the enemy at Chattanooga is established by the fact that he supplied his army at that place some six weeks without it." While McDonough believes Longstreet was mistaken, the fact is that the general was attuned to operational concepts. While the Cracker Line increased rations to Thomas and improved his soldiers' morale, the reinforcements under Hooker and Sherman were the Center of Gravity. Longstreet was correct to express concern that they could threaten their rear, but more importantly, these

21 Wert, *Longstreet*, 329-334; Carol Reardon, *I Have Been a Soldier All My Life*, (Gettysburg: Farnsworth Military Impressions, 1997), 42-43; Army FM 3.0. 8-1; Abstract of Returns, Army of Tennessee, *OR*, 31/2: 656-657; Bonekemper, Edward H., *Victor not Butcher*, (Washington DC: Regnery Press, 2004), 134. With the 20,000 under Longstreet and an additional 11,000 in between Knoxville and Missionary Ridge, estimates have Bragg at only 36,000 vs. Grant's approximately 80,000 for the battle the of November 23-25.

forces gave the Union the initiative. Longstreet correctly understood that there was no *tactical* solution to Bragg's *operational* problem.[22]

On October 24, Grant ordered Hooker to cross the Tennessee River at Bridgeport and move to Rankin's Ferry, a spot two miles west of Running Water Creek. On October 27, Hooker directed his subordinate, Oliver O. Howard, to march along Raccoon Mountain into Lookout Valley through Wauhatchie station and then on to Brown's Ferry. If the Confederates were to attack Hooker in Lookout Valley, it would require all of Longstreet's Corps, plus reinforcements, to assemble the combat power necessary to overpower Hooker. At that point, Hooker had 12,000 troops deployed in Lookout Valley, almost two divisions. Bragg claimed he told Longstreet that he was free to pull his two divisions plus another, out of the siege line to secure Lookout Valley. Longstreet countered in his memoir that he did not have these units under his control, but that all remained committed to siege by the commanding general.[23]

Regardless, Hooker deployed his force to fight, and this posture made the possibility of eliminating him less likely. On a related point, Bragg maintained that he directed Longstreet to conduct a reconnaissance near Bridgeport and determine Union activity. Although there were elements of Confederate cavalry around Bridgeport assigned to monitor Union activity, Longstreet had not received word from them on the day Hooker moved from the town into Lookout Valley. The cavalry belonged to the AOT and should have reported directly to Bragg as well as Longstreet, but neither received a dispatch.

The cavalry element did not do its job. When they saw Hooker's troops come into Lookout Valley, they should have reported the movement at once. When Longstreet saw this enemy movement from his position on Sunset Rock, he was taken by surprise. Longstreet thought the Union would probably march along Lookout Mountain when they decided to come; but they had any number of routes they could have taken. This action then became a point of contention between Bragg and Longstreet. Bragg thought Longstreet had failed him and he became agitated during their meeting. The military reality, however, was that Bragg never took action to occupy Bridgeport. Thus, it was only a matter of time before Hooker

22 James L. McDonough, *Chattanooga—A Death Grip on the Confederacy*, 85-89; *OR*, 31/1: 218.

23 *OR*, 31/1: 54-56.

would slacken his focus on running the Haley's Trace line and start to maneuver toward Chattanooga.[24]

Bragg had to decide. The Confederates either had to pull troops from positions on the siege line, and start a risky decisive battle in Lookout Valley, or allow the newly established supply line to run through it. He had to choose whether to become engaged decisively with Hooker's forces there and confront the new threat to his left and rear or yield the initiative to the Union and continue a defensive campaign from that point forward. Acting against this new force was Bragg's responsibility as commanding general, and the task was not as simple as ordering a corps commander to shore up the left flank. However, unlike the proposed earlier operation against Bridgeport, one that the Confederates could have executed against fewer troops and harnessed a Decisive Point, attacking in Lookout Valley carried significant risk. Bragg faced a situation that required him to attack a larger force. That force was fully deployed, prepared to fight, close to his flank, and working in concert with Union troops in Chattanooga.

A general attack by Longstreet required three to four divisions striking quickly to have any chance of overpowering Hooker. Unfortunately, this fight would not impact Bridgeport. The terrain in Lookout Valley further complicated the issue for the Confederates. The place was not ideal for massing a large force and it would have been impossible to move artillery over Lookout Mountain and down into the valley with enough speed to support the infantry. If the Confederates did not launch a large assault, and a division seized a defensive blocking position to stand against Hooker's 12,000 troops in Lookout Valley, the results still were not going to prevent the lifting of the siege or stop the flow of supplies over Haley's Trace. Hooker would still be there; forcing the Confederates to face Union troops from two directions. Doctrinally, and as a matter of tactical experience, blocking positions are intended for short periods, as the enemy will adjust his operations to counter or avoid the blockage.

Lookout Valley was helpful to Grant because it allowed him to open another shorter and more convenient supply line. Dubbed the "Cracker Line," this began at Bridgeport with small boats up the Tennessee River to Kelley's Ford, where the land route then ran across Raccoon Mountain to Brown's Ferry. There, it crossed the river over a pontoon bridge, across Moccasin Point, and once more across the river and into Chattanooga. It accelerated Grant's ability to restore full rations for the troops in the city. It was helpful that Grant approved of this plan, but the new

24 Longstreet, *Manassas to Appomattox*, 474-475.

line was not essential. Later, more supplies came by the steamer "Paint Rock" up the Tennessee River from Bridgeport. This route proved the most viable, since the Federals could ship larger loads than wagons and mules could carry. By November, the river was at a high-water level, which allowed steamers to clear the half dozen obstructions between Bridgeport and Chattanooga. Chattanooga would hold indefinitely until the arrival of these reinforcements, his Center of Gravity.[25]

So long as he had Bridgeport, Grant could wait for Sherman and simply flex his Center of Gravity, his numerical advantage, toward something else when he was ready. Grant had the initiative and dictated the movements. Preventing the operation of the Cracker Line would not have resulted in the starvation of the Chattanooga garrison, so there was no operational substitute for taking Bridgeport when the Confederates had the time to do so. No tactical movement into Lookout Valley could have prevented a Union seizure of the initiative if the Federals had been allowed to come into the Decisive Point of Bridgeport. Could a general attack against Hooker in Lookout Valley by the greater portion of Bragg's army have righted the situation? It is impossible to say. But severely thrashing Hooker was a long shot, one that was tied to the question of whether several Confederate divisions could effectively maneuver against Hooker's divisions. They could probably have done so, but only with great difficulty. There was not that much of an open, level expanse for the Confederates to mass effectively. One must also take into consideration that without artillery support, and in a hasty attack, success was much less likely than if the Confederates gave battle on better terrain west of Bridgeport.[26]

Confusion at Wauhatchie Station

On October 28, Bragg and Longstreet met at Sunset Rock, while the lead of Hooker's column neared Wauhatchie Station. For Longstreet, the sight of a fresh

25 Grant, *Memoirs*, 370; Connolly, *Three Years in the Army of the Cumberland*, 136; Hannaford, *Story of a Regiment*, 492. K. Jack Bauer, Ed., *Soldiering the Civil War Dairy of Rice C. Bull 123rd NY Vol. Inf.* (San Rafael, CA: Presidio Press, 1977), 97. It should also be noted that Sherman's force initially occupied a hidden camp at a spot called Crane's Hill, a few miles north of Chattanooga. This position did not receive all its supply from the Cracker Line, but from Haley's Trace and the steamer route. For the Confederate situation, putting troops in Lookout Valley against Hooker's larger force would be similar to the Ia Drang Valley battle in the Vietnam War, where a US platoon was cut off from its parent battalion and nearly destroyed by isolation and constant attack by overwhelming numbers.

26 Longstreet, *Manassas to Appomattox*, 474-475; Schurz, *Reminiscences*, 59-66.

force entering the campaign must have been infuriating. Now Grant had substantial numerical superiority, and with that came relative freedom of movement. Following the failure to seize Bridgeport, something like this was not unexpected. But Bragg was angry, and in a mood to verbally attack Longstreet. He thought this turn of events should have been prevented, even though the Confederates wasted more than a month on the irrelevant partial siege rather than taking Bridgeport. Longstreet knew Bragg still did not understand the big picture, but Longstreet could not argue with the commanding general. It was futile to discuss the fact that he did not personally have a situation report from the cavalry element near Bridgeport regarding Union activity on the day Hooker arrived. Longstreet did not like Bragg's demeanor, but felt it his duty to come up with some sort of action. Once Bragg's anger subsided, he and Longstreet decided to attempt a night attack on October 28 against Wauhatchie Station. Confederate generals assigned to the mission, Evander Law and Micah Jenkins, experienced problems between them that caused confusion and the attack ended in failure. The 6th Carolina Brigade under Law, fired on Howard's lead division, commanded by Prussian immigrant Adolph von Steinwehr. Coordination between Jenkins and Law never materialized, and Longstreet's troops did not score even a modest tactical success—which in any case would have been of no operational value. Some historians have given Longstreet's tactical plan decent marks, considering the attainable objective of destroying or capturing a supply wagon train and dispersing several Union regiments. These objectives were realistic, but there was nothing decisive that the Confederates could gain from this engagement. The complexion of the campaign had changed from a narrow focus on a city, to a struggle of relative resources and force ratios spread over a large area outside Chattanooga.[27]

Bragg still wanted to take Lookout Valley, and on October 31 he asked Hardee, who had replaced Polk, to consult with Longstreet and Breckenridge. The generals were to assess the situation and determine if the mission was practicable. The three concurred that it was impossible, as the Union now had several entrenchments in the Valley.

On November 4, Bragg "foolishly detached Longstreet's corps to overwhelm Burnside at Knoxville, and thus dangerously weakened himself." Grant surmised the purpose of this movement was to threaten Knoxville so the Federals would send troops to aid Burnside. Such a shift could reduce Union combat power enough to prevent an attack against Bragg. This movement also had another

27 Schurz, *Reminiscences*, 71.

purpose. Lee wanted his corps and corps commander back and moving Longstreet toward Knoxville put the corps in a better position to return to Virginia. Irreconcilable differences between Longstreet and Bragg were not the reason for this movement. That was coincidental. The corps belonged to the ANV and would have to return to it eventually.[28]

While Bragg and Longstreet had cold periods of non-communication, there were some instances where they did confer, plan, and work toward a common purpose. They met, for example, on November 3 to plan the movement against Knoxville. On November 4 Bragg wrote to Longstreet, "your quick recall may be necessary." The next day Longstreet wrote back, "by means of rail I hope to reinforce either point as necessary."[29]

Although at the time Grant was worried by Bragg's move against Knoxville, he posed an interesting question in his memoir. What possible military value would Knoxville be to the Confederates if the Union still held Chattanooga? In his opinion the "great blunder by Bragg was detaching Longstreet." Grant mentioned this three times in his account. Furthermore, he states that Bragg's action served only as a means of "reducing his own force by one-third and depriving himself of the presence of the ablest general of his command." As Grant readied his counter stroke, it was clear that Bragg would have had a better chance of avoiding defeat had he kept Longstreet's corps with him.[30]

The Final Act

The Confederate defeat was resounding. On November 23 and 24, Grant sent Sherman and Hooker to envelop the Confederate flanks. On November 24, Bragg lost Lookout Mountain to Hooker's forces as one Union division swept west to east across the top of the mountain. This was just what Longstreet thought would happen. Next, Hooker proceeded to Rossville to threaten Bragg's left and rear. On November 25, Sherman's troops struck the Confederate right at Tunnel Hill, but divisions under Cleburne and Stevenson repulsed the attack. Amazingly, four divisions of Thomas's Corps advanced directly up Missionary Ridge and routed the

28 Bragg, OR, 31/3: 634-635, Longstreet, OR, 31/3: 636-637.

29 Grant, Memoirs, 388, 393-394.

30 Alexander, Fighting for the Confederacy, 328; Schurz, Reminiscences, 76-77.

Confederate center as Hooker engaged their left. Bragg's Army of Tennessee retreated, and campaign victory belonged to Grant.[31]

In a most honorable and calm manner, Bragg sent Richmond an assessment of his position. He mentioned his concern to save Longstreet and included a request for Davis to relieve him of command of the AOT. On November 30, Davis granted Bragg's request and elevated Hardee to temporary army command. In October, Davis had scolded Longstreet for even suggesting such a change. Davis soon announced that Johnston would take command of the Army of Tennessee. Bragg later admitted to Davis, "I fear we both erred in the conclusion for me to retain command here after the clamor against me."[32]

Johnston would do the best he could to defend Atlanta. The following year he would fight some very notable and even brilliant defensive actions as he fell back toward the city. Johnston's dogged Fabian defensive campaign, along with Lee's actions in Virginia in 1864, would give President Lincoln angst about his upcoming election that year.

Since Chickamauga, the normally energetic and self-assured Longstreet found himself in a period of low confidence. Despite the fact he was eventually to return to Lee, he remained disturbed by Chickamauga and Chattanooga and the difficulties of trying to work with Bragg. Lee was usually appreciative and harmonious, but that environment did not exist under Bragg. Longstreet's brusque demeanor and his direct correspondence with Davis and other politicians, although common for generals in the Civil War, were problematic to Bragg. Longstreet saw his loyalty to the Confederacy as the first order of business. He sought to aid the Confederate cause via his offensive approach to war as well as by developing operational concepts. Longstreet was unable to understand Bragg, and all the difficulties took their toll on him.

It is also fair to say that Bragg was overwhelmed by his many personal difficulties. Many believe he was a sickly, paranoid, miserable man, who should not have commanded such an important army at this time. Still, no one should say he did not try to do the best he could as he understood it. He failed to grasp the operational level of war and was overwhelmed by circumstances that required him to do so. The massive amount of stress he endured piled onto his conditions and made him unable to visualize the necessary movements. This included his failure to

31 Bragg, OR, 31/2: 664-667, 682-83; William M. Polk, *Leonidas Polk: Bishop and General*, 2 vols., (New York: Longmans, Green, and Co.), 2: 308.

32 Bragg, OR, 31/2: 667.

recognize the enemy's Center of Gravity. Bragg could not put aside his disappointment over the failure of his plans at Chickamauga, and he could not brush that aside when he had spectacular success on his left wing. He could not clear his mind and make the adjustments necessary to exploit that success. He could not think creatively or imaginatively regarding the problem set he faced with a partial siege at Chattanooga. He was disinclined to conceive of operational maneuver. Sudden interaction with the confident, blunt, and outspoken Longstreet perhaps shocked him even further. They were two individuals who could not have been more different, and their ways were truly foreign to one another. Their lack of chemistry and harmony in planning was a misfortune of war, but if Bragg did have a moment of clarity amid the battles in northern Georgia and Tennessee, he expressed it in a letter to President Davis on November 20, 1863: "Our fate may be decided here."

Still, Longstreet gave Bragg the greatest victory of his career and a chance to eliminate an entire Union army. Longstreet knew what next steps had be taken to destroy the AOC and prevent its escape and reinforcement. He persevered through the difficult post-Chickamauga time, staying true to the overall defensive-offensive strategies that had worked at Chickamauga. When Bragg picked the wrong Center of Gravity and chose partial siege as his course of action, Longstreet correctly identified the true Center of Gravity and was able to understand intuitively what the next move should be.[33]

It is interesting to speculate what course the war might have taken had Longstreet been able to convince Bragg to strike Hooker with overwhelming force at Bridgeport. Longstreet was the only one in Bragg's command who envisioned such opportunities and intuitively applied at Chattanooga the principles that, in another age, became known as Operational Art and Operational Design—the hallmarks of modern campaign planning.

33 Bragg, OR, 31/2: 667.

Chapter 15

The Armies Entrench

"Imperturbable coolness which always characterized him in times of perilous action."

— Colonel Charles Venable

Robert Underwood Johnson, the grandnephew of Bushrod Johnson, was working as an editor for *Century Magazine* in the decades after the war. He helped Grant with several of his articles and in an interview, asked Grant, "General, you know, of course, that you have been criticized for not having intrenched against Albert Sydney Johnston at Shiloh: is this true?" "Yes," Grant replied. "At that stage of the war we had not yet learned to intrench."[1]

From late 1864 to 1865 this all changed. The maneuver that was predominant in the first three years of the conflict was replaced by more static warfare. The outnumbered, less well-equipped army relied more and more on entrenchment to provide some equalization in unequal circumstances. In Europe in 1864 a short war between Denmark and a German Alliance under Bismarck was fought almost exclusively from behind works by the Danish Army. The Danes had no choice, outnumbered, and up against an army with modern bolt action rifles and breech loading howitzers. They initially defended from behind a giant thirty- kilometer earthen wall on their southern border, built in three phases between AD 737 and

1 Robert Underwood Johnson, *Remembered Yesterdays*, (Boston: Little Brown & Co., 1923), 214.

AD 968, then falling back to the fortress town of Dybbøl, to hold out in trenches that looked like those of France in 1915.[2]

The War Between the States in 1864, saw the two major remaining Confederate field armies also entrench more and more. Soldiers fought mainly in trenches and the war took other steps towards what would one day be called 'total war.' Civilians were generally not targeted, except in those areas where the line between civilians and guerrillas became blurred. But as the Union armies moved into the South, they increasingly targeted the infrastructure that supported the war. The Shenandoah Valley was laid waste. Entire counties in Missouri were denuded of population, swelling the increasing flood of refugees. Warehouses and factories were burned, railroads and bridges destroyed, plantations ruined. As the Confederates entrenched at Kennesaw Mountain and Atlanta, Sherman besieged them. Sherman torched Atlanta's business district, and Columbia went up in flames. In the east, Grant unleashed his relentless attrition on Lee by ensuring that the Army of the Potomac followed the Army of Northern Virginia wherever it went and engaged without let up. Grant's arrival in Virginia prevented any repetition of Lee's earlier successes and spelled the eventual end of Lee's tendency to favor aggressive offensives. In time, attrition would take its toll on his force structure and Lee could no longer consider large-scale offensive operations. No longer would Napoleonic methods work against the Army of the Potomac. Grant's arrival also ended rest periods after each large battle. Henceforth, Grant ensured the pressure stayed applied to Lee, until his army was no longer a combat-effective force.

Following the big battles of 1863, the armies of both sides operating in Virginia and Georgia would have one more spring and summer of operational maneuver before settling into more static warfare, with the Confederates clinging to their key cities of Richmond and Atlanta. Longstreet would first undertake operations in Tennessee before rejoining Lee. Reflecting on where they stood, he summed up in his memoir that Chickamauga had forced the Union to react to a defeat, and that undertaking this type of operation earlier, to save Vicksburg, and not going into Pennsylvania would have been better. "The inference is fair that the earlier, more powerful combinations would have opened ways for grand results for the South, saved eight thousand in the march for defending Vicksburg, the thirty-one

2 The Second Schleswig-Holstein War began in February 1864 and lasted eight months. It ended, after the climactic siege at Dybbøl, with the Treaty of Vienna, whereby Denmark ceded the duchy of Schleswig to Germany in October 1864.

thousand surrendered there, Port Hudson and its garrison of six thousand, and the splendid Army of Northern Virginia the twenty thousand lost at Gettysburg." He added that, "The elections of 1862 were not in support of the Emancipation Proclamation." Longstreet felt in the closing months of 1863 that their strategies at the start of the year had been misconceived and had ignored the possible northern political ramifications if the South had *defended only* as a grand strategy. "With the Mississippi River still closed, and the Southern Army along the banks of the Ohio, the election of 1864 would have been still more pronounced against the Federal policy, and a new administration could have found a solution of the political imbroglio," Longstreet said of what might have been, had they combined their strategic defense of operational offensives, with a focus on the political defeat of Lincoln.[3]

Knoxville, Winter in East Tennessee, and Return to Virginia

November 5, 1863, Longstreet ordered the first elements of his corps onto trains at Tyner's Station, along the west end of Missionary Ridge, for a fifty-mile train ride to Sweetwater, Tennessee. Most of the troops' cars did not leave until November 7, and the preponderance of the corps would not arrive in Sweetwater until November 11. Longstreet had assembled a staff of specialists in Virginia to assist with the rail and logistics work for the movement west. He asked Bragg to provide him with people with knowledge of the rail system in Tennessee, but they never materialized. This made the rail use disorganized and time consuming. Unfortunately for Bragg, his army would also have to supply Longstreet's Corps wagons for operations into East Tennessee. Longstreet's Corps had brought no wagons and team animals from Virginia in September. They came to reinforce an operational-level maneuver, fight, win, and return to Virginia, primarily by rail. Since they would be dropped off within a few hours' marching distance from Bragg's army in Georgia, wagons were not necessary, nor was rail transport for wagons all the way from Virginia feasible. Operations in Tennessee, however, would require wagons for Longstreet's Corps. From Sweetwater the troops could march one-hundred miles to Knoxville, but this time they were not joining another

3 Longstreet, *Manassas to Appomattox*, 478-479. See again comments by Fitzhugh Lee, March 15, 1877, in Chapter 10: "it was a mistake to invade the Northern States at all, because it stirred up their military spirit . . . The invasion was the death blow to what has been called the Copperhead party." Lee's nephew also underscored the need for military strategy to support national political goals.

Confederate army from which they would receive logistical support. Longstreet had to provide his own subsistence however best he could.[4]

Once Longstreet's Corps was downloaded at Sweetwater, and once enough wagons were gathered, and foraging completed, Longstreet planned to cross the Holston River at Loudon, and drive on Knoxville. His objective was the high ground south of the city, to deny the location to enemy reinforcement of the area. This operation began on November 13, and two days later Hood's Division, commanded by Micah Jenkins, and McLaws's Division were across. Aside from harassment by Union sharpshooters, no significant force challenged Longstreet's bridgeheads over the Holston. Union troops from the I Corps retreating in haste left a "Park of eighty wagons, well loaded with food, camp equipment, and ammunition," and spades, picks, and various hand tools strewn on the ground. An incredible gift after two weeks of shortages of all kinds.[5]

Burnside's troops in the area were now falling back hurriedly behind their defenses at Knoxville, having only about 3,000 operating in front of Longstreet's Corps. McLaws and Jenkins chased Burnside's men as fast as they could toward the next main town of Campbell's Station, fifteen miles from Knoxville. "Cleverly," Longstreet acknowledged in his memoir, Burnside conducted his retreat as part of a ruse. He had come outside his defenses with a small force, to make contact with Longstreet and lure him to Knoxville. Longstreet would then be 150 miles from Chattanooga, and it would be much harder for him to go back to Chattanooga and reinforce Bragg when Grant was ready to take the initiative. Burnside was assisting indirectly in the defeat of Bragg by distantly stretching the *operational reach* required of Longstreet's forces in relation to Chattanooga.[6]

Having a head start, Burnside reached Campbell Station less than a half hour before McLaws did on November 16. Shortly thereafter, Jenkins arrived and about 11 a. m. they attacked the Union force in an attempt to envelope it in a double pincer. Burnside said of his men, "We held our own and inflicted serious loss on the enemy…We commenced retiring, and almost all the command is now within the lines of Knoxville." The Confederates came close to destroying this smaller Union force. McLaws attacked with great force, and pushed back the Union right,

4 Longstreet, OR, 31/1: 455-456; Wert, *Longstreet*, 339-341.

5 Sorrel, OR, 31/1: 482; Longstreet, *Manassas to Appomattox*, 489-491; Alexander, *Fighting for the Confederacy*, 315. According to Alexander the wagons were found near Lenoir Station.

6 Longstreet, OR, 31/1: 457; Longstreet, *Manassas to Appomattox*, 492; Alexander, *Fighting for the Confederacy*, 313-315; Dana, OR, 31/1: 260.

but Jenkins's attack was disjointed and thus, unable to harm the Union left. Burnside held long enough to escape. From this battle, a rivalry between Longstreet's subordinates flared up that would plague operations at Knoxville. McLaws claimed he had sent a note to Longstreet the night of November 15, with intelligence from one of his soldiers who had lived in the area before the war, identifying a route they could use during the night to cut off the Union retreat into Knoxville. The note apparently never reached Longstreet or was not read by him if he received it. This was an apparent opportunity missed, and it irritated McLaws, who was still resentful over his perceived treatment at Gettysburg by Lee and Longstreet. At Campbell's Station, poor handling of the infantry by Evander Law was cited by one of Porter Alexander's officers as the reason they failed to capture this Union force. Longstreet backed that artilleryman's assessment. If these Union troops had been captured, the Knoxville defenses would have been more thinly manned. Jealousy had flared up in Law. He felt he was entitled to command Hood's Division after taking over for Hood at Gettysburg, but it had since gone to Jenkins. It was a "most unfortunate state of affairs [to have] in a division," wrote Porter Alexander. Law was a civilian college professor before the war. Without military education, he clearly did not understand that who takes over division command, in an instance like General Hood's wounding, is determined by date of rank. Law simply thought, "He deserved promotion & considered himself unjustly kept out of it." According to Alexander, Law thought that Micah Jenkins did not deserve to assume command of the division at Chickamauga, because his brigade had not fought in any of the significant battles since Antietam. These opinions of Law's were irrelevant, and Alexander was right. This was an unfortunate situation to have in a division, and one that Longstreet should have addressed after Chickamauga. He now needed to do so immediately.[7]

November 18, Kershaw's Brigade leading the way to Knoxville on a foggy morning, skirmished with Union cavalry outside the town as they approached. Behind them the divisions of McLaws and Jenkins arrived, filed in around the Union defense line, and began to dig in using their new Union shovels and picks. Longstreet examined the Union ramparts and found they were stronger and more formidable than those at Chattanooga. Longstreet set a tentative date of November 20 to try and take the works but put it off as he had not yet identified a vulnerable

point to assault. Bragg then telegraphed Longstreet, urging him to attack as soon as possible. He needed Knoxville to fall to the Confederates, so that Grant would have to send troops to deal with Longstreet, and thus lack the strength to attack him atop Missionary Ridge.[8]

After days of carefully examining the entire Union fortification, Longstreet thought one section of the defenses named Fort Sanders had some vulnerability. The fort jutted out of the larger fortification at a corner, so if a corner of Fort Sanders was approached at least the attacking troops would not be exposed to fire from the larger garrison. Longstreet conferred with his officers and told them he was "loathe" to attack it at all, but they had to try and help Bragg. McLaws told Longstreet that two of his regimental commanders felt they could take the fort. He would prepare and make the attack with three brigades formed in narrow columns of regiments at night, hoping surprise and darkness would allow the attack to work. Meanwhile, Bragg sent another message, stating he was sending his Chief Engineer Officer and Bushrod Johnson with two more brigades.[9]

Like Bushrod Johnson, Bragg's engineer was a Yankee. Brigadier General Danville Leadbetter was originally from Leeds, Maine. He graduated from West Point in 1836, had a career in the Army building fortifications, and married a Southerner. His last US Army assignment in 1857 was in Alabama. When war came, he joined the Confederacy. Leadbetter had directed the building of much of the fortifications at Knoxville when the Confederates held it. Bragg presumably thought he was the expert who would know best how to undo its defenses. Upon his arrival, Longstreet asked him to perform his reconnaissance immediately, and identify the best point to assail the defenses. He first selected the far left, known as Mabry's Hill, which Longstreet had already ruled out as too wide a front, the approach under fire too long. The attack needed to be narrow and surgical if it were to have any chance: a thin Schwerpunkt angled so the least number of defenders could fire at it, and the column would have overwhelming numbers at a narrow point yards wide at the most. On November 27 another reconnaissance was carried out, and the conclusion was Fort Sanders, the same spot Longstreet had picked shortly after their arrival. McLaws wrote a note to Longstreet on November 28 stating that he had heard from locals that there has been a serious engagement at

8 Longstreet, OR, 31/1: 458; Longstreet, Manassas to Appomattox, 499-500; Wert, Longstreet, 346-348.

9 Longstreet, OR, 31/1: 459, 484; Longstreet, Manassas to Appomattox, 500-501; Alexander, Fighting for the Confederacy, 318-323; McLaws, OR, 31/1: 484. Johnson suffered quite a few desertions on the march to join Longstreet.

Chattanooga, and, "If we have been defeated at Chattanooga, do we not risk our entire force by an assault here?" He further pointed out that even if they took Knoxville, it would be of no use if Bragg had been defeated. Grant would bring overwhelming force against them next, thus it was best to make for Virginia. Longstreet replied that they did not know for sure the result at Chattanooga, and they would attack the fort.[10]

The attack was launched on November 29. After a short artillery fire plan was completed, the three brigades of McLaws surged forward in the dark toward the corner of Fort Sanders. The infantry was slowed by a low telegraph wire obstacle strung around stakes. When they reached the ditch, many were hit by rifle and canister fire in the ditch bottom, which was the kill zone. The few that got across the ditch then had to contend with the elevation of the slope that proved to be too slippery from frost and too great a distance for infantry to climb easily without scaling ladders. The Union defenders had an easy time tossing down bombs and firing at the men who tried to scale the incline. Longstreet came forward with Bushrod Johnson and his two units, as the assault was going on. 129 soldiers in McLaws's Division were killed, 488 wounded, and 226 captured. Johnson then pleaded with Longstreet to let him try with his two brigades, but Longstreet would not permit it. He ended the attack on the spot.[11]

Longstreet considered trying again, but a telegram came in from President Davis that told of Bragg's defeat on Missionary Ridge. McLaws's hunch that Bragg had been defeated had been right. The Battle of Missionary Ridge resulted in Bragg retreating to Dalton. There was no point in having even tried to take the fort. In hindsight, it certainly would have been better if they had simply waited for confirmation about Chattanooga. Enough time had already been wasted waiting for Leadbetter, and then more time was wasted by Leadbetter looking at a fort he built only to tell Longstreet to try at Fort Sanders—the very spot Longstreet thought best when he first arrived.

10 Longstreet, *Manassas to Appomattox*, 499-505; Longstreet, *OR*, 31/1: 486; Harry Gratwick, *Mainers in the Civil War*, (Charleston: The History Press, 2011), 97-101. Source covers the life and Confederate Army service of Danville Leadbetter. It is probable that Longstreet largely made this decision from the enthusiasm of the regimental commanders.

11 Longstreet, *Manassas to Appomattox*, 505-507; Longstreet, *OR*, 31/1: 486-489; Cummings, *Bushrod Johnson*, 275. In his memoir, Longstreet looked back and thought the report about the wire being difficult to get though was exaggerated, since it was at ankle height and randomly strung; he felt the suppressive fire by supporting infantry should have been better as well. He also mentioned Burnside's great kindness by quickly calling a truce for removal of wounded and dead.

Artist Lloyd Branson's depiction of the Confederate assault on Fort Sanders, in Knoxville, Tennessee, on December 2, 1863. (*Thomas William Humes, The Loyal Mountaineers of Tennessee Knoxville, Tenn.: Ogden Brothers and Co., 1888, frontispiece*)

Fort Sanders became another propaganda topic after the war for Lost Cause writers who wanted to pillory Longstreet as a failure. It was a failure, his attack was repulsed, and this one time he had gone against his better judgment. It must also be put into perspective. When Longstreet learned that McLaws's men had failed to break into the fort despite having the element of surprise, he called the attack off immediately to prevent further loss of life. Fort Sanders proves he put the lives of his men first when it became clear they could not come through the kill zone in any strength. As a modern thinking general, he did not allow the situation to get out of hand. It was a low point for him, but it was also later blown out of proportion to its significance in the overall state of military affairs for the Confederacy at that point. The war was arguably lost at Chattanooga by October. Taking Knoxville in November was irrelevant. Ten days of delays made no difference, but a few more days of delay would have saved 129 precious veteran lives.

Longstreet called his officers together in the following days, and McLaws motioned they needed to start heading to Virginia, and all present concurred. Johnson's two greatly-thinned brigades would go with them. He and his men who had fought in the west since Shiloh, had now joined the Army of Northern Virginia. The night of December 4-5, Longstreet's Corps departed Knoxville, and marched until December 9, halting at Rogersville. On December 13, Union troops

under Brigadier General James M. Shackelford pursuing the Confederates were at Bean's Station, the previous town along Longstreet's march before the halt. He decided to go back and attack Shackelford with a two-pronged attack. Bushrod Johnson led the assault, surprising the Union troops who took cover in the town's buildings. Street and house fighting raged all afternoon, as Johnson's 2,400 infantry wrested one structure after the next from the dogged Union defenders. Confederate momentum increased with the addition of the second prong of Kershaw's Brigade. Alexander's artillery also came into action, blasting holes in buildings. Late in the day, Shackelford gave up the town and retreated. Bean's Station was the last battle of the East Tennessee Campaign. Longstreet's Corps would winter at Russellville, and Johnson's command at Morristown, Tennessee. Longstreet ordered the troops to build huts and forage, so as to have a decent Christmas meal after all the misery they had endured. The troops were cheerful at Christmas once they had been able to hunt game and gather enough for a good meal on Christmas Eve. Longstreet himself, however, was despondent. The friction with McLaws, his lifelong friend, had come to a head. He relieved him of his command on December 17 for neglect of duty in the assault at Fort Sanders, and Mclaws left the corps to report to the Inspector General's Office in Augusta, Georgia. He also preferred charges against Law for unprofessional behavior: "obtaining leave under false pretenses" and excessive complaining of the conditions. Lastly, he relieved Robertson for voicing "lack of confidence" in front of the troops at Bean's Station and complaining of the conditions. The disputes were a symptom of the incredible stress they all endured. Even Lee's War Horse had his limits.[12]

Longstreet, the First Corps, and Johnson's small command stayed in Tennessee until April 1864. Morale had improved, shoes and new uniforms came from Richmond, Union activity around them had not been so threatening as to prompt a movement elsewhere, and the rate of desertions—high among Johnson's

12 Special Order No. 27, OR, 31/1: 497; McLaws, OR, 31/1: 498-499; Wert, Longstreet, 353-364; Cummings, Bushrod Johnson, 277-278. McLaws could not understand what happened. In his letter back to Sorrel, the adjutant and author of Special Order No. 27, he was dumbfounded as to what he did that constituted "want of confidence in the plans of the commanding general" at Fort Sanders. A court martial was held by the War Department. McLaws was eventually exonerated from two charges but found guilty of a third: "failing in the details of his attack to make arrangements essential to his success." He received a sentence of sixty days without rank or command. This too was also overturned, for improper court procedures. The War Department ordered him back to his division, but Lee refused to take him. McLaws finished the war in the Carolinas. Charges against Law were dropped, Robertson was not tried, but suspended.

Tennesseans during the Knoxville period—slowed. On April 7 Longstreet received orders to begin movement back to the Rapidan and rejoin Lee. By April 29, they had reached Gordonsville, and Lee came to see them and "review the command." In addition to the adulation of the troops by Lee, they were presented an official "Thanks of the Confederate Congress to Lieutenant General Longstreet and his Command," a joint resolution that had been passed on February 17, 1864. It was a welcome homecoming for the First Corps after seven months of a great victory then squandered, followed by months of hardships, isolation, and uncertainty. Bushrod Johnson said goodbye to Longstreet. He and his two skeletal brigades of Tennesseans were assigned to the defenses of Richmond. The two generals had known each other at West Point, Jefferson Barracks, and in Mexico. Longstreet appreciated what Johnson had done at Chickamauga and Bean's Station. He always thought Johnson was a good officer, cool in battle, and a kind person. He helped Johnson get promoted to Major General the following month on May 21. "I have found him to be one of the ablest division commanders that I have ever had with me," Longstreet put in his recommendation to the War Department.[13]

Whether Longstreet and Lee considered the war lost in April 1864 is unknown. Johnston was holding at Dalton, Georgia, but large portions of the Confederacy, and many important ports had been irretrievably lost. Signs of possible European recognition had ended, and the dwindling blockade runners were the only lifeline to Europe by which to purchase arms and goods. Northern Democrat and Copperhead dissent had been undercut by the Union military victories in July 1863, which benefitted the Lincoln administration. Conversely, the Confederate fall elections were a repudiation of President Davis. Some anti-administration representatives won seats, displacing incumbent supporters. While Longstreet was away, Lee had tried unsuccessfully to interpose between Meade and Washington in October. He then fell back to the Rapidan. There was still Lincoln's looming election later in the year. Perhaps that could still go their way, and with his defeat it might be possible to negotiate peace and Confederate independence.

13 Longstreet, *Manassas to Appomattox*, 520-521, 547-548; 550; *OR*, 31/1: 549, 1054; Cummings, *Bushrod Johnson*, 280.

Grant Arrives in the East

Grant's operational brilliance in his Vicksburg Campaign and in wresting the initiative from Bragg at Chattanooga was just the type of prowess Lincoln wanted in a General-in-Chief. On March 2 Lincoln revived the rank of Lieutenant General and promoted Grant. The last to hold the rank was George Washington, when the country was still a confederacy, and not yet a Federal Union. Halleck was retained, but only to continue with his focus on the minutia of Washington military administration. Grant's promotion in both rank and position was a de facto demotion for Halleck.[14]

Grant began to empty the artillery forts around Washington and along the Eastern seaboard. He pulled thousands of idle artillery soldiers from their coastal batteries in places like Baltimore, New York, and Boston. Large numbers of garrison troops quietly guarding depots, armories, and other installations throughout the North were also thinned out and redirected. He tapped garrisoned units everywhere to grow the size of the field army that would press Lee. Additionally, Grant leveraged the growing number of Negro regiments the North had trained and added them to the order of battle. This was something the Confederate Congress refused to do until it was too late. Grant made Lee's army the Center of Gravity of his operations. He considered Richmond irrelevant as an objective, so long as the Army of Northern Virginia still operated freely. This was a marked departure from his predecessors in the East. Grant issued guidance that all the Union armies would simultaneously take the offensive, making it nearly impossible for the Confederates to juggle forces across their interior lines and mass against any of them. Not having the force structure to match all these Union commands, more Confederate territory would be taken. Lastly, Grant positioned himself near Meade to ensure that his army kept up the pressure without let up.

On May 4, 1864, Grant crossed the Rapidan, opening his Overland Campaign. His objective was not any location, but Lee's army itself. He moved south of the Rapidan to get Lee to come at him, and establish the contact that Grant planned to make permanent until the end. Lincoln now had his relentless fighting general, but Grant had one problem that would materialize in 1864 and might threaten his plans. Three-year enlistments were going to end for many soldiers later in the year. Thus, if he did not make good progress towards finishing Lee, he could lose much

14 McPherson, *Battle Cry of Freedom*, 718. Winfield Scott had been promoted brevet Lt. Gen. in 1855, but brevet rank was only honorary.

of his army, and harm Lincoln's re-election chances. It would seem a corollary to Longstreet's vision following Fredericksburg of inflicting mass casualties to undermine Union resolve had appeared. He and Lee were keen to exploit it. They would have to be successful at crafting battles costly to Grant. Longstreet pointed out in his memoir that attrition was going to be Grant's weapon, estimating the Army of the Potomac numbering 116,000, and the Army of Northern Virginia 64,000.[15]

Gouverneur K. Warren had reached the tavern with his V Corps at the intersection of Germanna Plank Road and the Orange Courthouse Turnpike late on May 4 and the next day attacked Ewell and the Second Corps coming his way. A. P. Hill and his Third corps were just south of Ewell and parallel to him, moving on the Orange Plank Road. He ran into the Union division of Brigadier General George W. Getty from the VI Corps and elements of Hancock's II Corps. Somewhat similarly to the second day at Chickamauga, both sides faced difficulty trying to flank each other in the wooded terrain. The day ended inconclusively, and the Confederates began to entrench their front. Longstreet's Corps was still on the way, not expected until midnight.[16]

The next morning, May 6, Hancock with five divisions slammed into A. P. Hill's Corps waiting on the Orange Plank Road and pushed the Rebels back in relative confusion. The divisions of Heth and Wilcox were exhausted from the previous day's fighting and had not eaten either and gave way. The Confederate right flank was now threatened. Lee saw the retreating Confederates and rode into them and admonished a brigade commander, "This splendid brigade of yours is running like a flock of geese!" Hancock's Union troops were not far behind in pursuit. About 6.30 a.m. the first of Longstreet's men appeared, having marched since 3 a.m. and been on the move for thirty-five of the last forty hours. Longstreet's troops confidently came on and had plenty of sarcasm for A. P. Hill's routed men. "You don't look like the men we left here. You are worse than Bragg's men," quipped one of Longstreet's veterans. One of his brigades went right past Lee determined to get into the attack, which impressed him after watching other troops run. This prompted Lee to go to the unit's commander to ask who they were. The Texas Brigade, he was told. "I am glad to see it," Lee replied. Lee told the commander he would watch them. The brigade did not know they had passed Lee,

15 Longstreet, *Manassas to Appomattox*, 552-553.

16 Ibid., 558; Taylor, OR, 36/2: 948; Edward Hagerman, *The American Civil War and the Origins of Modern Warfare*, (Indianapolis: Indiana University Press, 1988), 235-254.

but their commander then immediately told the soldiers: "The eyes of General Lee are upon you. Forward march." Lee then shouted to the troops: "Texans always move them!" They became emotional and responded with yells back to their Chief. Lee followed them and wanted to lead the brigade in the fight "before my lines were well formed," noted Longstreet. An excited Lee wanted to be among such troops and go in with them but had lost sight of the fact that Longstreet was in the middle of arranging the attack. Col. Charles Venable of Lee's staff became worried, and asked Longstreet to ask Lee to back away from the brigade and stay out of Union musket range. Longstreet immediately sent Lee a note pointing out that the line would be ready to attack in an hour, "If he would permit me to handle the troops, but if my services were not needed, I would like to ride to some place of safety, as it was not quite comfortable where we were." The troops also shouted to him: "Go Back General Lee. Go Back!" Some men grabbed his horse and the unit slowed. "We won't go forward until you come back," they told him. The brigade commander also tried to convince Lee to back away and grant the troops their request. Longstreet, the brigade commander, and perhaps the troops most of all, convinced Lee that he could not join this unit in an attack. No doubt it was a tough request for Lee to curb his fighting spirit, when he wanted to show how proud he was of this brigade by joining them. The Texas Brigade was part of Longstreet's two-division attack to stop Hancock, and by 8 a.m. they were able to shove Hancock about halfway back to his starting point. Lee then decided to reinforce Longstreet with Anderson's Division and sent his engineer officer, Major Martin Smith, to look over the terrain for anything useful. Smith found an unfinished railroad grade south of the Plank Road with an unobserved axis into the flank of Hancock's phalanx of units. He found Longstreet at 10 a.m. and reported it to him. Longstreet quickly called over Moxley Sorrel and told him they had a, "Fine chance of a great attack on our right." "If you quickly get into those woods, some brigades will be found much scattered from the fight. Collect them and take charge." He told Sorrel to hit hard once he had his units together, and upon hearing gunfire from Sorrel's attack, Longstreet would direct a head-on attack with First Corps.[17]

* * *

17 J. B. Clifton Diary, May 6, 1864, *Clifton Papers*, Southern Historical Collection, UNC; Warren, OR, 36/2: 457-458; Longstreet, *Manassas to Appomattox*, 560-562; Sorrel, *Recollections*, 202; Longstreet, OR, 36/1: 1055. Clifton (1836-1902) was a surgeon with Longstreet's Corps. He kept a 72-page diary from June 1863 to July 1864.

Longstreet had many great moments that made him not only a modern general, but one of the great generals in the war. His last great attack of the war would dislocate Grant's opening move in this campaign. It was the act of a career infantry officer who could think fast and marshal considerable expertise and professional knowledge in a moment. Venable would describe Longstreet in this action years later as possessing the, "Imperturbable coolness which always characterized him in times of perilous action."[18]

Once Sorrel had four brigades gathered into an ad hoc division, they quickly moved into the railroad bed that led them to the Union left flank. The brigades of Wofford, Brigadier General William Mahone, and Brigadier General George T. Anderson were in a row about a quarter mile away from the Union flank. Stone's Brigade was behind Mahone in the center. The left front corner of the entire Union formation of fourteen Union brigades facing Longstreet's Corps was the brigade of Colonel Robert J. McAllister. McAllister himself went outside his picket line toward the railroad cut and saw some of the force Sorrel had deployed. McAllister sent a note to his division commander, Brigadier General Gershom Mott, a grandson of a Continental Army captain who was a participant in Washington's crossing of the Delaware, but nothing was done with the information in time. The Confederate attack went in and struck the flank of McAllister's Brigade almost at a ninety-degree angle. McAllister tried to adjust to create a new front at his flank, but in a time when units were wed to their linear structure, particularly in non-permissive terrain, it was nearly impossible to match an attacker's properly massed strength when surprised like this. He could not get enough troops redirected in time, and his brigade collapsed. As his position was swept, and troops began to run, so did the other Union brigades of Hancock's left. Hancock later said to Longstreet: "You rolled me up like a wet blanket."[19]

Hancock's command kept running, and only when the troops tired, could he reform them as they walked toward a line of earthworks at the Brock Road intersection. The whole Union corps was badly shaken, and Grant sent out orders to firm up that entire location. Recognizing their state of mind, he wrote to Meade the next day that any attack by the Confederates was sure to be delivered against

18 Helen Longstreet, *Lee and Longstreet at High Tide*, (Wilmington: Broadfoot Publishing Co., 2006), 112; Charles Venable, "The Campaign from the Wilderness to Petersburg," *SHSP*, 14: 525.

19 Longstreet, *Manassas to Appomattox*, 562-563, 568; McAllister, *OR*, 36:1: 489; Meade, *OR*, 36/2: 452.

Hancock. He wanted Meade to plan to resist in Hancock's location and to ensure his command was well supported.[20]

Although Longstreet had reversed Union progress, the good luck that had kept him safe from enemy fire since 1861 finally ran out. Once the attack started by Sorrel had reached its culmination, and the Union troops had run further than the Confederates in their linear formations could keep up, Longstreet began planning for the next push. This next attack would have the objective of pushing enough of Meade's army three miles back to the Rapidan, and thus force all his corps back over to the north side of that natural line. After giving a plum opportunity to his staff officer Moxley Sorrel to launch an attack, he now selected Micah Jenkins for a key role in the next stroke. Jenkins was exited. "I am happy," he told Longstreet as the two, Kershaw, and some staff officers rode forward to reconnoiter. "I have felt despair for the cause for some months, but I am relieved now, and feel assured that we will put the enemy across the Rapidan before night." The reconnaissance was completed, Longstreet had given his scheme of maneuver to Jenkins and Kershaw, and the party was riding back into the First Corps area, when one of Jenkins's units opened fire at close range. Jenkins, a staff officer, and an aide-de-camp were killed, and Longstreet was struck by a minie ball that travelled through his right shoulder and neck. Kershaw galloped toward the squad shouting: "Friends!"[21]

They were not far from where Stonewall Jackson had been hit by friendly fire a year earlier. Jenkins was hit in the temple, lost consciousness quickly, and died shortly thereafter. Longstreet recalled that the force of the minie ball that stuck him lifted him in the saddle and he began to bleed profusely. Sorrel saw this too: "He was actually lifted straight up and came down hard," he described. Before Longstreet could fall his staff got him down from the horse, then called for the surgeon and informed Lee. Longstreet was still trying to issue guidance for the planned attack, and he told those around him to get Major General Charles W. Field, who was the senior officer in the command, to take over. Once in an ambulance, moving slowly to the Confederate field hospital, troops nearby came close trying to find out exactly their general's condition. "I never on any occasion during the four years of war saw a group of officers and gentleman more deeply disturbed," said one major who witnessed the evacuation. Englishman Francis W. Dawson observed, "The sadness in [Lee's] face, and the almost despairing movement of his hands, when he was told that Longstreet had fallen." By nightfall,

20 Grant, OR, 36/2: 481.

21 Longstreet, Manassas to Appomattox, 563-564; Kershaw, OR, 36/1: 1062-1063.

Longstreet was moved to the Meadow Farm by his Quartermaster, Colonel Erasmus Taylor. Fortunately, once fully examined, it was determined that the wound was not fatal, but Longstreet was out of action for the foreseeable future.[22]

Longstreet was moved to Lynchburg, Virginia, and then transferred far south, spending several months recuperating near Augusta, Georgia. Lee decided to place R. H. Anderson in command of the First Corps, after talking to Longstreet's staff about their recommendation. Following the battle of the Wilderness Lee and Grant fought a series of bloody battles at Spotsylvania, North Anna, and Cold Harbor. Lee also lost Jeb Stuart on May 18, 1864, at Yellow Tavern. The battle at Cold Harbor was the type of defensive alignment that Longstreet endorsed and harkened back to his position at Fredericksburg. The Confederates were greatly outnumbered, but the combination of infantry, well-placed artillery, and strong field fortifications brought Lee one more lop-sided victory. Repeated Union assaults failed to breach strong Confederate defenses. "Grant gave up the offensive about one o'clock PM. eight and a half hours after the first attacks. Lee had only lost between 1,000 and 1,500 men along the six miles of his front. Grant's casualties totaled about 6,000 men." Although Longstreet was not there, he must have taken pride that his corps performed magnificently to the standards he had instilled.[23]

After Cold Harbor, Grant managed to slip around the Army of Northern Virginia and head toward Petersburg, south of Richmond. This initiated the final campaign in the Eastern Theater. Longstreet felt compelled to return to the army and do what he could for Lee and his men. Longstreet and Lee provided an example of a preeminent senior and subordinate team, and their reunion at Petersburg was evidence of their loyalty to one another. In October 1864, Longstreet got in the saddle of a horse named *Fly by Night*, an animal that Lee sent him from Virginia. After a few days, he arrived in Virginia for duty. Longstreet was still far from completely healed; he had not recovered his voice and he had not regained full use of his right arm. Longstreet told Lee that he would do whatever the commanding general deemed necessary. He did not want Lee to think him a liability. R. H. Anderson had assumed command of the First Corps, but Lee

22 Ibid., 564; Sorrel, *Recollections*, 233-234; Stiles, *Four Years Under Marse Robert*, (New York: The Neale Publishing Co., 1903), 247; Gary Gallagher, *Lee & His Army in Confederate History*, (Chapel Hill, NC: University of North Carolina Press, 2001), 194. Francis W. Dawson was a writer and adventure traveler who supported the Confederate cause. He had a reputation for energetic news gathering. After the war he wrote for various newspapers in the South.

23 Longstreet, *Manassas to Appomattox*, 572-573; Wert, *Longstreet*, 389-390; Hagerman, *Origins of Modern Warfare*, 263; Gordon C. Rhea, *Cold Harbor: Grant and Lee, May 25-January 3, 1864*, (Baton Rouge: LSU Press, 2007, 358-362, 382.

immediately restored Longstreet to command and the general joined his men at their position on the left flank. Anderson then took command of Lee's newly formed Fourth Corps.[24] Lee and his commanders held the trenches at Petersburg through the winter and into March 1865. During that period the strength of the Army of Northern Virginia dipped under 60,000. Longstreet's energy astonished Lee and in one correspondence the commanding general thanked his lieutenant for his "zeal," acknowledging that, "Were our whole population animated by the same spirit we would be invulnerable." Longstreet felt at home and in his element with his corps and with Lee. His diminished physical state and the overall declining military situation did not dampen his enthusiasm for duty to Lee and the ANV or to the Confederacy.[25]

The Army of the Potomac had grown more massive than ever and Grant was relentless. Little by little, throughout the siege at Petersburg, Grant extended his lines around the right of the Confederate front and forced Lee to extend his. This stretched the Confederates ever thinner and overtaxed the troops at Lee's disposal. Meanwhile, Grant continued to add new troops that he had pulled from other locations. It would only be a matter of time before the Union found a weak spot and Lee's dam would burst under the pressure.

In the first days of April, Grant finally broke Lee's lines and forced him to abandon the Petersburg defenses as well as Richmond. Lee was able to save his men from disaster and extricated the army from Petersburg to begin a retreat west. The Federals killed A. P. Hill during the final fighting around Petersburg and Lee gave Longstreet control over the war-weary remnants of Hill's Corps. Lee's escape would be short lived. The Army of Northern Virginia, now reduced to 35,000 men, scattered to rendezvous at Amelia Court House some thirty-five miles west. The starving troops expected to receive a trainload of 80,000 rations once they reached the place. But the food supply was not on the train. Instead, it was loaded with ammunition. Union cavalry were in hot pursuit and elements of the mounted force

24 Wert, *Longstreet*, 392; Piston, *Lee's Tarnished Lieutenant*, 90. Ewell had been reassigned to help manage the defenses of Richmond after Lee felt him no longer of sound mind adequate to hold a field command after he had an excessively emotional outburst in front of his troops and Lee at Spotsylvania. Jubal Early had the Second Corps but was detached and covering the Shenandoah Valley.

25 Ibid., 91; Lee to Longstreet, February 20, 1865, quoted in Sears Wilson Cabell letter to Nelson M. Shipp, June 10, 1940, in *Helen Longstreet Papers*, Georgia Historical Society; Longstreet, *Manassas to Appomattox*, 645-646.

The 12th Virginia was part of Longstreet's flanking force advancing perpendicular to the Orange Plank Road. As the troops approached the road, they ran into a small forest fire. Members of the right of the unit went around the right end of the fire, crossed the road and entered the woods. The left portion of the regiment went to the left of the fire and stopped before reaching the road. When the right portion realized they had left behind the rest of their command, they turned around and moved back toward the road. As they did so, the men of the left of the regiment saw soldiers approaching and opened fire, which drew a response. (*https://www.nps.gov/frsp/learn/photosmultimedia/longstreetw.htm*)

sought to get ahead of Lee to thwart resupply efforts and to cut off escape routes further west.[26]

On April 6, three Union corps defeated Confederates troops at Sailor's Creek. The Federals captured 6,000 Confederates and the battle cost Lee twenty-five percent of his army. That evening Grant sent a letter to Lee asking him to consider surrender. Lee handed it to Longstreet who read the note and simply said, "Not yet." Lee agreed. Three days later, Union cavalry under Sheridan got around the Army of Northern Virginia and took a position across their front. After an unsuccessful attempt to break out, Lee surrendered his army on April 9, at Appomattox Court House.[27]

Lee was down to fewer than 10,000 men under his immediate control at the time of the surrender. Only Longstreet's Corps functioned at anything near full strength. After Lee and Grant completed the surrender terms, Longstreet received the final review of the First Corps of the Army of Northern Virginia as it prepared to surrender. On April 12, the troops marched to the field in front of Appomattox Court House to meet their Union counterparts. There they stacked arms and were released from service as soldiers of the Confederacy. Lee and Longstreet said goodbye later that day. The most effective command team on the Confederate side left the profession of arms forever.

26 McPherson, *Battle Cry of Freedom*, 847.

27 Ibid., 848; H. W. Crocker, *Robert E. Lee on Leadership*, (Rocklin, CA: Prima Publishing, 1999), 155.

Chapter 16

Conclusion

"They were very indignant and stated I was a Republican . . ."

— James Longstreet, *Century Magazine*, 1886

If there was ever an important piece missing from the history of the American Civil War and the history of American military evolution, it was the role James Longstreet took in advancing modern military methods. While it is understandable that some of Longstreet's peers did not like his blunt and laconic demeanor, one can dismiss some of this criticism as the usual rivalries and personality conflicts that emerge among leaders in all armies. Most of the contemporary criticism should have dissipated shortly after the war, as the veterans passed away, but it did not. What became a true dishonor to Longstreet, and a true loss to generations of professional military men, was the critical focus of a second generation of authors and historians. These were men who had not actually witnessed the war. They had an express desire to malign Longstreet, primarily because of his postwar pro-Republican politics. Longstreet's endorsement of Constitutional amendments to secure equality for freed slaves and his support for numerous aspects of Reconstruction angered those who saw his support for President Grant as a betrayal. For these perceived disloyalties to the South, Longstreet's Lost Cause enemies obstructed the objective study of his wartime progressiveness.[1]

1 Brian Hampton, *The Influence of the anti-Longstreet Cabal*, www.tennesseesvc.org/longstreet/ control2, 1.

At the turn of the century, as an age of world war neared, the lessons of Longstreet remained largely ignored. The "anti-Longstreet cabal" was essentially a select group of men imbued with the Lost Cause ideology. They sought to obscure existing knowledge and understanding of Longstreet concerning the development of modern war from those who could have used it the most, the future leaders during the two world wars. Some of the Lost Cause influence still lingers even today.[2]

The focus and purpose for the twenty-first century student of warfare in studying Longstreet should be easier to ascertain today: his accomplishments and legacy have many lessons to teach about modern war.

Longstreet was a powerful instrument of change in the period 1862–65. Starting in the middle years of the conflict, warfare began to transition from the Napoleonic to Industrial Age modern war. Until the present day, however, Longstreet's contributions have remained shrouded in a locked box created by historians such as A.J. Eckenrode, Douglas S. Freeman, Clifford Dowdey, and several who worked on the *Southern Historical Society Papers*. The deliberate character assassination on the part of Jubal Early and William Pendleton greatly influenced the work of these historians, and their writings influenced generations. Even the military remained largely in the dark regarding Longstreet's lessons of war. This is surprising, since the military normally finds value in lessons of great leaders regardless of the government or cause they served.

A student of the Civil War may believe that the South lost the war because of overwhelming numbers and Northern industry. Yet, that it is far too simplistic. The Union held advantages in these areas, but the South's leadership did not develop strategies to reduce these advantages. The Confederate government and military did not adopt strategies, tactics, and techniques that directly addressed the disparities. The Confederate government never had a top general to direct priorities across the nation, and follow a sound strategy, such as Longstreet prescribed.

Longstreet tried to solve these problems and was the most progressive Confederate thinker with respect to wing/corps operations. He crafted a modern combined arms defense at Fredericksburg and his work there incorporated mid-nineteenth century improvements of firearms, trenches, and centralized artillery coordination. This artillery concept became the future of artillery employment after the invention of the field telephone and radio. The combination

2 Ibid.

of factors yielded a radical lethality at Fredericksburg and enabled three of Longstreet's brigades to stop seven times their number while suffering minimal casualties. Other multipliers of this modern defense also increased, including superior Confederate marksmanship and fire control. This added to the strength of the Confederate position, whereas Union exposure reduced the effectiveness of their fire.

These threads continued to appear in Longstreet's operations during 1863, with a recurrence of centralized artillery for all three of Lee's corps. On July 3, the placement of most batteries at Gettysburg was wrong, but they did attempt to implement a modern fire support plan that included fire upon both enemy artillery and infantry, and to converge the fire of batteries from three corps to support Longstreet's assault. It did not work, largely because the Confederates did not have the ability to observe and adjust fire for accuracy. Also, due to poor quality ammunition, many of the guns were not accurate at extreme range. Nonetheless, the idea of centralizing fire support was another step toward modern flexibility of artillery employment.

Longstreet crafted a type of offensive Schwerpunkt which, properly employed, achieved the right mass to overcome the defense. In principle, this was the blueprint for offensive armored warfare organization developed in the 1930s by German military thinkers. He envisioned and demonstrated twentieth century massed force projection between theaters with the largest strategic movement of men and material undertaken by the Confederates. At Chattanooga, his plan to strike Bridgeport, Alabama, was bold, decisive, forward-thinking, and the correct action. Braxton Bragg, however, failed to grasp the concept.

Longstreet's more prominent accomplishments are the focus of this work, but there are undoubtedly other details and not so easily identifiable evolutionary changes that emerged from his efforts. Other areas that are virtually unexplored are improvements in his staff, the use of intelligence, and the use of agents. All these topics have only minor mention in the historiography. Even the book written by Moxley Sorrell, one of Longstreet's staff officers, is much more of a reminiscence than a presentation of the improvements and innovations that the general brought about during the war.

Alexander is probably the closest to having captured in writing his thoughts and observations regarding Longstreet's staff. He pointed out that Longstreet understood that modern war required a staff structure to coordinate movements between divisions, brigades, and regiments. Alexander indirectly discussed how Longstreet began to improve the staff after Gettysburg, as the "difficulty in securing concentration of effort over long lines," illustrated the great complexity of

movement that Lee asked the Army of Northern Virginia to execute. This was particularly evident in the time just before Pickett's Charge. Lee had asked division commanders to perform a level of "battlefield calculus" complex beyond the level they had executed previously. Furthermore, the commanding officers did not have the staff to go out among the units to manage and clean up misunderstandings. This is an important function of a modern staff.[3]

By the time of Chickamauga, Longstreet's work on his staff had evolved to something akin to modern changes in staff instituted by Prussian contemporary Helmuth von Moltke. Both Longstreet and Moltke sought to assemble a group of staff officers who possessed the experience and education "that made them competent to judge correctly." These officers would provide advice and help set the conditions to facilitate tactical success. A modern staff also had to be a cooperative family of specialized experts who could weigh concrete situations as a "system of expedients," from which to create or build the next tactical move.[4]

One can certainly make an argument that Moltke's idea of building upon concrete known situations was precisely how Longstreet derived his defensive-offensive strategy. He saw that the best chance for the Confederacy was to make sound operational choices for battles and that from those successes would come realistic strategic opportunities.

Thus, from aiding the commander with achieving tactical success, Longstreet's vision of the functions of staff officers also helped make more fluid the overall links between tactics, operational art, and strategy. In this modern world of a fully functional staff, strategies for the army are not merely an end state objective selected by commanders prior to a campaign season. Commanders and leaders must shape strategy *during* campaigns, as something that builds upon tactical successes achieved.

In this way of thinking, Longstreet followed the need for good chemistry in his staff. He sought officers who were intelligent and talented in different ways. This was a vast departure from the process used by most of his contemporaries. Frequently commanders selected friends or influential individuals for important staff or command positions. Politics often played a role. Decisions made from emotionally based cronyism happened at all levels of command during the Civil War and the results were often tragic. Even President Lincoln and President Davis

3 Alexander, *Fighting for the Confederacy*, 242.

4 Helmuth von Moltke, *Moltke on the Art of War: Selected Writings*, Edited and translated by Daniel J. Hughes, (Novato, CA: Presidio Press. 1993), 9.

were guilty of placing unqualified people in critical positions. Many such choices thrust incompetent or militarily untrained politicians into key battlefield commands and staff positions. Costly mistakes, lost opportunities, and damage to the war effort were all part of the cost paid by both sides.[5]

To Longstreet's credit, he did his best to groom qualified and talented officers for both command and staff positions. He looked for ability and special skills that could be focused on specific problems and tasks. This was the direction that the refinements of the military staff took in the latter half of the nineteenth century. Setting up a staff of different capabilities meant the members could become experts in their areas and not lose focus by having to tackle too many unrelated tasks. Once he had good choices in place, Longstreet kept them for the duration. This was not because they became his friends, but because a modern staff functioned best once all the members were familiar with the abilities of the others. This helped establish the boundaries of a staff officer's specific area. Quality teamwork of a staff and harmony in planning were dependent upon the chemistry between the individuals who comprised the staff. Each officer was dependent upon the professional competence of the others.

Longstreet was also a pioneer with mission analysis. He made the most of the limited time available during preparation and during an unfolding battle to understand the tactical issues in front of his corps. He was keen to gather various types of intelligence before mounting an assault. At Second Manassas one sees this in practice. Through his careful examination of the Union axis of attack, coupled with his own tactical patience in carefully arranging his units to strike at the decisive moment, Longstreet enjoyed great success. The situation was the same at Chickamauga. While not the same attack formation, Chickamauga provides another example of exacting preparations for an attack column, planned with terrain intelligence. He conducted mission analysis in the modern sense, by collecting the data he needed to be sure of when and where to launch the bulk of his corps. The conclusion of his mission analysis enabled Longstreet, his commanders, and his staff to see and solve the tactical problems in front of them.

As Longstreet prepared to move to Georgia, he made improvements and additions within his staff, to better manage the rapid pace of a modern large-scale

5 For an excellent example of political appointments impacting military efforts see Ludwell Johnson, *The Red River Campaign: Politics and Cotton in the Civil War*, (Baltimore: Johns Hopkins University Press, 1958). It should be noted, however, that the appointment to a senior military position of a leading figure from a demographic minority could boost recruitment sharply and thus aid the war effort—as the popular German American slogan, "I fights mit Sigel" attests.

strategic movement. As the movement illustrates, he was open to inviting and enlisting help from what became known as "special staff officers." These men had a narrowly defined area of expertise. One example was Major Frederick W. Sims, who in civilian life worked for the railroad, and during the war worked with Longstreet and his staff to execute the rail movement to Georgia. Longstreet incorporated Sims quite smoothly into his organization and helped create a more coordinated control over the movement. This was another marked departure from the decentralized separate mentality that pervaded military thought until the creation of the Prussian General Staff by Moltke a decade later. Longstreet helped bring forward a form of centralized organization by involving the Department of the Army in his movement, where that level of organization had been absent before.

Another type of special staff member Longstreet liked to keep close at hand was one who could provide forms of intelligence. Better known and documented than Longstreet's staff work is his keen use of reconnaissance. He devoted a portion of his time for personal reconnaissance of enemy dispositions, used scouts extensively, and used civilian agents. Longstreet's most famous agent and scout was Harrison who worked for Longstreet during the Gettysburg campaign. Harrison was an elusive personality who disappeared for nearly three decades after the war. He was a key source in Longstreet's ability to plan in early 1863. As a tribute to Harrison's espionage, Longstreet wrote in an 1887 article for *Century Magazine* that Harrison provided him "with information more accurate than a force of cavalry could have secured." To this day, the subject of the Harrison-Longstreet relationship is shrouded in obscurity as both a Civil War story and a source of historical learning regarding the methods of intelligence preparation of the battlefield.[6]

If we recognize Longstreet as a modern innovator in the evolution of warfare, objectivity should lead current historians to reject the contrived postwar attacks on his record as politically motivated propaganda. Clearly Longstreet's politics offended many unreconstructed Southerners. They were hard at work shaping an historical interpretation to advance the notion that the Confederacy was

6 Longstreet, "Lee's Invasion of Pennsylvania," *Century Magazine*, Vol. 11, November 1886–April 1887, 622-636; Longstreet, "Lee's Invasion of Pennsylvania," in *Battles and Leaders*, 3: 249-250; Coddington, *Gettysburg Campaign*, 180-181, 188-189, 651.

overwhelmed by numbers and betrayed by certain officers at pivotal moments. This was the myth that ensnared Longstreet.[7]

The result of the Civil War was that the national power defeated the eleven states that based their secession from the Union on the States Rights doctrine that harked back to the founding of the nation. Militarily, the national power proved superior in the contest of arms. The Lost Cause then continued this war between the two viewpoints and the conflicting interpretations of the Constitution.

Lost Cause writers, speakers, academics, and politicians fought a war of words against those on the winning side. It was the winners who implemented Reconstruction, and the losing side believed they were being punished harshly, unfairly, and unconstitutionally. For the defeated South, part of their war of words was to attack those on their own side who they perceived as inadequate in terms of fervor for the unreconstructed viewpoint. For those who had joined the Republicans, there was only vitriolic wrath, and Longstreet was on the receiving end of that fury.

Thus, Longstreet became embroiled in the wider political struggle of the Lost Cause because of his positions and opinions on the issues of the day. His adversaries used propaganda against him and misrepresented his accomplishments during the war as retribution. Even if Longstreet was right to advise Lee not to make the type of attacks he did at Gettysburg and elsewhere, the retribution brought with it an attack on his record and an assassination of his character. However, postwar sentiments aside, the facts are clear that many in the Confederate leadership chose to fight a Napoleonic war at the beginning of Industrial Age warfare.

It took most of the war for leaders to understand the realities of improvements of firearms, mobility, and industry. There is no denying that Lee won several great victories, and he was a superb army officer, one who was admired by many on both sides. Nor was he completely oblivious to the technical progress of the mid-nineteenth century. Yet, he simply did not have the formative experience and education as a combat arms branch officer necessary to make the transition from Napoleonic thinking to concepts of modern warfare. Lee was an old-world gentleman imbued with Jomini and Napoleon. He clung to long-held assumptions about land warfare and seemed to compensate for not having practical infantry experience with a Napoleonic boldness for the attack.

7 Gallagher, *Lee and His Army in Confederate History*, 267-286.

Longstreet understood Napoleon and Jomini as well as any general of his time, but he only used the older formulae when and where still applicable. Most of his thinking sought to practice the art of war through finding advantages and innovations that would defeat the traditional ways of war. In 1862, by the time of Fredericksburg, Longstreet had made a leap forward in his professional thinking and was ahead of most of his peers and his superior. By 1863, he was a practitioner of methods of land warfare that would become the hallmarks of war in the twentieth century. In 1864 and 1865 many of the methods he pioneered were inculcated into the Army of Northern Virginia. This was a period when the conflict was taking on an increasingly modern aspect. Longstreet helped to bring some of this thinking forward. On the corps level he was the only one on the Confederate side who innovated on a large scale—and therefore Longstreet deserves recognition as the Confederacy's most modern general.

Appendix A

Confederate Fire Support Failure at Pickett's Charge

The failure of the Confederate artillery to support Pickett's Charge was the sum of a myriad of factors. Most treatments of the Battle of Gettysburg provide only a basic observation of what happened—that the Confederates fired over the Union infantry and did not suppress the Union artillery. This sidebar summarizes several primary contributing problems that explain why.

First, and foremost, the failure of fire support was a reflection of the Confederacy's inadequate industrial base. Not enough cannon production was set aside for field artillery pieces; most went to larger, stationary coastal guns. The smaller field artillery pieces manufactured were medium range weapons, and no standard model was produced that might have incorporated uniform, best manufacturing standards. Also, many guns that the Army of Northern Virginia had in 1863 were captured Union pieces. Hence, Lee's army had a mix of types, each with different capabilities, characteristics, and ammunition requirements. All were capable of accurate fire out to medium ranges between 400 to 700 yards, but only a small percentage could hit targets at long range beyond 800 yards.

Second, accurate long-range fires depends on high quality propellant, which was not manufactured by the Confederacy. Most of the powder was of poorer quality than that produced in the North, resulting in retarded range. Fused shells designed to explode on contact were also of poor quality and many were duds. After the battle, many unexploded shells were found by Union soldiers.

Third, training of Confederate artilleryman in long-range fire support was nonexistent. Most battles in 1861-1862 were fought at short and medium-artillery ranges, in terrain surrounded by trees and hills. Long-range fire was rare in those years and was not practiced between battles. The limited amount of ammunition manufactured did not allow for live-fire exercises that would have enabled Confederate gunners to become proficient at long-range fire support. Primitive

range-finding equipment did exist, but due to the absence of training most crews were not proficient in this equipment's use either. Displacement of cannon when firing was also a factor that affected range accuracy. When a cannon fired, it rolled backward, and in a time before hydraulics, muzzle breaks, and spades to absorb recoil, as well as collimater sights † to reset the piece to its exact firing position, the best gunners could do was roll it back where they thought it had been. However, inexact replacement of the piece by even a few inches, translates into geometrically greater inaccuracy at longer range. Lack of training and the inherent limitations of wheeled cannon that displaced greatly after each firing, degraded long range accuracy.

Fourth, terrain made range estimations difficult for leaders to plan fire support, and for the battery commanders to estimate range. Rolling, hilly terrain, such as at Gettysburg, can cause a washboard effect that distorts distances. Modern Forward Observers (FO's) for artillery are given a great deal of training in how to determine ranges and mitigate the washboard effect. Modern FO's also have the ability to adjust fire. Adjustments are done by mathematical computational procedures done at the battery and applied to all guns.The result is accurate predicted fire that overcomes the terrain issues the naked eye cannot. These advancements the artillery observer of 1863 did not have. It should also be noted that terrain at Gettysburg masked much of the Union artillery. A Confederate private on picket duty witnessed Lee and Longstreet come forward to his location east of the Emmetsburg Road, and conduct a reconnaissance of the Union artillery. He heard them discuss what they saw, but during the battle it was clear to this private that Lee and Longstreet never saw a large portion of the Union artillery that was hidden from their view further back. The private saw this grouping of Union artillery when he advanced with Pickett's Division, and witnessed its devastating fire into the division's ranks.

Fifth, the Confederate Chief of Artillery, William Pendleton, was not up to the task of planning, coordinating, and supervising all the Confederate artillery from three different corps. He did nothing to mitigate the inherent problems of having many cannon types with different ranges, poor ammunition, lack of training in long-range fire support, and observational difficulties. The Army of Northern Virginia had approximately 250 cannon divided among three infantry corps and a

† Modern Field Artillery employs the use of aiming points of angular reference to lay a battery of guns in a required direction known as an azimuth. The azimuth at the battery location is set to cross hairs in a reflecting device placed in from of each gun called a collimater. After a gun fires, a crewman aligns a scope on the cannon to the collimater to ensure the piece is re-aligned to the correct azimuth and the displacement is eliminated.

cavalry corps, but Pendleton did not deploy all of it in support of the attack. On the morning of July 3, 1863, Porter Alexander positioned Longstreet's 1st Corps artillery, beginning at 3 a.m. and completing the process by 6 a. m. Pendleton then observed the 1st Corps Artillery at sunrise to his satisfaction, but ordered no movements of the 2nd and 3rd Corps' batteries, only a few of which had been moved in order to participate in the fire support plan. As a result, eighty two of the 250 cannon the ANV possessed—thirty two percent of the total—never fired a shot. Pendleton's ammunition management was equally neglectful. All the artillery that did fire expended most of their ammunition shooting at targets they could barely make out or not see at all. Yet, they kept up a high rate of fire, despite many shells falling short of Union batteries, or exploding in the air on the down trajectory, flying beyond maximum effective accurate range, or just landed as duds. They did rake the areas where they were sure there was artillery, but they had no clue as to the effects on target. The 111 Union cannon waiting to engage the Confederate infantry attack, lost many caissons destroyed, and horses killed in the trains' area. Thirty-four Union cannon were hit and had crews killed and injured, but seventy seven cannon were unharmed. When the Confederate infantry advanced, these guns were reinforced by additional Union artillery that was not on Cemetery Ridge when the Confederate bombardment started. At the climax of the Confederate infantry attack, 134 Union cannon were engaged. When the Confederate infantry advanced, most of their supporting artillery's ammunition had been wasted. Many batteries that had been tasked to move forward did not, due to the danger to their caissons (those that still had some ammunition) of being hit by so much still undamaged Union artillery. Thus, only a handful of Confederate guns in the 1st Corps and a few in the 2nd Corps actually moved forward with the advance. These did not make any difference.

As stated in the chapter on day three, the mission of the Confederate artillery was to suppress, neutralize, and destroy enough Union artillery so it could not attrite the Confederate infantry attack, and then also suppress, neutralize, and punch a hole in the Union infantry line to make the way for the Confederate infantry. Neither goal was achieved, due to the many inherent limitations in the artillery arm of the Army of Northern Virginia. Lee planned, without ever having conducted any training in long-range fire support, a plan so far beyond his Artillery Coordinator's level of experience and competence, there was little chance it could work. With an inadequate understanding of the mostly poor quality of fire at long-range, Lee and Pendleton believed that whatever limitations they may have abstractly suspected could be compensated for by quantity of fire. This was a faulty assumption, borne out by the results. They also thought that engaging the Union

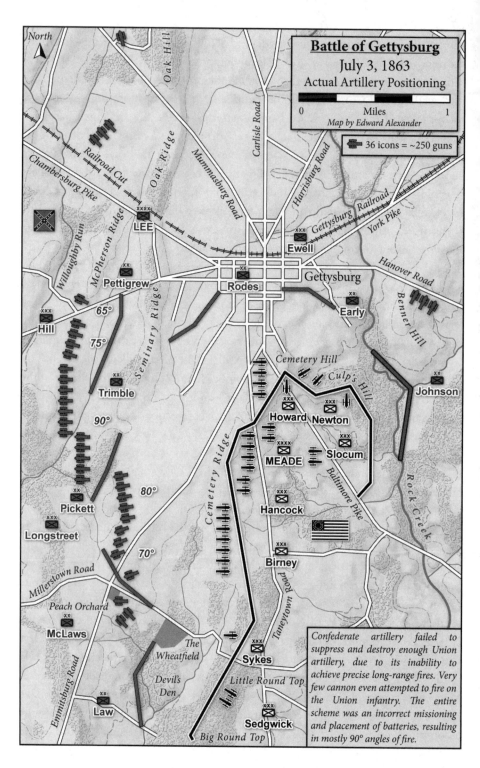

North

Battle of Gettysburg
July 3, 1863
Actual Artillery Positioning

0 Miles 1
Map by Edward Alexander

36 icons = ~250 guns

Oak Hill

Carlisle Road

Chambersburg Pike

Railroad Cut

Oak Ridge

Mummasburg Road

(Harrisburg Road)

Gettysburg Railroad

York Pike

LEE

McPherson Ridge

Willoughby Run

Pettigrew

Rodes

Gettysburg

Ewell

Hanover Road

Early

Benner Hill

Hill 65°

75°

Seminary Ridge

Cemetery Hill

Culp's Hill

Johnson

Trimble

90°

Howard Newton

Slocum

MEADE

Cemetery Ridge

Pickett 80°

Hancock

Rock Creek

Baltimore Pike

Longstreet

70°

Birney

Millerstown Road

Peach Orchard

McLaws

Taneytown Road

Emmitsburg Road

The Wheatfield

Sykes

Devil's Den

Little Round Top

Law

Sedgwick

Big Round Top

Confederate artillery failed to suppress and destroy enough Union artillery, due to its inability to achieve precise long-range fires. Very few cannon even attempted to fire on the Union infantry. The entire scheme was an incorrect missioning and placement of batteries, resulting in mostly 90° angles of fire.

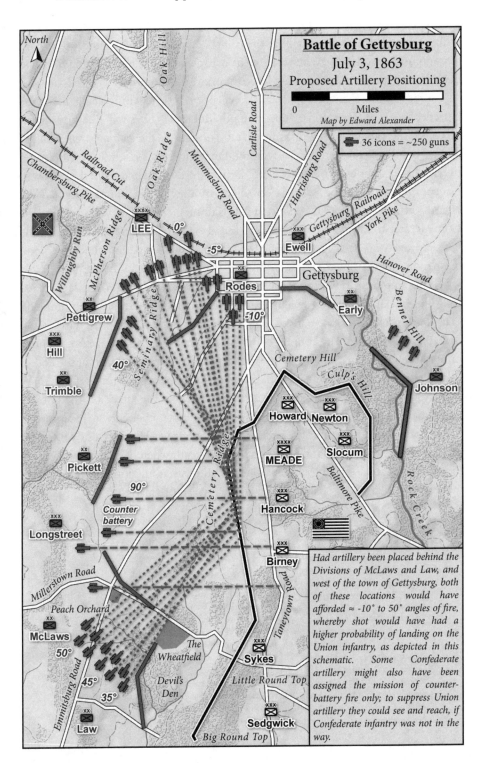

North

Battle of Gettysburg
July 3, 1863
Proposed Artillery Positioning

0 Miles 1
Map by Edward Alexander

36 icons = ~250 guns

Oak Hill

Carlisle Road

Oak Ridge

Mummasburg Road

Harrisburg Road

Railroad Cut

Chambersburg Pike

Gettysburg Railroad York Pike

LEE 0° Ewell Gettysburg

Willoughby Run

McPherson Ridge

-5°

Hanover Road

Pettigrew Rodes -10° Early

Benner Hill

Hill 40° Seminary Ridge Cemetery Hill Culp's Hill Johnson

Trimble Howard Newton

Pickett 90° MEADE Slocum

Counter battery Hancock

Longstreet Baltimore Pike

Rock Creek

Millerstown Road Birney

Peach Orchard Taneytown Road

McLaws 50° The Wheatfield Sykes

Emmitsburg Road 45° Devil's Den Little Round Top

35°

Sedgwick
Law Big Round Top

Had artillery been placed behind the Divisions of McLaws and Law, and west of the town of Gettysburg, both of these locations would have afforded ≈ -10° to 50° angles of fire, whereby shot would have had a higher probability of landing on the Union infantry, as depicted in this schematic. Some Confederate artillery might also have been assigned the mission of counter-battery fire only; to suppress Union artillery they could see and reach, if Confederate infantry was not in the way.

artillery would be accomplished in a reasonable amount of time, and not use up ammunition excessively. When this went awry, and too much ammunition had been wasted, they had not enough left to support the infantry.

Some of these limitations might have been lessened by placing most the batteries west of Gettysburg, and behind McLaws's Division. Getting closer increased their chances of hitting more Union cannon, as did gaining smaller angles of fire to enfilade portions of the Union infantry line. This might have eliminated the need for batteries to move forward, in front of the gun lines, and thus allowed for continuous fire support right up to the moment their infantry reached the enemy infantry line. This alternate positioning might have enabled the Confederates to hit more Union targets, but also invited greater risk. Perhaps the best approach was to forgo attacking the Union artillery and commence fire upon the Union infantry line the moment the Confederate infantry advanced.

It became clear to Lee, after the fact, that the inherent limitations of his mixed cannon force and the lower quality ammunition, could only result in random and inaccurate shelling at long range—something a live fire training exercise would have revealed. His artillery could accomplish short and medium range fire support, but not accurate en masse long-range fire. Writing to President Davis at the end of July he admitted: "I am alone to blame, in perhaps expecting too much if its [ANV] prowess & valor. With my present knowledge . . . that the attack on the last day would have failed . . . I should certainly have tried some other course." Supporting his former commander after the war Longstreet wrote to Hood in a private letter: "I have always thought that Genl Lee spoke the truth when he said of Gettysburg "It is all my fault." Having so generously made this admission I have not been inclined to say anything that might make the error more glaring."[1]

1 Lee to Davis, Camp Culpepper, July 31, 1863, Clifford Dowdy, Ed. *Lee Papers*, 564-568; Longstreet to Hood, New Orleans, July, 8, 1873, in Stephen M. Hood, *The Lost Papers of Confederate General John Bell Hood* (El Dorado Hills, California: Savas-Beatie, 2015), 207; this essay draws from the author's experience as an artilleryman and paraphrases details from three articles in *North & South* magazine written by Richard Rollins. They are: "Lee's Artillery Plan for Pickett's Charge," September 1999, 2.7, 41-55; "Failure of the Confederate Artillery at Gettysburg," January 2000, 3.2, 44-54; "The Failure of Confederate Artillery in Pickett's Charge," April 2000, 3.4, 26-42. Supporting his former commander after the war Longstreet wrote to Hood in a private letter: "I have always thought that Genl Lee spoke the truth when he said of Gettysburg "It is all my fault." Having so generously made this admission I have not been inclined to say anything that might make the error more glaring."

Bibliography

Primary Sources

Unpublished—Manuscript Collections

Cazenove G. Lee Notebooks, Lee-Fendall House, Alexandria, VA.

Cazenove was Robert E. Lee's nephew. He asked questions of his uncle about the war, the years 1866-1870. Later, he was planning to write a book about his uncle, which is the reason he recorded recollections of the talks with Robert E. Lee periodically, c.1871-1907. The planned book was never written. Cazenove became an attorney in Washington, DC, and lived in Alexandria.

Jubal A. Early letter to Jedidiah Hotchkiss, Mar. 24, 1868, Hotchkiss papers, MSS2/H7973/b/2 VHS.

Robert E. Lee Papers, Missouri Historical Center, St. Louis, MO.

Two original letters written by John S. Mosby to the editor of the Times. A rebuttal to General Longstreet's letter in the Times, answering Mosby's view on Jeb Stuart's conduct in the Gettysburg Campaign. Written in San Francisco. Dated Mar 8 and Apr 24, 1896.
Letter written by Robert E. Lee to James Longstreet. A request by Lee of Longstreet to verify scout reports and statements in the Washington Chronicle on the whereabouts of General Burnside and his corps. Dated Mar 30, 1863.
Lafayette McLaws Letter to James Longstreet, Egypt #4 Central R. R., June 12, 1873, Lafayette McLaws Papers, S. H. S. P., University of North Carolina Library, Chapel Hill, N.C.

Correspondence in the Atlanta History Center, Atlanta, Georgia.

Letter written by James Longstreet to Robert E. Lee. Longstreet offering his opinion after Gettysburg that the best chance for success was now in Tennessee; suggesting moving a corps to Tennessee and holding Virginia with two corps. Dated Sep 2, 1863.
Robert E. Lee to James Longstreet, February 20, 1865, quoted in Wilson Cabell letter to Nelson M. Shipp, June 10, 1940, Helen Longstreet Papers, Georgia Historical Society.

Published—Books

Alexander, E. Porter. *Fighting for the Confederacy: The Personnel Recollections.* Chapel Hill, NC: The University of North Carolina Press, 1989.
Anderson, Archer. *The Campaign and Battle of Chickamauga: An Address Delivered Before the Virginia Division of the Army of Northern Virginia, October 25, 1881.* Richmond: William Ellis Jones Steam Book, 1881.
Annals of the War Written by Leading Participants North and South. Dayton: Morningside, 1988.

Bauer, K. Jack, Ed., *Soldiering the Civil War Dairy of Rice C. Bull 123rd NY Vol. Inf.* (San Rafael, CA: Presidio Press, 1977. 97. Also add source to bibliography.

Besler, Roy P., Ed. *The Collected Works of Abraham Lincoln.* 11 Vols., New Brunswick, NJ: Rutgers University Press, 1955.

Blackwood, Jerome, Ed. *To Mexico with Scott: Letters of Capt. E. Kirby Smith to his Wife.* Cambridge: Harvard University, 1917.

Cheney, Newel. *History of the Ninth Regiment, New York Volunteer Cavalry, War of 1861 to 1865.* Poland Center, NY: Martin Mere & Son, 1901.

Chestnut, Mary. *Mary Chestnut's Civil War.* Ed. C. Vann Woodworth. New Haven and London: Yale University Press, 1981.

Clark, Walter, Ed. *North Carolina Regiments, The Histories of the Several Regiments and Battalions from North Carolina in the Great War, 1861-1865.* Vols. I-IV, Goldsboro: Nash Brothers, 1901.

Clifton, J. B. *Clifton Diary.* Clifton Papers, Chapel Hill, NC: University of North Carolina, 1863-1864.

Cochrane, John. *Memories of Incidents Connected with the Rebellion.* New York: Roger & Sherwood Printers, 1875.

Coles, R.T., Ed. Jeffrey B. Stocker. *From Huntsville to Appomattox: R.T. Coles History of the 4th Regiment, AL Vol. Infantry, CSA and the Army of Northern Virginia.* Knoxville: Knoxville University Press, 1996.

Connolly, James A. *Three Years in the Army of the Cumberland: The Letters and Diary of Major James A. Connolly.* Bloomington, IN: Indiana University Press, 1959.

Cox, Jacob Dolson. *Military Reminiscences of the Civil War.* 2 Vols. New York: Scribner's Sons, 1900.

Crist, Lynda Lesswell, Ed. *Papers of Jefferson Davis,* Vol. 8, 1862, Baton Rouge: LSU Press, 1995.

Cross, Harlan Eugene, Ed. *Letters Home: Three Years Under General Lee in the 6th Alabama,* Fairfax, VA: History4All, 2010.

Dana, Charles A. *Recollections of the Civil War.* New York: D. Appleton and Company, 1898.

Davis, Jefferson. *A Short History of the Confederate States of America (1890).* Coppell, Texas: Arcadia Press, 2017.

Dooley, John. *John Dooley, Confederate Soldier: His War Journal.* Georgetown: University Press, 1945.

Douglas, Henry Kyd. *I Rode with Stonewall,* Chapel Hill, NC: UNC Press. 1940.

Early, Jubal, Ed. R. H. Harrison. *Lieutenant General Jubal Anderson Early, CSA.* Philadelphia: J. B. Lippincott Co., 1912.

_____. *War Memories.* New York: Kraus Reprint Co., 1969.

Eggleston, George G. *A Rebel's Recollections.* New York: G. P. Putnam's Sons, 1905.

_____. *The History of the Confederate War.* Vols. I & II. New York: Sturgis & Walton, 1910.

Eisenhower, Dwight D. *Crusade in Europe.* Baltimore and London: The Johns Hopkins University Press. 1948. *Selected for insights from a practitioner of Operational Art.*

Fremantle, James Arthur. *The Fremantle Diary.* Boston: Little, Brown, and Co., 1954.

Grant, Ulysses, S. *Personal Memoirs of U.S. Grant: Two Volumes in One.* New York: Charles L. Webster & Company, 1894.

Guderian, Heinz. *Panzer Leader.* Washington, DC: Zenger Publishing Co., Inc., 1952. *Selected for his insights on modern offensive armored warfare and the Schwerpunkt.*

Hill, D. H. "Chickamauga—The Great Battle of the West," *Battles and Leaders of the Civil War,* 3, New York: The Century Co., 1884.

Hood, John Bell. *Advance and Retreat Personal Experiences in the United States and Confederate Armies.* New Orleans: Burke & McFetridge, 1880.

Hood, Stephen M. Ed. *The Lost Papers of Confederate General John Bell Hood.* El Dorado Hills, CA: Savas Beatie, 2015.

Howard, Oliver Otis. *Autobiography of Oliver Otis Howard.* 2 Vols., New York: Baker & Taylor Co, 1907.

Hunt, Henry J., "The Third Day at Gettysburg." *Battles and Leaders of the Civil War*, 3: 369

Jackson, Mary Anna. *Memoirs of Stonewall Jackson*. Louisville: The Prentiss Press, 1895.

Johnson, Robert Underwood, *Battles and Leaders of the Civil War*, 4 Vols. New York: The Century Co., 1884-1888. *Robert Underwood Johnson was the grandnephew of Bushrod Johnson. He interviewed the contributors and/or edited the articles written by veterans of the war who contributed to Century Magazine, and later republished them in these four volumes.*

_____. *Remembered Yesterdays*. Boston: Little Brown & Co., 1923.

Joseph E. Johnston. *Narrative of Military Operations Directed During the Late War Between the States*. New York: D. Appleton and Company, 1874.

Kettell, Thomas Prentice, *History of the Great Rebellion*. Hartford: L. Stebbins, 1866.

Law, Evander. "From Chickamauga to Chattanooga," *Philadelphia Weekly Press*, July 25, 1888.

Lee, Robert E., Ed. Clifford Dowdey, *The Wartime Papers of R.E. Lee*. Boston: Little, Brown, 1961.

Long, A. L. and Marcus J. Wright. *Memoirs of Robert E. Lee: His Military and Personal History, Embracing a Large Amount of Information Hitherto Unpublished*. New York: J. M. Stoddard and Co., 1886.

Longstreet, James. Several articles, *Battles and Leaders of the Civil War*, 3, New York: The Century Co., 1887.

_____. *From Manassas to Appomattox*. Philadelphia: J.B. Lippincott Co., 1896.

Loring, William W. *Report of the Battle of Baker's Creek and Subsequent Movements of his Command*. Richmond: R.M. Smith, Public Printer, 1864.

Mahan, Dennis H. *Advanced Guard. Out-Post, Detachment service of Troops with the Essential Principles of Strategy and Tactics*. New York: John Wiley, 1863.

Manstein, Erich von. *Lost Victories: The War Memoirs of Hitler's Most Brilliant General*. Chicago: Regenery Press, 1958. *Selected for his insights on Operational Art, modern offensive armored warfare, and the Schwerpunkt.*

McGuire, Judith W. *Diary of a Southern Refugee During the War*. New York: E. J. Hale and Son, 1867.

Moltke, Helmuth. *Moltke on the Art of War: Selected Writings*. Ed. Daniel J. Hughes, translated by Daniel J. Hughes and Harry Bell, Novato, CA: Presidio Press, 1993.

Mosby, John S. *Stuart's Cavalry in the Gettysburg Campaign*. New York: Moffat, Yard, & Co., 1908.

Mullin, Martin P. *Memoir of a Soldier. Diary of Benjamin Taylor Smith*. 1st Book Library, 1999.

Oates, William. *War Between the Union and the Confederacy and its Lost Opportunities: With a History of the 15th Alabama Regiment and the 48 Battles in Which it was Engaged*. New York: American Society for Training & Development (December 1995), 1905.

Owen, William M. *In Camp and Battle with the Washington Artillery of New Orleans*. Boston: Ticknor & Fields, 1885.

Peass, Theodore C. and Randall, James G. Eds. *The Diary of Orville Hickman Browning*, 2 vols. Springfield, IL: Illinois State Historical Library, 1925.

Pollard, Edward A. *The Lost Cause a New Southern History of the War of the Confederates*. New York: E.B. Treat and Co., Publishers, 1867.

_____. *Southern History of the War: The Second Year of the War*. 1863 reprint, New York: Charles B. Richardson, 1865.

Schurz, Carl. *The Reminiscences of Carl Schurz*, 3 Vols., New York: The McClure Company, 1908.

Sedgwick, John. *Correspondence of John Sedgwick, Major General*. Baltimore: Butternut and Blue, 1999.

Sherman, William Tecumseh. *Memoirs of General W.T. Sherman*. New York: The Library Press of America, 1990.

Simpson, Brooks D., Ed. *The Civil War Told by Those Who Lived It*. 4 Vols. New York: Library of America, 2011-2013.

_____. and Jean V. Berlin, Ed. *Sherman's Civil War Selected Correspondence 1860-1865*. Chapel Hill, NC: UNC Press, 1999.

Smith, Benjamin Tylor. *Memoirs of a Soldier*. 1st Books Library, 1999.

Sorrel, G. Moxley. *Recollections of a Confederate Staff Officer.* Jackson, TN: McCowat-Mercer Press, 1958.

Stout, L. H. *Reminiscences of General Braxton Bragg.* Roswell, GA: Heartman's Historical Series No. 63., 1876.

Stiles, Robert. *Four Years Under Marse Robert.* New York: The Neale Publishing Co., 1903.

Taylor, Walter H. *Four Years with General Lee.* New York· D. Appleton & Co., 1877.

Turchin, John B. *Chickamauga.* Chicago: Fergus Printing Co., 1888.

Warfield, Edgar. *A Confederate Soldier's Memoirs.* Richmond: Masonic Home Press, 1936.

Published—Periodical Collections

Bean, W. G., Ed. "Memorandum of Conversations Between General Robert E. Lee and William Preston Johnston, May 7, 1868, and March 16, 1870." *VMHB* 73 (October 1965).

"Gen. Longstreet Paid Uncle Sam in 1862." *Confederate Veteran,* XII, 2. Nashville, TN: Feb 1904.

Ratchford, George. "General D.H. Hill at Chickamauga," *Confederate Veteran,* XXIV, Mar 1916.

Shanks, W. F. G. "Chattanooga and How We Held It," *Harpers Monthly Magazine,* XXXVI, January 1868.

Southern Historical Society Papers.

 Alexander, E. P. "Causes of the Confederate Defeat at Gettysburg." *SHSP.* 4 (1877).

 Early, Jubal. "General Lee's Final and Full Report of the Pennsylvania Campaign and Battle of Gettysburg." *SHSP.* 1 (1872).

 Heth, Harry. "Causes of Lee's Defeat at Gettysburg." *SHSP.* 4 (1877).

 Hood, John Bell. "Leading Confederates on the Battle of Gettysburg." *SHSP.* 4 (1877).

 Lee, Fitzhugh. "Causes of the Confederate Defeat at Gettysburg." *SHSP.* 4 (1877).

 Venable, Charles. "The Campaign from the Wilderness to Petersburg." *SHSP.* 14 (1886).

Published—Newspapers

Galena Daily Advertiser, "The Invasion of Pennsylvania," June 30, 1863.

The Mansion in Ruins: General Longstreet's House Destroyed by Fire. *The Atlanta Constitution* (1881-2001); Apr 10, 1889; ProQuest Historical Newspapers Atlanta Constitution (1868 -1929)

Secondary Sources—Books

Ames, Jessie E. *Leadbetter Records.* J. E. Ames, 1917.

Bassett, John Spencer. *Anti-Slavery Leaders of North Carolina.* Baltimore: The Johns Hopkins Press. 1898.

Battey, George Magruder Jr. *A History of Rome And Floyd County.* Atlanta: The Webb & Vary Co., 1922.

Bonekemper, Edward H. III. *A Victor, not a Butcher: The Battle that Doomed the Confederacy.* New York: Harper Collins, 1928.

Buck, Irving A. *Cleburne and His Command,* New York: Neale Publishing, 1908.

Burton, Brian K. *The Seven Days Battles.* Bloomington, IN: Indiana University Press, 2010.

Carmen, Ezra. *The Maryland Campaign of September 1862 Vol. II: Antietam,* ed. Thomas G. Clemens, El Dorado Hills, CA: Savas Beatie, 2012.

Catton, Bruce. *Gettysburg, the Final Fury.* New York: Doubleday & Co., 1974.

_____. *Grant Moves South.* Boston: Little, Brown, and Company, 1960.

_____. *Never Call Retreat.* New York: Doubleday & Co., 1965.

Clark, John E. *Railroads in the Civil War: The Impact of Management on Victory and Defeat.* Baton Rouge: LSU Press, 2001.

Clausewitz, Carl von. *Principles of War.* Harrisburg: The Stackpole Company, 1960.

Coakley, Robert W. *The Role of Federal Military Forces in Domestic Disorders 1789-1878.* Washington DC: US Army Center for Military History, 1988.

Coddington, Edwin B. *The Gettysburg Campaign: A Study in Command.* New York: Charles Scribner's Sons, 1968.

Coffin, Charles Carleton. *The Boys of '61.* Boston: Estes and Lauriat, 1887.

Coker, Christopher. *War and the 20th Century, A Study of War and Modern Consciousness.* London: Brassey's, 1999.

Collins, Richard. *The War in the Desert.* Morristown, NJ: Time Life Books, 1997.

Conrad, W.P. and Ted Alexander. *When War Passed This Way.* Shippensburg, PA: White Mane Books, 1982.

Connelly, Thomas L. *Autumn of Glory: The Army of Tennessee 1862-1865.* Baton Rouge: LSU Press, 1973.

_____. and Bellows, Barbara L. *God and General Longstreet: The Lost Cause and the Southern Mind.* Baton Rouge: LSU Press, 1982.

_____. *The Marble Man: Robert E. Lee and His Image in American Society.* New York: Knopf, 1977.

Coulter, E. Merton. *William G. Brownlow, Fighting Parson of the Southern Highlands.* Knoxville: University of Tennessee Press, 1971.

Crocker, H. W. *Robert E. Lee on Leadership.* Rocklin, CA: Prima Publishing, 1999.

Cummings, Charles M. *Yankee Quaker, Confederate General: The Curious Life of Bushrod Rust Johnson.* Cranbury, NJ: Associated University Press, 1971.

Daniel, Larry D. *Shiloh, The Battle that Changed the Civil War.* New York: Simon and Schuster, 1997.

Daniel, Larry J. *Cannoneers in Gray: The Field Artillery of the Army of Tennessee.* Tuscaloosa: The University of Alabama Press, 2005.

_____. *Days of Glory the Army of the Cumberland, 1861 1865.* Baton Rouge: LSU Press, 2004.

Dickert, Augustus D. *History of Kershaw's Brigade.* Newberry, SC: Elbert H. Aull Co., 1899.

Desjardin, Thomas. *Joshua L. Chamberlain: a Life in Letters.* Harrisburg: The National Civil War Museum, 2012.

Divine, John E. *35th BN Virginia Cavalry.* Lynchburg: H. E. Howard, 1985.

Doughty, Robert A. *Warfare in the Western World.* Lexington: D.C. Heath and Co., 1996.

Dowdey, Clifford. *Lee's Last Campaign.* New York: Bonanza Books, 1960.

Dunning, William A. *Essays on the Civil War and Reconstruction and Related Topics.* New York: The Macmillan Company, 1898.

Eckenrode, H. J. and Bryan Conrad. *James Longstreet: Lee's War Horse.* Chapel Hill, NC: UNC Press, 1936.

Evans, Clement A., Ed. *Confederate Military History.* Dayton: Morningside Bookshop, 1975.

Fishwick, Marshall W. *Lee After the War.* New York: Dodd, Mead, and Company, 1963.

Foote, Shelby. *The Civil War A Narrative: Fort Sumter to Perryville.* New York: Random House, 1958.

_____. *Fredericksburg to Meridian.* New York: Random House, 1963.

_____. *Red River to Appomattox.* New York: Random House, 1974.

Freeman, D. S. *Lee's Dispatches: Unpublished Letters of General Robert E. Lee to Jefferson Davis and the War Department of the Confederate States of America 1862-1865.* New York: G. P. Putnam's Sons, 1915.

_____. *Lee's Lieutenants: A Study in Command,* Vols. I-IV. New York: Charles Scribner's Sons, 1942-1944.

_____. *Robert E. Lee,* Vols. 1-4. New York. Charles Scribner's Sons, 1936.

Gallagher, Gary W., Ed. *Antietam: Essays on the 1862 Maryland Campaign.* Kent, OH: Kent State University Press, 1989.

_____. *Chancellorsville the Battle and its Aftermath.* Chapel Hill, NC, & London: UNC Press, 1996.

_____. *The Fredericksburg Campaign Decision in the Rappahannock*. Chapel Hill, NC & London: UNC Press, 1995.

_____. *Lee and His Army in Confederate History*. Chapel Hill, NC & London: UNC Press, 2001.

_____. and Alan T. Nolan. *The Myth of the Lost Cause and Civil War History*. Bloomington and Indianapolis: Indiana University Press, 2000.

Gratwick, Harry. *Mainers in the Civil War*. Charleston: The History Press, 2011.

Gunn, Ralph White. *24th Virginia Infantry*. Lynchburg: H. E. Howard, 1987.

Hagerman, Edward. *The American Civil War and the Origins of Modern Warfare*. Bloomington & Indianapolis: Indiana University Press, 1988.

Hallock, Judith Lee. *Braxton Bragg and Confederate Defeat, Vol. II*. Tuscaloosa: The University of Alabama Press, 1991.

Hannaford, Ebenezer. *The Story of a Regiment*. Cincinnati: Published by the author, 1868.

Haskell, Frank. *The Battle of Gettysburg*. Boston: Mudge Press, 1908.

Hessler, James A. and Isenberg, Britt C. *Gettysburg's Peach Orchard*. El Dorado Hills, CA: Savas Beatie, 2019.

Horowitz, Tony. *Confederates in the Attic; Dispatches from the Unfinished Civil War*. New York: Pantheon Books, 1998.

Johnson, Ludwell. *The Red River Campaign: Politics and Cotton in the Civil War*. Baltimore: Johns Hopkins University Press, 1958.

Jones, Archer. *Civil War Command and Strategy; the Process of Victory and Defeat*. New York: The Free Press, 1992.

_____. *Confederate Strategy from Shiloh to Vicksburg*. Baton Rouge: LSU Press, 1961.

Jordan, Thomas, and J. P. Pryor. *The Campaigns of Lieutenant General Nathan Bedford Forrest and of Forrest's Cavalry*. New Orleans, LA: Blelock and Company, 1868.

Katcher, Philip. *The Army of Robert E. Lee*. London: Arms and Armour Press, 1994.

Konstam, Angus. *Fair Oaks 1862, McClellan's Peninsula Campaign*. Westport, CT: Praeger Publishers, 2004.

Korn, Jerry. *War on the Mississippi: Grant's Vicksburg Campaign*. Alexandria, VA: Time-Life Books, 1985.

Lee, Ron and Lambert, James Dennis. *Bridgeport, Alabama—Gateway to the Sequatchie Valley. A Pictorial History*. Kingdom of Bahrain: Dar Akhbar Al Khaleej Printing and Publishing, 2007.

Livermore, Thomas L. *Numbers and Losses in the Civil War in America, 1861-1865*. Boston: Houghton Mifflin Co., 1900.

Longstreet, Helen D. *Lee and Longstreet at High Tide: Gettysburg in the Light of the Official Records*. Gainesville, GA: Published by the Author, 1904.

Major Connolly, James A. *Three Years in the Trenches in the Army of the Cumberland*. Bloomington: Indiana University Press, 1959.

Marvel, William. *The Battle of Fredericksburg: Civil War Series*. Washington DC: Eastern National, 1993.

McDonough, James L. *Chattanooga–A Death Grip on the Confederacy*. Knoxville: The University of Tennessee Press, 1984.

McPherson, James M. *The Battle Cry of Freedom: The Civil War Era*. New York: Oxford University Press, 1988.

_____. *Crossroads of Freedom: Antietam, The Battle That Changed the Course of the Civil War*. New York: Oxford University Press, 2002.

McWhiney, Grady. *Braxton Bragg and Confederate Defeat, Vol. 1: Field Command*. New York: Columbia University Press, 1969.

Mitchell, Joseph B., Lt. Col., *Decisive Battles of the Civil War*. New York: Putnam, 1955.

Moore, Jerrold Northrop. *Confederate Commissary General Lucius Bellinger Northrop and the Subsistence Bureau of the Southern Army*. Shippensburg, PA: White Mane Publishing Co, 1996.

Newell, Clayton R. *On Operational Art*. Washington DC: Center of Military History, 1994.

Newman, Ralph and Long, E. B. *The Civil War Digest*. New York: Grosset & Dunlap, 1956.

Nichols, James L. *Confederate Engineers*. Tuscaloosa: Confederate Publishing Co., Inc. 1957.

Nicholson, James L. *Grundy County*. Memphis, TN: Memphis State University Press, 1982.

Nolan, Alan T. *Rally Once Again! Selected Civil War Writings of Alan T. Nolan*. Chapel Hill, NC: UNC Press, 1995.

_____. *Lee Considered*. Chapel Hill, NC and London: UNC Press, 1991.

Pfanz, Harry. *Gettysburg: The Second Day*. Chapel Hill, NC: UNC Press, 1987.

Piston, William Garrett. *Lee's Tarnished Lieutenant: James Longstreet, and his Place in Southern History*. Athens, Georgia: The University of Georgia Press, 1987.

Polk, William. M.D. *Leonidas Polk; Bishop and General*. Vols. I-II, New York: Longman's, Green, and Co., 1894.

Pullen, John J. *The Twentieth Maine: A Volunteer Regiment in the Civil War*. Dayton, OH: Morningside House, Inc., 1997.

Rable, George. *Fredericksburg! Fredericksburg!* Chapel Hill, NC: UNC Press, 2002.

Reardon, Carol. *I Have Been A Soldier All My Life: General James Longstreet, CSA*. Gettysburg: Farnsworth Military Impressions, 1997.

Reed, Rowena. *Combined Operations in the Civil War*. Annapolis, Maryland: Naval Institute Press, 1978.

Rhea, Gordon C. *Cold Harbor: Grant and Lee, May 25-June 3, 1864*. Baton Rouge: LSU Press, 2007.

Ridley, Jasper. *Lord Palmerston*. London: Constable, 1970.

Robertson, William Glenn. "Bull of the Woods?" *The Chickamauga Campaign*, Ed. Stephen W. Woodworth. Carbondale: Southern Illinois University Press, 2010.

Ryan, David D., Ed., *A Yankee Spy in Richmond: The Civil War Diary of "Crazy Bet" Van Lew*. Mechanicsburg, PA: Stackpole Books. 1996.

Sanborn, Margaret. *Robert E. Lee: A Portrait 1807-1861*. New York: J. B. Lippincott Co., 1966.

Sanger, Donald. *James Longstreet*. Baton Rouge: LSU Press, 1952.

Sears, Stephen W. *Landscape Turned Red: The Battle of Antietam*. Boston: Mariner Books, 1983.

Smith, Justin H. *War with Mexico*. New York: The MacMillan Co., 1919.

Smith, Stuart W. *Douglass Southall Freeman on Leadership*. Newport, RI: The Naval War College Press, 1990.

Snow, William Parker. *Southern Generals: Who They Are, And What They Have Done*. New York: Charles B. Richardson, 1865.

Spruill, Matt. *Guide to the Battle of Chickamauga*. Lawrence, KS: University Press of Kansas, 1993.

Stackpole, Edward J. *From Cedar Mountain to Antietam*. Harrisburg, PA: Stackpole Books, 1993.

_____. *They Met at Gettysburg*. New York: Random House Publishing, 1986.

Stevens, Norman. *Antietam 1862: The Civil War's Bloodiest Day*. Westport, CT: Osprey Publishing Limited, 2004.

Swinton, William. *Campaigns of the Army of the Potomac*. New York: Charles Scribner's Sons, 1882.

Symonds, Craig L. *Joseph E. Johnston: a Civil War Biography*. New York: W.W. Norton and Company, 1992.

Thomas, Emory M. *The Confederate Nation 1861-1865*. New York: Harper and Row Publishers, 1979.

Thomas, Wilbur. *General James "Pete" Longstreet, Lee's "Old War Horse," Scapegoat for Gettysburg*. Parsons, WV: McClain Printing Co., 1979.

Tucker, Glen. *Chickamauga: Bloody Battle in the West*. Indianapolis: Bobbs-Merrill Co., 1961.

_____. *High Tide at Gettysburg*. Indianapolis: The Bobbs-Merrill Co., 1958.

_____. *Lee and Longstreet at Gettysburg*. New York: Bobbs-Merrill Co., 1968.

Wert, Jeffry D. *General James Longstreet: The Confederacy's Most Controversial Soldier*. New York: Simon and Schuster, 1993.

_____. "James Longstreet and the Lost Cause." *The Myth of the Lost Cause and Civil War History*, Ed. Gary W. Gallagher and Alan T. Nolan. Bloomington and Indianapolis: Indiana University Press, 2000.

Williams, Harry T. *Lincoln and His Generals*. New York: Alfred A. Knopf, Inc., 1952.

Wilson, Charles Regan. *Baptized in Blood: The Religion of the Lost Cause, 1865-1920.* Athens: University of Georgia Press, 1980.

Wilson, Clyde N. *Carolina Cavalier: The Life and Mind of James Johnston Pettigrew.* Athens, GA: University of Georgia Press, 1990.

Woodworth, Steven E. *Jefferson Davis and His Generals: The Failure of Confederate Command in the West.* Lawrence, KS: University Press of Kansas, 1990.

Wyeth, John Allen. *The Life of General Nathan Bedford Forrest.* New York: Barnes and Noble, 2006.

Periodical Articles

Allardice, Bruce L. "Longstreet's Nightmare in Tennessee," *Civil War*, Vol. 18, Jan 1, 1989.

Berringer, Richard E. "Jefferson Davis's Pursuit of Ambitions: The Attractive Features of Alternative Decisions," *Civil War History*, Kent State University Press, 38: 1, March 1992.

Clifford, Chaplain George M. "Duty at All Costs," *Naval War College Review*, Vol. 60 Winter 2007.

Cook, Martin L. "Revolt of the Generals: A Case Study in Professional Ethics," *Parameters* Vol. XXXVIII, No. 1 Spring 2008.

Hattaway, Herman, and Jones, Archer. "Lincoln as Military Strategist." *Civil War History*, 26, Dec. 1980.

Murphy, Nell Robert. "The South and Longstreet." *Gainesville Times*, Jul 13, 1938.

Rollins, Richard. "Lee's Artillery Plan for Pickett's Charge." *North & South*, Sep 1999, 2.7, 41-55.

_____. "Failure of the Confederate Artillery at Gettysburg." *North & South*, Jan 2000, 3.2, 44-54.

_____. "Failure of the Confederate Artillery in Pickett's Charge." *North & South*, Apr 2020, 3.4, 26-42.

Sanger, D. B. Lt. Col. United States Army, Was Longstreet a Scapegoat? *Infantry Journal*, vol. XLIII, No. 1. Jan-Feb, 1936.

Savas, Theodore P. "Longstreet Takes Command." *America's Civil War*, Vol. 2, March 1990.

Tucker, Glen. "The Battle of Chickamauga," *Civil War Times Illustrated*, May 1969.

Online Sites

Becker, Bernie "Civil War Spy Henry Harrison." http://members.aol.com/spyharrison/ home/ (accessed on October 16th, 2003)

Combined Arms Research Library Digital Library http://cgsc.cdmhost.com/cdm4/ search.php

Flank, Lenny. "Gettysburg: The Strange Story of Private Wesley Culp," *Dailykos*.com, January 27th, 2015.

Hampton, Brian. "The Influence of the anti-Longstreet Cabal," www.tennessee-svc.org/ long control2, 1. Pentagon Library www.whs.mil/library/

Rand Corporation. "The Visionary: MacArthur at Inchon," rand.org/pubs/monograph reports/MR775.chap 6. *Class text from the Joint Forces Staff College, Norfolk Naval Station.*

Dissertations, Theses, and Presentations

Barnett, Luke J., III. *Alexander P. Stewart and the Tactical Employment of His Division at the Battle of Chickamauga.* Master of Military Art and Science Thesis, Ft. Leavenworth, Kansas, 1989.

Piston, William Garrett, "Longstreet's Military Experience," *Longstreet Society Seminar*, Gainesville, Georgia, October, 2010.

Government Documents

Misc. U.S. Army Publications

Combined Arms Operations 3 Vols., E716/3. Fort Leavenworth, Kansas: Combined Arms and Services Staff School, U.S. Government Printing Office, 1990.

Department of the Army Pamphlet No. 20-269. *Historical Study, Small Unit Actions During the German Campaign in Russia*, Washington, DC: Center of Military History. Jul, 1953.

Professional Memoirs Corps of Engineers, United States Army and Engineer Department at Large, Vol. IX, Jan-Feb, 1917, No. 43, Engineer School, Washington Barracks, D. C. *Contains an article on Dennis Mahan by his son and the Mahan quote in Chapter 4.

Congress

United States Congress. *Committee on the Conduct of the War: Reports* (8 Vols., Washington, DC, 1863-1866).

War Department

United States War Department. *The War of the Rebellion: A Compilation of the Official Records of the Union and Confederate Armies*, 128 Vols. Washington, DC, 1880-1901.

Abbreviations Used in Text and Notes

ANV	Army of Northern Virginia
AOP	Army of the Potomac
AOC	Army of the Cumberland
AOT	Army of Tennessee
CoG	Center of Gravity
DP	Decisive Point
KIA	Killed in Action
LSU	Louisiana State University
NCO	Non-Commissioned Officer
SHSP	Southern Historical Society Papers
UNC	University of North Carolina
VHS	Virginia Historical Society
VMHB	Virginia Magazine of History and Biography

FM 3-0 OPERATIONS, 2/27/2008

FM 3-09.8 FIELD ARTILLERY GUNNERY, 7/31/2006

FM 3-09.12 TACTICS, TECHNIQUES, AND PROCEDURES FOR FIELD ARTILLERY TARGET ACQUISITION, 6/21/2002

FM 3-09.21 TACTICS, TECHNIQUES, AND PROCEDURES FOR THE FIELD ARTILLERY BATTALION, 3/22/2001

FM 3-09.22 TACTICS, TECHNIQUES, AND PROCEDURES FOR CORPS ARTILLERY, DIVISION ARTILLERY, AND FIELD ARTILLERY BRIGADE OPERATIONS, 3/2/2001

FM 3-09.31 TACTICS, TECHNIQUES, AND PROCEDURES FOR FIRE SUPPORT FOR THE COMBINED ARMS COMMANDER, 10/1/2002

FM 3-90 TACTICS, 7/4/2001

FM 3-90.1 TANK AND MECHANIZED INFANTRY COMPANY TEAM, 12/9/2002

FM 3-90.5 THE COMBINED ARMS BATTALION, 4/7/2008

FM 3-90.6 THE BRIGADE COMBAT TEAM, 8/4/2006

FM 3-90.12 COMBINED ARMS GAP-CROSSING OPERATIONS, 7/1/2008

FM 4-0 COMBAT SERVICE SUPPORT, 8/29/2003

FM 4-01.011 UNIT MOVEMENT OPERATIONS, 10/31/2002

FM 4-01.30 MOVEMENT CONTROL, 9/1/2003

FM 4-01.41 ARMY RAIL OPERATIONS, 12/12/2003

FM 5-0 ARMY PLANNING AND ORDERS PRODUCTION, 1/20/2005

FM 6-0 COMMANDER AND STAFF ORGANIZATION AND OPERATIONS 5/11/2014

FM 6-20-10 TACTICS, TECHNIQUES, AND PROCEDURES FOR THE TARGETING PROCESS, 5/8/1996

FM 6-20-30 TACTICS, TECHNIQUES, AND PROCEDURES FOR FIRE SUPPORT FOR CORPS AND DIVISION OPERATIONS, 10/18/1989

FM 6-20-40 TACTICS, TECHNIQUES, AND PROCEDURES FOR FIRE SUPPORT FOR BRIGADE OPERATIONS (HEAVY), 1/5/1990

FM 6-20-50 TACTICS, TECHNIQUES, AND PROCEDURES FOR FIRE SUPPORT FOR BRIGADE OPERATIONS (LIGHT), 1/5/1990

FM 6-22 ARMY LEADERSHIP, 10/12/2006

Index

Harold M. Knudsen is an Illinois native. His career spans 25 years of active-duty service with the U.S. Army and includes seven resident career artillery, command, and staff Army schools and colleges. He spent many years of tactical experience in the integration of fire support into maneuver plans and fire control computation for cannon units. Harold is a combat veteran of Desert Storm, where he performed extensive artillery fire planning and execution in support of the U.S. breakthrough of the Iraqi line and penetration into Iraq. His years of staff work at the Corps, Army, and Pentagon levels give him a strong understanding of Army operations from the lowest to highest levels.